AFRICAN ART

In memory of my father
For Magda, Yannick and Sacha

Ivan Bargna

AFRICAN ART

Jaca Book

ANTIQUE COLLECTORS' CLUB

On the jacket:
Alusi figures, Igbo, Nigeria
Giorgio Bargna Collection

Translated by
Jacqueline A. Cooperman

Revised by
Michael Thompson

British Library Cataloguing-in-Publication Data
A catalogue record for this book
is available from the British Library

ISBN - 88-16-69005-4

Printed and bound in Italy

Antique Collector's Club:
5 Church Street, Woodbridge, Suffolk IP12 1DS, England
Tel. 01394 385501 Fax 01394 384434
and
Market Street Industrial Park
Wappingers' Falls, NY 12590, USA
Tel. 914 297 0003 Fax 914 297 0068

Editoriale Jaca Book:
Via Gioberti 7, 20123 Milano, Italy
Tel. 39 2 48561520/29 Fax 39 2 48193361

Contents

Introduction

The Invention of African Art

The societies and cultures of Africa have long been considered through the sign of closure and immutability, their arts contracted in the rigid space of classification that consigned them to immobility within the confines of a static and mannered otherness. In the *gran partage* that contrasted the primitive and the civilized, "cold" societies from "hot", "closed" societies from "open", Africa found itself on one side, with Europe on the other[1].

What we would like to suggest here instead is a reading of African art under the sign of "openness", the sign of complexity, the sign of openness to encounter and change. We will not present it under the sign of *permanence* but of *transition*[2].

We will therefore seek to demonstrate how the identity of African works of art is not reintroduced from the outside; it remains the same. The work of art does not derive from an unaltered archetypal foundation but from its capacity to articulate the present, reinvent the past, and give itself a future.

In its openness to the Other (men, gods, and cultures), in the communal elaboration of the work, in the assumption of a situational identity relating to multiple interpretative contexts and use, in attempting to give shape to the invisible and trace the internal and external thresholds and passages of the humanized world, in all of these African art finds the conditions of its possibilities.

The African work of art has the power to open to the sacred and give it shape within a context which sees the artwork come to life. For against the impossibility of containing it completely, art leads back to its boundaries, to its character of incessantly retaken and continually reborn attempts, which explains its longevity and its changes.

This opening to the outside world does not signify the decadence of the African work of art, but corresponds to its beginning. The relationships between diverse African cultures as well as the relationships with other continents multiply, on the one hand, the artistic shapes of the sacred in a syncretic way while, on the other, they weaken the intensity or reduce the reach, favoring other forms of expression or taking the art to the land of the profane.

A work of art opens the world up, making it thinkable and livable, allowing the work to create a web of relationships and take its place in the world. Art defines places and appears as an object in them, offering itself as a point of anchorage for power and a point of emergence for a form of knowledge.

The identity of an African work of art and its relationship to the sacred mutate in time and space, and it flourishes only within an interpretative horizon.

In this sense, we can say that in great part the history of "African Art" has developed outside of Africa, even if, in the end, it belongs there. If we can, in fact, speak, as we have done so far, of "African Art", we can do so only by starting with the arrival of certain African objects in Western countries and their inclusion in a determined discursive order and field of visibility.

The identity of an object is defined starting with its relationship with the background

from which it stands out, the history of its reception, and how it was used, defining and modifying its conditions of visibility and sense, which are integral parts of the object's identity.

Before landing in the realm of art, African objects in the West are therefore objects of curiosity (*objèts trouvés*), of disdain ("fetishes"), of documentation (first naturalistic objects, then ethnographic ones). The objects go through different space and time contributing in greater or smaller measure to their definition, both shaped by and shaping the gaze of those who look upon them.

Their physical movement (from Africa to the West, from museum to living room) is the result of their inclusion in new semantic fields; this is what determines their destruction and their worthiness (symbolic and economic).

The objects move in clusters. These migrations are formed by masses of objects, but not always the same objects that we find under various labels. Some are lost and others are added since, with the mutation of the devices of power and knowledge, various filters arrive through which to view them; relationships of proximity are established; representations of reality look to assert their worth[3].

The African object is remodeled by its movements within Western epistemological frames, and from time to time it becomes a culturally neutral object in Renaissance space, a satanic or superstitious object in missionary discourse, a fossil, or perhaps evidence of the primitive stage of humanity within evolutionary anthropology's spatialized concept of time.

No less relevant from this point of view will be the metamorphoses working on the internal movement within the realm of art. Passing from primitive art to "*art nègre*" to "tribal art" to "African art", such objects will appear within completely different spatial-temporal frames, becoming survivors of ancient phrases of humanity, permanent foundations of the human psyche, products of broad geographic-climatic conditions, or symbols of circumscribed ethnic identity.

"African Art" is not, therefore, a linguistic term or conceptual category that indicates or defines an objective and preexisting identity in a neutral way, but the expression through which, during a certain historical period, "foreign" was translated into "ours".

The concept of "art" as much as the concept of "Africa", historically variable in terms of their significance and reach, are culturally rooted in the West[4]. "African art" was born in twentieth Century Europe under the impulse of the artistic *avant garde* and exported later to "Africa" to become a constructed element of pan-African identity.

The necessary conditions for the existence of "African art" are the institution of the museum and the development of an outward look on the continent.

It requires the arrival of Vasco da Gama to circumnavigate the globe, the technology that allows him to do so, the cartography that collects his experience, the writing that transmit this memory.

It requires that the museum be recognized as a space of classification and visibility in which disparate objects (in terms of history, function, or geographic provenance) are placed under the common denominator of "form" and *assimilated* in the "universality of works of art", united among themselves and *distinct* from us because of their geographic provenance.

The stylistic and conceptual identity of African works of art is a result contingent on encounter: it emerges from the comparison between "their" art and "our" art, rebinding in the background the local systems of relationships, whose fabric of resemblance and difference is reduced to internal variations and regional stylistic differences.

The reality of African art is therefore *artificial* (in the sense that it comes after the production of the manufactured objects that incorporate it) and *intercultural* (in as much as it finds Western acceptance one of the conditions of its existence).

Even the blacks who contribute to this creation do so from the outside. The African identity claimed by pan-Africanism is an invention of African-Americans. It is the cultural leveling brought about by slavery – the unity of American space – that makes it possible to conceive of Africa as a "nation", a single spiritual identity[5]. African identity is a recent creation, and the fact that a history of pre-modern Africa existed is an invention of modern Africa[6].

When Senghor in Paris invents the ideology of *négritude* proclaiming – in opposition to the Greek philosophy of reason – the primacy of emotions and therefore the primacy of art in black identity, it resounds, changing the sign, the racist Gobineau (art is "the king of infancy where the black man is king"), and the platonic distinction between art and science (with the inferiority of the former)[7].

We cannot say *what* Africa is, only *when* there is "African art"[8], drawing up a genealogical map of the transformations through which certain objects are positioned under this label: it is an identity which gradually develops.

The extension and field of application of the concept of "African art" vary in time, excluding and including from time to time different objects, geographic areas, and cultures, with a tendency towards a progressive expansion of boundaries, towards an ever more vast assimilation. Objects like wooden stairs (Plate 10) that until not so many years ago fell outside the category of "art" are now included with full recognition. It is a question neither of the recognition of a denied identity nor of the mercantile mystification of an adulterated identity; it is more a matter of an active transformation, of the acquisition of a new identity. Under the contemplative eye of a gaze with aesthetic leanings, the relevant reference is not to the context of usage but to the sculptures of Brancusi.

The great London exhibit *Africa '95: The Art of the Continent*[9] clearly displayed the tensions between the diverse paradigms that currently give shape to African art. Egyptian art, Islamic art, and Sub-Saharan art (not without resistance) have found a place in the same container, melting old geopolitical alliances and connecting them anew, while the works of the 20th century, which may have better demonstrated the Euro-American influence within African art, were not admitted (despite requests) but hosted in parallel exhibits and around the edges[10].

The summary recognition that we have set forth by way of introduction does not have any truth to disclose, but seeks only that we avoid taking words for things, knowing full well that the reality of things continues to be constructed, and necessarily constituted, in large part by words. It is not a question of abandoning the arbitrary subjectivity of stereotype and prejudice to embrace a representation that is neutral or corresponds to the way

1. Sebastian Munster, map of Africa, Geografia, 1540

The geographic and cultural identity of Africa has been transformed over time with the relationships that arrived from outside of Africa: diverse names were attributed to the continental mass that we today call "Africa", and the spaces gathered under this label are variable: in Munster's map, the term designates the whole (as can be inferred from the wording "Africa extremitas") and the part (the ancient Roman province) at the same time. In the map, names of Greek origin, of "Aethiopia" and of "Lybia" also appear.

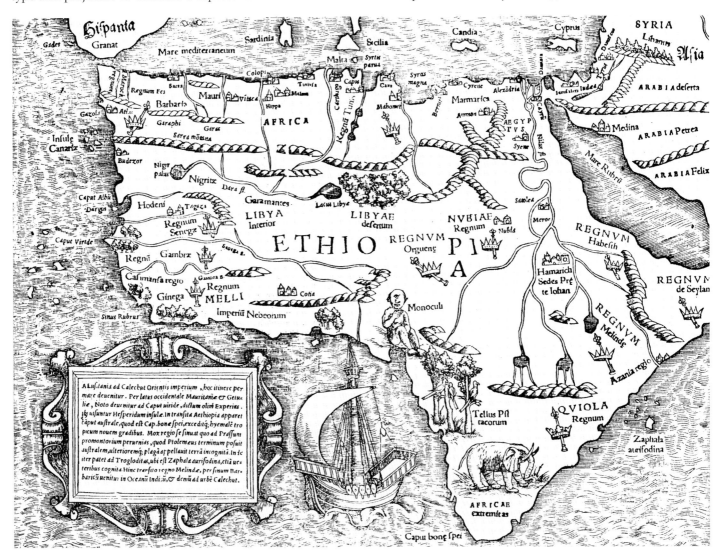

in which the other views himself. It is rather a matter of opening a space of consciousness in *chiaroscuro*, in light and shadow, of the strategies of the production of otherness that our culture has put forward. We construct the identity of the object based on the signs that the other, the work, sends us. This is the direction taken by many of the organized exhibits since the 1980s, which have had as themes not African art, but our relationship with it: the criteria by which the objects are selected (*The Art of Collection African Art* – 1988), our projections on African artifacts (*Perspectives: Angles on African Art* – 1987), or the role that the museum performs in the definition of an object as a work of art (*Art/Artifact* – 1987)[11].

The "thing" in itself remains enigmatic, showing itself only in foreshortened and partial views, reassembling itself in different ways, as much here as in Africa, according to the view that perceives it; its reality is not closed but open and in the process of becoming. It cannot give itself but in an historically and culturally situated interpretation, from one culture to another, a translation of the visible to the utterable. None of the interpretations succeed however in fully gathering and exhausting the object, and it reveals itself therefore in a way that is inevitably dated and incomplete. The "thing" is irreducible from the "object", and objects exist as such only in relation to the practices that define them. The "thing" is given only as an open multiplicity of objects within determined constellations of power-knowledge[12].

It is a question therefore of seeking a point of equilibrium, dynamic and unstable, between welcome and distance, of knowing how to see our own perspective as a pretense while remaining necessarily within it[13]. The awareness that otherness is the result of an interpretive construction of reality, and not a preexisting object in the interaction, has the effect of decentralizing us from ourselves.

The admission of the variability and arbitrariness of our constructions does not make them false, but opens them up to a work of mediation, making them partially available to an intercultural negotiation in the event of a provisional agreement.

In the attempt, therefore, to trace a common thread, to delineate a common profile within the kaleidoscope of forms and cultures that go under the label of "African art", we cannot but exhibit our limits, with the understanding that the existence of truth is in its wanderings.

In a conventional way we will speak of "African art", using the term to mean "the art of sub-Saharan Africa", while looking to build bridges to the outside. We will concern ourselves with "traditional arts" while underlining how the traditions are not extraneous from time and how African art is not given only to the past. We will trace an outline of "African space" while underlining the inevitably "fictitious" character of the coordinates we will assign.

In the first section, we will adapt the pretense of the "ethnographic present", describing the cultures as if they had an indefinite duration and were not the result of unremitting circumstantial adjustments, though we will insist on the dynamism of these spaces. In the second section, we will instead give greater attention to historical periods, looking more to the opening towards the present and the future than the roots of the past.

Viewing African Art

Frequently, in front of African statues, our attention is drawn to certain characteristics: frontality, symmetry, motionless, deformation of natural proportions, fixity of expression (Plate 76).

To the recognizable familiarity of the anthropomorphic element (it is unquestionable that we are discussing the human form), we add sentiment from a distance. Each one of us perceives detachment from the organic point of reference and from the representations of humans to which we are accustomed, modeled as they are on the precepts of classical sculpture and photographic representations.

From this implicit comparison, we have the impression of finding ourselves before something incomplete, unfinished, or imperfect. The human form seems harnessed in the material; the body does not succeed the form of an initial wooden block, but inserts itself in it, taking its place.

These sensations, while not being "true", are not "wrong"; the aesthetic experience that we have before the work relating itself to our aesthetic codes allows us to perceive the deformity, to notice the extraneousness, but not to explain it. In the lack of words and the awkwardness, we have the experience of those limits outside of which our cultural references waver and become useless.

We can decide to find a remedy for any such discomfort through a simple projection of our interpretive schemes outside of their fields of pertinence, as when we attribute to African sculptors the intentions and objectives that were those of a Greek or Renaissance sculptor, then assign them to failure, or as when we lend them the conceptual preoccupation of a cubist or surrealist artist, calling them precursors. Though the results are different – in one case rejection, in the other acceptance – they are both annexations and inclusions with little respect for the autonomy of the meaning of the work. Even if it is true that the identity and history of a work include all the transformations induced by the ways it is used, we still need to distinguish between *use* and *interpretation*. The way a work is used can ignore the author's intent deposited within. It is free with regard to the circumstances of production and bound to the context of utilization. The interpretation of a work, in the measure to which it looks to conserve some kind of "truth" must, on the other hand, be found in the "rights of the text", the limits of its own liberty[14]. If interpretation is always inventive, perceptive, and situated, it then becomes a falsehood when it attributes to another its own vision of reality. If one cannot find an agreement on the best, one can at least exclude some part of the infinite number of potential interpretations.

Understanding an African work of art demands the effort of connecting it to its place of provenance and integrating the aesthetic experience with ethnographic information.

We cannot ask the ethnologist, though, to give us a direct hold on a living reality, to reinsert the work in the original context as if nothing has happened, to restore to our eyes a virginity they never had, to see through the mask with the eyes of the indigenous person.

Ethnologists, in fact, are not the ones who can restore other cultures to us in all their purity. Travelling to the place does not make them indigenous. Even if it did, it would make them indigenous through and through, equal to the Africans about whom we want to learn, and we would finish by losing them. Passing to the other side would not build any bridges, but leave the situation of separation unchanged.

Anthropologists, in the first place, cannot estrange themselves from their own culture, unless it be provisorily and partially. They bring with them their personal histories, their academic careers, their bibliographic and iconographic references; their work in the field has publication as an end, its transcription in the body of knowledge, and that selectively prefigures the ways and possibilities of the experience they can have[15].

Their comprehension of the situation comes in terms of comparison with, analogy to, or rejection of what they already know. The scientific or popular communication of the results of their research takes place within the rhetorical and stylistic conventions of a determined literary genre. Anthropologists, therefore, are not only observers but authors who travel and write for a reading audience whom they must help to understand and whose needs they aim to satisfy. From this point of view, the reality of "ethnic art" can be seen as a product of an ethnographic monograph, a form of descriptive essay that, intending to treat a single population in an exhaustive manner, finishes by cutting off or concealing its ties to others.

However, this limitation is also and inseparably the condition for the possibility of success, for the fact that anthropologists can tell us something that will have significance.

This work of mediation is not given in terms of a mechanical transfer of information and news; the work of *transcription* is in fact a work of *translation*: translation from the visible to the utterable, from one language to another, from the spoken to the written, from a reality lived in the first person to a literary precipitate that makes it communicable. None of these passages comes in a homogenous continuum but includes jumps from qualitative transformations that allow the insertion of data in the coordinates of a different system. The translation, in fact, lives in the relentless contrast between two contradictory needs: making the foreign understandable by reducing it to the familiar, seeking inside of our own culture the words and experiences that allow us to give it meaning, while avoiding, in the same process of moving from the unknown to the familiar, the loss of the precise difference we want to articulate. Paradoxically therefore, the ideal of a complete translation without changes would hide the true negation of difference that we want to understand, while acceptance of the partiality of the translation, with all its rejections, alterations, and shifts of meaning, would preserve in the other his differences. To translate, therefore, is not look at the other as he views himself, but to find a sense in the other that also makes sense to me, while avoiding a reduction of the other to me[16].

The ethnographic contextualization through which there is recognition of the indigenous aesthetic can thus amplify our aesthetic experience, bringing it beyond the cultural limits of our vision.

An important role from this point of view is that of ethno-ethicism, a branch of eth-

nology that aims towards the recognition and reconstruction of indigenous aesthetics in their difference with respect to Western aesthetics and each other. But as a field of knowledge, ethnology, as with aesthetics, has its roots in the West; only after having isolated and constructed the "aesthetic experience" as an object of knowledge can we begin the research of the ways of other cultures. We speak therefore of a culturally rooted frame of mind, a prediction of meaning, in relationship with which other people's experiences emerge for contiguity or contrast, constituting an intertwining fabric of similarity and difference[17].

NOTES

[1] B. Latour, "Le Grand Partage," *La Revue du MAUSS*, Jan. 1988

[2] M. Perniola, *Transiti*, Cappelli, Bologna 1985; J.G. Bidima, *La Philosophie Négro-Africane*, PUF, Paris 1995; Id., *L'Art Négro-Africain*, PUF, Paris 1997

[3] J. Clifford, *The Predicament of Culture. Twentieth-Century Ethnography, Literature and Art*, Harvard College, 1988 (Italian translation *I frutti puri impazziscono. Etnografia, letteratura e arte nel XX secolo*, Bollati Boringhieri, Turin 1993, pp. 249-288)

[4] P.D. Curtin, *The Image of Africa, British Ideas and Action, 1780-1850*, University of Wisconsin Press, Madison 1964; C.L. Miller, *Blank Darkness, African Discourse in French*, University of Chicago Press, Chicago 1985; V. Y. Mudimbe, *The Invention of Africa. Gnosis, Philosophy and the Order of Knowledge,* University of Indiana Press, Bloomington and Minneapolis 1988

[5] A. Irele, "Pan-Africanism and African Nationalism", *Odu*, June 1971

[6] I. Wallerstein, *Unthinking Social Science*, 1991 (Italian translation *La scienza sociale: come sbarazzsene. I limiti dei paradigmi ottocenteschi,* Il Saggiatore, Milan 1995, pp. 137-145)

[7] L. S. Senghor, *Liberté 1. Négritude et humanisme,* Seuil, Paris 1964 (Italian translation *Libertà 1. Negritudine e l'umanismo*, Rizzoli, Milan 1974, pp. 208-221); A. Irele *"Négritude Revisited" Odu*, May 1971

[8] N. Goodman, *Ways of Worldmaking*, Hackett Publ., Indianapolis 1988, pp.57-70

[9] T. Phillips, editor, *Africa: the Art of a Continent*, Prestel, Monaco – New York, 1995

[10] J. Picton, "*Africa '95* and the Royal Academy", *African Arts,* March 1996

[11] S. Vogel, editor, *The Art of Collecting African Art*, Center for African Art, New York 1988; S. Vogel, editor, *Art/Artifact. African Art in Anthropology Collection*, Center for African Art, New York, 1987; S. Vogel, editor, *Perspectives: Angles on African Art*, Center for African Art, New York, 1987

[12] M. Foucault, *Microfisica del potere*, Einaudi, Turin 1977; M.-J. Borel, "Le discours descriptif, le savoir et ses signes" in J. – M. Adam, M. – J. Borel, C. Calame, M. Kilani, *Le discours anthropologique. Description, narration, savoir*, Payot, Lausanne 1995

[13] P. A. Rovatti "Retoriche dell'alterità" *aut aut*, 252/1992

[14] U. Eco, *I limiti dell'interpretazione*, Bompiani, Milan 1990, pp. 5-55

[15] C. Geertz, *Works and Lives. The Anthropologist as Author,* Stanford University Press, Stanford 1988 (Italian translation *Opere e vite. L'antopologo come autore*. Il Mulino, Bologna 1990); J. Clifford, G. E. Marcus, editors, *Writing Culture: Poetics and Politics of Ethnography*, The Regents of the University of California Press, Los Angeles 1986 (Italian translation *Scrivere le culture. Poetiche e politiche in etnografia*, Meltemi, Rome 1997)

[16] S. Borutti, *Teoria e interpretazione. Per un'epistemologia delle scienze umane,* Guerini and associates, Milan 1991, pp. 79-120

[17] L. Sthéphan, "La sculpture africaine, essai d'esthéthique comparée" in J. Kerchache, J. – L. Paudrat, L. Stéphan, *Art africain*, Mazenod, Paris 1988

Part one
THE TOPOLOGIES
OF AFRICAN ART

2. Map of the ethnic groups and cultures cited in the captions

1 Ashanti (Ghana); 2 Baga (Guinea Bissau); 3 Bamana (Mali); 4 Bamileke (Cameroon); 5 Bamun (Cameroon); 6 Bariba (Benin); 7 Bassar (Togo); 8 Baulé (Ivory Coast); 9 Bembe (Congo); 10 Bena-Lulua (Congo); 11 Bidjogo (Guinea Bissau); 12 Bobo-Fing (Burkina Faso); 13 Bwa (Burkina Faso); 14 Chokwe (Angola); 15 Dan (Ivory Coast); 16 Djenné (Mali); 17 Dogon (Mali); 18 Edo, kingdom of Benin (Nigeria); 19 Eket (Nigeria); 20 Fang (Gabon); 21 Fante (Ghana); 22 Fon (Benin); 23 Gourunsi, Kassena (Burkina Faso); 24 Hausa (Nigeria, Niger); 25 Hemba (Congo); 26 Ife (Nigeria); 27 Igbo (Nigeria); 28 Ijo, Kalabari (Nigeria); 29 Jimini (Ivory Coast); 30 Kantana (Nigeria); 31 Kirdi (Cameroon); 32 Kom (Cameroon); 33 Koma (Ghana); 34 Kongo (Congo); 35 Koro (Nigeria); 36 Kuba (Congo); 37 Kwele (Gabon); 38 Lobi (Burkina Faso, Ivory Coast); 39 Luba (Congo); 40 Luguru (Tanzania); 41 Maghetu (Congo); 42 Makonde (Mozambique, Tanzania); 43 Malhafay (Madagascar); 44 Marka (Burkina Faso); 45 Mbuti, Pygmy (Congo); 46 Mende (Sierra Leone); 47 Mfinu (Congo); 48 Mossi (Burkina Faso); 49 Nafana (Ivory Coast); 50 Ndengese (Congo); 51 Nkana (Congo); 52 Nok (Nigeria); 53 Ntomba (Congo); 54 Nupe (Nigeria); 55 Ogoni (Nigeria); 56 Pende (Congo); 57 Peul, Fulani (Mali, Burkina Faso, Nigeria); 58 Punu (Gabon); 59 Sakalawa (Madagascar); 60 Sapi (Sierra Leone); 61 Senufo (Ivory Coast, Mali); 62 Songye (Congo); 63 Swahili (Tanzania); 64 Teke (Congo); 65 Widekun (Cameroon); 66 Wojo (Congo); 67 Yoruba (Nigeria, Benin); 68 Zigua (Tanzania); 69 Zulu (South Africa)

1. To Stay in Proximity, to Ensure Distance
The Relational Field of African Cosmologies

African space can be considered a relational field in which the identity of everything that exists depends on the strength that is in everyone, which in turn depends on the position it occupies in the web which makes up the world and whose map is furnished by tradition.

The identity and the relationship between people, things, animals, spirits, and divinities develops then against the background of a common consistency. It is the same strength – impersonal, divisible, transmittable – that in its unequal distribution constitutes the actual in all its multiplicity of aspects. At the foundation then of African representations of the world, there would be a concept of a monist type separate from any ontological dualism, a concept which would render useless those categories striving to introduce into the substantial fundamental differences among the diverse aspects of reality, categories such as material-spiritual, inherent-transcendent, natural-supernatural, sacred-profane, and magic-religious. In order for a supernatural world, object of faith and beliefs, to exist, it needs to be contrasted with the natural world, with a science constructed on the basis of hypothesis and subject to verification. In African religions, one does not believe in the existence of spirits; one experiences them[1].

The afterworld and the present world are not, therefore, incommensurable worlds but two aspects, two regional variations, of the same reality. The alternating of life and death in the cycle of reincarnation with their reversibility precisely demonstrates the continuous coming and going which categorizes them. The afterworld and the present world draw their own reality from the porous borders that divide and unite them; their identity, i.e. what distinguishes them, is the result of their relationship, i.e. what unites them.

African space is not a homogeneous geometric entity, divisible in equivalent and measurable parts but a discontinuous and stratified space, tied to concrete situations. No empty space to fill exists, but a whole of places created by events. We are discussing a topological space which cannot be defined using formal properties or metric measurements on the basis of qualitative relationships: internal-external, open-closed, all-part. For as far as we can attribute the sky to the gods and the earth to men, and for such a relationship to be graphically or plastically represented, it would have nothing to do with a transcendence situated in a spatialized afterlife. The afterlife is immanent in, and sustains the world of, the living. For this reason, it is completely credible for an ancestor to be in the sky at the same time he or she is on earth.

People and things, spirits and divinities, acquire an identity in relation to the position they occupy in a web of multiplicity and changeable relationships that define time and space as elastic.

It so happens that a very clean symbolic distinction between African and agricultural cultures – like that between the humanized space of the village and that of the wild space

of the savanna or forest (*brousse*) – would not, however, be as exclusive and physically definable as we might think.

The Gourmantché of Burkina Faso distinguish between the civilized space of the village and the adjacent cultivated land (fecund and feminized space) on the one hand and on the other the abandoned or never cultivated land (sterile and masculine earth), which is instead the dwelling place of the roaming spirits, and places between the two, temporarily or discontinuously, the intermediate space of cultivated earth.

The distinction though, is only apparently geographic. Rather, the *brousse* is the place that is far from the human while being physically very close at times; it does not involve distance as much as the indistinct appearance, the absence of differentiating outlines. While the village is modeled on the structure of the human body, in the *brousse* one does not grasp any clear principle of organization; it is the non-space of ubiquity and metamorphosis. For this reason, at night, with its obscurity, every space outside the house tends to become *brousse*, and for this reason we also see that advancing under the dazzling light of midday flattens the figure, rendering it less distinct[2].

Things proceed similarly among the Hausa of Nigeria, whose concept of *garii*, which in an improper way can be translated as "city", includes not only the real settlements but also the areas that are uninhabited and potentially inhabitable, the single village as the entire inhabited world: a space that in reality they also extend over and under the earth's surfaces, including the sky and the wells whose water is indispensable for life on earth. Outside the *garii*, there are not only desert areas, places outside of a determined border, but all the unfruitful lands that are behind or outside the settlement (lavatories, trash deposits, areas of untended growth).

The *garii* expand at dawn, when their inhabitants go to work in the fields, and contract at night when the inhabitants return to the village[3].

Similarly, the Ashanti of Ghana contrast the orderly space of the village with the disorderly space of the forest and connect the marginal areas on the edge of the borders: the cemeteries, the forests of the ancestors, the huts of menstruating women, the lavatories, the rubbish. Pushing the "dirt" towards the outside, they try to distance their village from death. With the same intention, heaps of trash were placed on the roads used by English soldiers to "hinder" their advance[4].

The primary need is to preserve the social and moral order that constitutes human space from disintegration. the Ashanti, while having built their fortune on the commerce

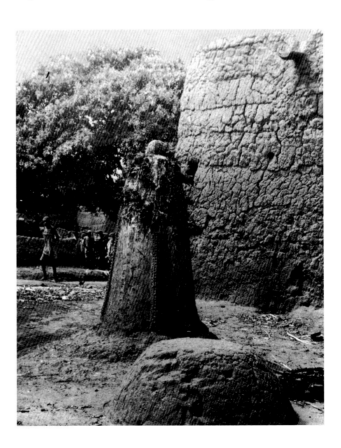

3. Altar to the ancestors, Bobo, Burkina Faso, 1957

The presence of ancestors, male and female, is insured through earthen altars shaped like cones, placed near the entrance into homes; they mark the central generator of life and are the object of sacrifices. On the peak are the chicken feathers offered to the progenitors.

of gold dust, have probably also seen a danger there. Its continuous moving and passing from hand to hand, its capacity for making the most diverse things equivalent, made it a threat to the ordering of the world and brought them closer to the indefinite space of the forest. Perhaps it is for this reason that some important subjects are missing from the figurative system of gold weights, a collection of bronze figurines that visualize the cultural universe of the Ashanti and that, together with the proverbs, transmits their traditional knowledge. The representation of houses and certain animals that are domestic or somehow associated with the village would be excluded, becoming possible only in symbolic systems in which the differences are clearly marked, as in the hierarchical distinctions of staffs[5].

It is not only the *brousse* that penetrates the territory of men. Men also, with changing results, adventure into the *brousse*, annexing parts of it in ways that can be permanent or transitory. The hunting expeditions of the Lobi hunters of Burkina Faso thus cut out territories of an ephemeral duration in which hunting becomes possible through sacrificial practices that use statuettes (*bateba*). Through their intervention, the undifferentiated expanse of the savanna is locally transformed into a protected place, neutralizing the spirits that live there[6].

In general lines, the separation does not go from man to nature but from humanized nature to wild nature. The need for demarcation accompanies that of the connection: we are not speaking of exercising a dominion over nature but of grafting a human space onto its breast.

Between the artificially modified space and natural space, bridges are built through the preparation of natural places, which are modified in ways that are nearly imperceptible. Such places include rock shelters, trees of a certain shape, and springs and waterways, places which all introduce into the perceptively relevant differences of the *continuum* of the savanna or forest the suggestion of the presence of a non-human intentionality. Into this, men insert themselves in ways that seem to follow the same design, underlining the continuity between the two orders.

In an analogous way, the altars of the ancestors placed at the entrance to or in the center of familial compounds often present themselves as simple mounds of earth, almost protuberances of dirt. The element of rootedness in the past and in the earth where the dead live is returned in the similarity between natural and artificial form.

African space is socially relational and emotionally connoted – welcoming, uncertain, hostile, a proxemic space in which the distances grow or are reduced according to the course of the relationship[7]. The harmony of individual life, social and cosmic, comes from the positive relationships that constitute themselves in the maintenance of "proper dis-

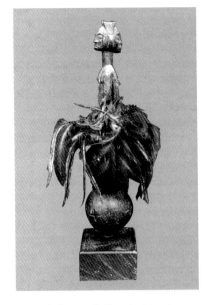

4. Rattle/harness bell, Luba/Hemba, Congo;
wood, feather, height 22 cm

The Janus-shaped figures, in the hands of the clan leader, mediate between the world informed by the spirits of the forest and the world of men, or between men and ancestors, taking part in the sacrifices that seek to construct a reciprocal relationship between the parts. On the conical summit is a cavity that contains the magical substance that activates the statuette; the serene countenance of the figure contrasts with its formidable nature and expresses the gathered, contained, and potential energy.

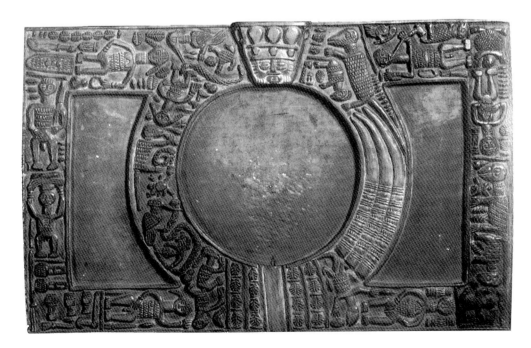

5. Plate for divination (opon ifa),
Yoruba, Nigeria (16th-17th centuries);
wood, height 15.8 cm

The iconography of opon ifa plates gives sculptural form to the world's copenetration of order and disorder: the segmented and multifocal design that associates figurative and abstract elements in a discontinuous aggregate, without a determinable relationship, suggests the autonomy of the powers; the quadrangular and circular forms echo the delineated and thus regulated field that is the arena. The distinction between frame and center recalls instead the reciprocal implication of visible and invisible.

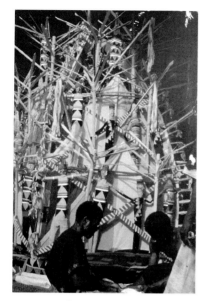

6. Ijele mask, Igbo, Nigeria; wood, fabrics

More than five meters high, it is probably the largest African mask. It has an architectonic structure that recalls circular edifices with a conical head. Made from an interlacing of wood covered by brilliant, multicolored fabrics, the mask incarnates the idealized leadership of the ancestors and at the same time expresses the collective opposition against the illegitimate pretensions of living leaders. The group that actively participated in the construction, with a great spending of resources, affirms its own identity through the building. While the inner-most part of the mask, the carrying axis, symbolizes the unalterable principles of the community, the outer-most part recalls the dynamic aspect of life: the mask's dimensions grow, always including new fabrics, representations of ancestors, divinities, animals, minor masks, and other cultural elements, changing with the position of the group and its components.

7. Sculpture of the Egba *altar, Yoruba, Nigeria; wood, metal, traces of color, height 70 cm*

8. Gelede *mask, Yoruba, Nigeria; wood*

In Yoruba art, single figures are flanked by groups of sculpted works. Within the focal center of maternity, diverse figures are placed in a circular arrangement and on two levels (the group head with the fly swatter, the flute player, the pregnant woman, etc.). In their togetherness, the figures reaffirm the value of social relations, taking them back to the origins. At the same time, there is public censure for unbecoming behavior, and sexuality that is sterile, individualistic and mercenary.

tances" between gods and men, between the sexes, between different age groups, between relatives, between social ranks. If the world of men can be born with the original Fall or defect in creation, in Africa as elsewhere, the effort does not go in the direction of the absorption of the fracture, to a return to the sky that will mark the end of an earthly exile, but in the direction of the preservation of the world one lives in with the equilibrium of the other. The world of men is its own because it participates in and is distinct from the worlds of gods and animals. People are who they are precisely because they participate in and are separate from the community they take part in.

This is why the myths of the Ashanti explain the estrangement of Nyame, God the Creator, from the world of men with the annoyance caused by the noise of women preparing food. The separation is not caused by an unusual incident but by an essential life activity[8].

Life arises from the discontinuity and cross-reference that guarantee individual identity in the relational participation of all. Precisely for this reason, the Yoruba of Nigeria represent the world as a pumpkin cut in half, with one part serving as a container (the earth, *Aye*) and the other the lid (the sky, *Orun*). The possibility of life runs only along the opening, the cut that separates and unites.

One complementary duality is expressed in a dynamic key by the divinities Ifa and Eshu, who preside over divination. One guarantees the order of the world while the other causes the disorder that introduces change. This is a cosmic order which provides the base for a political system based on a king whose power comes from the god of the sky, Olorun, from the secret *oghoni* society of elders, from the worshipers of Onile, the god of the earth (or of the ancestors who have been gathered in the earth), and from the council of state (*Oyo Misi*), whose members represent the people and therefore, on another level, humankind.

The abolition of distance and the reunion of men and divinities that can be realized through *trance* or dancing mask are regulated, ritualized transgressions of limits that are reconfirmed precisely because of the exceptional nature of the infraction[9].

These are regulated routes of approach involving a going and a returning that sometimes take the form of a movement in space. In the pilgrimage, one leaves the village to face the test of a voyage, to reach the "full space" of a sanctuary and return to the point of departure, an itinerary that does not annul the distances between men and gods but that makes them practicable[10].

When things go well, it is because every one is in their place. When, instead, individuals and communities are struck by illness or misfortune, it is because certain distances between people or between people and things which are symbolically incompatible have become shortened. These errors are repaired by identifying the forbidden transgression and paying the proper debt through a sacrificial offering that reintroduces the separation between the elements that accidentally came into contact[11].

Everywhere, the relationship comes first. Individuality does not exist before it, nor have sense in and of itself. Society is not the result of the union of independent individuals and bearers of rights; individuality is nothing outside of the relationship, and for this rea-

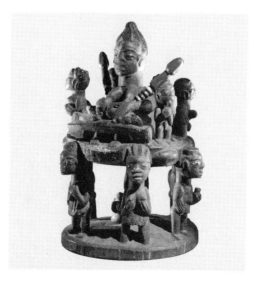

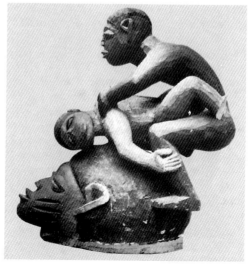

son exile from a community is equivalent to a death sentence, to letting oneself die. Individualism is on the side of deviance[12].

African religions are not based, therefore, on conversion, on the personal and intimate rapport between an individual and divinity but, profoundly falling on the structures of the societies themselves, are a way of collective life that does not demand any other choice: the existence of God does not require any other act of faith and asks no other demonstration[13].

The communal identity of a people is sometimes expressed iconographically. The miniature masks that the Dan of the Ivory Coast wear on their necks ensure an individual protection, thanks to the relationship they establish with the larger community masks that have to protect the entire village[14]. The Ashanti of Ghana, instead, use chairs that they believe contain elements of the person who owns them, while the 'soul' of the nation is held in a gold chair[15].

The relational life of the Yoruba becomes an explicit artistic theme with the creation of sculptor groups who, in the arrangement and proportions of figures, express the hierarchical ordering of the cosmos and the society (Plate 3).

In the African game of *awele* (Plate 22) – which exists in close to 200 names and local variations – competition, cooperation, and the interdependence of the sides all combine on a playful and symbolic level[16]. The two or four rows of boxes correspond to the "tillable fields" of each player, while the pieces, which are often actually seeds, correspond to the "seeds". Even if one is allowed to occupy the field of another to gather one's own harvest, there is no right to leave the adversary without any seeds, thus reducing him to "starvation".

In the Fang version of the game (*mbek*), one can instead read the mood and dynamics of the village: the boxes correspond to the two rows of huts that host the two segments of lineage. The winning strategy – to capture the "houses" on the opposite side, moving the "people" (pieces) who live there – is analogous to the practice of numerically expanding one's own segment until arriving at the construction of homes on the other side of the village. But in the game, as in life, the opposition and competition of the parts are united in a circular, unifying movement from one side of the village to the other, contradicting one[17].

Biological death does not involve the destruction of the person, nor his or her relational existence. It is, instead, solitude, isolation, separation, and the absence of relationships that lead from impotence to death. The dead person does not really die if a descendent conserves the memory of the deceased in perpetuity and solicits an intervention, calling out among the living.

The only true death is the one driven by sterility, cutting off definitively any chance of a relative. Procreation therefore becomes an imperative in as much as it is the only way to return to earth, to ensure immortality, or at least postpone one's death for generations until every memory of oneself has become extinct. In that moment, the person will disappear into the anonymous and indifferent mass of the spirits of the dead, the minimum level of existence.

The development of a person and a community lies in the amplification of the relational fabric (familiar, clannish, communal, inter-communal, religious) in the multiplication of life. This development of life through participation does not only pertain to the living on earth but also, more than anything, to those living in the invisible otherworld who can be recalled in this world or penetrate it in some undesirable way. The life of a group of people who are part of it will be as full or as tight as the chain that unites the ancestors and their descendents. The life of each will therefore be the prolongation of those who preceded them and the preparation for those who will follow.

For this reason, sterility can lead to the social, if not physical, death of an individual. Sterility is suspect and often looked upon as a sign of witches who have cut every relationship with the community, condemning themselves to hostile isolation.

The centrality attributed to fertility places in a primary position two orders of closely-connected relationships: that between men and women and that between ancestors and descendents. The circularity of the relationship between life and death rests upon their base. Procreation not only requires the presence of a man and woman, it also puts them under the protection of their ancestors, drawing them to the source of their lives, the central generator of the community, where they find their place along a line of descendents (Plates 1,2).

The complementary opposition between masculine and feminine is at the base of many mythologies and cosmologies, as well as social organizations and the art of the African people. Sky and earth are often thought of as divinities, the one masculine and the other feminine. The parts, thus distinct, find themselves within their own internal symbol-

9. Mbek *game, Fang, Gabon*

Through this game, the Fang express the tensions that oppose the two complementary halves of the village. The two lines of inhabitation mark the rivalry of the parts and at the same time realize the village's defensive unity. The playful valences do not exclude sacral implications. In the Ivory Coast, playing awele *during the night could have cost a life, because that was the time reserved for the game of the gods. If one spoke of choosing a leader however, the claimants to the throne, after appropriate rituals, were made to play for the entire night: the winner would be the one pre-selected by the gods.*

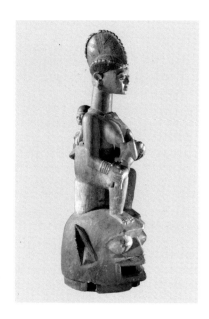

10. Epa Iyabeji ("*mother-of-twins*")
*mask, Yoruba, Nigeria; wood, pigments,
height 102 cm*

*The sexual roles are represented here in
their specificity and their relations,
making the object a treatment that is
stylistically differentiated and of a
component integration. It is idealized
realism on one side, severe schematicism
on the other. The sweet and serene
expression of the woman, the attention
to detail, is contrasted with the rigidity
and hardness of the masculine face. The
contrast is emphasized as much on a
sculptural level as on a chromatic one
(red, black — blue, white).*

ic duality, so that the earth will have its feminine side, cultivated and fecund, and its masculine, uncultivated or sterile. For the Fang of Cameroon, the "cold" and inhospitable forest is the place for the activity of men (hunting, harvesting fruit, cutting plants, war) while the "hot" space of the village is the place for women's activities (cooking, child rearing)[18].

The cosmos are thus constructed on the base of a binary order that proceeds in pairs, whose members are diverse but similar, ambivalent, rediscovering the opposite in their own internal selves.

In the cosmogonic Dogon myths – which sink their roots in a religious substratum shared among the people of western Africa – the creation that lands on man develops through successive phases that alternate complementary figures of duplicity with figures of singularity, figures of tearing, figures of completion, of lack, of change[19]. The possibility of self-generation from the first ones is a sign of their perfection, but the impossibility of maintaining themselves in that state, the inevitability of movement, is added.

The earth created by the god Amma is as much masculine as it is feminine, but this impedes the relationship between them, and as a consequence there is the birth of a single being, the jackal, symbol of disorder. Order can only be restored through exsection, the destruction of the masculinity of the earth, passing through a stage of androgyny and on then to that of relations between the opposite sexes. After the creation of genies called Nommo, other figures of androgyny, and the twin births, Amma proceeds to the creation of men and women who are sexually opposite but who conserve both a masculine and a feminine soul within. The oneness, the total separateness represented by the jackal who lives in the uncultivated *brousse* remains the sign of disorder, of that which must be avoided. Order is always relational and communal. But here also, identity suddenly involves distinction and distance, feminine exsection and masculine circumcision. Human life and the entire cosmos is marked by the compromise between aspirations towards perfection and completeness and the necessity of determining oneself as an individual entity. Here, then, one finds the life of relations understood as an attempt to construct a manifold destiny.

The centrality and problematic nature of man-woman relationships explain the frequency of this theme in African iconography. The androgyne as the ideal figure of a complete being is present as much in Congolese mythology as in western Africa (Plate 5, 28). Here we find the coupling of twins of the opposite sex in which duality is governed by the shared birth but which already opens an initial passage into chaos. This mythic couple establishes the first relationship between the sexes as a precarious alliance of differences[20].

Masks often dance in couples – as in the case of the *gelede* mask (Yoruba), the *bedu* (Nafana), and the *chi wara* (Bamana) – and their aesthetic runs along the masculine-femi-

11. *Couple, Dogon, Mali; wood, metal,
height 73 cm*

*The complementary relationship that is
realized between man and woman is
rendered in the strong resemblance of
the figures in volume, posture, and
expression; the differences draw from
the details which, however, mark the
sexual differences in an irrefutable way.
While the left arm of the man takes the
hand to the penis, the right arm passes
over the shoulders of the woman to
touch her breast with his hand, a gesture
that in one sense establishes a
relationship between the figures, at least
on appearances, of intimacy (the penis-
breast connection as an echo of the
procreative function of the couple) and
in another sense hierarchizes on the
basis of male activity and female
passivity.*

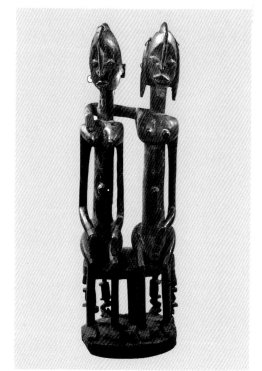

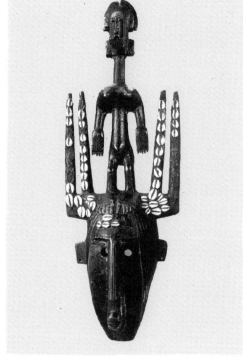

nine polarity (Plates 40, 41). So too among the Dan of the Ivory Coast, where *deangle* masks are described as feminine, beautiful, and sweet. They have a fineness of lines, broad forehead, almond-shaped eyes which are sometimes painted white, a slim nose, and full mouth. *Bagle* masks, on the other hand, are seen as masculine and grotesque. These have narrow forehead, tubular eyes, sloping lips, and a flat nose[21].

In the *n'domo* masks of the Bamana of Mali, man is imagined as he was when he exited from the hands of God. The horns are a symbol of fertility and vary in number, from mask to mask, according to a precise sexual symbolism. Three and six are tied to masculinity, to the impulse of desire and knowledge, four and eight to femininity, to passivity, corporeality, and life. Two, five, and seven are instead tied to androgyny, to the coexistence of activity and passivity, to the duality of intelligence and animality, to the necessity of work, and the combination of masculine and feminine in married life, as well as in social life and the unity of the individual person. Human beings exist in the oscillation and combination of these extremes, and the masculine face of the mask and the feminine figure that rises above it are expressions of this[22].

Precisely because the African representation of the world is a monist type (one is the life force) and the identity of parts is a relational type, great care is put into tracing thresholds and boundaries. Words and things operate only as long as the world does not fall into the undifferentiated space in which every distance is eliminated or does not resolve itself conversely in the fragmentation of unrelated singularity and deprivation of communication.

This internal differentiation of the life force is not, therefore, superfluous in that it can be life (and in particular, human life) without separation and distance, relations and articulations, to each one its place.

This determines that the search for an intense relational life is accompanied by the need for reserve, tact, the prohibition of an expression overly directed towards the sentiments and opinions that lead to the use of names and substitutive objects, to proverbs, and to eloquent silence.

Particularly guarded are the borders between the world that is visible and the world that is invisible (rites of birth, funerals, rites of periodic renewal, cults of the ancestors and divinities), between the world of men and wild nature (rites of foundation, rites of agriculture, propitiatory rites for hunting and the spirits of the *brousse*).

The webs of dialogue and marriage ensure the circuit of communication and the movement of the judicious progression tied to the continuation of life.

Thus, in Dogon mythology, a close correspondence is realized between speaking, weaving, cultivating, and procreating, all operations that consist of articulating relations ordered among the parts. The earth created by Amma becomes a significant space in that it is articulated, and thus directed. "It stretches itself from east to west, separating its membranes like a fetus from the uterus. It is a body, therefore a thing whose membranes are separated by a central mass." Interlaced fibers that function as clothing place a remedy on the disorder the naked wordless earth finds itself in following the incident with Amma that gave life to the jackal. With these fibers, there is a language that causes them to appear because the word, much like a humid stream, like every other form of water, divides the helicoid course among the interwoven fibers and therefore finds inside itself the transport most appropriate for diffusion; the technical perfecting of the weaving will contemporaneously bring about improved speech[23].

2. The African Dwelling

The structure of dwellings and settlements favors the grouping of firsts; the living model that guarantees the greatest relational intensity, and therefore the greatest strength, is privileged, combining into everything a religious symbolism, codes of behavior, and practical defensive needs.

In Africa, the most widespread living unit is that which corresponds to the extended family, which collects multiple generations under a single roof, as well as the guidance of an elderly family member. The different extended families belonging to a single lineage divide the perimetrical walls, sharing courtyards and kitchens and using interior doors to move from one area to another. Sometimes lineages that are part of the same clan (families with ties of real or fictitious kinship traced back to a common ancestor) tend to place themselves in the same quarter.

The grouping – the growth, the union – proceeds at the same rate as the differentia-

(Facing page)
12. N'domo *mask, Bamana, Mali; wood, cowry shells, 60.9 cm*

These masks are used in the context of the N'domo *society that represents the first step of the Bamana initiating process; the masks associated with each level transmit knowledge to the initiates. The N'domo mask is the image of man as he exited from the hands of God. Its symbolism echoes the complementary dynamic between masculine and feminine.*

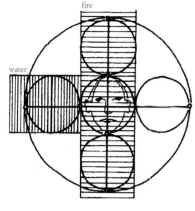

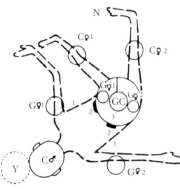

tion of the living space towards the outside and as its internal diversification. It is a space defined by an oriented disposition, thresholds, routes regulated by crossings, spaces of transition or of connection, private, inaccessible places.

The village or building is structured in a way that respects the hierarchical ordering of the forces represented by the different social groups living there. The introverted space of Hausa houses, which reduces the openings to the outside to a minimum, allows the "veiled" movements of women within their homes. The sequential disposition of space in the dwellings of the Yoruba, with the succession of rooms moving from grandfather's to father's to first born's, follows the same route as the succession of generations[24].

The principle of the gradation of space assumes a particular emphasis in the case of African monarchies, where fulfillment is found in a progression that leads from open spaces (the paths of the city destined to host public manifestations of power) to the internal courts of the palace where government business is regulated, moving to the inaccessible rooms that preserve the talismanic depositories of the sacral power of the king.

The articulation of a hierarchical, sexual, integrated space is sometimes realized by representation in terms of an animal's body. The distinction between body parts and their distribution allows for their multiplication within an ordered system of correspondences, spatially reproducing the collective distribution of sacrificed animals in the foundation rites of the settlement. The body, human or animal, allows for the definition of a qualitatively differentiated and oriented space. The distinction between right and left presupposes that of front and back, ahead and behind, and lends itself to being thought of according to a polarity of positive and negative. And so, among the Yoruba, rites and normal daily activities favor the use of the right hand and the right side of the body, while the use of the left hand and the left side characterize exceptionality, those zones of existence most filled with danger and power which are the exclusive patrimony of the secret association of the *ogboni*[25].

In addition, the human body does not merely represent a metaphor of space but constitutes the first significant united space, with all the problems pertaining to distinction and relation in an internal and external field and their communication. As such, the body is branded and protected, rendered culturally recognizable. Here is the widespread practice of ornamentation, the temporary or permanent deformation of the body, which becomes a surface for the inscription of signs or a mass to model plastically, lending particu-

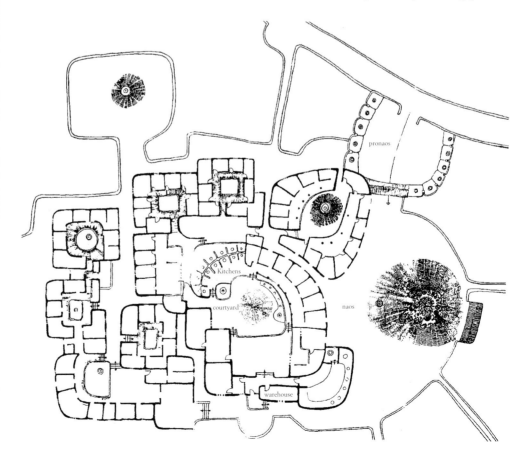

lar care to the most exposed parts and the orifices in which the internal and external, introjection and expulsion, dangerously overlap[26].

The corporal gestural character in its ritualized form institutes, reconfirms, and passes beyond the borders of physical space. And this is how the king of the Nupe had to ritually reconfirm the possession of his own palace, moving around it on a horse every day[27].

The dance opens communication with the gods by enlarging the vertical orientation of the body and extracting from it its heaviness. There are widespread dances that include jumps, acrobatics, or the growing in stature of the dancer through masks or stilts.

Doors assume a predetermined role in the management and control of spaces. Doors mediate between inside and outside, allowing a selective and regulated access (Plates 8,9). Doors, in fact, signal the interruption of a border in a line of insuperable principle (the one traced by the enclosure or perimeter walls) while at the same time, through the lock, strengthening closure. Their function of protection is ensured not only by their material consistency but often by the apotropaic power of the figures and designs carved on them. When, among the Bamana, a feminine figure appears on the locks of the houses used by a man to receive friends, it is to guarantee the faith of the husband through the admonishing figure of the wife. If one places a certain magical substance on a lock, it has the effect of "closing its (the lock's) mouth"[28].

Significantly, the name the Igbo use for doors (*Mgbo ezi*) is that of a "covering" or 'skin"; the door provides the same protective function in the context of living space that the skin provides in matters of the body. The analogy is reconfirmed by designs on the doors that re-employ both the masculine scarification *ichi* and pictorial motifs of the feminine body *uli*. The combination of masculine and feminine designs on the surface of the door allude to the structure of familial relationships, to the complementary nature of men and women, and, at the same time, in the compression of feminine designs within a masculine format, to the predominance of the man within the patrilinear structure[29].

Living structure is not a rigidly defined architectonic space but a pulsating space that changes with modifications in the relational fabric.

Among the Fali of Cameroon, for example, the house is subject to continuous modifications that signal phases of the course that cyclically, for each generation, leads life towards death. It thus passes, with the growth of the family and by successive enlargements, from the minimum living unit, a just-married man and his lone wife, without children, to a structure sufficiently articulated as to be able to host four wives and their children. Once the apex of living development and life has been reached, the phases descending towards old age then begin, with children getting married and living on their own and wives who die or divorce. In a parallel way, the living space contracts until it returns to the minimum

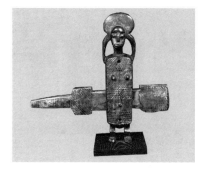

15. Granary door, Dogon, Mali; wood, iron, height 86 cm

The two parts of the door, joined by two metallic joints, may have alluded to twin birth, to the primordial couple, and to the unity of the Mandé people. The figure of the lizard (nay) is part of the Dogon mythology.

16. Lock, Bamana, Mali; wood, metal, height 38 cm

The lock symbolizes the matrimonial union. The vertical element represents the woman, while the horizontal element, the bolt, represents the man; in the western part of the Bamana country, the locks are connected on the outside, while in the eastern part, probably due to the stronger influence of Islam, they are placed inside, allowing for closure from within.

17. Maghetu woman, Congo

18. Mask on stilts, Punu, Gabon

The body becomes an object of manipulation through temporary or permanent alterations of surfaces and volumes, as in the cranial deformations and tubular Maghetu hairstyles or in the stilts of Punu masks that incarnate the dead.

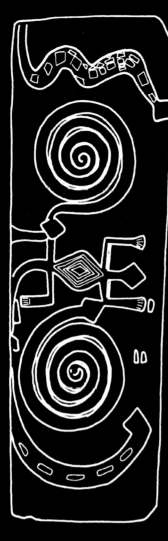

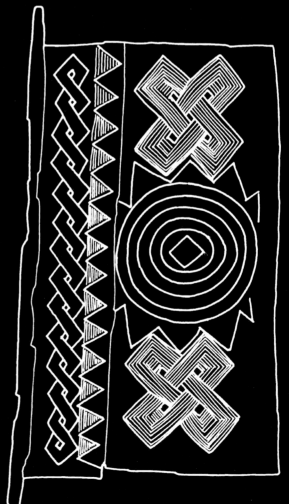

beginning of a single room while alongside, according to the same processes, the children's houses develop[30]. Hausa houses are also subject to a continuous process of construction-destruction following the demographic evolution of the family. In general, all the mutations come within the boundary walls, but if the number of married sons with children is such that they cannot be contained within the walls, they proceed to construct a new compound[31].

Such a process of cyclical renewal of architectonic structures finds expression, in a different context, not in living arrangements but in veneration in the earthen sanctuaries (*mbari*) of the Igbo of Nigeria. These structures can last up to two years and are then abandoned to time and severe weather conditions. The emphasis is not on the duration of the structure but on the periodic renewal of the edifice and the Igbo world that is sculpturally represented[32].

This habitation principle favoring the duration and intensity of ties extends along generations, embracing the dead as well, sometimes in architectonically visible ways, as in the case of the royal palace of the Fon of Abomey (Benin) where, over a vast area, structures that hold the remains of diverse successive kings rise side by side, a multitude of palaces in one palace, a sort of city within a city, resting on the principle of a permanent tie between the dead and living and illustrating and celebrating the genealogy of the monarchy, giving time a spatial expression[33]. While a cyclical spatiality and temporality prevails in Fali and Hausa dwellings, with their shrinking and swelling in alternate phases, here the emphasis falls instead on succession, on the linearity of dynastic time and its parallel, the progressive swelling of space inside the palace.

Differently, the capital of the Congolese king of the Kuba is abandoned and reconstructed in another location for each new king. The other settlement is abandoned with the body of the king buried in his palace. On an urbanistic level, the idea of renewal prevails, demanding of the commemorative statuary the principle of the continuity of the monarchy (Plate 74). This continual relocation of the capital is not, however, random or arbitrary; it moves in a precise direction, from west to east, following the mythical migration begun by the cultural hero Mboom. The movement in space and the memory of abandoned settlements thus become a temporal index and – at most – what happened very far away can be understood as having happened a long time ago. The time of origin coincides therefore with the oldest and furthest place in the sense of the current that moves towards the west[34]. The palace, built with wooden poles and panels that use the ribbing of palm leaves, is constructed straddling the midway point between the northern and southern halves of the city, looking towards the east[35].

African space is thus defined locally and in relation to time, and both are thought of not abstractly but in relation to their contents, to what happens there, to the relationships that linger there. There is a penetration of time and space that in the Bantu language sees the presence of a single term indicating both. Their distinction comes in a subordinate way, as a specification of a "localization", an individuation of things and events on the basis of a place occupied in the dimensions of space or the duration of time[36].

At times, the representation of space is constructed with the salient elements of the landscape (rivers, hills, rocks, woods, springs, termitarium) that are ritually and economically significant and temporally framed in history and myth. At other times, the spatial imaginary world is not tied to the physical environment but draws from the language of descent and genealogy that establishes not only the basis of social assembly but also terri-

20. Motifs of Uli *feminine corporal painting, Igbo, Nigeria*

21. Panel of a palace, Edo, Nigeria; wood, length 139.5 cm
The panel is divided into two sections: on one part, the imago mundi *of the crocodile that bites his tail appears, on the other part the king* (oba) *with his attendants. The crocodile, enveloping creation, conserves it and prevents it from disintegrating; the circle that it traces recalls the cyclical nature of time; the act of devouring itself recalls the reversibility of life and death.*

(Facing page)
19. Door, Baulé, Ivory Coast: two snakes — symbols of water and of the solar spiral — attack a crocodile.
Door, Igbo, Nigeria: in the linear and angular motifs of the masculine Igbo aesthetic, the curvilinear motifs of the feminine body are inserted in a complementary and subordinate way.
Door, Nupe, Nigeria: human figures, animals, and objects appear on Nupe doors and give a representation of the natural and cultural world.
Door, Yoruba, Benin: in western Africa, the geometric motifs of zigzag lines and concentric circles are very widespread and generally echo the movement of life.

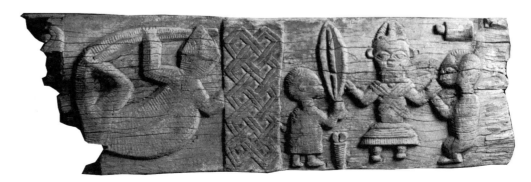

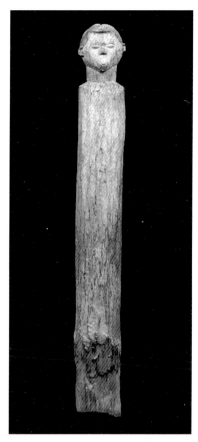

22. Lagalla *post, Luba, Congo; wood,*
height 107 cm

These anthropomorphic posts, figures of
the custody of lineage, are placed in
open spaces between the huts of villages;
sacrificial offerings are directed to the
posts, and placed on their heads.

torial gathering in such a way that the arrangement of groups of relatives on the basis of common ancestors constitutes space as a "genealogical map"[37].

Precisely because it is linked to the provenance, origins, and becoming of the community, land is not an object of private appropriation, some valuable object that can be abstractly quantified, monetized, and alienated, but an integral part of personal and collective identity. Being separated from the land of the ancestors means being separated from oneself.

Altars and statues of divinities and ancestors placed in familial and village sanctuaries, along streets, at intersections, in squares, or in sacred forests signal this space.

The adventures of the community and village do not have, however, sense in themselves, but only as references to the other, to the development of the world in its entirety, to the relationship between men and gods. Historical time is defined in relation to the time of origin, microcosm in relation to macrocosm. African living space does not respond just to the logic of material and function or to economic activity; in materializing social order, it reproduces the order of the cosmos to which it is tied.

The radial development of the Yoruba city is ascribable to the city of Ile-Ife and to the cosmological symbolism that it is connected to. Situated in the navel of the world, the place in which divinity descended to establish the first *terra firma* in the primordial marsh, it shares with the world its circular form, with its subdivision into sixteen parts prepared along two perpendicular axes ('streets') moving from their point of intersection. The city thus places in the center the palace of the king-priest (*oni*), then four peripheral quarters corresponding to the four cardinal points of the compass, then, among them, another twelve quarters each filled by a clan, for a total of sixteen, sixteen being the number of principal Yoruba divinities commanded by Olokun, god of the sea, who, according to tradition, was born to Ife. Ife then gave birth to the sixteen sons of the first King Oduduwa, who founded other cities on the basis of this same scheme[38].

The stories of the origin and beginning of the world ideally preside over – in many parts of Africa – the organization of all aspects of life, giving them meaning, correlating the single parts to the whole, assigning to each his or her proper place, cyclically reestablishing an order, that of creation, which is both spatial and temporal at the same time. Creation is in fact a process of the generation of an oriented space; it moves from the center tracing one or more axes, usually perpendiculars, which define and divide surfaces, imprinting an orientation that is bipolar (male-female, village-*brousse*, center-periphery) or tripolar (north-central-south, tall-medium-short)[39].

In a principal line, the mental representation of space corresponds in this way to the model of the founding ancestors of the settlement and runs spatially along the temporal

23. *Symbolic outline of Dogon village,*
Mali: the organization of space retraces
the phases of mythical history: "The
village has to extend itself from the
north to the south, as a man who lies
supine; his head is the house of Cabinet,
built in the principal square that
symbolizes the primordial field."
(Ogotemmeli) To the north of the
square, there is the forge, at the point
where the civilizing blacksmith's was.
From the east to the west, there are
houses for menstruating women, round
like uteri: they are the hands of the body
of the village, while the large family
houses represent the breast and the
stomach; lastly, the communal altars,
built to the south, are the village's feet.

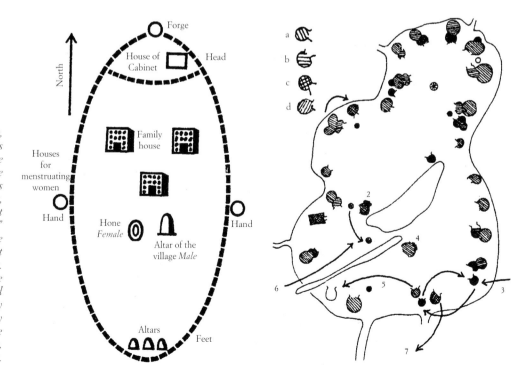

course of the creation of the cosmos. Buildings and settlements thus assume an aspect oriented as much in space as in time.

This reconnection of the created to the movement of creation does not, however, impede the grasping of their difference. For the Dogon, the passage from the world of the gods to the world of men occurs as a conversion from a spiral movement to a reticular structure (an intersection of vertical and horizontal lines that is at the base of the human body, the weave of fabrics, the division of fields, the form of villages). The spiral indicates a movement that has neither beginning nor end, befitting the immortals, towards the creative force of God and genies such as water beings deprived of articulation. In contrast, the orthogonal structure, which is of the human body, villages, and cultivated fields, defines human space in its limitations. For this space to be fruitful, it needs to revive the original creative motion in its spiralform dimension. This explains the frequency of the zigzag motif (read as a projection of the spiral on a plane), of the spiralform dances accompanying seeding rites or the curvilinear forms of the altars which reconnect the earth to the sky[40].

Assigning a representation to space in terms of a story, as is done in the creation myths, means putting places and events in succession rather than in a picture of simultaneous representation, such as the geographic one, where distinct places coexist and preserve their identity in time[41].

If the relationship between origin and present can find a spatial dimension along the direction of center-periphery, this does not correspond as much to a physical space subsistent in itself as to an energetic space, a space of transformations. Thus can it be that in Pigmy encampments and villages every house, hut, or cot is found symbolically at the center where creation began[42].

The definition of a ritual space that, in a construction, takes back the cosmogonic act of creation can make any place its center. Since the cosmogonic act is developed starting from the center, every new foundation cannot but place itself at the center of the world. "Through the paradox of the rite, every consecrated space coincides with the Center of the World, just as the time of an ordinary ritual coincides with the mythic time of "the beginning"[43].

For the same reason, if it happens among the Merina of Madagascar that a king dwells even for a short time in a village of the plains, those plains are considered mountain peaks, since the place of the sovereign is necessarily high, and the king cannot be installed in an inferior position[44].

3. The Weaving of Space

The centrality of the relation takes form, as we have already indicated, in the importance conferred by the acts of weaving and interlacing.

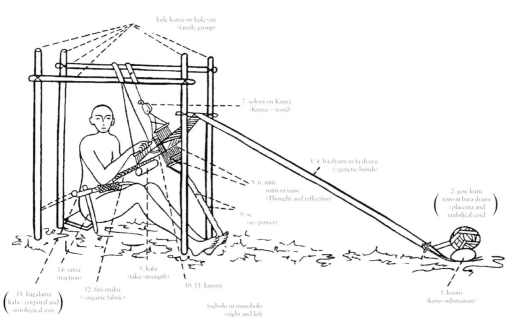

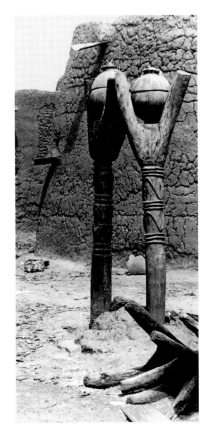

25. Altar of Duba, Bobo, Burkina Faso

The altar for the Duba spirit, present in every village and consecrated to the struggle against witchery, consists of a pole upon whose tripartite summit a vase is placed; the roots of the African azfelia are enclosed in the jar full of water, the receptacle of the spirit. Very similar poles (do ba) found among the Fulbe nomads symbolize, in a sedentary way, the act of appropriation and the center of the encampment, similarly to the sacred trees and the conical altars erected by agricultural societies.

26. Description of the symbolic correspondences between the loom for weaving and the components of a person, Bamana, Mali.

(Facing page)
24. Plan of Pygmy encampment, Mbuti, Congo: Pygmy villages change their positioning according to the evolution of interpersonal relationships: a. first day; b. second day; c. third day; d. fifth day. 1) The wife moves and constructs a new hut at the arrival of the son of the husband's sister. 2) Posterior entrance closes the 12th day. 3) constructed on the 2nd day and abandoned on the 3rd; reoccupied on the 5th day; 4) the closed side of the 12th day; 5) moving of the 11th day; 6) Communal hearth removed the 12th day. 7) movement to another field.

The compactness and consistency of the fabric – which derives from the overlapping of threads which, taken separately, have no strength – results also in its ability to be torn, the precariousness of ties, making it a symbol of reality that exists only as a relation composed of parts, a metaphor for all the generative and degenerative processes.

This property of fabric is clearly evident in Dogon mythology, which establishes an explicit correspondence between fabric, word, and cultivated fields.

A fabric of human relations exists in the word, and fabric is called word because its threads intersect as the elements that constitute language. At times, to cultivate is to weave because the procedure of the farmer plowing his fields recalls the movements of the weaver. Cultivation, as does weaving, allows the germination of the word of the ancestors, the spreading of the life force, "As weaving is a word and fixes the word in the fabric through the coming and going of the bobbin on the warp, cultivation, through the coming and going of the farmer in the field, makes the word of the ancestors penetrate, so the dampness in the tilled earth cancels impurity and extends civilization within inhabited places."[45].

The gestural nature of weaving and the functioning of the loom, far from describing a purely technical process of the production of manufactured goods, is a glance thrown at totality, retaken and present in the precise perspective of daily work. For the Bamana of Mali, the warp for weaving "is the most beautiful expression of the creation of life"[46]. In the warp, all the movements of the universe (the rotary movement of the pulley, the helicoid movement of the torsion of the thread, the coming and going of the shuttle, the zigzag movement of the woof, the ups and downs of the heddles, the vibrations of the structure) are present, placed in their correspondence to the gestural movements of the weaver (the movement of the feet back and forth, the movement of the arm from right to left, the sense of the work evolving from the direction of the warp beam). In the noise produced by these movements, the voice of the world and the person is embodied; in the diverse parts of the loom, the different components of the human body are gathered. The role of the thread symbolizes the embryonal fabric; the heddles' alternating movements send us back to thought and reflection; the pulley's squeaking recalls words; the striped fabric's "grains" remind us of the cell of human fabric; the warp beam through which the fabric is rolled materializes the axis of the person (*kola*); the traction created by the movement of rotation that the weaver imprints on the warp beam to make the work move forward corresponds to the energy (*ni*) that makes it move. In the end, the fitting of the parts

27. Jénu bànu cover ("red ally"), Dogon, Mali; detail from the central rectangle

The cover is carried by priests who preside over the ritual of seeding. The white squares are truth, the clear and feminine word, and the fertile white earth of the plain; the black squares are instead dishonesty, the obscure and masculine word of the initiates, and the poor black earth of the plateau. The large checkered squares are the fields of the family head, while the small rectangles on the border are the fields furthest from the village, those which the family head gives to his married sons. The village, placed at the center of the cover, is represented by a rectangle bordered by colored stripes; the three squares on the lower level and the four on the upper level recall, in their numerical symbolism, the men and women who live there. The colored stripes that define the village echo the waters, the sky and the earth, indispensable to every human settlement; within them, in other small white and black squares, animals and vegetables are found.

of the loom in the framework is analogous to the insertion of the individual person into the family group.

Fabrics and weaves not only open a metaphoric space that allows us to think of a culture distinguishing it from nature through the polarity of nude-clothed, they constitute a large quantity of differentiated areas and allow their representation.

Fabric acts as a mediumistic nexus between sky and earth, divinity and mortal, human and animal, and between men themselves, knotting and dissolving ties. It marks distances, distinguishing by sex, age, community, social as well as professional status; it also allows passages and transitions. It appears in the exchange of gifts that structure alliances, in the funeral ceremonies that permit the passage of the dead, and in the rites that signal the return to earth.

Fabric accompanies the Dogon on their travels toward the world of the ancestors as vestment, outfit, and shroud. The dead person rolled in fabric like a fetus in the uterus is thus fortified in the weave of the living and – since to weave is also to cultivate – is regenerated in the fruits of the cultivated field that covers. The velvets in embroidered raffia that are the sign of wealth and good taste among the powerful members of the Kuba follow them to the grave and make them recognizable from others they will meet in the afterlife.

Fabric offers the symbolic representation of space a surface. It is not a physical space to be mapped, but a world of life, a living space.

The way of conceiving and organizing space is not clearly the same for sedentary farmers, hunter-gatherers, and pastoral nomads. While the perception of the world is, for the former, realized chiefly in a "static" way, placing within itself a series of concentric circles that diminish until they reach the limits of the unknown, the latter two groups produce perception in a "dynamic" way, gradually realizing that they cross through a determined route (Plate 12). We thus have a radiating space centered on the home, more than on the territory[47].

The checkered Dogon fabrics indicated here testify precisely to a conception of the first type. They show us a fully humanized landscape with the village at the center, cultivated fields and water within, the disorganized space of the wild savanna without[48].

The space painted on the fabrics of beaten bark (*murumba*) of the Mbuti Pygmies of the Congo is instead an itinerant expanse: the signs that appear there recall those left in the forest when leaves are burnt and echo the traces on the ground in rituals that propitiate the hunt and those of corporal pictures. These signs make space significant, recutting from passages while seeming to diminish the distinction between encampment and forest, mixing objects of both, supplying a kind of camouflage to wearers of the fabric and assimilating them within the forest itself (Plate 69)[49].

The distinction between a sedentary and a nomadic space is, however, only partially translatable in terms of an opposition between a static and dynamic vision of space[50]. As we have already seen, the borders between the world of men and the indefinite space of the *brousse* are extremely uncertain and mobile. Despite the seemingly radical nature of the dichotomy, civilized space is not in reality civilized in every part. It is not entirely civilized in the center, and even less so towards the borders. The limits then, without ceasing to be such, constitute a transformational space that has its agents of mediation, figures who, for the interstitial position they occupy, are only as indispensable as they are thought to be and have therefore a social status that is marginal and ambiguous[51].

These spaces of transition, no different than the points of passage among their diverse phases of life, are, for their equivocality, for their not being more and not being again, full of danger and promise. They constitute as much a threat to the existing order as a source of its reinforcement or the possibility of alternate orders.

This particularity makes for an intense treatment of objects. Rites of initiation and passage emphasize and define the liminarity, ripping it from the indefinite, giving it a precise spatial-temporal connection that makes it controllable[52].

Fabrics and costumes can treat this inassimilable space (whose confines in reality move continuously) individuating those figures who live in the *brousse* and are therefore the personification of disorder on the periphery of the social field.

The figure of the smith, for example, is often indicated by an essential ambiguity. His ability to master fire and metal and his control over the instruments of production and war make him the holder of a superior power and an element of mediation between the world of the underground depths, the sky, and the world of men.

29

Similarly, social importance is recognized in the hunter, at the same time conferring on him a contrasting marginal status that attests to, and seeks to control, obscure power. The ambiguity of the hunter responds to this ambivalence of the community. The hunter, spending long periods in the *brousse*, lives physically and emotionally outside of society. He is proudly free of any conditioning but often and contradictorily moved by the desire of fame among those he flees from.

All of this relational complexity is communicated by the polarity of the clothes. The fully titled members of the community wear white or colored cottons, a sign of "precision and clarity" (*jayau*) exhibiting that measure and elegance that are the mark of civilization. The hunter, on the other hand, wears a dark tunic with amulets in skin, horn, fur, and cowry shells that recall the wild creatures of the *brousse* and the power of controlling them (Plate 13). When an animal is killed during the hunt, a perceptively significant part is added to the clothing, which evolves continuously in this way. With the passage of the years, the animal elements cover the surface of the fabric; the clothing comes to increasingly resemble the *brousse*, and the hunter increasingly identifies with the place of his success. This is a transformation, however, that does not include a passage to the other side: the hunter remains a cultural operator who moves along the lines of the frontier. The natural element sewn on the clothing mutates into an artifact that articulates the biography of the hunter, recounting the past and developing strength for the future. It reconstructs the vitality of the *brousse*, but it reflects that vitality with different humanized valence[53].

A partly analogous discourse can be applied to the social position of the woman in African society. It is through the woman, in exogamic exchanges that bind alliances, that men symbolically and materially produce society[54]. But, paradoxically, it is exactly this centrality that implies women's lesser and subordinate social insertion, since women are defined as an "object of exchange", positioned and migrating between two groups. In a polygamous society like that of the Lele, when raffia fabrics were not enough debts were paid off through the transfer of property to the creditor, including rights to women and, when necessary, even to those who had not yet been born. This is not as much an economic transaction, and even less so a bankruptcy, as it is the establishment of a kind of relationship of kinship between creditor and debtor[55].

The woman is always situated in places where differences and discontinuities are marked and where the insurance of ties is allowed. She has no existence but in difference and relation[56]. Fabrics and body ornaments express this situation: premarital availability, the condition of the married woman, the state of pregnancy, the number of children and their social position, and widowhood. Prohibitions, as for example the ban on seeing masks or approaching the looms of men, reveal the ambiguity, the extraneousness placed within the heart of the social system itself. The affectionate mother is established as an opposite to the evil witch, and the fertile woman contrasts with the sterile either permanently or temporarily. Life is associated with the first, death with the second.

28. Couple of Ere ibeji *twins, Yoruba, Nigeria; wood, beads, height 28.5 cm - 28 cm*

The symbolic and aesthetic accent falls on the head, oversized in comparison to the body and emphasized through the prognathism of the face, the rising of the eyes, and the development of the hairstyle into a crest shape. While the small dimensions of the statues recall their infantile character, the mature breasts define them sexually. The arms symmetrically pushed away from the body, with the hand turned towards the body to touch the hips, suggest the composure of an interior equilibrium.

29. Two faced mask, Baulé, Ivory Coast; wood, black paint overlapping a background of red in the face on the left, height 29 cm

Among the Baulé, the birth of twins is considered an auspicious event; the masks that celebrate it entertain and recall happy episodes. The two faces, similar on the whole, differentiate themselves in the hairstyle and facial traits.

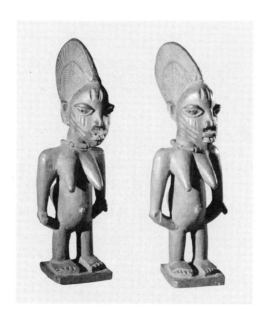 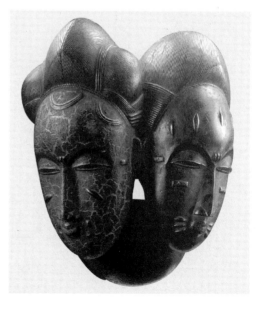

Babies also constitute a figure of duplicity for their coming from elsewhere, their being on the border between the world of the spirits they have just left and the world of men where there is no definite role. The fact that babies will remain among men in the first years of life is anything but certain; the ties to the other world are still strong and the probability that they will return there very high.

The crawling on all fours, the inability to speak, and the obscure vocalizing are other signs of babies' ambiguous status, of their being in collusion with the spirits of the *brousse*.

Babies in Africa are, in fact, not fully titled humans but fragile potentialities of life: already-born but not-yet-living. Access to full humanity only comes with social insertion, through the initial path of graduated acquisition of knowledge that, along with sexual maturity, guides the child to adult life. This process is marked by fabrics. Among the Dogon, for example, tunics and pants lengthen with the aging process; babies are generally nude while the newly-circumcised wear a loin cloth and a short tunic open at the sides. Until he is 40 years old, a man will wear a short, sleeveless tunic while the loin cloth is replaced by shorts whose maximum length reaches mid-thigh. The long, closed tunic, with sleeves and long pants is instead the prerogative of the elderly[57].

While the ambiguity of women makes up one of the central iconographic themes of African sculpture, babies are instead suspended by their social marginality to the borders of the field or artistic representation. Babies are in fact rare presences in African sculpture and for the most part appear in relation to the mother, functioning purely as an accessory and exalting her fertility. It is for this reason that when portraits are done, they present sexual and cultural characteristics of adult age (breasts, hairstyles, tattoos).

The suspicion that surrounds children, based on their obscure provenance, accentuates itself in the case of twins. If the birth of twins is considered the principle of original perfection among certain populations (the Dogon, Bamana, Malinke), in many others (the Gourmantché, Ewe, Yoruba, Igbo, Bantu), twin birth is considered an inauspicious event or an event full of danger, a cancellation of the necessary distance between opposites, a monstrous intrusion of animality into feminine fertility and therefore a threat to the cultural order or, where twins are thought to be children of the sky or moon, a threat to the cosmic order constructed on the separation of earth and sky[58].

The nature of this danger explains why children were once killed or abandoned in the forest, which was thought to be the place from which they came.

In more recent times, the Yoruba, Ewe, and Fon have revised the ancient aversion, instituting a cult of twins that makes use of small wooden sculptures (Plate 4). The birth of twins is now considered a sign of good fortune, although it has not led to the complete disappearance of the fear of twins' obscure power and their supposed monkey origins. For

30. Internal courtyard of the royal palace of Fumban, Bamun, Cameroon, circa 1910

31. Verandah of the royal palace of Ogoga, Yoruba, Nigeria, 1959

The carved pillars that support the verandahs of royal palaces are attributes of power. In the pilasters of the Fumban palace, a series of human figures are placed in twos, with one above the other; sometimes they represent a man and a woman, more often they are masculine figures. We are probably seeing advisers to the court: the position of the hands, the one on the chin and the other at the waist, are typical of the behavior of reverence that one must demonstrate before a sovereign. In the poles of the Ogoga palace, carved by the Yoruba artist Olowe between 1910 and 1914, an equestrian figure and a feminine figure (the queen) look in the direction of the central statue, that of the king, who is seated with his first wife at his shoulders; at his feet are the figures of servants. The large dimensions of the feminine figures, here as a bird that surmounts the crown, recalling the "power of the Mothers", a source of masculine political power.

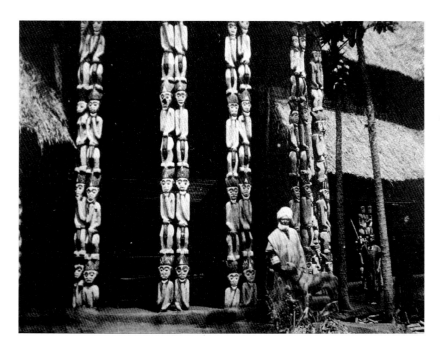 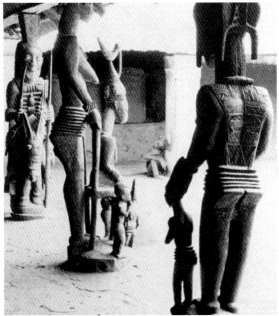

this reason, when one or both twins dies, statuettes are sculpted that the mothers ritually feed, dress, and wash because they are the depositories of the children's spirits: to neglect them could provoke ire and grave consequences. The exceptional status of twins expresses itself sculpturally in the coexistence of opposed elements. Sexual characteristics, facial traits, and adult hairstyles are added to the small dimensions that display their condition of childhood. The very fact that they are sculpted independently, without the mother, highlights their extraordinary character[59].

Ambiguity and duplicity are most concentrated in African kings, whose function is not only that of guaranteeing social and political order but also, more than anything else, maintaining cosmic order. The center that they occupy symbolically and often socially (the palace around which living space is arranged) coincides directly with their frontier, in as much as it is a place of intersection between two worlds. Their placement makes them large collectors of the strength that comes from gods and ancestors. The kings' wisdom is expressed in their capacity to distribute it for communal prosperity. The course of the seasons depends on them, as does the fertility of the fields, women, and animals. Conversely, they can receive the blame for sterility, aridness, and catastrophes.

The wisdom of the king is mirrored by an obscure and ill-willed side, whose strength can be developed uncontrollably and devastatingly. It is as respected as it is feared. It is omnipotent but tightly controlled, until it becomes a kind of hostage in the hands of the king's subjects.

The space of the king is in many ways a space of confinement, and the palace protects the people on the outside perhaps even more than the king on the inside; the center of power also has to be the place of its containment. This is cautionary space, signaled by the increasing frequency of taboos. The king's throne and the sandals he wears isolate him from the earth while a parasol separates him from the sky above because the king cannot tread on the bare ground or move himself freely without running the risk of releasing an uncontrollable and devastating force. He is prohibited from eating or drinking in public, prohibited from leaving the palace, prohibited from touching or being touched by commoners. He cannot speak, nor can he be asked to utter a word, except through his spokesman.

The king is at the heart of the community, but he is also irreducibly outside, in as much as his sacredness places him beyond the world of humans. The rituals of the settlement – which often require ritual incest with the mother or the sacrifice of relatives – mark this transformation. A man becomes king by separating himself from his true past, canceling his true particular and personal identity to reenter as a "community body" in which he incarnates the spirits of the ancestors. The king is thus a figure subtracted from ordinary life. One presumes that he does not eat, does not drink, that he does not get sick or die, that he is capable of the most unthinkable marvels.

In Africa, as elsewhere, the exceptional nature of the figure of the king has created a propitious land for a rich celebratory art and an art of court. Art plays a central function in the affirmation and prestige of African kings, giving a visible form to the foundations of power, ensuring the permanence of the monarchy in interregnal periods, and promoting its expansion. Among African monarchies, art has thus taken the active function of political affirmation that was exhibited elsewhere by armies. Art has permitted affirmation and absorbed excess. There were not, in fact, permanent armies except for the royal guard (numerically very limited), and the power of the kings rested more on a togetherness of shared beliefs and their good reputation (for which art acted as a banner) than on the monopoly of violence[60].

4. The Site of African Art

The continual return between parts and whole – for which everything is in everything – in a relationship of analogy and participation makes the same application of categories we have used for dividing the world into clear, distinct parts problematic.

In fact, as far as African cultures are concerned, not only should art not be considered in terms of the Western concept of beautiful work, the economy should not be thought of in terms of the Western concept of market, religion not of church, and rights not of court but their distinction into autonomous spheres becomes problematic; religion does not pursue the individual salvation of the soul; the production and exchange of goods does not follow the logic of maximization of use; power does not have the face of law and territorial state.

Objects and figures in wood and terracotta, fusions in bronze, and mural designs have

no term equivalent to "art" which can place them all in the same semantic area, under an umbrella of shared meaning.

Art in Africa does not constitute a conceptually and institutionally separate territory: there are no "artists"; "works of art" do not exist.

As a rule, we have instead objects of aesthetically elaborate use, objects in which the aesthetic dimension is connected to functional valences (social, ritual, religious), attributing operative endowments to its beauty. Among many populations, this concentration of levels finds a corresponding language in the terminological indistinction between "beautiful" and "good". Something which is desirable and appropriate from the viewpoint of communal values, something that agrees with the ordinatory principles of life[61], is beautiful.

The fact that intentions and aesthetic perceptions are spread among innumerable objects with instrumental valences, and that only rarely, in some handmade items, are they present in an exclusive way, does not, however, impede their gathering themselves in aesthetically privileged areas. In statues, masks, fabrics, and verbal or musical compositions, the body is temporarily or permanently modified on the surface and in volume[62].

Therefore, as little known as categories of "works of art" are in Africa, a distinction still exists between stylistically elaborate words and objects on the one hand and ordinary words and things on the other. Such a distinction does not, however, present a dichotomy between the works. Rather, it arranges them along an identical line, differentiating them in a gradual way. Beyond that, objects that reenter the first category are only in part those that we would include in the category of "works of art".

Also from the side of words, the elaborate construction of epigrammatic forms and rhythmic sequences of assonance and alliteration retakes and strengthens the characteristics of daily communication without introducing any discontinuity. What we would call "poetic word" is, for the Dogon, very close to "prayer", both ascribable to "the beautiful disposition of words", "the good word", and "the pleasing word". A greater efficiency, a

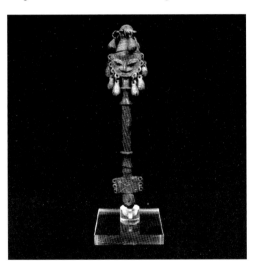

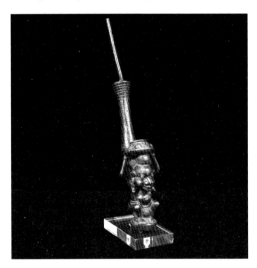

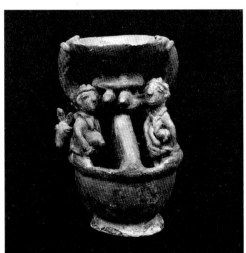

32. Ogboni *cultural scepter, Yoruba, Nigeria, bronze, height 36.5 cm*

It is the prerogative of the Alaase, *the members of the* Ogboni *who possess the vital force* (ase) *and utilize it for the well-being of their followers.*

33. *Pipe, Grassland, Cameroon; bronze, 46.5 cm*

Pipes with anthropomorphic subjects or animals, in bronze or terracotta, are among the prestigious objects displayed by important people in the Cameroon Grassland.

34. *Ritual vase, Bariba, Benin; terracotta, height 29 cm*

It probably served to gather offerings to the gods; the body of the vase, through the figurative elements of breasts, arms, and hands that grasp the border, assumes the semblance of a feminine figure around which turn a pregnant woman, a nursing woman, a man who pushes a donkey.

35. *Vase for sorghum beer, Zulu, South Africa, terracotta, height 34 cm*

Utilitarian and symbolic functions are strictly bound here: not only the living but also the ancestors drink from these vases.

higher strength, or a greater quantity of "body oil" corresponds to their high level of formal elaboration, and that is communicated to the listener, strengthening the life force[63].

Tales, for the Dogon, are fertile because their creation of new meanings contributes concretely to advancing the world, signaling the cultural progress on the *brousse*. Strictly associated with fertility, stories are exchanged among the young on the days preceding a wedding, but their circulation is prohibited among relatives, for whom they would constitute a kind of incest. This preoccupation about their continuity of becoming recalls the dynamic of the temporal development of the generations and is clearly present in the styles of telling stories themselves. The recounting has to proceed without interruption, with no backtracking, until completed, and without overlapping two stories. The important thing is that the storyteller not let any words fall: when one person does not know the story another promptly picks it up[64].

We are not speaking therefore of stylistic exercises, of fictions without effects. The difference between myth and tale does not correspond (in Africa, as elsewhere) to the difference between truth and fiction. "Invented" stories are humorous tales and animal fables, but true stories are as much myth as historical legend, exemplary and didactic tales. The distinction between myth and tale has a fluid quality because the significance of words is always stratified and multiple, and, proceeding in the interpretation on the most esoteric levels, the story finds inside of itself the profundities of myth. Similarly, the aesthetically elaborated object is neither distinct from the utility object on the basis of its ornamental or contemplative value nor from the absence of functional implications.

Sculptures, as much as oral literature, transmit, through their elevated level of formal elaboration, a *surplus* of strength that objects and ordinary words lack. This is also true in cases of works that speak of a purely formal search released from, or weakly tied to, meaningful contents. The motivation lies precisely in the fact that more strength, a greater degree of reality, is attributed to the form rather than the contents. The benefits produced by a poetic elegy rest more on the rhythms of the words than on their meaning.

Neither stories nor sculpture have the characteristics of fiction.

Fiction does not mean the deprivation of the authority of words and things nor does it constitute a genre but a tactical diversion, a strategy of the containment of their power. The incapacity on the part of women, children, and Europeans to perceive the impact can lead to a weakening of the works.

The sculptural object is not the duplicate of an external reality. It does not aspire to physiognomic portrait and mimetic representation. It is not even the expression of a physiological internal reality or the subjectivity of the artist. It is, more than anything, the instrument of an evocation and the locus of an apparition: it gives form to beings that are without shape – spirits and divinities – and offers itself as a substitute for beings that have lost form, the ancestors. It allows and conserves a presence.

It is destined not for contemplation but action. It is one of the means through which it is possible to establish a relationship. Its objective is not to resemble reality but to contribute to its articulation, to modify and improve it, establishing harmonious relationships between the forces it puts in contact. We are not speaking of depicting a situation but of inducing a behavior: arousing veneration, insuring protection.

36. Headrest, Mfinu, Congo; wood, height 13 cm

The figurative element of the human body, a frequent element in African headrests, is traced back here to essential geometric forms, realizing a perfect integration between representative and functional elements. The headrests allow the users to preserve their hairstyle at night, and privilege dreams through which divinities and ancestors appear.

37. Royal Kiteya cup, Luba, Congo; wood, height 28.5 cm

In the nineteenth century, during the rite of investiture, the new king would drink a beverage composed of human blood and palm tree wine from these cups; the assumption of human blood, which would have been his predecessor's or a designated victim's, sanctified his power. The cups were also used in the context of divinatory rites; the feminine figures on the side would then be seen as spouses of the spirits that possessed the diviners and to whom were attributed curative powers.

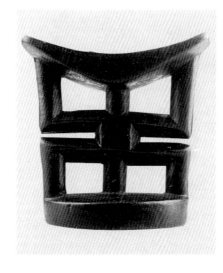
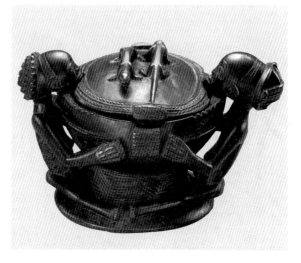

Objects do not arrange themselves in the illusionistic space of the frame. They are not isolated on a pedestal but occupy a space in the foreground of reality. The altar, the sanctuary, and the initiating enclosure define the spaces of concentration and irradiation of the life force.

African figurative sculpture cannot be considered in terms of mimetic fidelity, the valuing of the resemblance to a model, whether it be interior or exterior.

In reality, it is the practice of representation itself. With the exception of Western naturalism, that does not implicate resemblance: two things can resemble each other without one representing the other, and one thing can effectively substitute the other without having to resemble it[65]. The dimension of substitution sets aside that of imitation, and it is therefore mistaken to consider modes of figurative traditional art as distortions of reality. The anthropomorphic string figures used by the Bassar of Togo in funeral rites act, in fact, in an exceptional way as substitutive figures of the dead, while not "resembling" them except in an extremely generic fashion (Plate 36).

The shared element of symbol and symbolized that makes an object an adequate substitution is not sought in the "realism" of the reproduction but in the pragmatic and functional element. The suitability of the figure is determined by the consensus achieved by the participants in the funeral ceremony, by the conventions on which it is built, and by the belief in it efficacy.

Verisimilitude becomes only one of the many possibilities one can strategically use, not the ultimate goal of the representation. "Naturalism" and "schematicism" are different ways of signifying representation that find their conditions and stability in relationship between two distinct ways of signifying the identity of the person who is to be represented. Western culture, emphasizing individual identity, has conceived the portrait in terms of physiognomic resemblance, seeking to express the personality through physical traits and facial expressions. African culture, which gives priority to social identity, has instead produced a more generalized aesthetic which defines in terms of participation and positioning within a defined group[66].

Confirmation of this can be found in the fact that within the same group, these different representative methods can be combined and applied selectively: Africans will be represented in one way, Europeans in another.

The same can be said of the use of color, which strives not for realistic representation but for the transformation of reality[67]. The strength is not so much in the color itself, which as such is an abstraction without content, but in the concreteness of the colored object. The Igbo have given a symbolic value to the color white (which they contrast with black), and it is closely associated with the therapeutic qualities and moral attributes of the colored substance, the kaolin[68].

The Bamana have given colors the tasks of releasing energy (*nyama*) from both fabric and individuals and of protecting people from danger. The efficacy of the colors depends on their combination on a strip of cotton (*buguni*) and the place where it is applied to the garment. Their protective power lies in creating a combination that is analogous to the relationship between health and sickness: white (the warp yarn) makes a prisoner of black (the threads of the weave) in the same way peace and fertility prevent the eruption of evil and misfortune[69].

The symbolic use of the trichromatic black-white-red is also found among the Pende of Congo, who associate red with life (the healthy body is sprinkled with red powder), black with the struggle to which life is subject (with the danger of the disassociation of the elements based on personality), and white with the return of the spirits of the dead, who arrive to aid the living. The separate and combined use of the colors, based on precise codes, is seen in masks that can be monochromatic (black, but never all white or red), bichromatic (black and white or red and black, but never white and red) (Plate 64), or trichromatic[70].

Color is not a superficial effect, a secondary quality, but rather a principle based on objects, each of which consists of color and visual harmony, a mix of white, red, and black (the three fundamental colors in the African chromatic spectrum), with the distinctive prevalence of one of the three. The thaumaturgic intervention of color is used to reestablish order in the universe. The individual passage of life towards death and reincarnation is a cyclical procedure of color in color in a maturation process that resolves itself in the dissolving and relaunching of an individual's transitory synthesis: white (the color of the afterlife and the fragility of infancy), red (youth taken as a dynamic process of initiation), and black (the color of elderly power and wisdom), returning again to white.

In masks and statues, color constitutes an indispensable element of their activation,

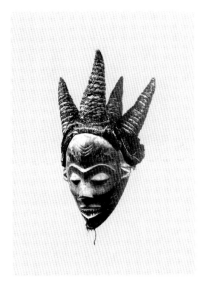

38. Mukanda(fumu) *mask, Pende, Congo; wood, blackened raffia, height 61 cm*

This is a mask that dances in the closing of initiation rituals (mukanda) *and that takes its power from the ancestors. The head covering in points and the small beard are those of the head of the clan and the head of the village. These masks are black, white and red with a predominance of the last color.*

and for this reason, color is periodically restored during each performance. The periodic restoration of color has the important role of connecting the past to the present, the world of the ancestors to the world of the living.

The fact that Africans only resort to realistic representation in moderation is explained by the temporality that is characteristic of a large part of African art.

Within a conception of the cyclical nature of time, in which everything returns, the idea is not one of freezing the moment of time in solid material, of narrating the story of individual lives. Attention does not fall on the transitory, but on what is and what will always be, on typical characteristics, and on the common matrix of the multiplicity of events. The common repetition of themes and motifs, the apparent absence of expressive figures and movement, and the selective concentration on certain iconographic elements thought to be essential all come from this concept. These characteristics become defects only if they are read along our linear conception of time.

Let us take the emblematic case of African maternity. At first glance, we may be disconcerted by the absence of affection the mother seems to demonstrate towards her child; however, it would be an error to give this a psychological interpretation and conclude that it comes from distance and coolness. The image is not the mirror of an interpersonal relationship. We do not find ourselves before a summary account of determined individual experiences, but rather before a representation of maternity as a founding figure of female ancestors and female divinity. It is what is shared by all mothers past and future, beyond their differences.

From this point of view, the descent into particular details with reference to people and concrete experiences would not strengthen the sense of the figure. On the contrary, this would impoverish it, limiting it to determined domestic space and diverting attention from what is truly important. It is precisely for this reason African sculpture does not follow an ideal of complete, realistic, and detailed representation, but that of selective concentration on symbolically essential elements: the breast, the stomach, the navel, the hairstyle, the scarring and feminine corporal pictures, all emphasized in greater or lesser detail according to the various cultures.

The accent on a common matrix does not in any way bring a negation of the diversity of experience, reducing and immobilizing it in an abstract universality: individual representation is as foreign to African sculpture as conceptual representation is. Sculpture does not describe nor cancel a concrete experience. Rather, it is the occasion for it. The statue propitiates maternity, making maternity possible, allowing the ritualistic retrieval of the generative force of the beginnings, and grafting a new life on the stem of the one left by the ancestors. For the Dogon, every procreation repeats that of the original couple, unit-

39. Maternity figure, Ashanti, Ghana; wood, height 62.5 cm

African maternity figures do not establish a psychological relationship between mother and child. The gazes do not meet; the mother looks ahead, far away. The representation is not a particular biography but maternity as such. The identity of these figures varies in relation to the cults in which they appear.

40. Maternity figure, Dogon, Mali; wood, height 49.2 cm

The kneeling position is that of the supplicant and of thanksgiving to the god Amma; these figures make their appearance during the funerals of women and in the sacrifices that propitiate fertility.

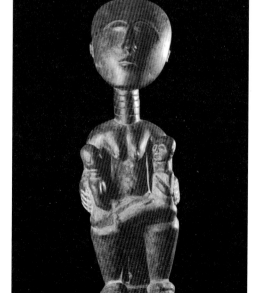
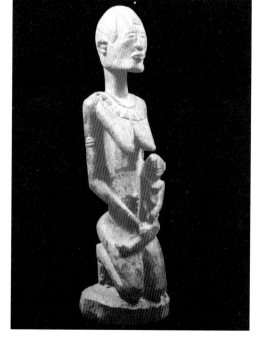

ing the aqueous nature of the female stomach with the earthy nature of the male seed that envelops the stomach with the spiralform of creation.

Acting factually, renewing a past that does not pass in sight of the future, sculpture does not have the responsibility of recounting the adventures of life but of increasing life.

The apparent immobility and absence of expression are explained by the same elements. African maternity has no need of representing movement in its exteriority; the scope is more one of indicating its source, the propulsion center, the place where movement is power and virtuality. This is the origin of the dynamic equilibrium of many African sculptures, which are not immobile while not engaging in movement, the presence within them being a held gesture, suspended, impending.

And if the figures do not represent emotions, it is only because they have no need: they are both inspired by emotions and encircled by them. Around them, one does not have a distanced eye but a welcoming hand.

Maternity is both the same and different for everyone; in its typicality, wooden sculpture reaffirms this communal element. The uses to which the statues are put, with the visible outlines they leave on the surfaces (level of consumption, sacrificial coatings, various accessories), articulate the story of each.

Unlike the mimetic image that is simply an appearance, a fiction that has no other reality but the resemblance to what it is not, the symbolic object is the perceptible appearance of a duplicate reality, a bridge from this world to the next.

It is in this sense that the African object is not reducible to representation, whatever the mode in which it was conceived .

The object is much more than a simple representative of the spirit which gives it form. It does not limit itself to exercising a vicarious function, but acts as a complementary element, the mask and the statue, allowing spirits and ancestors to be present. Translating an invisible strength into a visible form allows the action, or rather keeps it in check and inhibits it, functioning as a trap for spirits.

In the Baulé sculpture of the Ivory Coast, we can observe all the diverse functions, propitiatory and apotropaic[71].

Thanks to their elaborate ugliness and ephemeral duration, the mud sculptures that the Baulé place outside of their village allow the villagers to be rid of evil spirits. Conversely, the anthropomorphic forms given to natural spirits (*asie usu*) mediate between the world of men and the wild earth, carrying the "things of the *brousse*" into the village, making them, when possible, beautiful.

The same is true of the afterlife. The Baulé, in fact, believe that every person on this earth is tied to a person of the opposite sex in the otherworld. The statues of the "lovers of the afterworld" materialize this relationship, seeking with their beauty to placate the jealousy found in confrontations with earthly spouses. They do not, therefore, have to please

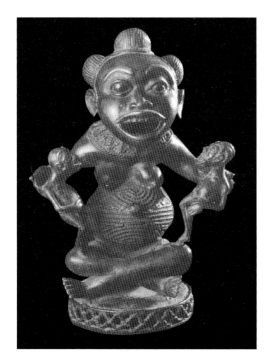 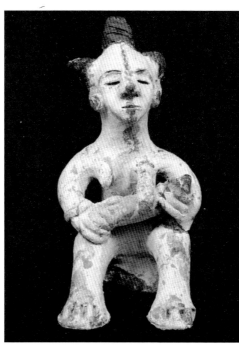

41. Maternity figure, Bamun, Cameroon; bronze, height 29 cm

Physical contact appears reduced; the babies lean on the mother, and she sustains them but does not embrace them; the plastic and symbolic accent falls on top of her, on the globular forms of her head and her densely decorated stomach.

42. Maternity figure (ntekpe), *Igbo, Nigeria; terracotta, pigments, height 22 cm*

These figures, often placed on altars in couples, are considered "children" of the gods, and must help and protect them; the art of terracotta sculpture is a feminine prerogative among the Igbo.

either the sculptor or the earthly buyer, but rather the heavenly force whose satisfaction will be understood through the persistence or disappearance of the problem, often of a sexual nature, that originally inspired the request for the production of the statuettes. These figures, which we could say give expression to repressed desires, have tangible effects on conjugal relations. The site of a woman from the afterlife who is pregnant or carrying the child of her own husband would create anxiety in the childless wife; the sight of his own wife's man from the afterlife dressed in a jacket and tie would put the farmer in an inferior position; it would be the stimulus to improve his own social position and would guarantee the woman a certain margin of independence.

The statue thus assumes a relational identity in the contrast with the antagonist. It expresses the internal pressures found in matrimonial ties and rearticulates them.

5. *The Work of Art as an Articulation of Differential Identity*

The active role of art in the construction of ties and the definition of relational identities emerges with clarity in the cult of the ancestors.

If the community is rooted in the ancestors whose procreation is indispensable, ancestors are such not because they are ontologically distinct from other beings or because they are endowed with an existence and unalterable identity, but because they receive sacrifices from the descendents and because the effigies that hold them guarantee their survival[72].

The respect due to the ancestors is not unconditional but presupposes, even in asymmetry, a certain reciprocity, a giving in order to receive. Ancestors that are overly demanding or insufficiently generous can be abandoned and forgotten, dissolved. Those long celebrated can, instead, be raised to the range of divinity.

Rigid and stable hierarchies and unequivocal and definitive identities do not exist. There are instead relationships of varying strengths within which relational and dynamic identities exist in a fragile equilibrium of distinction and participation.

The identity of men, gods, and ancestors is equally uncertain. The reciprocal recalling from one to another in which only they can exist also harbors the possibility of them losing themselves, of their confusing the one for the other. Oneness and multiplicity do not exclude each other but coexist. The Legba divinity Fon and Ewe, present among the Yoruba, is a singular god, a multiplicity of personal divinities that tend to get confused with the individuals themselves and the first Yoruba king from the city of Ketu[73].

Man rediscovers that multiplicity in his own interior. Individuality in Africa is not intrinsic to people, but the result of their existential path, the combining forces of predestination, and biographic cases. It is not an original but composite unity, a successful and more or less coherent combination of perishable "corporal souls" (the body and shadow that become dust and sand with burial), "immortal" souls (like those that man loses with folly), or

43. Altar of the Ile ori *head, Yoruba, Nigeria; fabric, cowry shells, skin, height 52 cm*

The interiority of the head is rendered abstractly. The altar of the head repeats the quadrangular form with a pointed summit of the royal crown, and shares the symbolism of power. The cowry shells that cover it, used in ancient Africa as money, indicated the wealth of the head: their white color designates "good character" (iwa rere) and the success that it would be able to guide, as well as the feathers of the "bird of the head" (eiye ororo), those that God places on the head of each one at the moment of birth as an emblem of his head; on the peak, the theme of the bird is figuratively repeated to recall the presence of the Mother.

44. Anthropozoomorphic osamasinmi *head, Yoruba, Nigeria; wood, height 47.5 cm*

These heads add ram horns to the human appearance and are placed on the altars of the ancestors; in the combination of human elements and animal elements they render the liminal status of the ancestor. The horns, seen generally in Africa as a symbol of vital growth, reinforce the power that is already within the head. An iron collar encircles the neck, and on the forehead there is a belt with amulets.

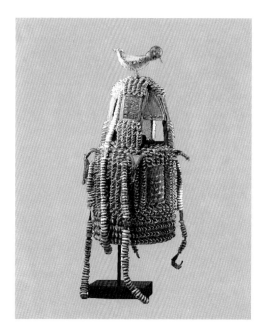
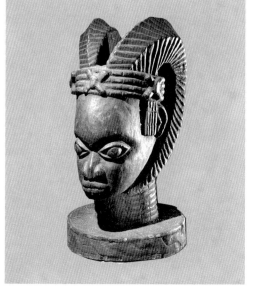

"imperishable" souls (those which the Yoruba call *emi*, the vital breath that animates man and leaves after death, or *ori*, the head, seat of destiny and personal intelligence)[74].

The body itself does not respond to a principle of organic unity, but reveals itself more as an aggregate of parts that are relatively independent and endowed with a life of their own, like something difficult to control which is experienced during bouts of illness, the bites of need, the wave of desire – a kind of "interior exteriority" that can be projected to the outside in a cult of its own organs, each one of which is identified as a divinity. People thus find themselves contemporaneously inside and outside of themselves, as author and object of the offering[75]. This makes itself evident in objects, at times those of a figurative type, which include corporal elements such as hair, nails, saliva, and blood in their interiors.

The segmentation and decomposition of volumes, the differing treatment of the parts that is true of many African sculptural styles, and their lack of "naturalism" or organic fluidity seem to express these conceptions well.

In this precarious and transitory synthesis of multifarious objects, some disappear with the overcoming of death while others exist before the person and survive after, making themselves available for new unions. People finds themselves variously dislocated in time and space in this position because of the heterogeneity of the parts that constitute them. A preexisting part of them can choose its own destiny, among those remaining, made available by divinity. Diverse ancestors can partially reincarnate themselves. Blood alliances can create participation with another person of a different ethnicity. Privileged relationships can be established with certain spirits, animals, places, and objects.

Thus, fundamental parts of oneself can be found in a temporary or permanent way outside of corporal confines: in all the parts of the universe with which the body is in correspondence, in the placenta and secretly buried umbilical cord, in one's own human or animal twin. Taken in this network of relationships, man is subject to continuous metamorphoses, some definitive – like those that are produced in initiating rituals – some temporary, as when one puts on a mask or one's own shadow shrinks.

Every one of these transformations, adding or subtracting strength, leads towards an increase or decrease in being, allowing to greater or lesser effect the realization of one's own destiny, the translation of one's own potentiality into action. If witches and sorcerers are among the most feared dangers, it is precisely because they are the ones who devour the "souls of the others".

Precisely this metamorphic and composite character of the African person ensures that he is never entirely alive or entirely dead, but at differing levels and partially both, "that he remains always himself and other than himself, that he is always here and at the same time elsewhere"[76]. Like infants – already born but not yet living – the elderly also straddle a line between the two worlds. Death, in fact, is not the cessation of life, but the dissolution of a relationship, a separation of the parts. It is for this reason that, in cults reserved to one's own person, all the parts of oneself that precede and survive are honored. One is what is other than oneself precisely because the identity of a person consists of relationships (Plate 49). The efforts are applied in the direction of the strengthening of syntheses, the integration of parts, the annexation of external spaces. The search for an agreement and an equilibrium among people and society becomes one with the search for coherence among the constitutive parts of oneself, forever being outside and already being inside the person.

If the African person "does not exist but in the measure in which he is 'outside' and 'different' from himself"[77], the relationship between men and animals is not only instrumental but also ontological and existential. The death of one can lead to that of another. In successive lives, parts of the previous personalities, made free, can participate in diverse syntheses and be reincarnated in animals, so that the animals can assume the appearance of spirits and divinities. The borders are mobile and precarious; dangerous metamorphoses are always possible because the animal lives the man as its Other.

For this reason, in sculptures, parts of animals are often untraceable to a specific species or fused within anthropomorphic representations, to finish by offering material support to invisible beings.

If, as we have seen, cultural space is always defined by the exclusion of what is wild, there is however a cross-reference as well in the contraposition: the one being for the other. Dark and dangerous nature is also fecund and nutritive. We do not speak therefore of conquering nature – that would be like taking the earth on which one stands out from under one's own feet. We speak, rather, of stamping a centripetal orientation that pivots on

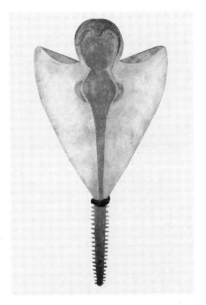

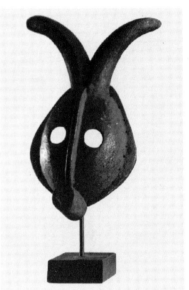

45. *Swordfish mask* (kaissi), *Bidjogo, Bissagos island, Guinea Bissau; wood, pigments, height 127 cm*

Among the Bidjogo, the masks of wild animals, of earth and sea animals, are used in the context of age groups to give life to warrior virtues. They are carried as a kind of head covering, in a horizontal position.

46. *Antelope mask* (karikpo), *Ogoni, Nigeria; wood, height 40 cm*

Among the Ogoni, the masks of wild animals danced, acrobatically, on the occasion of agrarian rituals. The features of the animals are expressed through essential geometric shapes that privilege symmetry and curved lines; the protruding cylinder of the mouth responds to the circular cavity of the eyes.

the human world on nature's strengths. Animals thus find their place in the African taxonomy on the basis of their familiarity to or foreignness from man, proceeding from the close to the distant[78].

The animal penetrates and participates in the world of man as prey, as domesticated animal, and as sacrificial and therapeutic animal. Alliances are born with it and relationships of kinship remain. Through the animal, gods manifest themselves and communicate with men (Plate 42-49).

Thus considerations of a solely economic and utilitarian type cannot fully explain the human-animal relationship: the Dijula of Senegal may attribute the highest value to the oxen they raise, but they do not eat them, nor does the meat generate a monetary profit, because their only destination is that of sacrificial distribution.

Animals therefore are not divided up and valued as "good to eat" on the basis of immediately material urges, but neither can we conclude that they are chosen as "good to think about" on the basis of purely intellectual needs. In as much as symbols represent the world they constitute, the operative aspect is not an alternative, but is inseparably connected to the speculative aspect.

In this context, art actively intervenes as an instrument of symbolic domestication, humanizing the animal element, converting and channeling it to the benefit of the community. The masks for the *chi wara* initiation rituals that preside over the rites of fertility for humans and for the fields permit the transformation of the wild, impure earth into a humanized and cultivable earth. Fearing the wrath of the spirits that live there, man, through the mask, temporarily assumes the identity of a wild animal – the antelope – who, by tracing his own territory, distances all others[79].

Often attention falls on the animals that, because of their characteristics, do not fit into a single category but straddle the line between species. Specifically because of their "monstrosity", they are rendered symbolic mediators among the parts. This is the case, for example, of the pangolin which, according to the Lele, accumulates the property of aquatic animals (the scales and tail similar to those of fish), terrestrial animals (the movement on four paws), and air-borne animals (living on plants like a bird). In addition, the fact that,

47. Buffalo mask, Kantana, Nigeria; wood, length 53 cm

This crest was used in cults of the Mangam *association that had among its aims the preservation of social order and the celebration of agrarian rites. The buffalo probably found a place as a symbol of power; in Africa, horns are often associated, in their push towards the other, with the growth of plants.*

48. Bracelet, Bamun, Cameroon; bronze, height 18 cm

The lizard is an intermediary between the sky and the earth; it is the lizard to guide the souls of the dead to the afterlife, under the form of serpents. Fooling the chameleon that would have brought to men the gift of immortality; the lizard instead brought death.

49. Nkisi figure, Kongo, Congo; wood, iron, height 67.5 cm

Among the Bakongo, dogs are thought to be figures of mediation between the world of the living and the world of the dead; dogs are said to have four eyes, the possibility thus to see beyond that which is ordinarily visible. For this reason, they are represented in nkisi *statues with two heads. The blades and nails that are affixed to them activate the figure on the occasion of a consultation.*

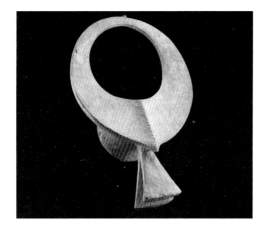
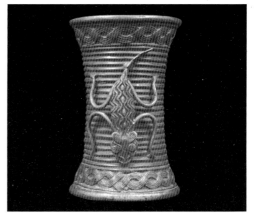
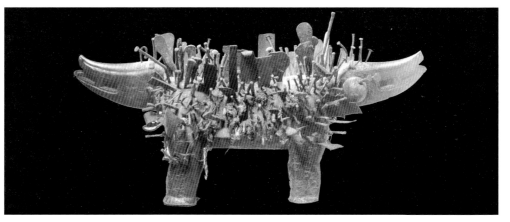

like men, it puts just one child at a time on earth makes the pangolin a kind of representative of the human world within the forest[80]. Among the Kuba, the exceptionality of the pangolin symbolically expresses that of the king, who is as much inside as outside of human order[81].

In the kingdom of Benin, the pond fish (*clarias lazera*), with its apparent death during the hibernation of the dry season, its return to life during the damp season, and its capacity to move itself not only in water but on land, offers, with its capacity to exceed limits and move within different spaces, an image of superhuman character of sovereign power that is sometimes represented by legs in the form of a fish[82].

The symbolic associations between men and animals do not however respond to a fixed scheme, but vary culturally. This way the same animal, the dog for example, can be seen in one population as "pure" and as such is eaten as a sacrificial meal while being seen as filthy in others[83].

The animals sometimes become attributed to human beings, stabilizing a relationship of symbolic participation with them. Leopards, lions, elephants, and horses celebrate the strength of the sovereign or people of status, appearing among objects of apparatus as iconographic motifs or parts of their body, paws of ivory, leopard skins, eagles' feathers (often the monopoly of the rulers) recalling, in a metonymic way, the animals from which they came.

In the Benin kingdom, domesticated or tamed animals like the chicken, ram, cow, antelope, or pangolin become, because of the vulnerability or submission, symbols of the human order that is affirmed on nature. On these, in fact, man can exercise the right to life or death, analogous to what the king (*oba*) exercises on them. Differently, certain dangerous water or forest animals – the leopard, elephant, eagle, python, and crocodile – are expressions of the antagonistic reign of the *brousse* and instruments of the vengeance of the gods on men. They signal the limits of the human world, and at the same time, because of the danger they constitute for men and their dominion over other animals, they become symbols of the power of *oba* and the court over his subjects. Animals are not, however, only the instrument through which order is affirmed, but are also the means of its infractions: borders can be crossed; witches mutate into hostile animals and transform their victims into prey. The witch hunters (*obo*) can follow them through the same territory to try to recover the life force which has been taken[84].

In the Cameroon Grassfield courts, the subjects turn to the king (*fon*), attributing the honorific title of "leopard" to him because one sees in the animal the alter-ego of the monarch. The king can transform himself into a leopard at will, as the leopard can transform itself into a human being. Strength, power, rapidity of action belong to both. A leop-

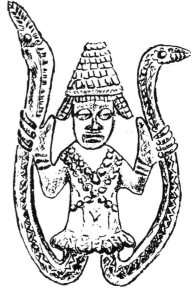

50. *Figure with legs in the form of serpents, Yoruba, Nigeria*

In Yoruba and Edo (city of Benin) iconography, there is the presence of a figure with human features and legs in the form of fish, or, sometimes, of snakes. It is interpreted as an image of the god of the sea, Olokun, or of that of a king who, in contrast with the other powers of the city, loses the use of his legs. It functions as both a reference to the superhuman character of royalty and at the same time as a warning to the sovereign, whose power must be socially controlled.

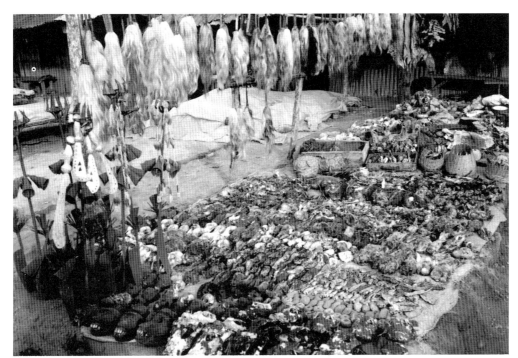

51. *"Fetish market", Lomé, Togo*

The animals are used in the preparation of medicines. In the "fetish market" on the periphery of the capital of Togo there are altars, ceremonial swords and fly swatters, many small dried animals, and, in the front, baboon skulls.

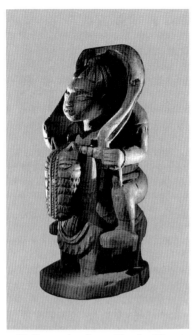

52. *Equestrian figure, Yoruba, Nigeria; wood, height 63 cm*

In tropical Africa, the horse is a rare presence and thus lends itself to becoming a symbol of power. For this reason, the animal does not have any autonomy on the sculptural plane: undersized compared to the human figure, he is covered by decorations that indicate his rider's status.

53. *Bogolan fabric, Bamana, Mali; cotton, 186 cm*

The fabric is first tinted in yellow and then decorated using mud that makes the yellow change color and turn brown. The mud is that of the backwaters in which the souls of not-yet-born babies are found: the woman who, wearing the cloth, carries it on her own body, will assume fecundity.

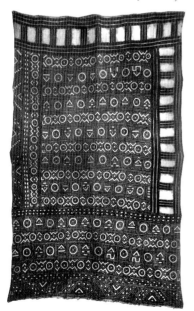

ard skin is laid on the bed of the *fon*, for the figure of the leopard appears as a caryatid in royal thrones, while teeth and jaws, in both natural and sculpted forms, are present in his insignia.

Like the elephant and the serpent, the leopard is also an iconographic motif used exclusively by the sovereign. A collection of symbolic references, different but convergent, whose coherence is visually confirmed in iconographic integration (the sculpted figure of an elephant that presents the maculation typical of a leopard) or in graphic schematization (a frog that, reduced to its elementary components, becomes a sign interchangeable with the spider's)[85].

Spiders, serpents, oxen, monkeys, dogs, birds, and lizards often figure in their role as sacrificial animals, intermediaries, and messengers of the gods or ancestors. Among the Bushongo, when the demiurge Mboom finished the creation, the beetle intervened, weaving a great cloth on which the creatures were maintained in order to avoid their dispersion, introducing communitarian life and solidarity to men.

Among the Bakongo, who believe in the existence of a place between the world of men and the world of the dead populated by dogs, dogs are seen as mediators between the two worlds, while their exceptional senses of sight and smell make them discoverers of negative forces. In this capacity, they appear in *nkisi* statuary, often with two heads looking in opposite directions[86]. Among Cameroon populations, the spider, instead, intervenes in divining practices, moving the signs that are put on the exit of his lair, while the lizard is seen as an animal that, betraying the other divine messenger (the chameleon), brings death to men.

The serpent is also seen in Africa as a figure of connection, because of its creeping, which strictly associates it with the earth, and because of its penetration underground. This is also true for the Bamana, for whom the cross-reference of serpent-ancestor is one of the first symbols of masculine fertility. Because of its fluidity of movement and lack of articulation, the serpent is instead associated with origins, with water, with rain, and assimilated into the rainbow that many – the Igbo, the Yoruba, the Songye, the Luba – call "python-in-the-sky", representing the ties between sky divinities and water divinities. In both cases, whether they speak of sky or of earth, the return is to fecundity.

What is true for the relationship between men and animals can also apply for the relationship between people and things. The relationship is not that of a subject freely arranging an object; the ability to manipulate emerges from a base of the one's essential participation in the others. This is particularly true for objects that are in contact with the body and that constitute a kind of prolongation, as is the case with clothes.

The clothing that covers the body is, in fact, not a stranger to it. Clothing modifies the body's visual appearances; it extends the body's confines and protects it, physically and magically, communicating its own properties to it. In another way, and in a certain measure, it itself becomes the body by contact, collecting heat, sweat, and blood there and preventing the life force from scattering. The *bogolan* fabrics of the Bamana are worn by those who need to endure blood loss. Fabrics defend the hunter from the vital energy freed by the killed animal, absorbing the blood in the fibers and the twists and turns of the design. Fabrics allow a woman to maintain her own strength, collecting the blood at the moment of circumcision, menstruation, and child birth. Later, the fabric that has accompanied her through all the salient phases of her life will envelop her in the tomb[87].

The fabric is the double of the body, similar to the placenta of pre-natal life: a filter between the external and internal, a porous border between oneself and what is foreign. As the placenta demonstrated the belonging to the *brousse*, so too the fabric defines the belonging to the humanized field of the village.

The members of the secret *ogboni* society of the Yoruba mark their diversity, the exceptional nature of their social position and their closeness to the dark forces of life, by wearing fabrics inside out. To make the internal part of one's costume visible is as good as demonstrating one's own interior, as good as becoming transparent[88].

From this point of view, the relationship that establishes itself between a person and his chair is significant (Plates 30, 31; 94-96).

The African seat is not an object of furniture but an extension of a person. The chairs are not arranged around a table; one cannot sit freely on them. They either follow the person like a shadow, or they are secured in place with the same care one extends to one's own safety.

Among the Ashanti, for example, it is thought that the seat contains parts of the person who owns it. The periodic washings to which it is subject are not only done for hy-

giene and decorum but because they contribute to proper purification. Conversely, leaving a chair to deteriorate brings one loss. The reason that one cannot sit in another's chair, or why the chair is turned upside-down when not in use, thus becomes well understood: we would not want an evil spirit to install itself in us, penetrating through the chair[89].

As a microcosm, man is in the center of the world and of African arts, the maker of greatness and fragility. Creation converges in and radiates from him; in creation, man can find or lose himself.

Man as a microcosm is not limited to re-mirroring a creation complete in itself, but actively sustains and maintains himself in life, completing the creation.

African "humanism" is open to the sacred (man only understood by referring to another), but African religions are not theocentric. Spirits and divinities are kept alive by, and for the well-being of, men. More than to God, the attention of African religions goes from man to his corporal survival on earth in the generations that follow him[90]. This is particularly evident in the great importance that the cult of the ancestors assumes with respect to the cult of primordial divinity.

In this context, the distinction between "expressive" character (disinterested, socialized by religion) and "operative" character (utilitarian, individualist from magic) reveals itself as inadequate. Meaning and function, morals and relationships of strength, are considered together. The good coincides with the strengthening of life, the bad with its weakening. Sin, or rather error, does not come from a lack of morals but from the failure to comply with certain ritual practices. The sacrifice that presents a remedy does not pursue the salvation of the soul but the reordering of the world. Good and evil (like beauty and ugliness) are not defined in absolute terms but always in relation to specific situations, times, and people. An object that protects its owner from an evil influence may be dangerous for the outsiders who ignore the prohibitions associated with it. So it is that what is beautiful and good is really what is appropriate in a specific context.

Spirits and divinities do not behave themselves in a way that is very different from the others. If they can look after things and rescue them, it is only because they are the cause of the evil they heal. Their behavior is often unpredictable and capricious, but never disinterested.

The work of art is at once vehicle of truth, instrument, and aesthetic object. Beauty is the way in which truth takes form (in art, the divine manifests itself) and the stratagem that allows man to capture it and appropriate or dissolve it.

Religion and art rotate this way in large part around the practices that favor fecundity and the appropriation of strength.

The prevalence of anthropomorphism in African sculpture thus finds correspondence in the anthropocentrism of African visions of the world[91].

The deformation of natural corporal proportions does not reveal a distortion in perception, but reveals the insufficiency of human beings. What is found in sculpture is the relationship of reciprocal (though asymmetric) dependency between men, ancestors, spirits, and divinities.

The gods are not identified with their corporal manifestations; nevertheless, these be-

54. *Ketu, man seated on a chair, Yoruba, Benin*

African chairs are generally of small dimensions, avoiding direct contact with the ground but resting very close to it.

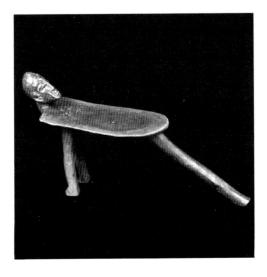

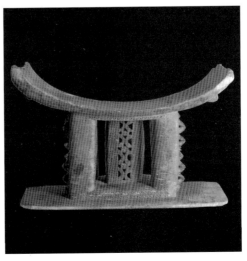

55. *Chair, Lobi, Burkina Faso; wood*

All of the initiated men own a chair like this; the echo of masculine identity is in this case made explicit by the head the makes the three leaning points of the stool into the legs and penis of a human figure. In movements, the stool is transported on the left shoulder and used when needed as a weapon.

56. *Chair, Ashanti, Ghana; wood, height 32 cm*

Among the Ashanti, the chair is strictly associated with the person who owns it and contains some of the owner's elements. We see here a single wooden block, presented as a perforated column into whose center protective substances are often inserted.

long to them and are indispensable to them. If the objects are not fetishes, they do not resolve themselves even in signs of devotion[92].

We are not speaking of an inadequate representation. The reference is not human (the divinities are not even "people", but "powers") and the intention is not imitative. We speak of the appearance of "spiritual entities" within human forms; it is not fiction but presence. The human form renders the divinities approachable; the distance from natural proportion preserves their differences.

This mingling, affected by recognition and estrangement, is easily perceivable in the mask that reveals an invisible entity, concealing the forms of the person wearing it. The effect of depersonalization is also often obtained through inducing states of trance. The mask, which generally absolves from judiciary functions and social control, is often the monopoly of secret and initiating societies and comes from elsewhere, arrives in the village from the outside. It cannot be touched and often cannot even be seen by the uninitiated, women, and children. It is enough that one knows it is there. The spectacle of the mask is precisely for those who are excluded from it: the women. The masks often have the principal function – in the intentions of men – of controlling women. The mingling of anthropomorphic and zoomorphic elements or the mingling of different animals, in their extraordinary character, would theoretically render the masks dreadful and confer a superhuman character on the authority, removing it from critics.

In reality, the women know more than they say and what men pretend to believe they know. The women know that a man is hiding under the mask, but if they decide not to unmask him, it is not because they want to sustain the fiction, but because they continue to believe that the violation of a prohibition would threaten their fertility[93]. Distancing therefore goes along with participation, which could come from women closed up in the house, anxious in the darkness of night, only sensing the passing of the mask on the street, or, in the case of collective parties, with the participation of those present with dance, song, and the rhythmic clapping of hands.

6. Words, Things, Inscriptions: Saying the Invisible, Seeing the Unutterable

The centrality of visual arts in African cultures is also explained by the oral character of these societies or, more precisely, with the absence of phonetic writing.

Sculptures, fabrics, and objects interact with the world (mythic, oracular, therapeutic), performing, in different ways, many of the functions that are assumed by writing in our society. They privilege the articulation of thought, allowing the communication and transmission of knowledge[94]. In African societies, the plastic and graphic element is thus seen

57. Wall inscriptions of Songo, Dogon, Mali; trichromatism in white, black and red.

The scope of the inscriptions is, as with masks, to conserve the energy (nyama) of words. Periodically restored, they receive their strength from their duration, from the old age of the first author, and from the accumulation of the qualities of those who followed to renew them. Here, we find the design of the masks, that of the moon, of the great serpent yurugu menu, of the lizard, geni gyinu, of ceremonial objects, and objects of daily use (agricultural and domestic utensils, weapons, musical instruments).

as the surface and instrument of the inscription of knowledge, providing material support to oral transmission.

The idea of an Africa without writing is, more than the establishment of an objective fact, the product of a Eurocentric perspective that, strictly associating language and writing, declares phonetic writing the highest point in an evolutionary process of all humanity, classifying all other forms of writing in relation to their greater or lesser proximity to the alphabetic model[95]. Cultural diversity is negated, taking it back to a temporal scale that reduces the differences by the stages of a single process that points to a single end. The "mythographic" writings that evoke ideas without referring to specific words are thus perceived as incomplete, limited, imperfect, preparatory, hiding their peculiar virtues, like the possibility of being read by a person of a different language or stimulating creative interpretation.

The remainder of the cultured African *élites* themselves have contributed to the spread of such "prejudices", as has been well attested by the famous affirmation of Amadou Hampaté Bâ, according to whom, "Every elderly black person who dies is a library that burns." Assuming the European presumption of an Africa which lacks writing, cultural dignity in terms of purely oral communication is affirmed[96].

To negate this teleological vision of the history of writing, it is enough to note that the establishment of a daily vital coexistence in Africa of all the forms of writing that are typically presented as successive versions of each other – no less than in computers. One does not render another obsolete; they are used alternatively, for different situations and aims.

Precisely the attention that various scholars have recently focused on the different technologies of writing was of particular importance, in as much as it allowed the interpretation of specific cultural characteristics, like the correlation of observed practices instead of the postulation of abstract forms peculiar to thought. What would exist between "them" and "us" would not be a difference of logic but a difference of instrumentation and therefore of functioning[97]. We would not speak therefore of opposing a prelogical thought with a rational one, and neither would we contrast preliterate cultures with literate ones, but would analyze the different written practices in their specificity. In fact, if the notion of writing cannot be limited just to the written expression of the language, but includes all the forms of representation of thought-mediating signs, the assumption from which we must depart is in reality the assumption that there are no societies that are completely without writing. This naturally takes nothing away from the differences that exist among different systems of writing in their social capacity and their influence on thought, which are enormous. We speak therefore of defining the particular relationship that exists in Africa between the visible and the utterable, between word and things, between the visual and the spoken arts.

Engravings and paintings (parietal and corporal), hair styling, gestured languages, chromatic compositions, figures, objects and graphic symbols, and dances that trace graphic signs and architectonic forms on the ground (like those of the Efik, Ibibio, Bambara, and Dogon) can all be considered as writing that conveys meaning. In fact, a communicative intention is present in them, a system of codification attested to by the regulated repetition of signs in different configurations with the possibility of communicating from a distance and the transmission of collective memory through time.

Among the Pygmy, for example, the ordering of the village huts as signals that indicate the paths to the forest constitutes a precious sign system for the one who has to join the residential space of the collective group without damaging its harmony – be it relative, ally, or visitor. Forms, orderings, orientation, scale, and the materials of the huts rapidly inform about group composition, group origins, possible alliances, the presence of a therapist or hunting master, making it easy to find the elderly and the young and sterile and fertile women. This information is even more important as Pygmy bands are characterized by semi-nomadism and by a large variability of composition[98].

African cultures have elaborated a profound reflection on the state of the world, whose lines generally seem reducible to a common denominator that takes the ability to speak to an "African conception of the world"[99].

The relationship that words exchange with things is read, as we have already seen, on the basis of a common background that makes them into differentiated incarnations of the same force, a common background from which they emerge. Words and things are endowed with power and men use them to guarantee the continuation of life, to try to utter, and to try to materialize the spirits and divinities that, while ordinarily invisible and incomprehensible, are present and are agents in the world of men.

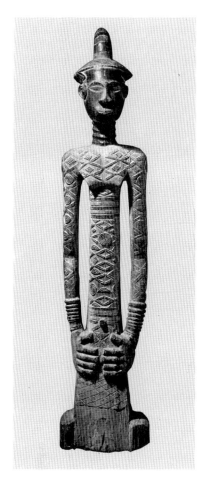

58. Figure of a chief, Ndengese, Congo; wood, 139 cm

The body, tattooed and carved, becomes a text. The bust and arms of the figure lengthen to accommodate the symbolic inscriptions that recall the relationship between the chief and those who are subject to his authority. The motif in concentric circles that appears on his chest, on his temples, and on his arms assumes different meanings according to the arrangement and the number of circles; when they are arranged in a group of three, they recall the principle of cohesion between the king, nobles and the people.

45

Among the Bamana and Dogon of Mali, the word is at the origin of creation, and it is also thus among the Luba of Congo. Among the Akan of Ghana, the divine creator is instead given the title of *Borebore*, which means creator, architect, sculptor[100]. On one side, the world of men offers the instruments of thought to the world of the gods; on the other, every human creation is thought of as a repetition and continuation of the gesture and strength of the originators. Through the production of words and things, man retakes and nurtures imperfect creation. As the god Obatala modeled the bodies of men and the "potter" Alaja modeled the head, perhaps it is better – given that malformed heads were attributed to Alaja and left to burn on the fire – that Yoruba sculptures are made of clay[101].

Words and things work as long as the distances do not become too big to be bridged, but constitute the space within which relationships are established, avoiding the equally crushing extremes of confusion and solitude. Their point of contact is in their capacity for articulation. Language does not simply name things, creating collections of names, but establishes a relationship among words and unites all of the people who use them. The articulated character is what distinguishes it from a simple noise and what allows the attribution of "word" even to musical instruments or looms for weaving. Similarly, the distribution and relationship of objects in space and time is realized in a culturally coherent fabric.

Words, things, and engravings are thus not simply inside the world; they do not inform about the state of the world already built, but give it form. In relationships that intertwine among them, they make what there is of a world. What is said of visible forms, the impossibility of reducing them to a copy and replicating an already existing reality, is also true of words: we do not discuss the arbitrarily associated signs with the things they indicate, without ties to those things, if not for the purely extrinsic or conventional link for which a certain sequence of sounds corresponds to a determined sequence. They participate in the thing, making it possible. Among the Gourmantché of Burkina Faso, the choice of sacrificial victims comes through the geomantic practices that allow the stabilization of the requisite needs of the situation, which are then inscribed on a piece of pumpkin. The fact that the immolated animal often does not correspond, except partially, to the prewritten characteristics does not constitute a problem because the word of the sacrificer transforms it, rendering it appropriate[102].

Reality is what is given in words and what the word says. The mythic tale, for as much as it is improbable, is thought to be true not if it reflects a reality of independently existing facts, but if it retakes the word and gathers an agreement and corresponds to what came before it in the chain of testimonies[103].

Pronouncing the name of an object or a being means evoking it, carrying it to existence: as the Dogon say, giving water to one's seeds actualizes their potential. The simple act of calling a person by name can increase or diminish the forces, and for this reason, a name itself is often known only among a few intimates and shielded by other public names. Similarly for populations of the Bantu language, "The name is not a simple label; it is the reality itself of the individual."[104]

This tie between names and a person's profound identity is confirmed by initiation rituals in which symbolic death and rebirth arrive through the abandonment of the old name and the acquisition of a new one.

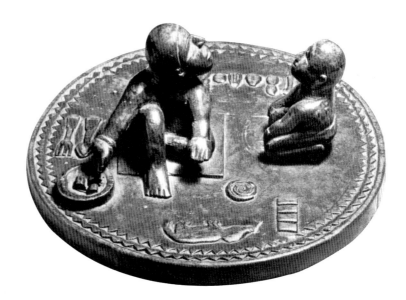

59. Lid-proverb, Wojo, Congo; wood, diameter 19 cm

These lids, carried by the woman at mealtime, represent and reconstruct domestic disagreements; the images that appear on them refer to proverbs, allowing a communication that is mute but explicit. A singular proverb can have diverse representations and a singular image can recall, according to the areas, more than one proverb; it is thus difficult to give them an interpretation outside of their context.

The power of which the word is the carrier is probably at the root of the stylistically diffused course of spoken language, of literature that is oral and then written, of the turn of words and allusion. If the name provokes, the euphemism neutralizes and functions as a strategy for the containment of the strength of the word.

Sometimes the recourse to elliptical expression brings a passage from word to image, as in the case of the figurative covers used by Wojo women, whose scenes refer to proverbs that are not recited but exposed allusively through the image. Through these indirect forms of expression, conjugal tensions are released, confirming the subordination of the woman but at the same time allowing her to express herself critically, eluding the prohibition that falls on the word[105]. The Ashanti weights for gold might have served an analogous function in court, allowing the discussion of questions and objects of dispute[106].

The image and the object do not have to be considered, however, in every case as expressions weakened by words. Often it is the power of things, and sculpture in particular, to be so strong as to require forms of expression or indirect exposition. The Yoruba sculptor, in creating the figure of a devout old woman, will form her with great tact; he will indicate the signs that render her social status recognizable, but will give her a youthful body because any reference to her physical decay could result in offense. It is what we have already seen for "horrible spirits"; here the Baulé gave beautiful forms to placate them. Art is thus a cautionary expression to use diplomatically, filtering and screening it until finally subtracting it from sight.

Words and things are not signs but symbols, in as much as they signify and represent only in the measure in which, participating in what is said and shown, they make it exist. If, in the world created by God, all is "sign", it is because God the Creator works through words and graphic signs. For the Bamana, "Things were designed and named silently before existing, and they were called into being through their name and their sign."[107] The message is of divine origin, but if it assumes a sense, it is because of the capacity of men to interpret it, to translate the silent word that concerns them.

To say and to sculpt are ways of doing and of making done. Just as the adequacy of a representation does not depend on exactitude but on the capacity to inspire the desired response in the viewer, so too the word introduces modifications in the situation that defines it, changing not simply the opinion of the interlocutors but their behavior.

The importance of words and things is not therefore in the forefront of the meanings that they carry but in the mutations they can create in their pragmatic and operative carrying. The power of objects and engravings does not come from the ideas that are themselves expressed but from their capacity to express them. The name indicates the dead because it preserves its individual identity in the memory. If the statue of the ancestor that receives offerings from relatives represents the ancestor, it is because it maintains it in life. The ancestor is not reduced or confused with the name and object, though these are a part of him; he could not exist without them. Naturally, the same can be said for the descendents, who, gathering the memory of and the offering to the ancestor, construct their togetherness and, in differentiated ways of participation, the diversity of their roles. The private Hemba lineage of the statues of their ancestors would lose their reason to be together. The sacrifices officiated over by the chief descendent define the unity of the group, putting the chief in the dominant position and arranging all the rest at diverse distances. Participation in this relationship signifies distance and distinction. The experience of group unity is really done through the differentiated participation of words and things, interpreting the same things and words in different ways in relation to the social positions occupied.

Shoowa fabrics, for example, circulate diffusely in Kuba society (Congo) and contribute to the building of their outside image. However, the ways in which the designs that appear are interpreted vary enormously according to sex, age, and profession[108].

The complementary nature of the parts to the whole, which is truly from the Greek notion of symbols, is thus also true of the African symbol as a confirmation of the presence of terms that translate analogous conceptions in African languages[109].

The symbolic thickness of words and things, their capacity to articulate relationships, the fact that together they are forces since – in the African vision of the world – everything is strength, makes it that, even while remaining the same, words are the things and the things are words and can act on one another, and together on man.

The word is not a logical-linguistic entity, but has its own material consistency. For the Dogon, the word has a body that, like anything else, is made of air, water, fire, and earth and, like the human body, is articulated and sexualized, can be born and die, can be nur-

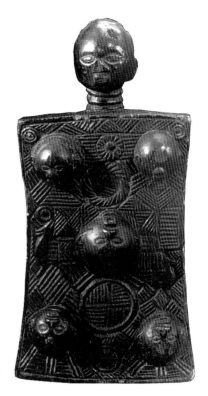

60. Lukasa tablet, Luba, Congo; wood, height 45.5 cm

These tablets, carved and inscribed, often covered with beads and pins, function as memory supports; they are used by the Luba genealogists to whom the transmission of rites, stories, and the lists of kings are entrusted. The signs are susceptible to more than one reading, according to the interpreters and the periods; composing the scenes that form the base of narration, there are signs of Luba countryside, of migratory passage, of the space of the court. We are not looking at a collective past that is transmitted unaltered, but a memory that is continuously renewed in relation to the political contingencies of the present.

Color Plates

1. Ventral mask, Makonde, Tanzania
wood; height 59 cm
A mask that celebrates the return of the young men to the village after they have been initiated into adult life. The men who wear them cover their faces with a mask of a feminine face. The feminine mask dances with great composure while a masculine mask dramatizes the pains of childbirth.

2. Ventral *gelede* mask, Yoruba, Nigeria
wood, pigments, fabrics, nails, twine; height of bust 49 cm; height of infant 30 cm
G*elede* masks celebrate the power of Mothers, thought to be "masters of the world" in that they are the possessors of the secret of life. The *gelede* festivals pay honor to them so that they function in a fecund manner and not a destructive one, and with their approval the festivals lead to a ritual reordering of the cosmos.

3. *Egba* altar statue, Yoruba, Nigeria
wood, traces of color, height 55 cm
The relational life among the Yoruba becomes an explicit artistic theme with the creation of sculptural groups. Here maternity is celebrated (with one baby on the breast and another on the back) with the probable reference to the earth god Odudua. Such symbolic centrality hierarchically arranges the figures as much in their connection to each other as in their relative proportions: while the towering mother is in the center in a seated position, the figures of the officiators, while being adult characters (the breasts for women, the fly swatter at the head for men), are rendered in dimensions close to those of infants. Laterally connected, standing and with a symmetrical obliquity that focuses the attention on the center, they denounce their status of filial dependence.

4. *Ere Ibeji* figures, Yoruba, Nigeria
wood; male height 26.5 cm; female height 27 cm
The great frequency of twin births and the heightened infant mortality rate have found sculptural expression in the Yoruba territory through *ibeji* figures. Sculpted at the sign of the diviner at the death of one or both twins (and in this case the statues are a pair), they are looked after and venerated by the mothers who feed them, clothe them and ritually wash them because they are the depositories of the spirits of the children. A lack of attention could provoke the ire of the spirits and bring disastrous results. The cult of twins is not therefore exempt from ambiguity: if their birth is celebrated as a fortunate event and a sign of prosperity, the perception that they have of twins also echoes with the oldest convictions surrounding their obscure power and their monkey-like origins.

5. Edan, Yoruba, Nigeria
bronze, fusing and lost-wax process; height 19.5 cm, 19 cm
The secret *Ogboni* association is dedicated to the veneration of the ancestral community of influential men and women who live in the earth and who gather strength from the forces that live there. The *Ogboni* hold a political and social role of the first importance as a guarantee of the ancestral law and in the control of the actions of the king. The exercise of such activities occurs in a more complex action of cosmological reordering tied to returning unity in the universe divided among the feminine principle of the earth and the masculine principle of the sky. The *edan*, individual emblems of affiliation, sculpturally present the couple of founding ancestors and allude to the individual *Ogboni* member in the ancestral form of the hermaphrodite. The chain that unites the figures by the head underlines such symbolic unity and the action of those who make it possible.
The *edan* are loaded as instruments of ancestral action in multiple functions: they indicate and punish the guilty in the ordeals; they reveal to their proprietors their life span in the initiation, cure their illnesses, and intervene in their defense.

6. Courtyard of a residence, Kasena, Burkina Faso
The Kasena, a population of the voltaic group known as Gourunsi, are farmers; their homes are grouped together according to clan ties. The women decorate the walls in geometric motifs.

7. Dance, Kirdi, Cameroon
In the festivals that accompany the harvest period, Kirdi women dance, exhibiting the tools of their work. The hand on the breast establishes a connection between feminine fertility and the fertility of the fields.

8. Door, Nigeria
wood; height 143 cm
Some figurative motifs are added to the geometric designs that cover the surfaces of the door: a serpent is wrapped around itself and some ritual objects.

9. Element of a portal, Yoruba, Nigeria
wood; height 119.5 cm
Two crowned figures, displayed on the registers above, are the center of their respective scenes. The figure in the lower panel embraces the two other figures, of similar dimensions, that are next to him. The symmetrical appearance of the scene is broken only by the diverse position of the arms of lateral characters. In the upper panel, there is instead a dense group of characters, exhibited on several planes, with the partial overlapping of different characters. We should note two children dressed in European style. The harmony of the collective came from the knowing combination of the lines of the clothing and hairstyles.

10. Stairs of the granary, Dogon, Mali
wood; height 230 cm
These wooden stairs, leaning against the walls in a lightly bent way, lead to the entrance of the granary doors. Stairs appear in Dogon creation myths; their horizontal plane is thought to be feminine, while the vertical is considered masculine. Together, they represent the primordial ancestral couple.
In the patina, the stair conserves traces of the people who have walked over it: the surfaces become remarkably smooth in the places where they have been in contact with feet, while the places where they have been touched by hands are well visible on the sides.

11. *Togu na*, Dogon, Mali
wood; height 152 cm
Elderly Dogon would group themselves under a high covering of a stele of millet seeds supported by sculpted poles. The *togu na* shelter corresponds, in the anthropomorphic structure of the Dogon, to the "head" and it is the place in which the wisdom of the elders is stored, from which the "words" which govern the life of the community take form. The limited height of the internal space is such that it requires a sitting position, which among the Dogon is the most favorable position for pondered words. The sculpted poles—ideally there are eight of them—represent the eight primordial ancestors, four male and four female, that sit in the first hut of the word; the woman is then excluded from it following the incestuous relationship with Amma, the creation god, from which comes menstrual blood, the first element of disorder to be introduced into the world. The feminine presence continues nonetheless to be indispensable and as such is sculpturally guaranteed. The imprints are instead those of Amma's sandals.

12. *Khasa* cover, Fulani, Burkina Faso
wool; 249.5 cm X 118.5 cm
On the surface of these covers, it is possible to trace a combi-

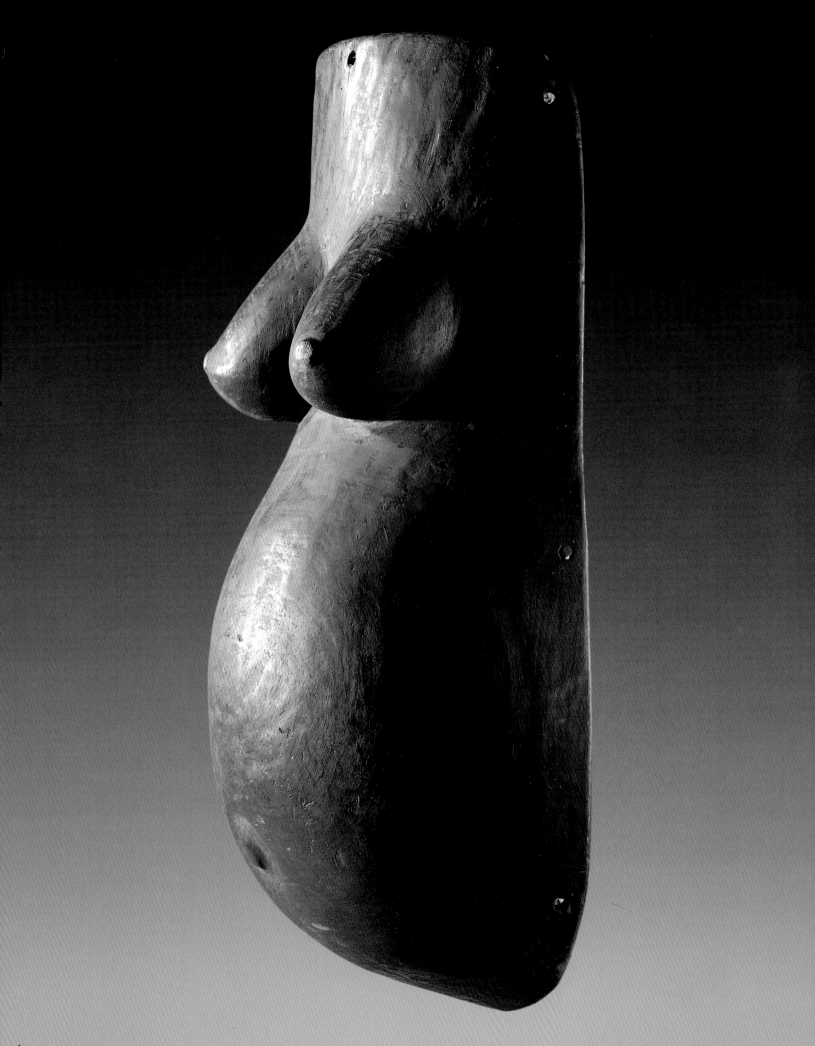

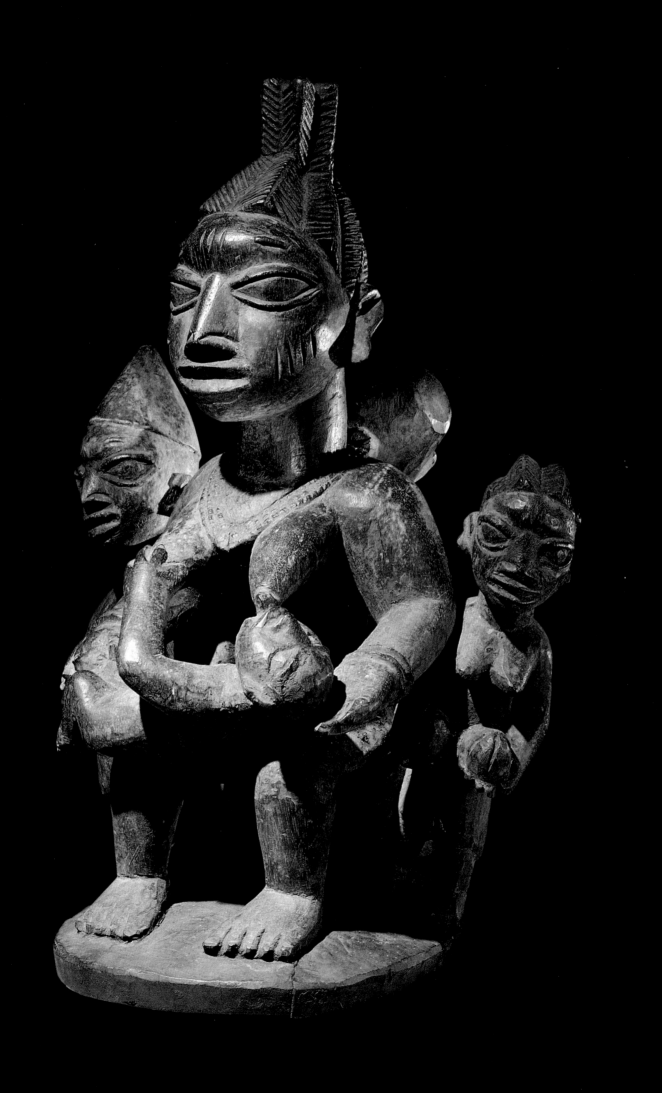

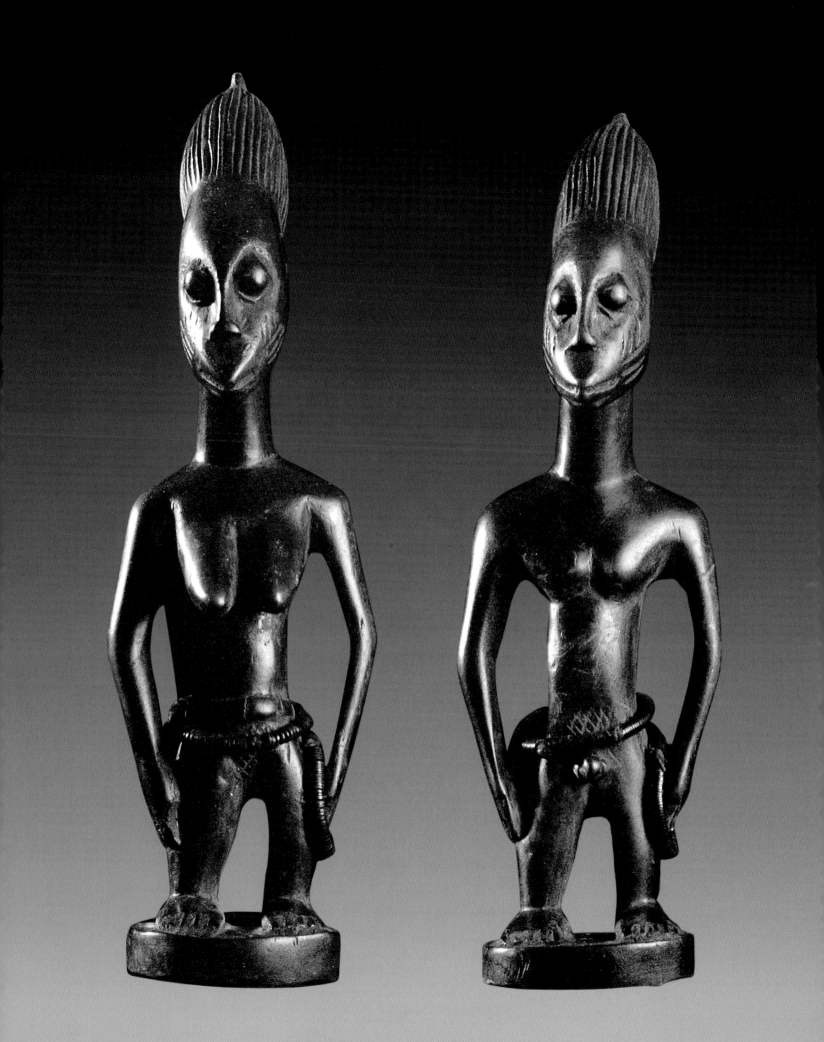

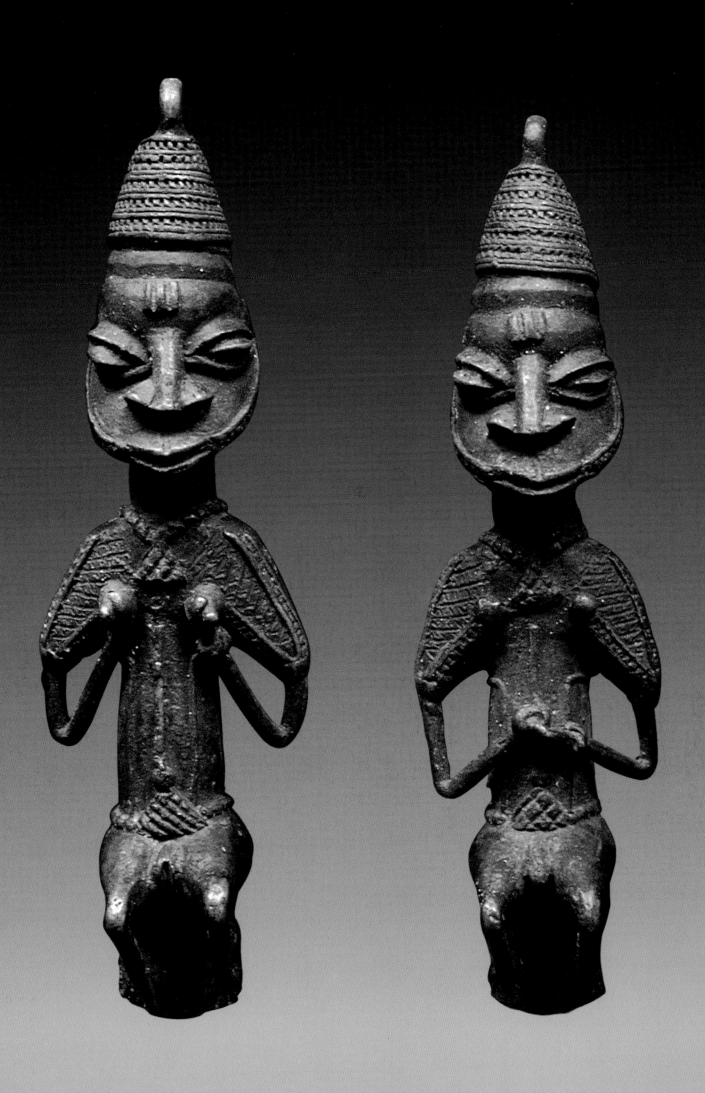

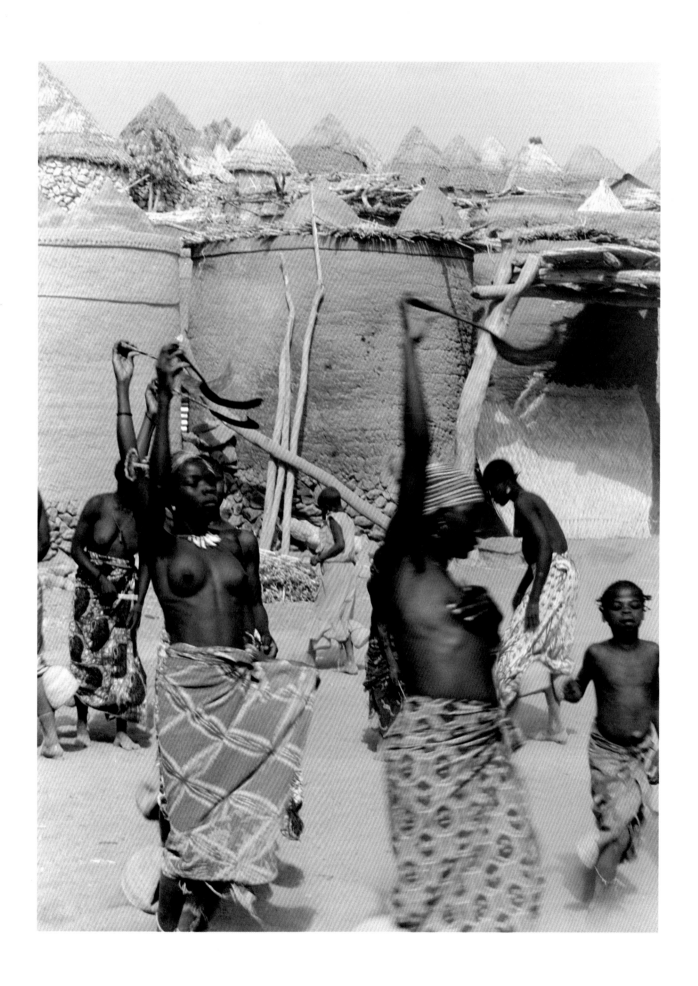

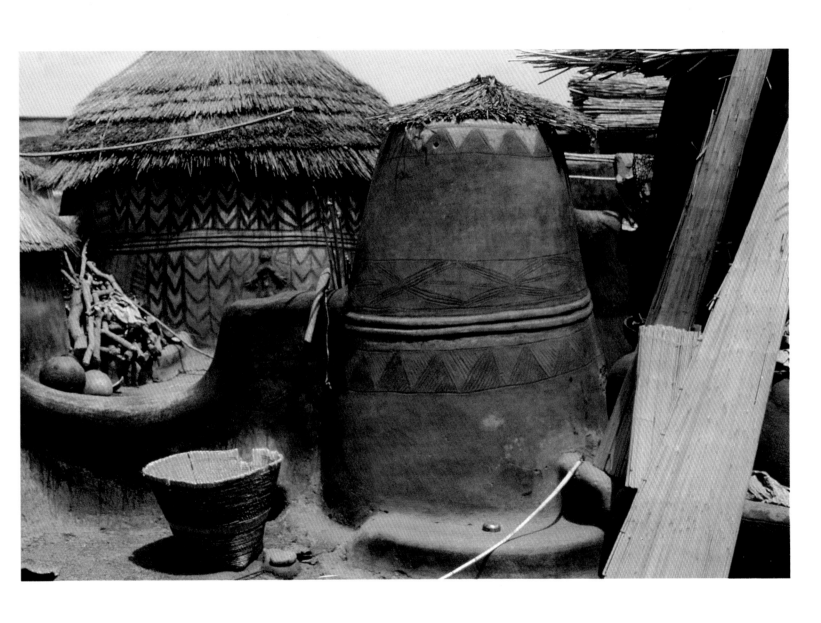

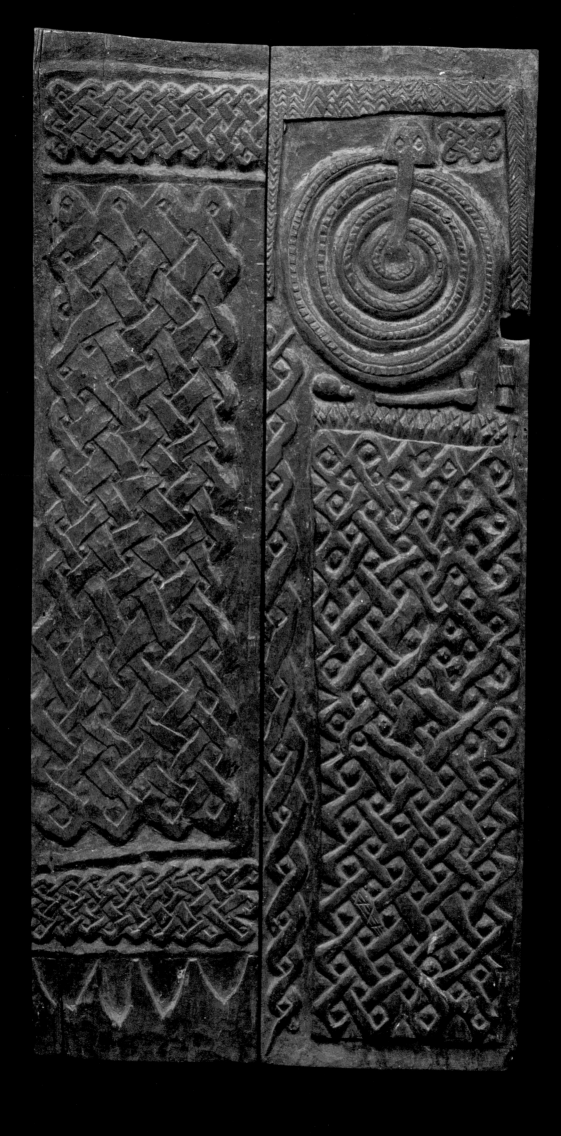

8

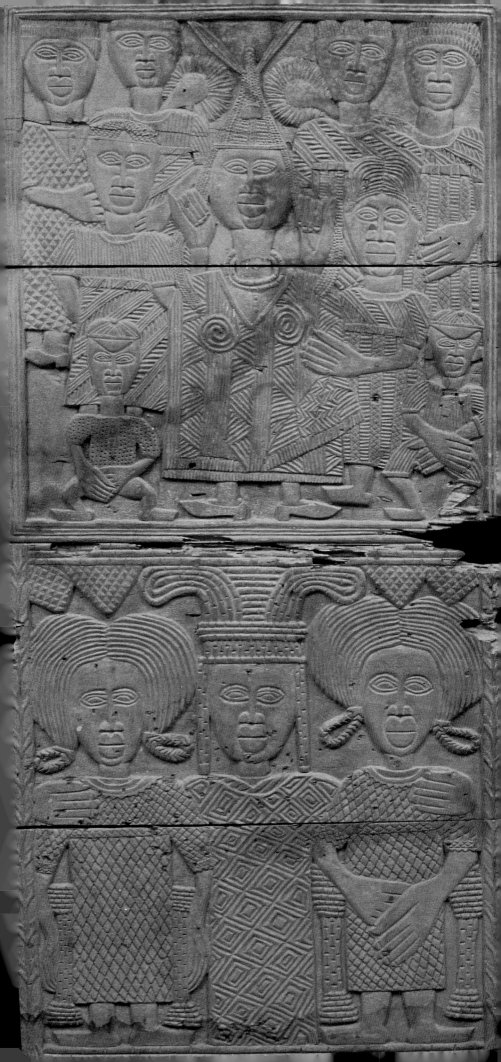

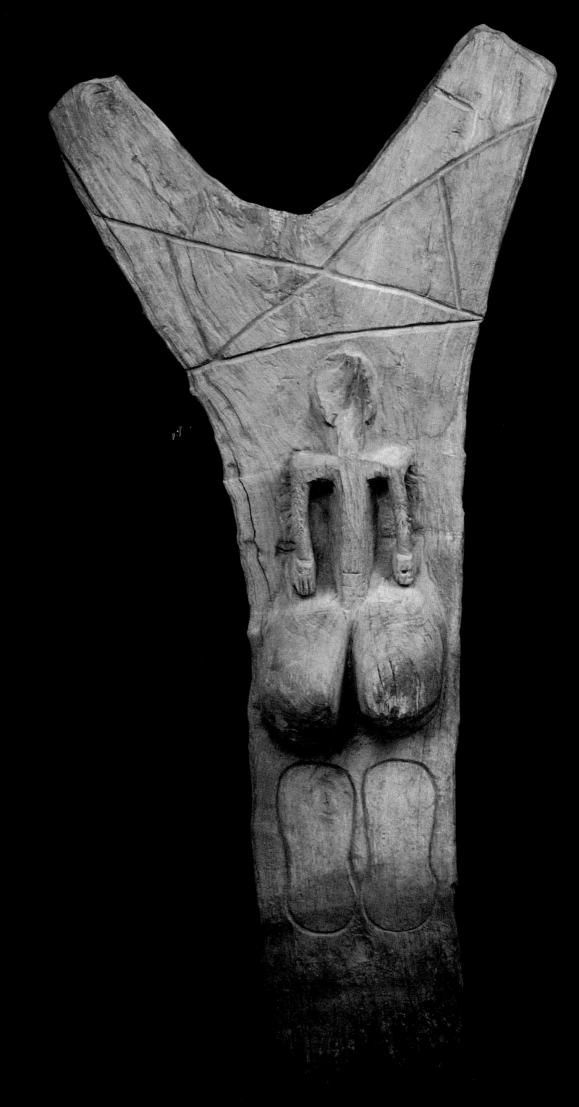

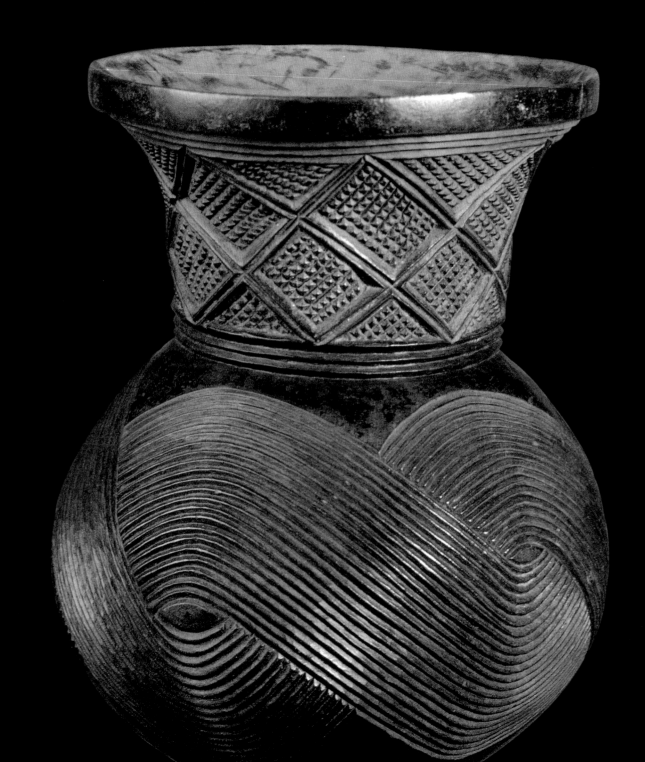

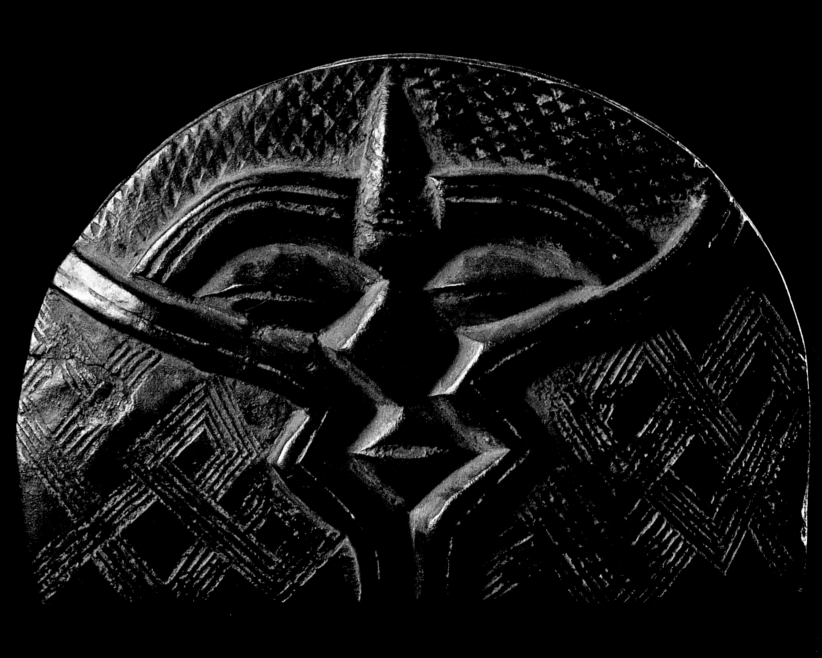

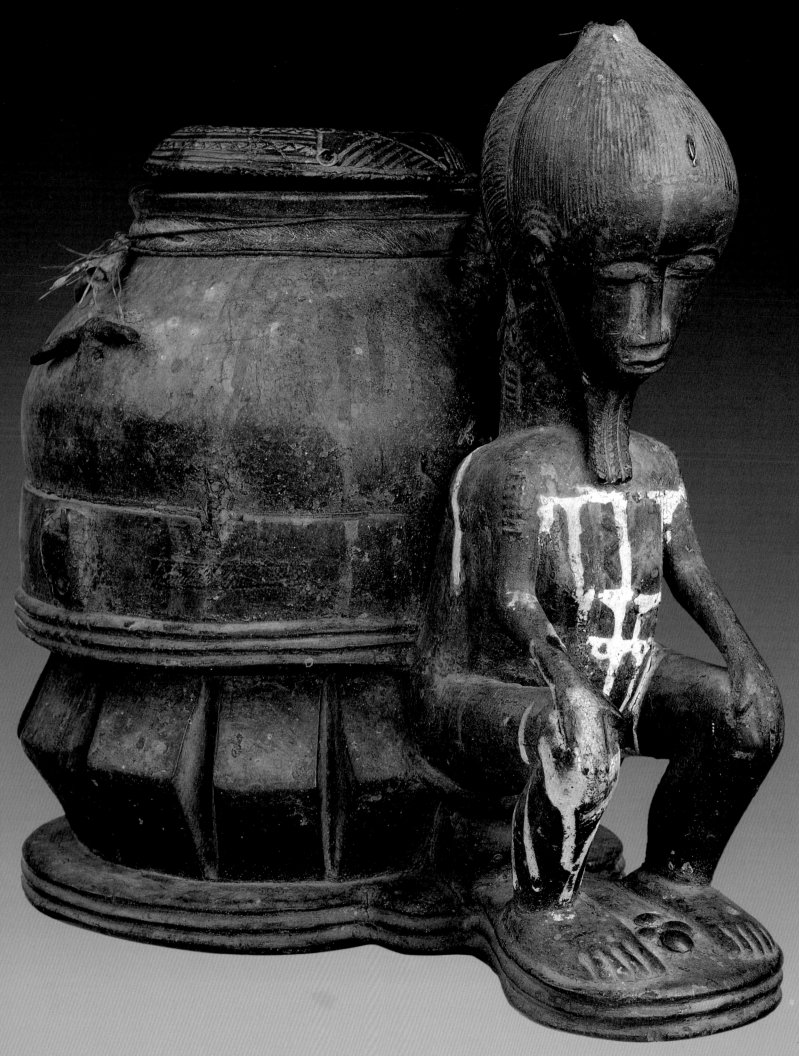

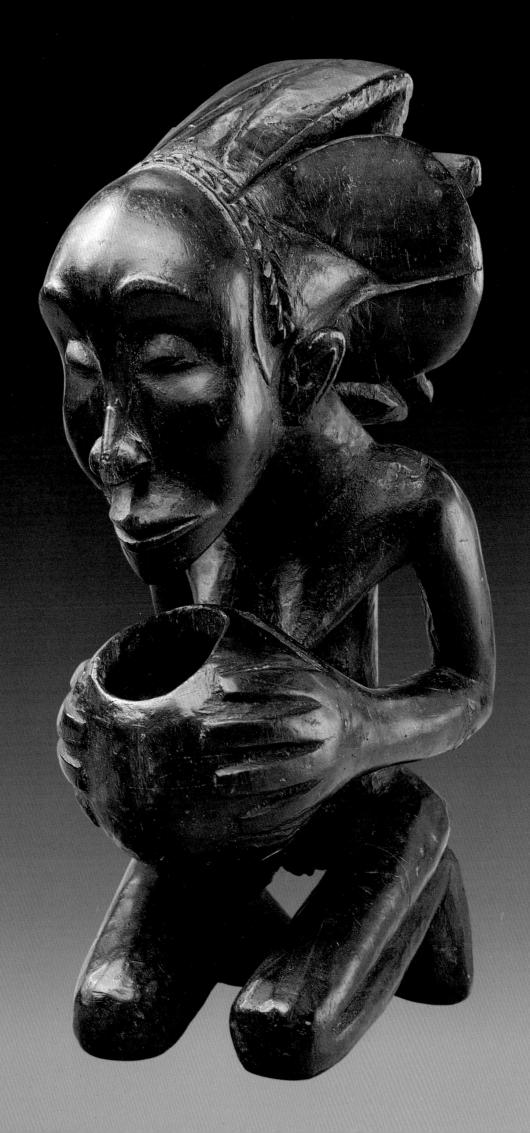

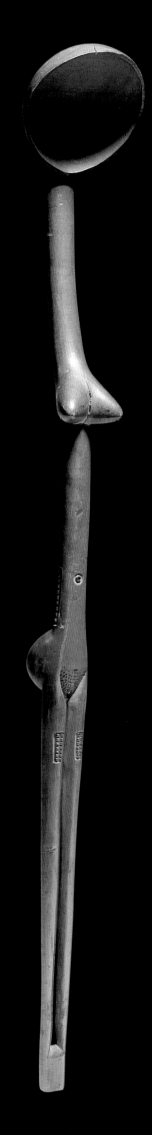

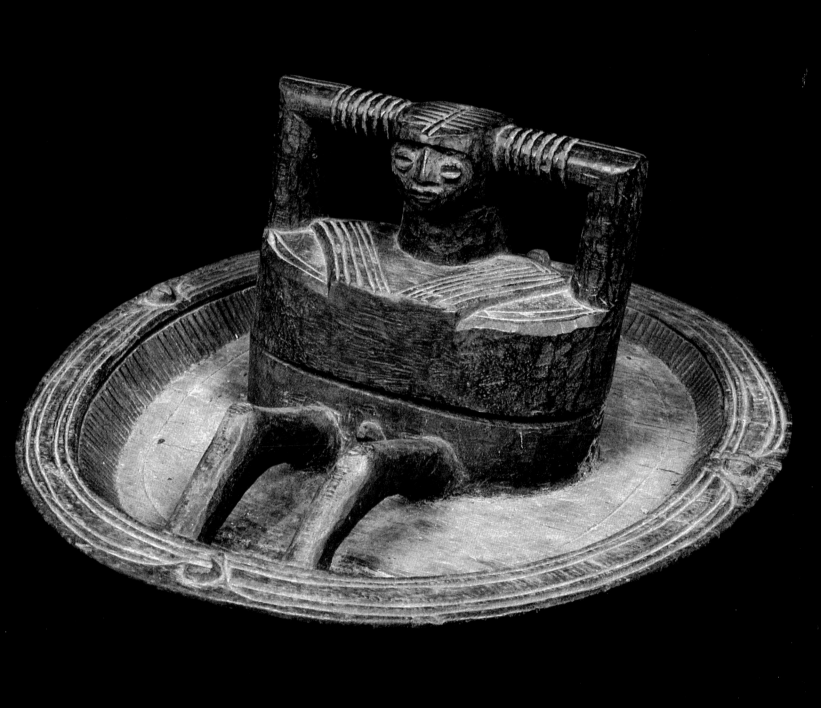

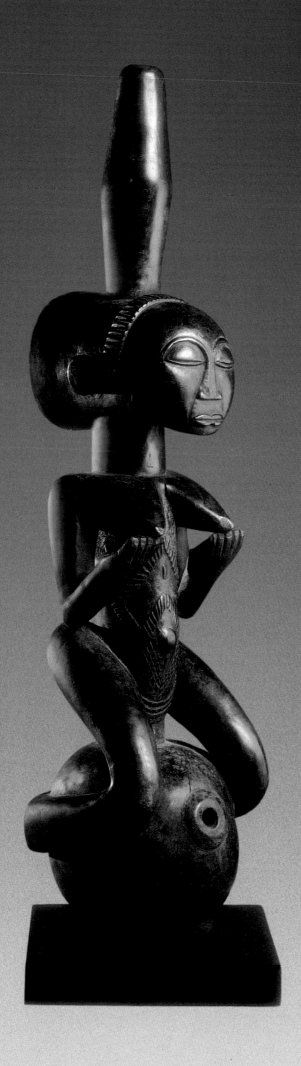

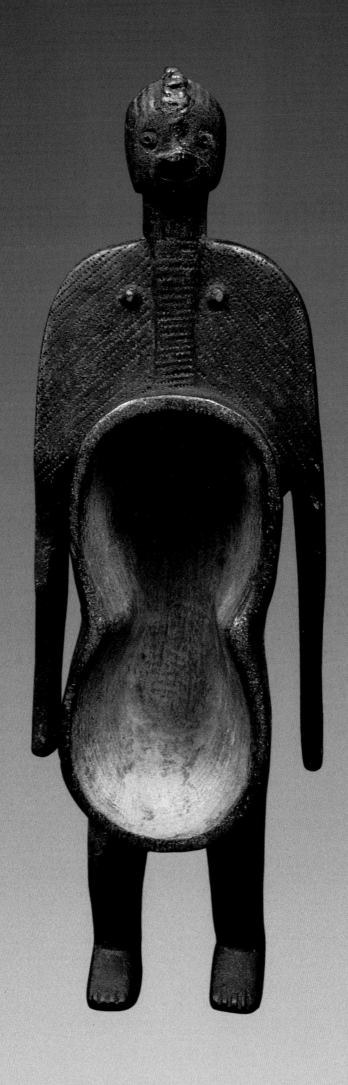

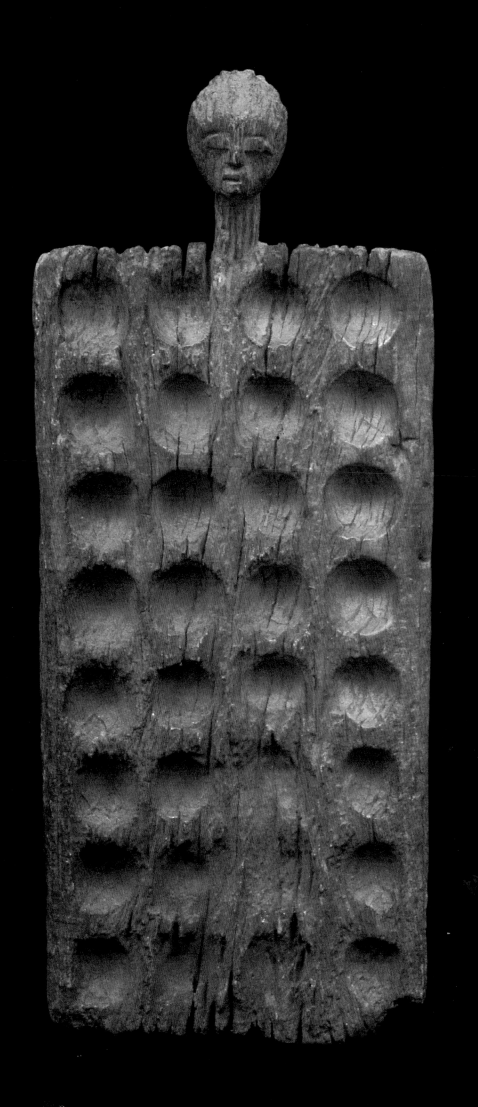

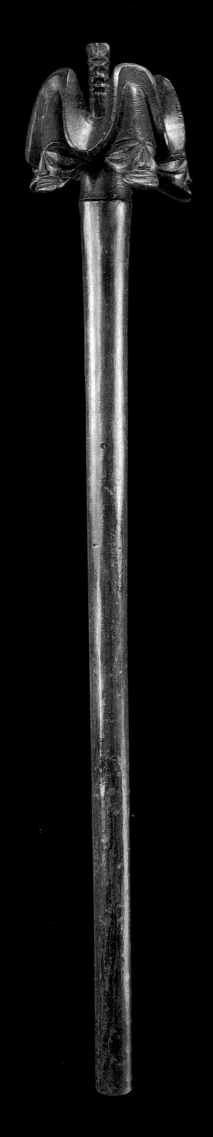

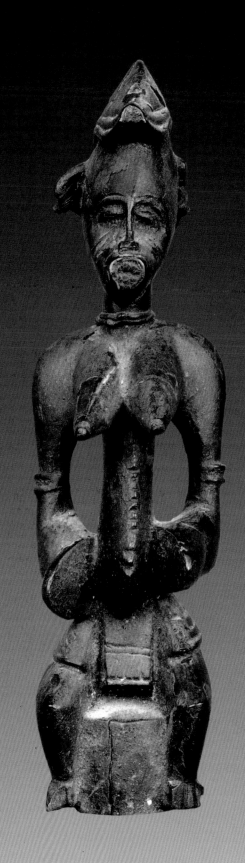

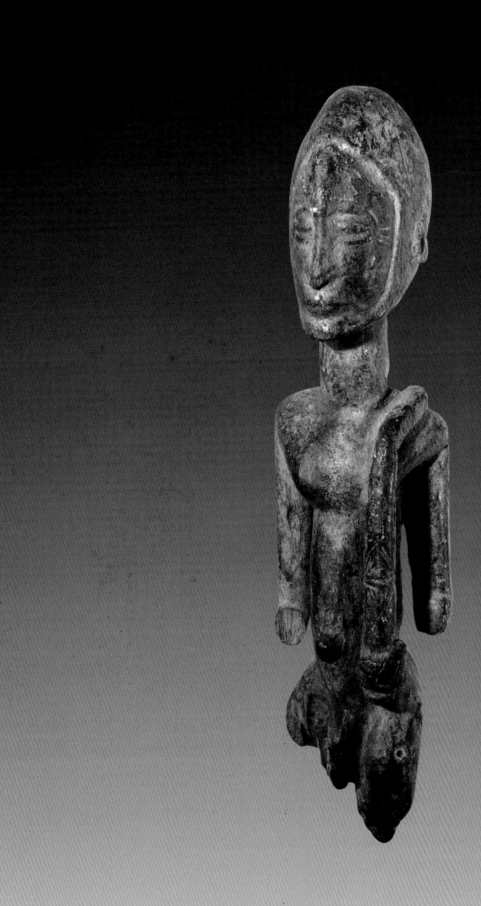

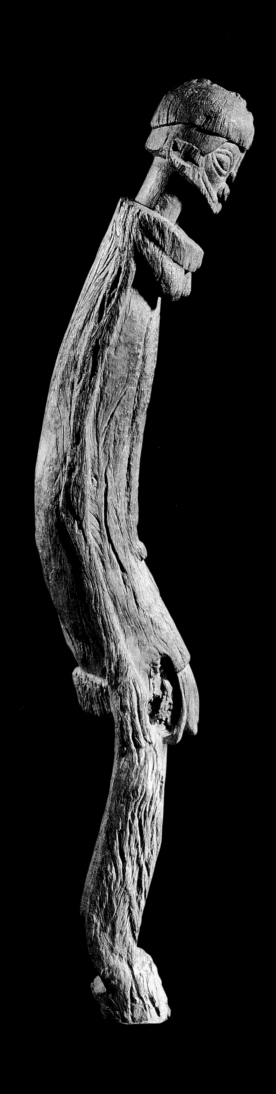

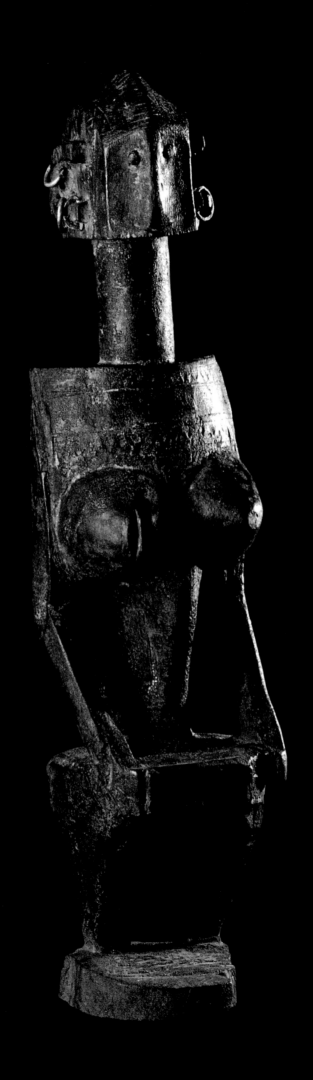

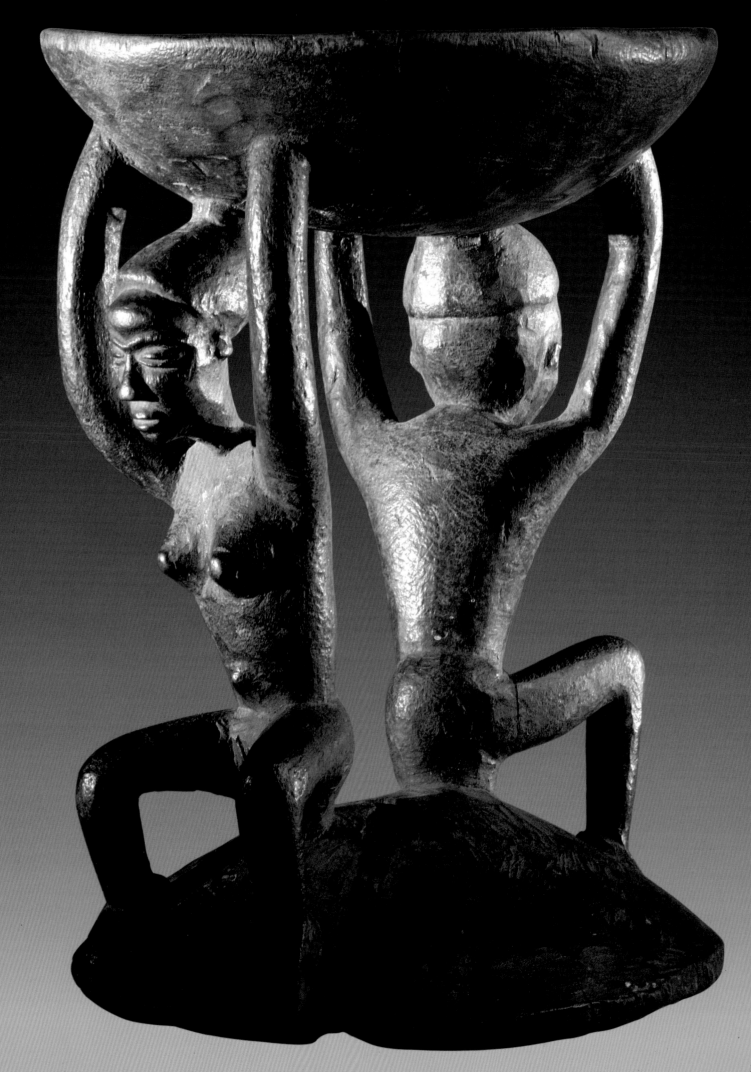

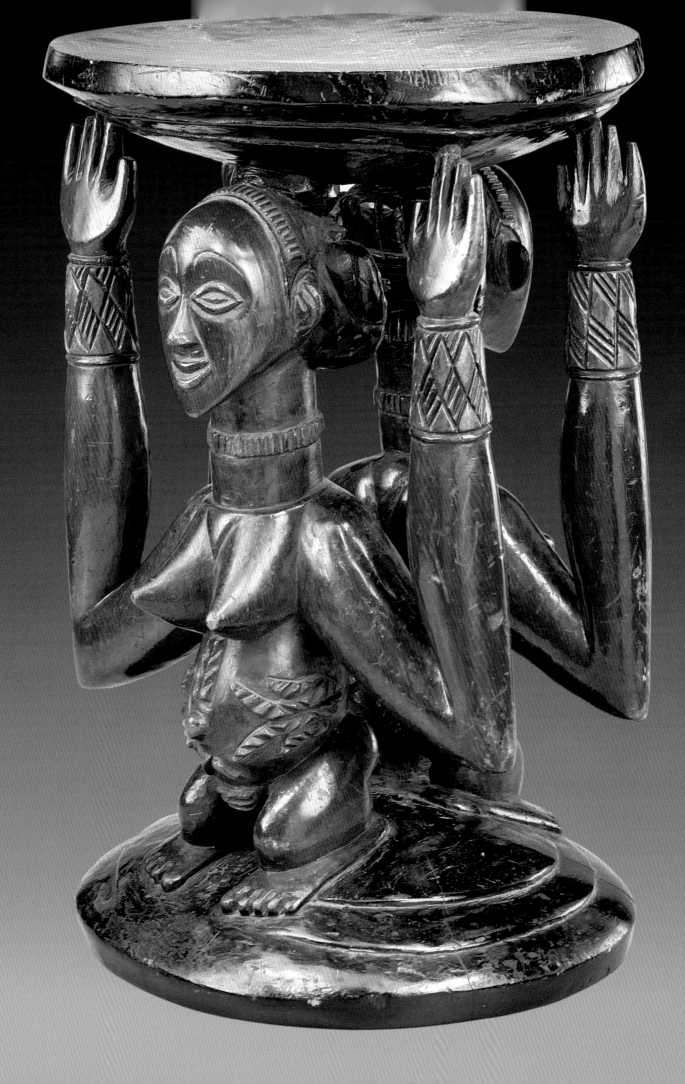

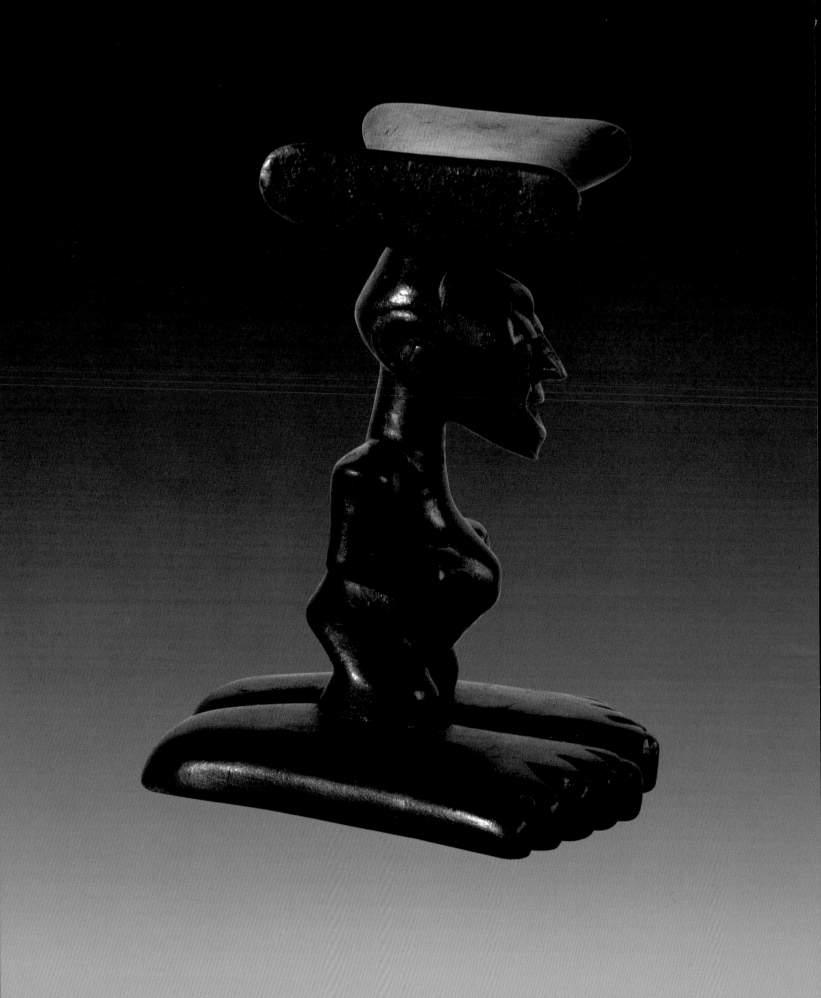

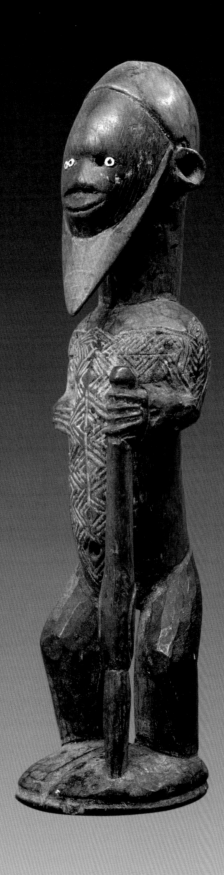

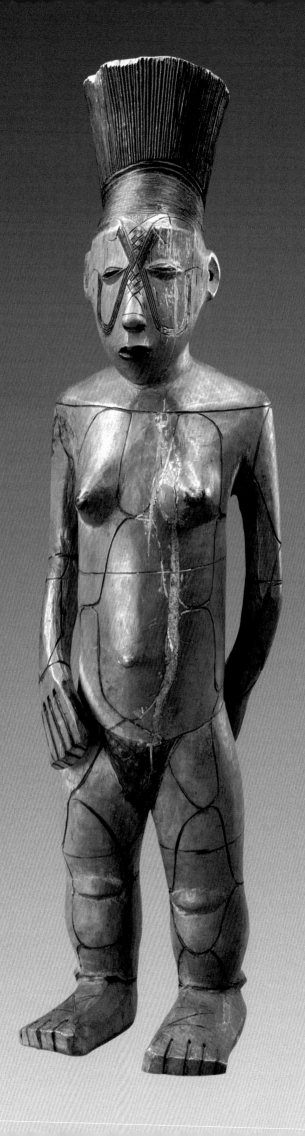

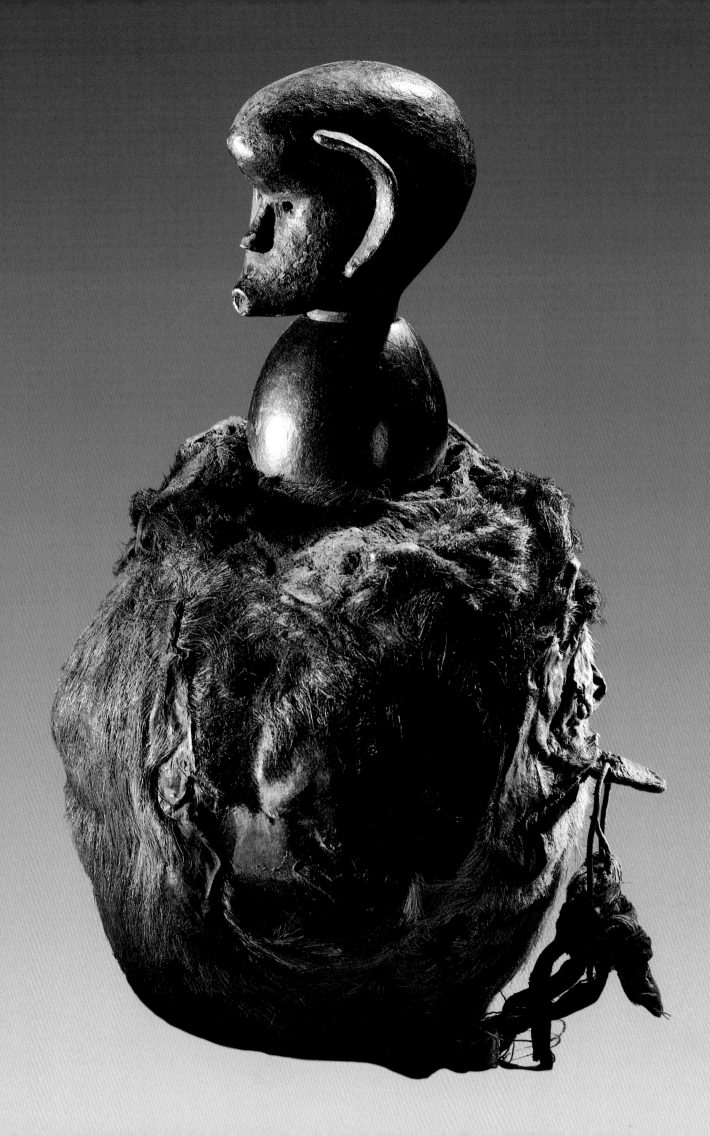

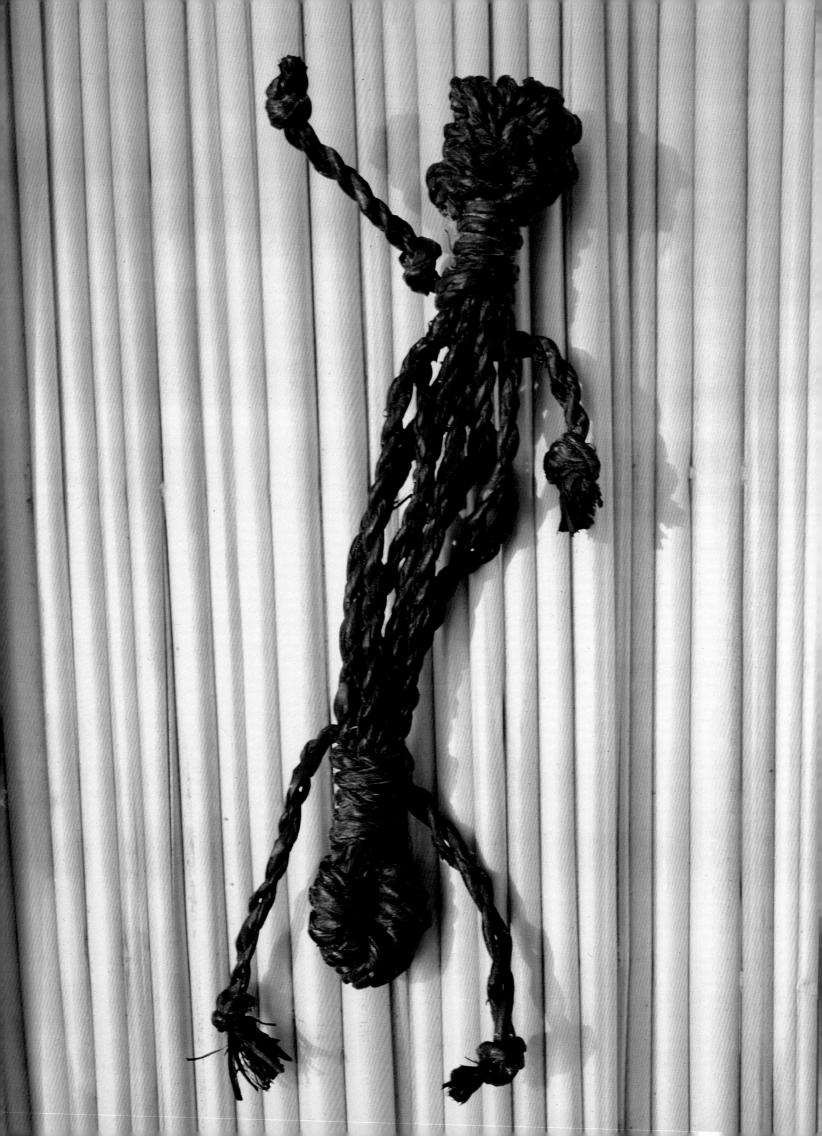

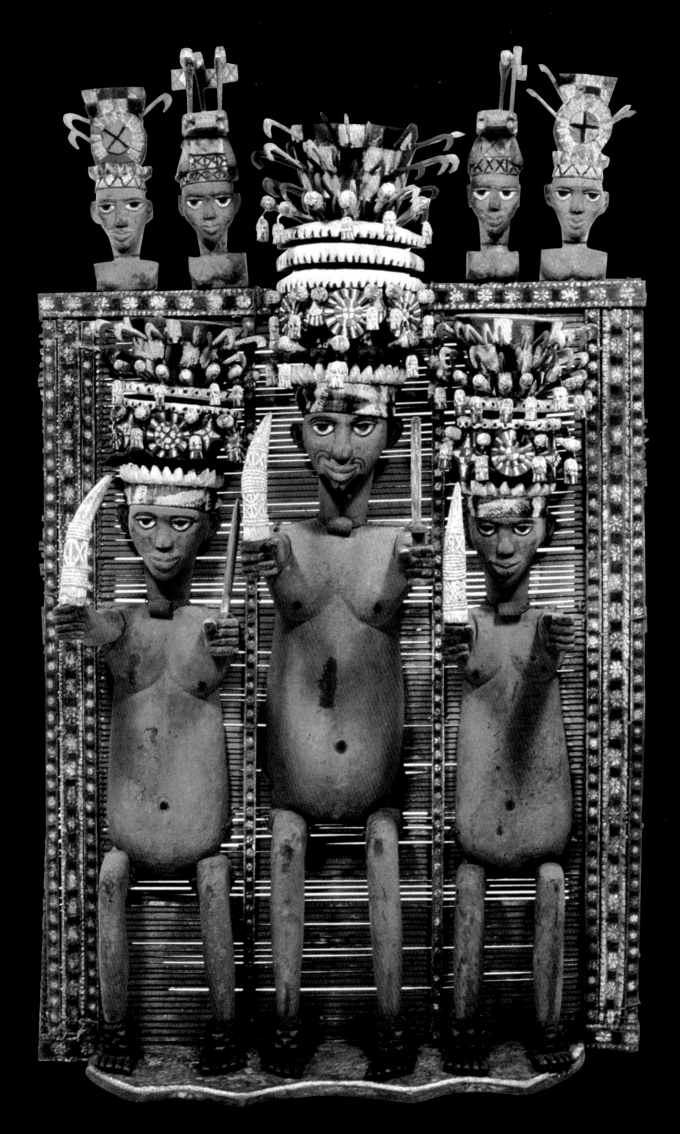

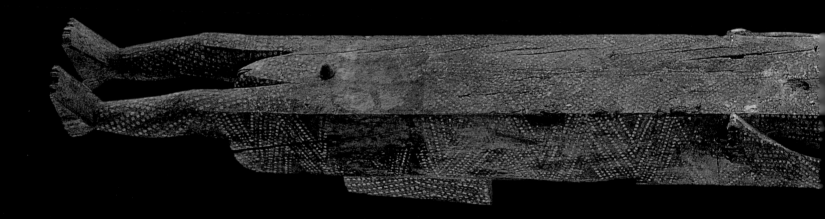

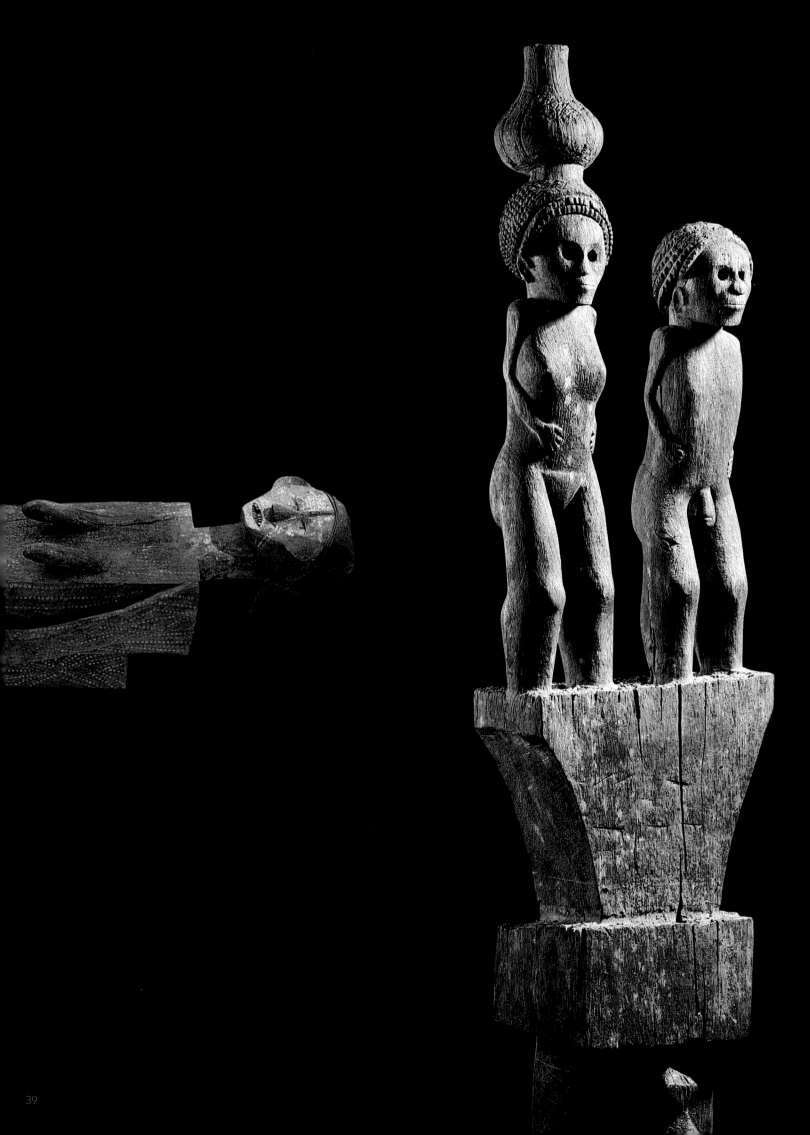

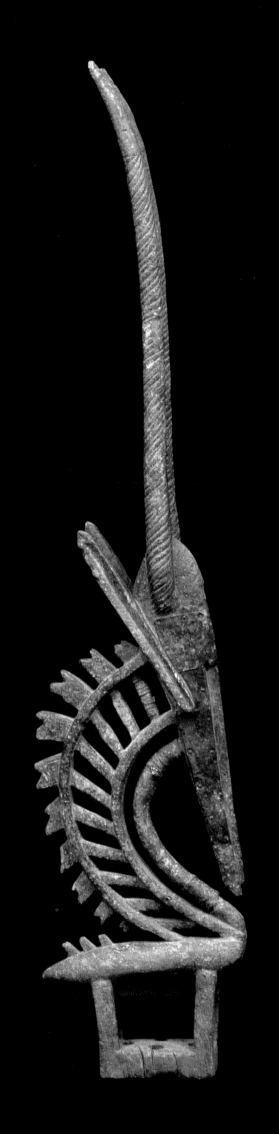

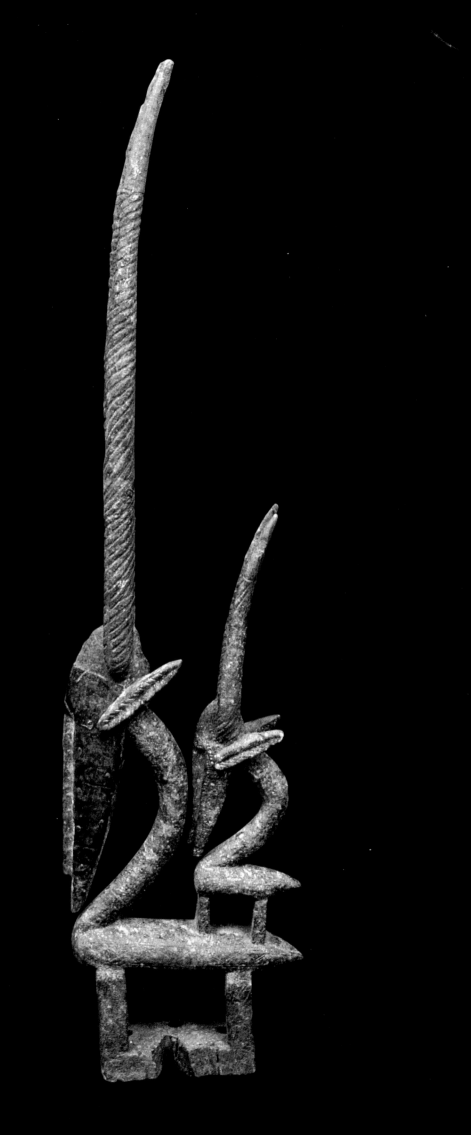

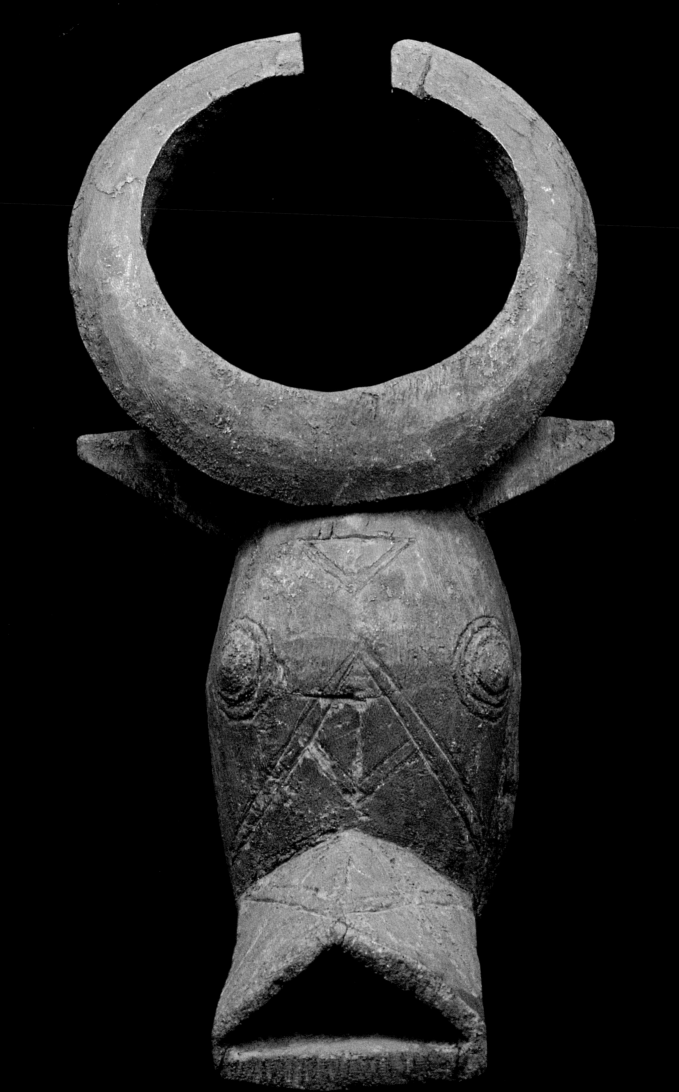

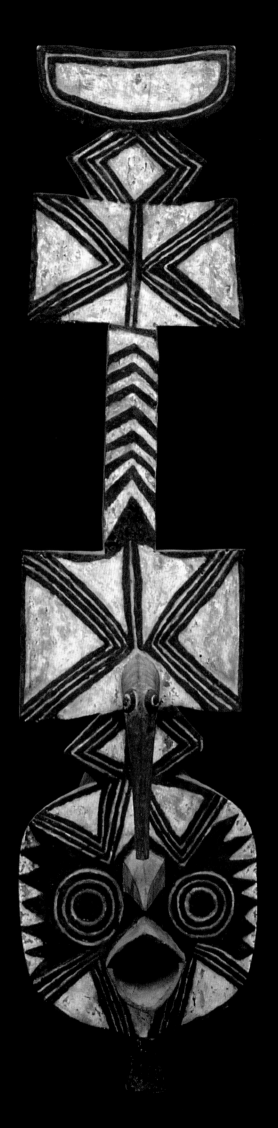

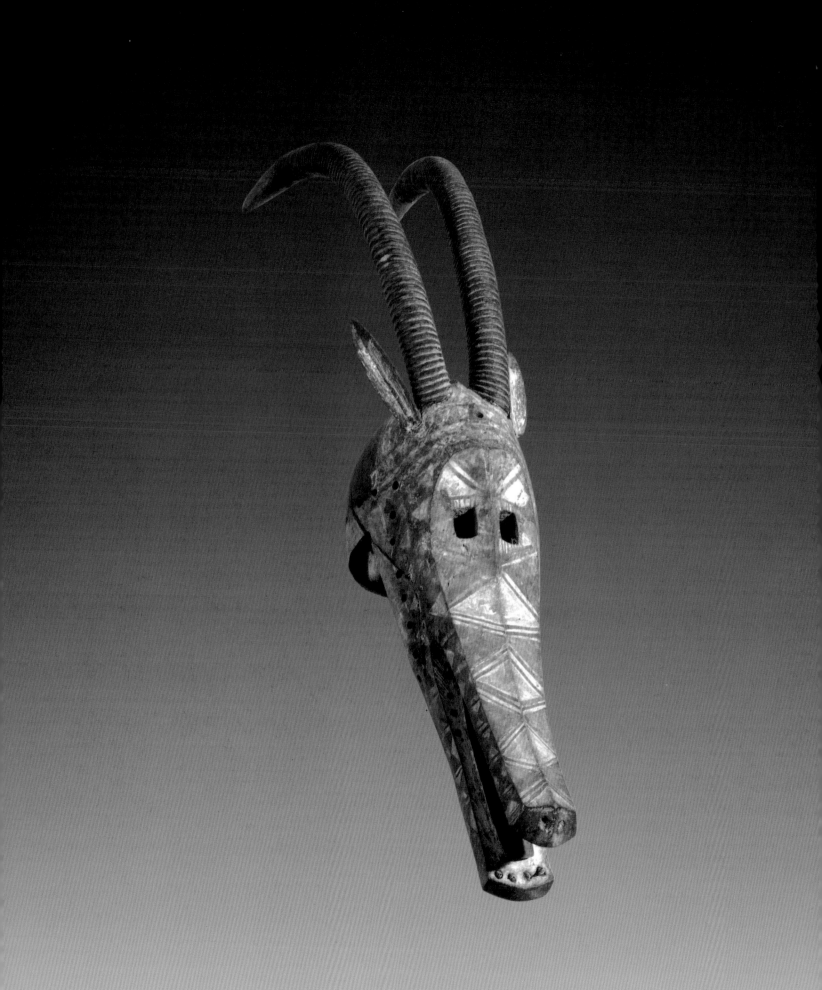

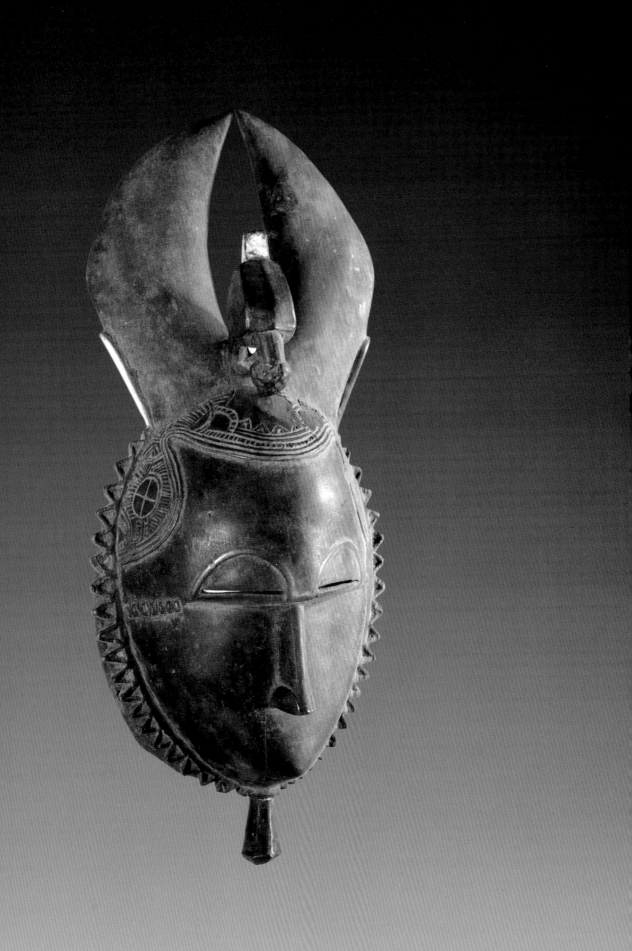

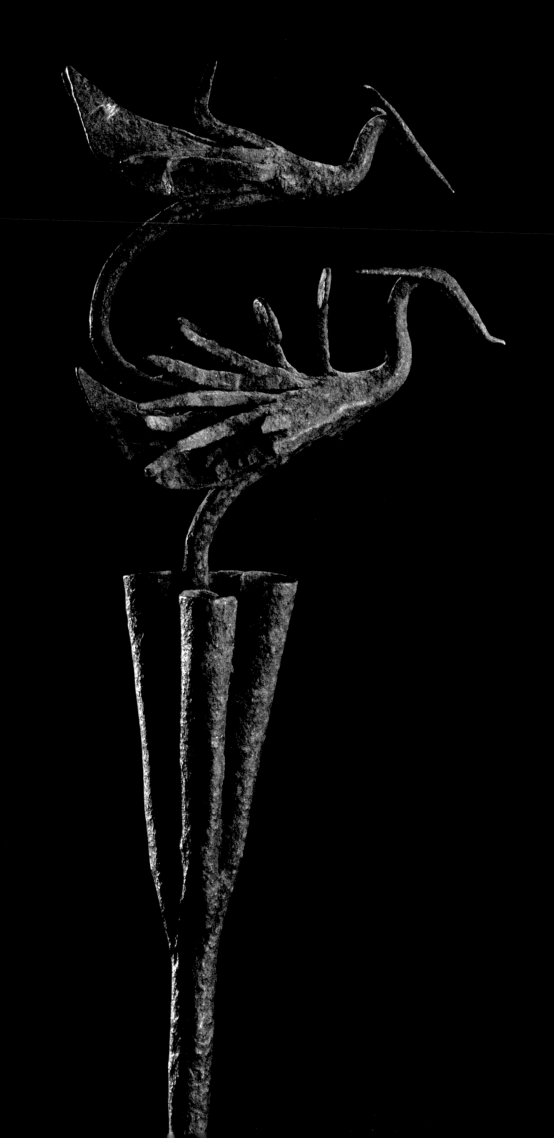

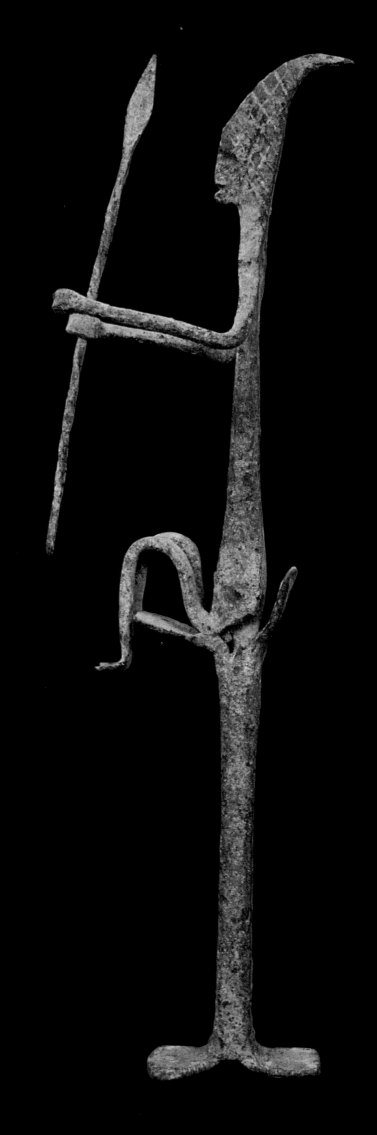

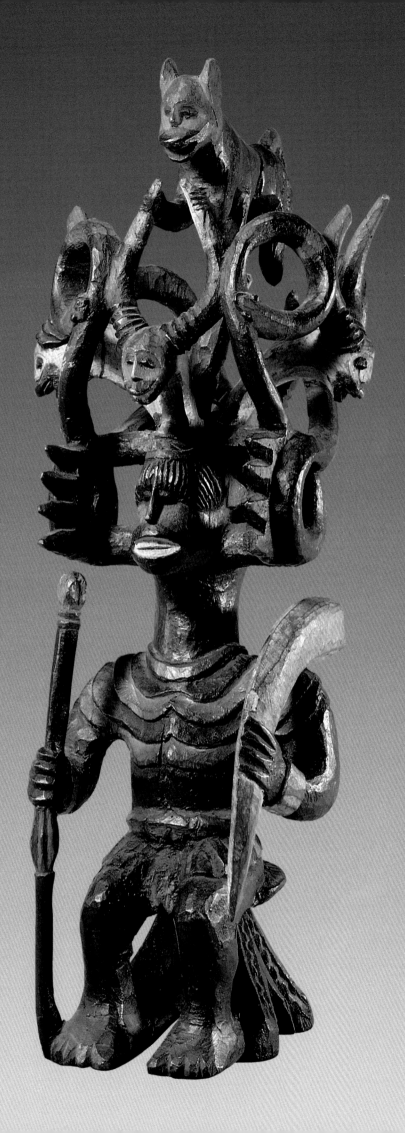

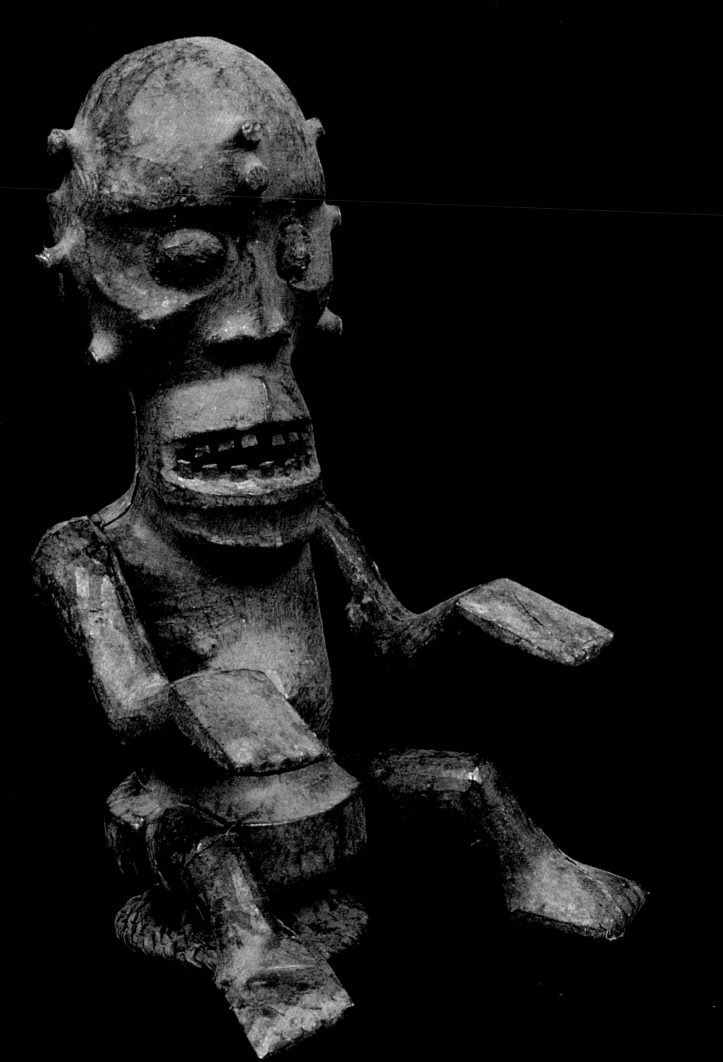

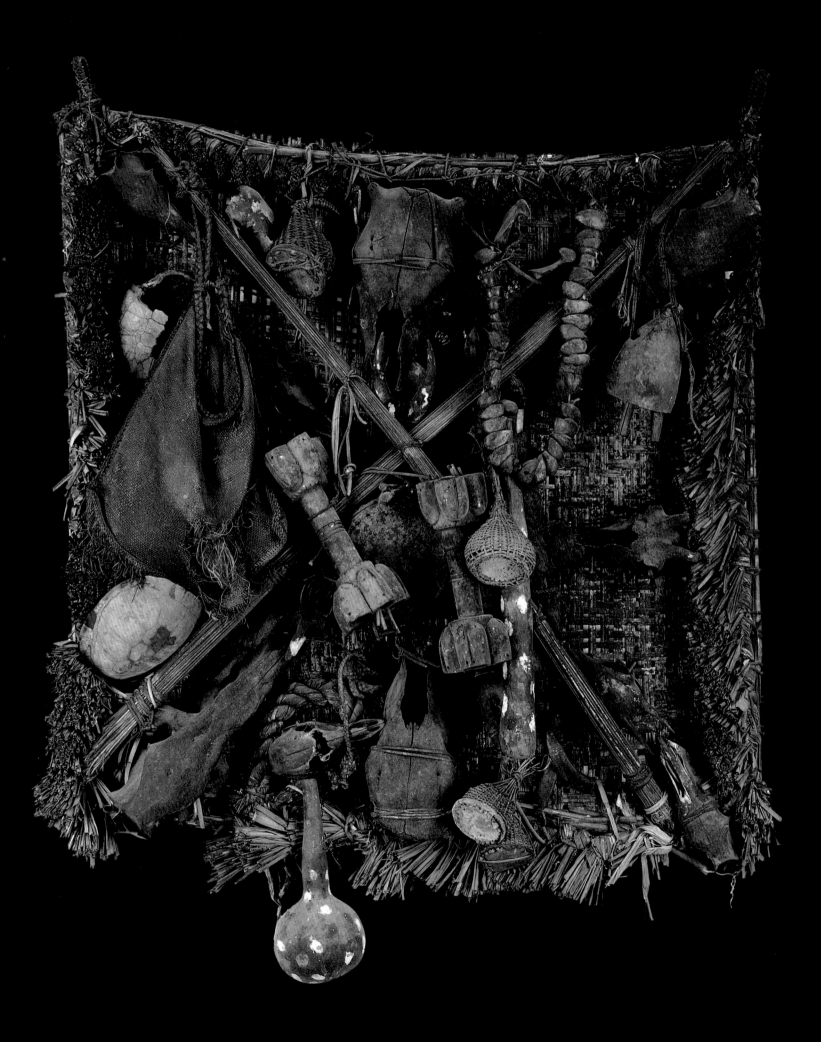

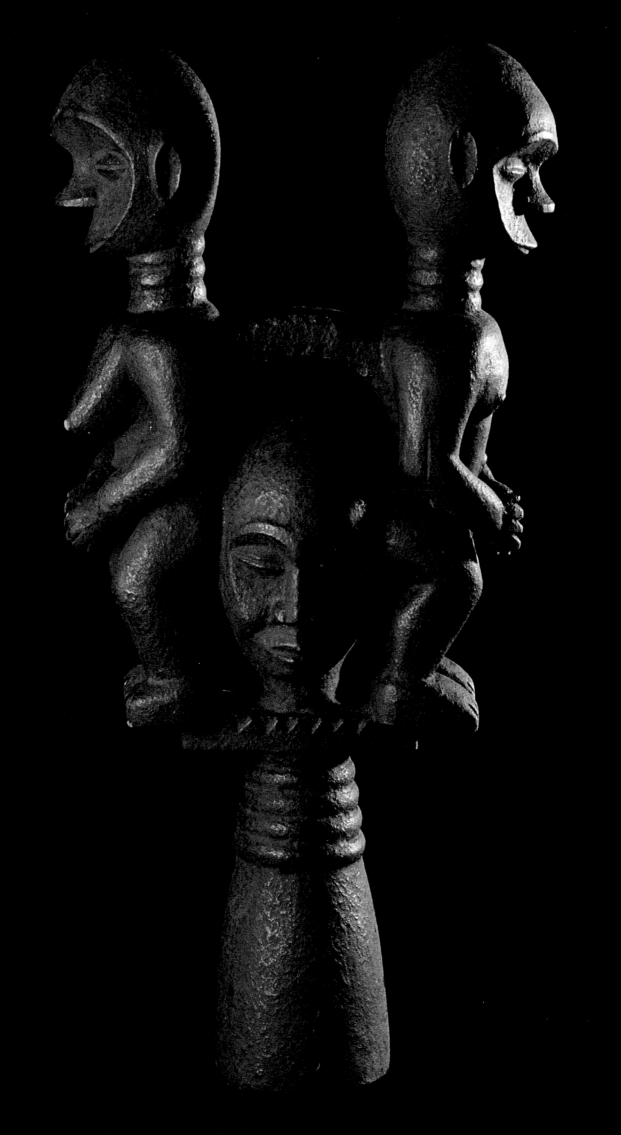

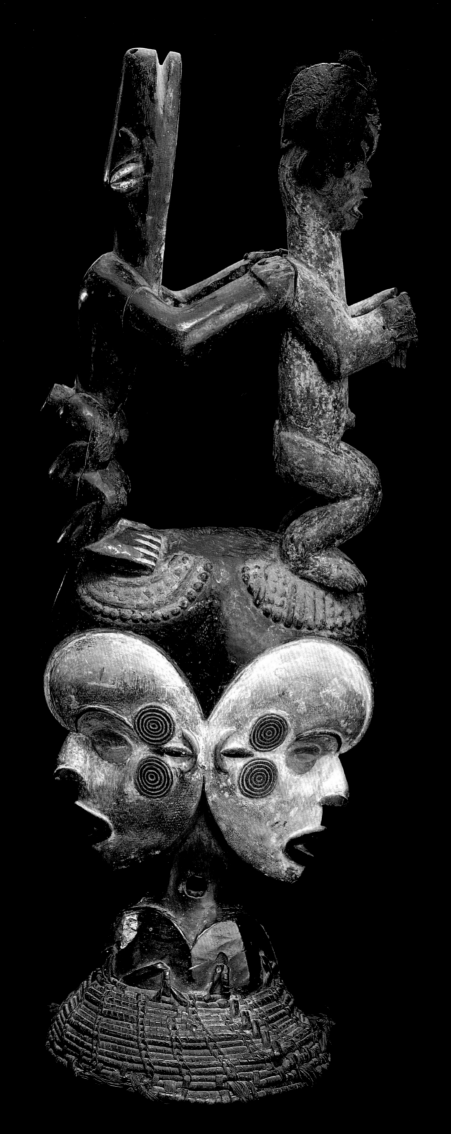

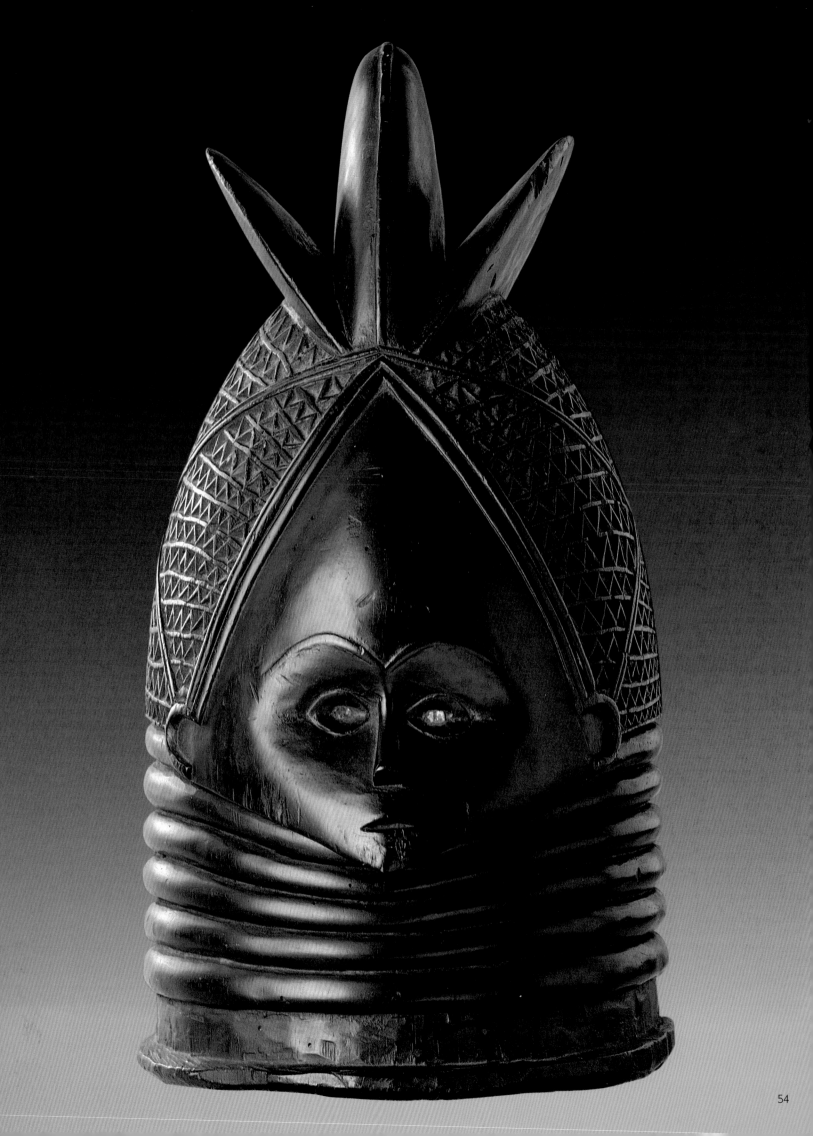

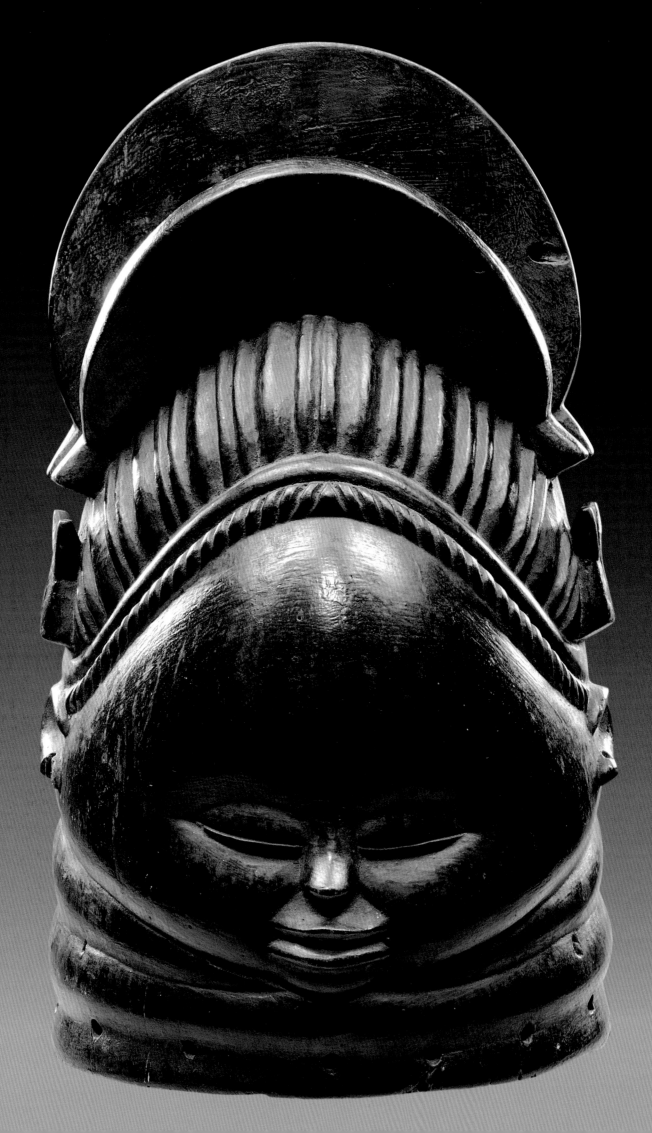

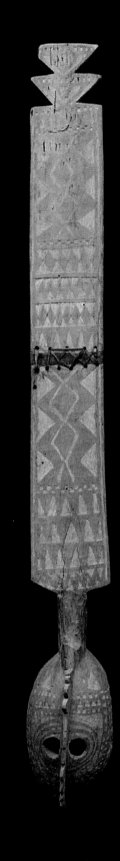
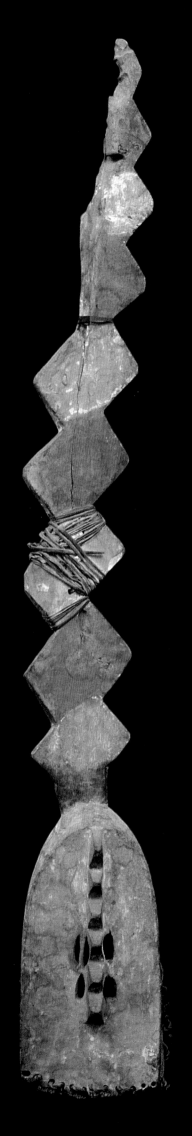

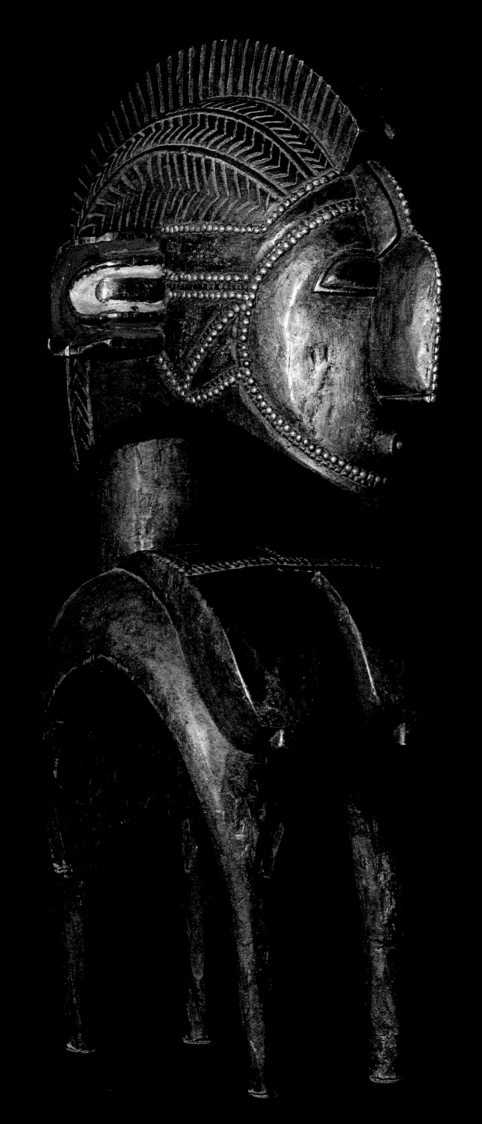

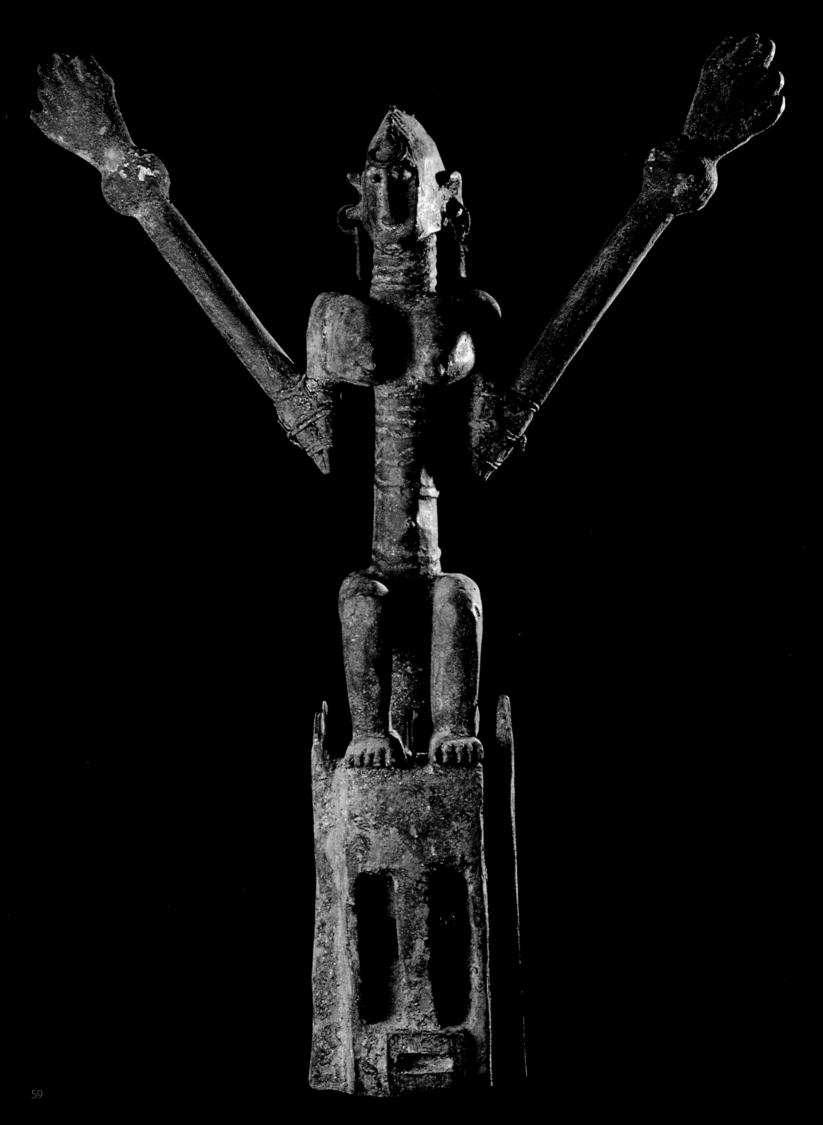

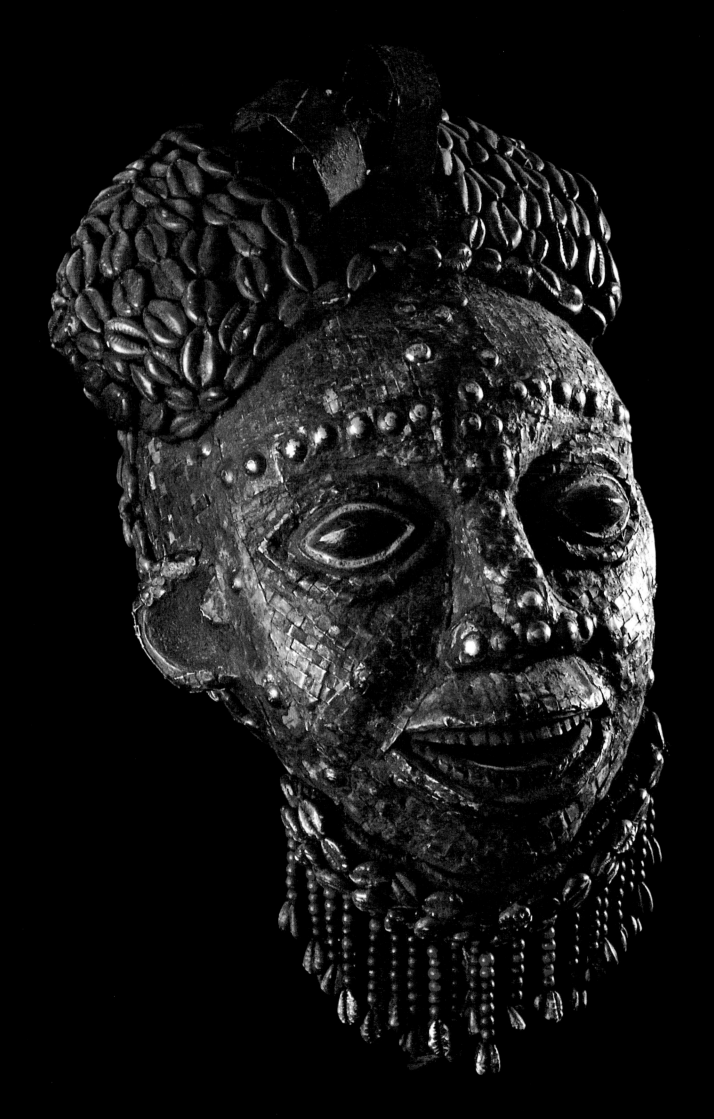

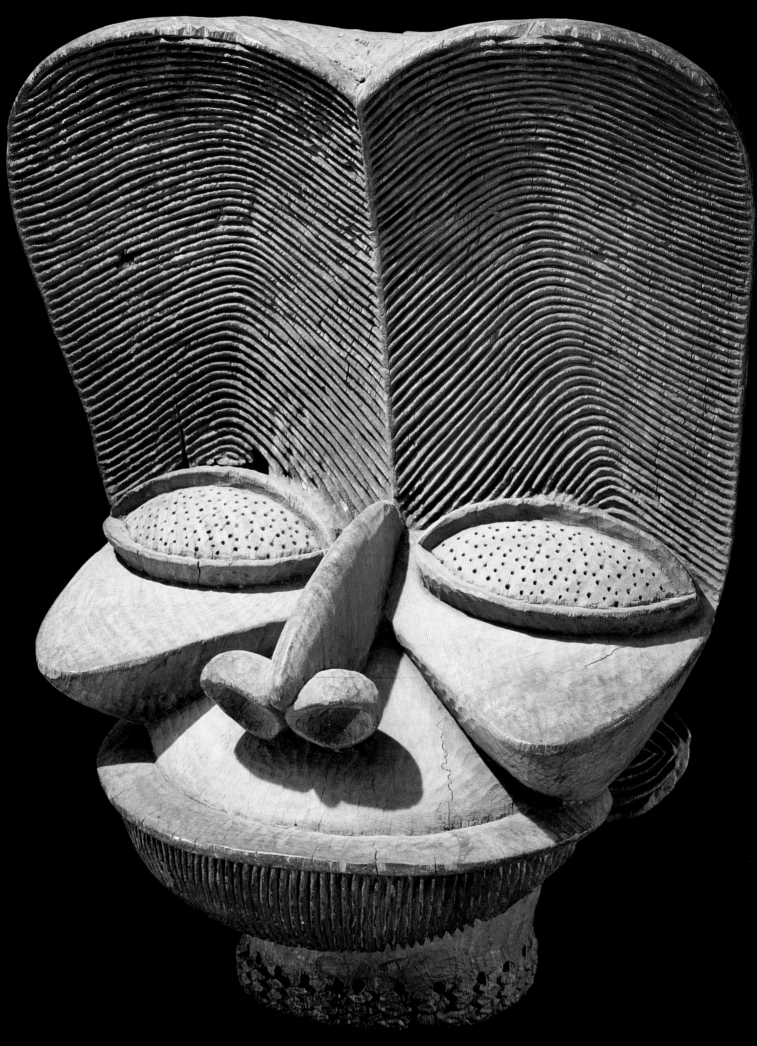

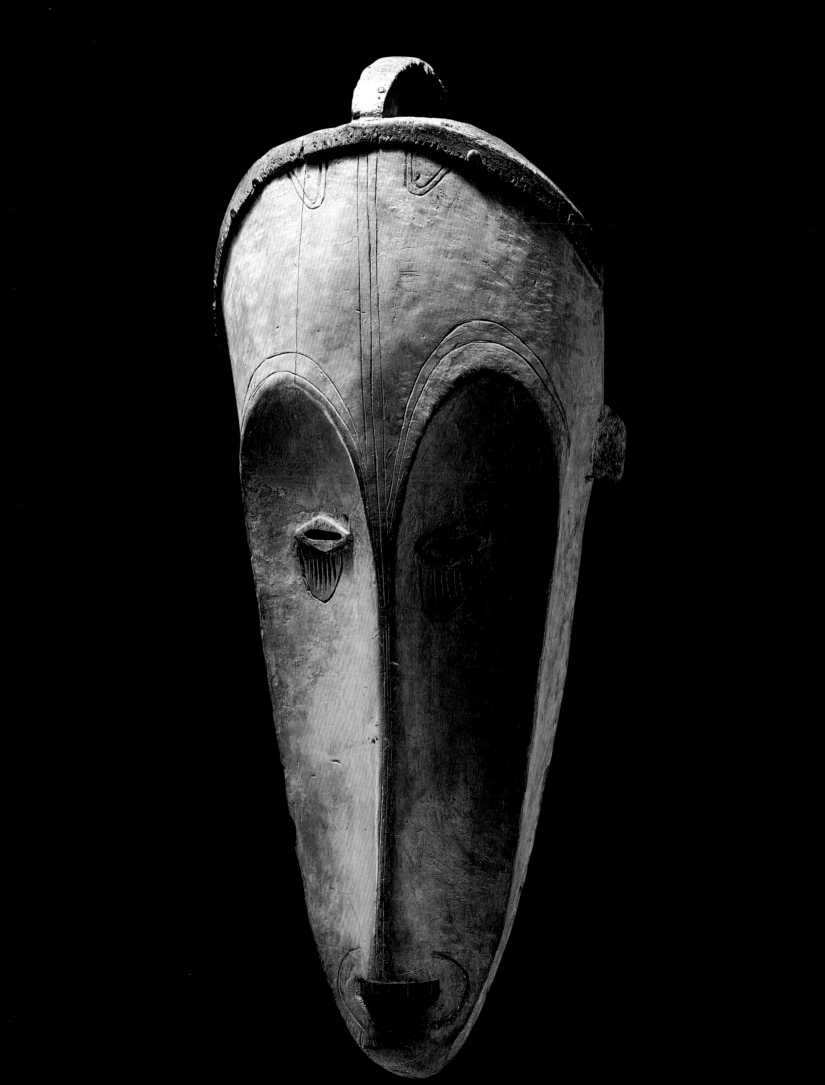

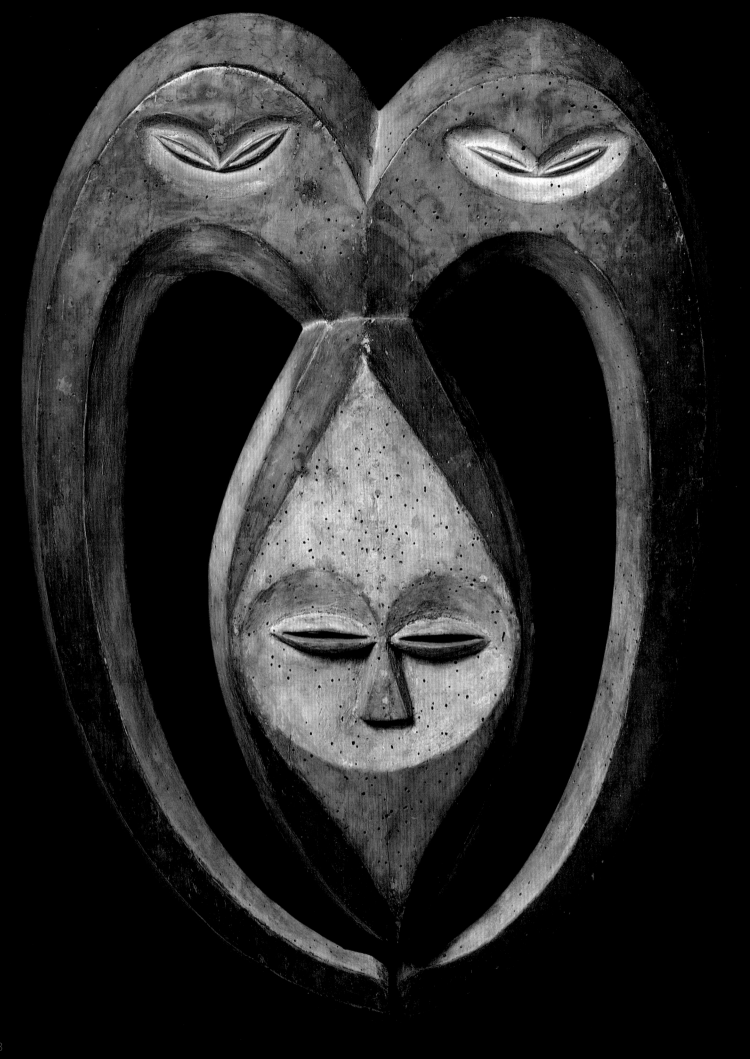

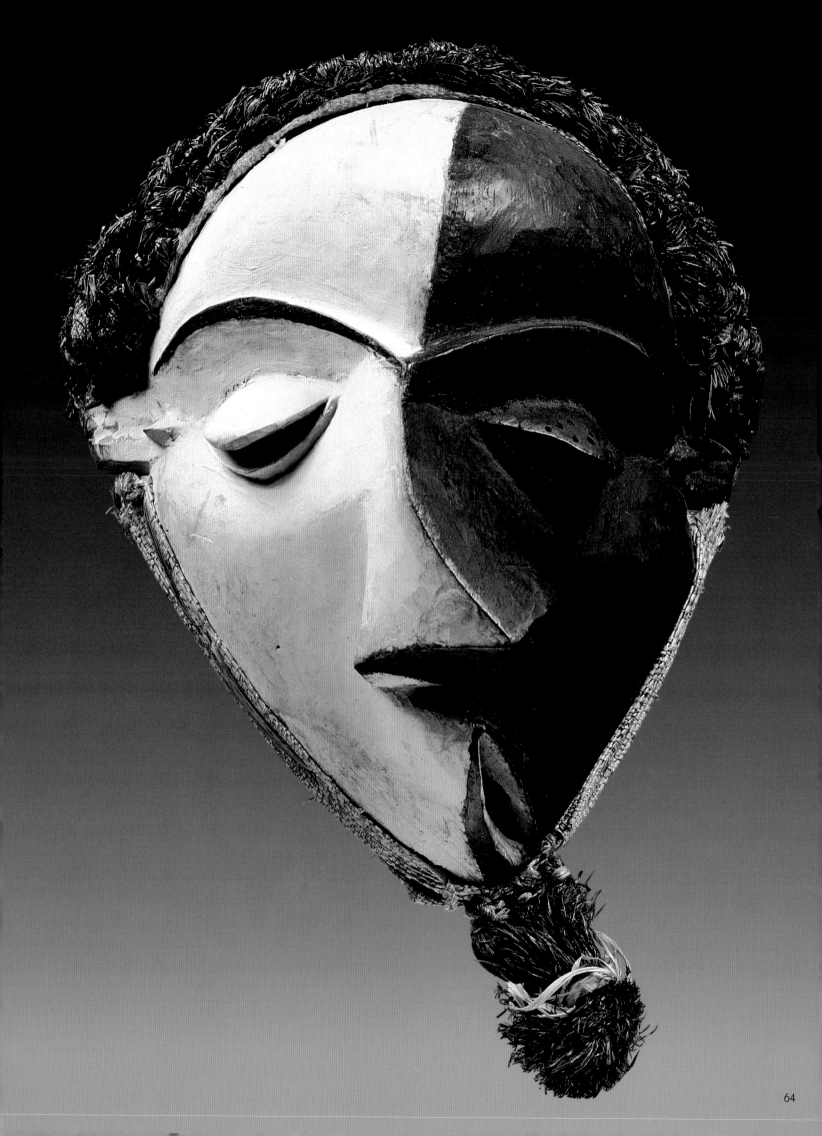

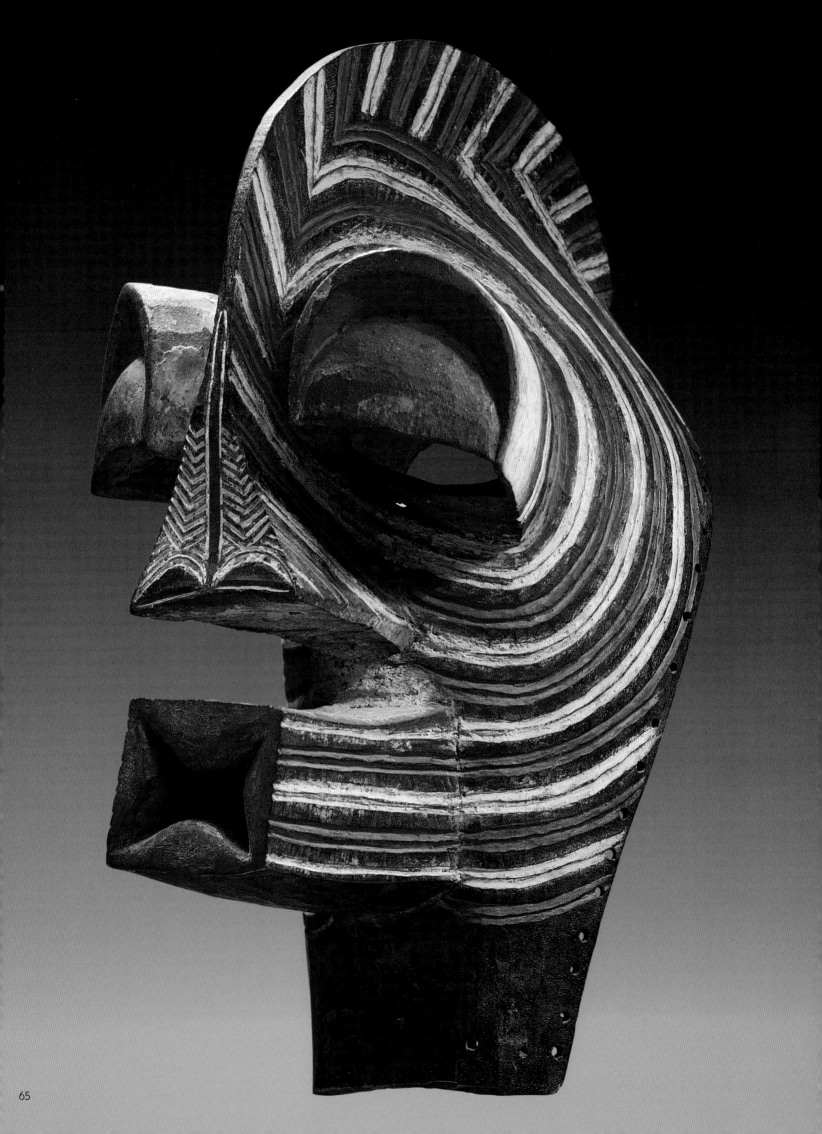

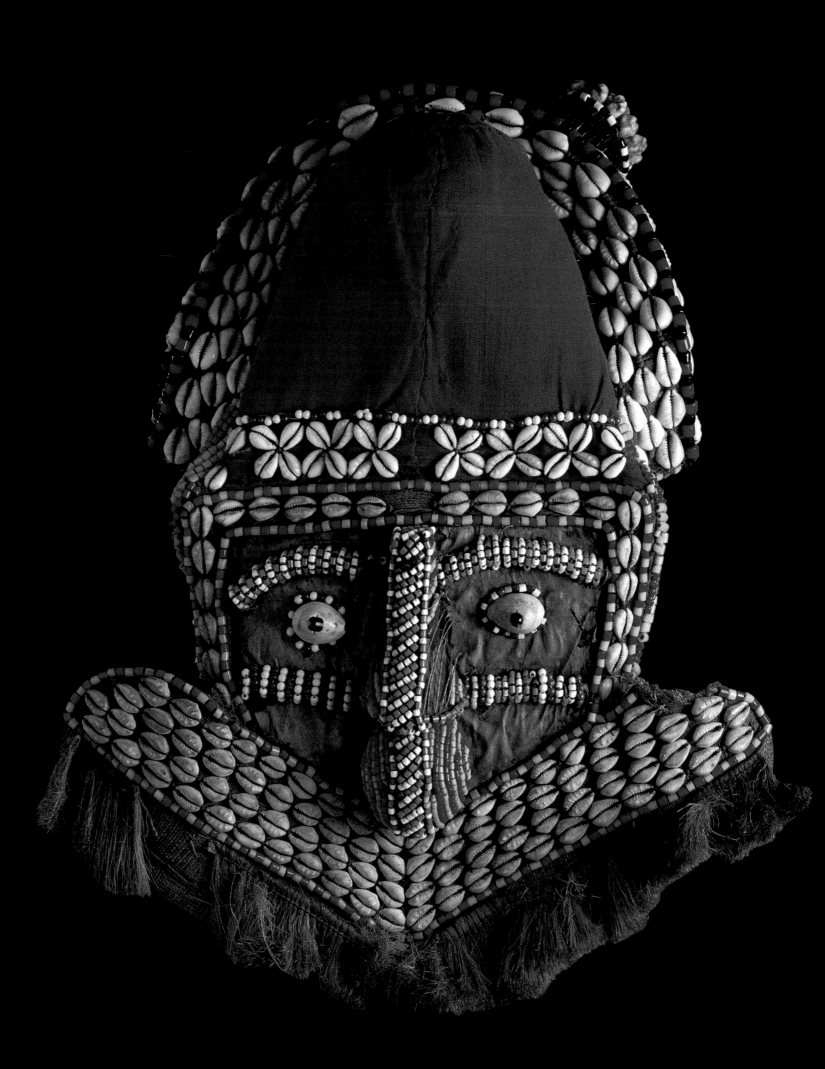

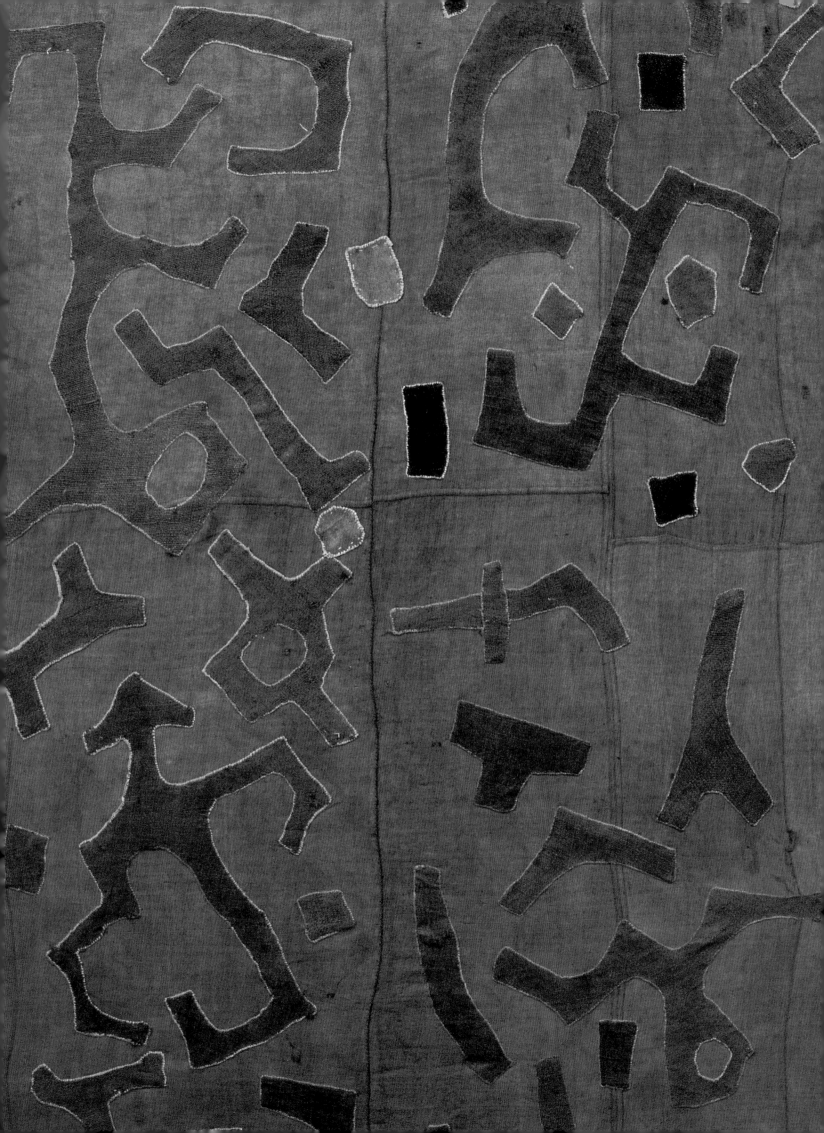

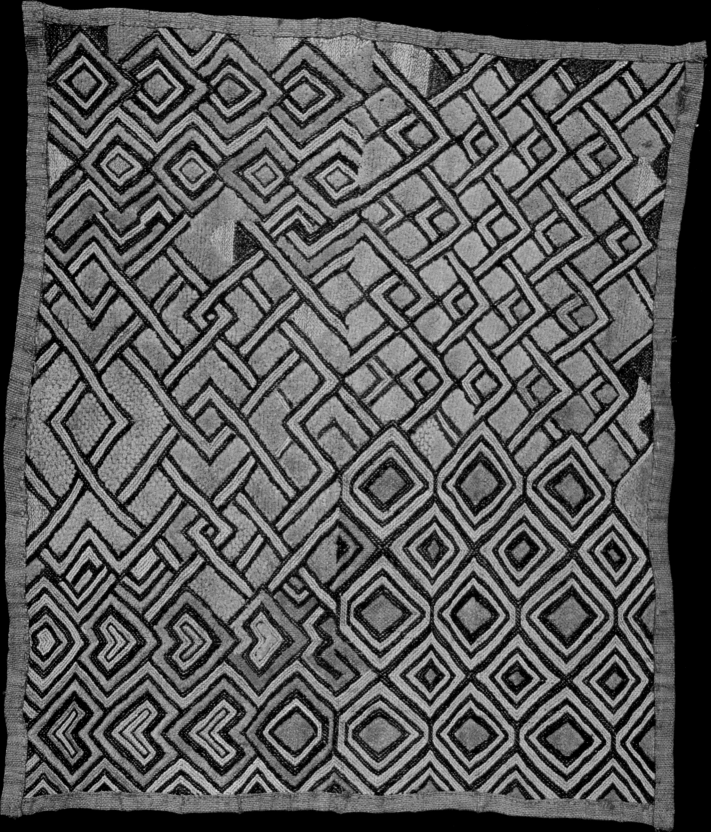

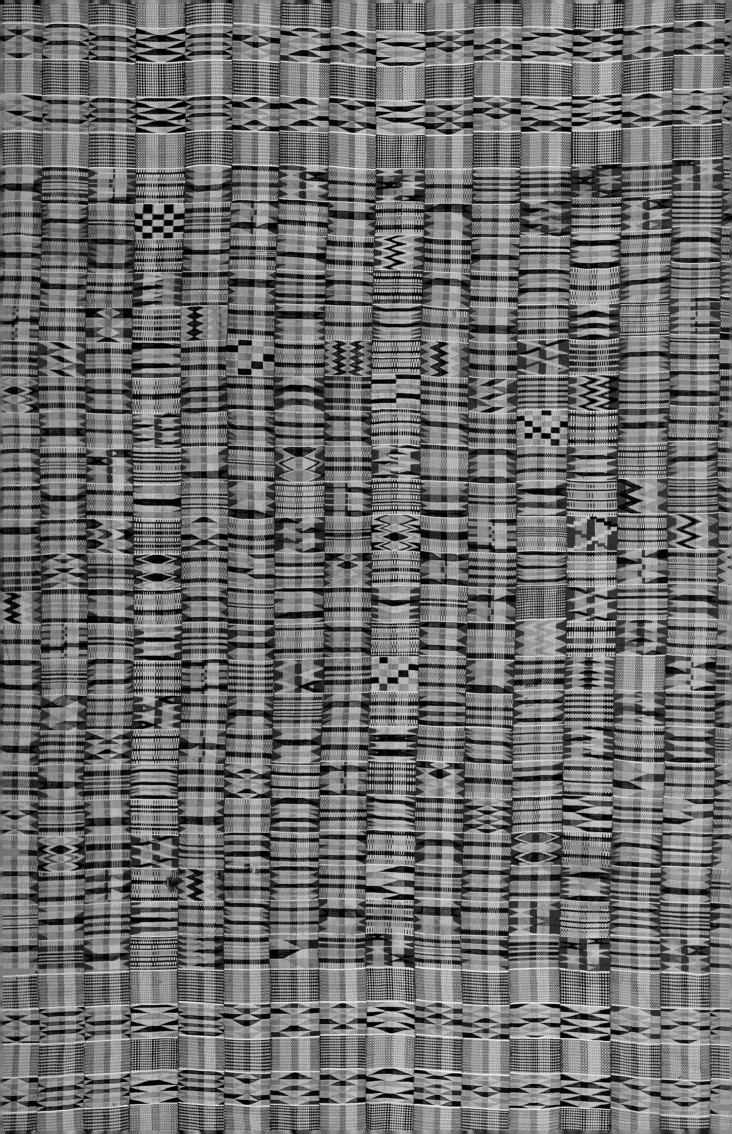

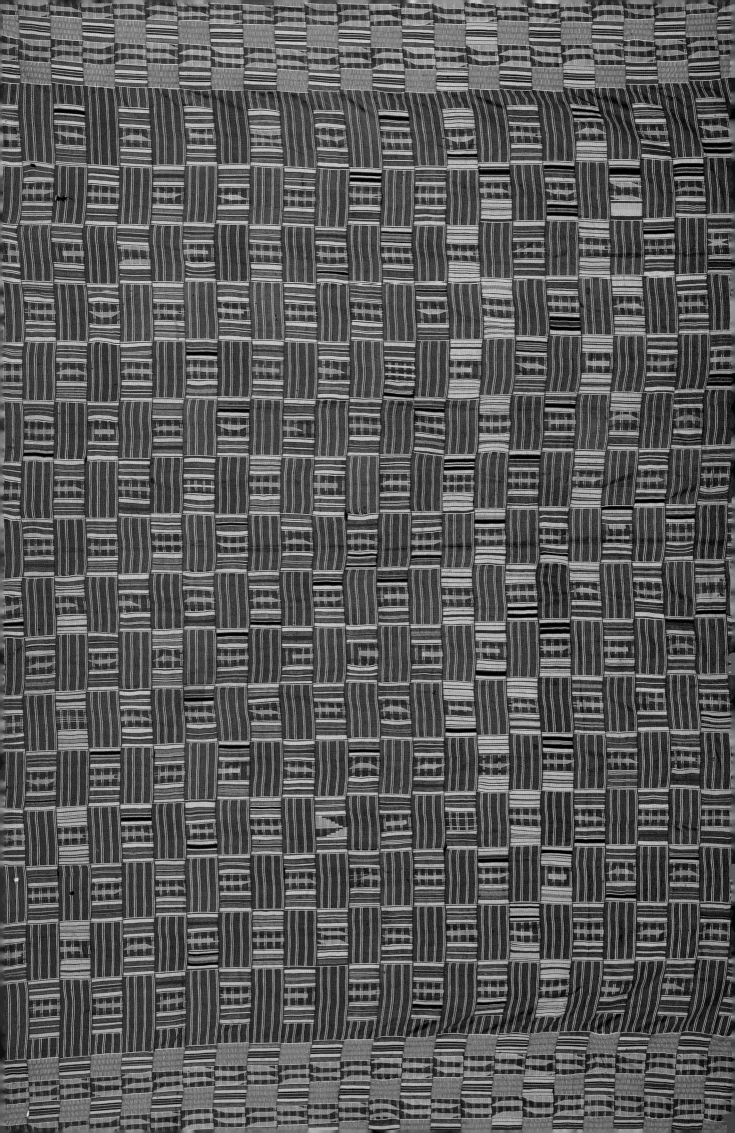

nation between the model of spatial representation of the nomads and of sedentary people. At the bottom, we find the recipient of water, called the "mother of the Khasa," which recalls the sources of life and therefore of woman. The large triangles placed in the center indicate, instead, the little hills of earth on which the Peul, to escape the flooding that happens during the rainy season, build their villages. The horizontal lines trace the voyages of the transhumance, while the little triangles dispersed over the cover represent familial residences. For as much as the central symbolic element is that of the village, this does not in and of itself cover all of the space; what prevails is more the clear base of the Sahelian expanse on which men are dispersed.

13. Hunter's tunic, Bamana, Mali
Cotton, leather, animal parts; height 72 cm
West African hunters and warriors gain the necessary protection for travelling in the *brousse* by placing amulets that contain Koranic inscriptions or that draw from medicine or traditional faiths on their tunics. The appearance of these tunics changes according to the basis of the completed tasks, thus articulating the biography of the hunter and favoring his luck.

14. Cup for palm wine, Woyo, Congo
wood; height 21 cm

15. Cosmetics case, Kuba, Congo
wood; length 25 cm
Among the Wongo and the Kuba, cups for palm wine and boxes for camwood dust *(tukula)* take the forms of the human body and are engraved with elaborate geometric designs. The aesthetic effect rests on the symmetry of the forms and on the composite balance of decorative motifs, which draw from the repertoire of braided wicker and of raffia fabrics.

16. Box for divination using mice, Baulé, Ivory Coast
wood, skins, vegetable fibers; height 25 cm
Among the Baulé, the diviner can find a solution to the problem of his clients by looking to the mediation of a mouse placed in a box. The animal, moving the sticks that are contained in the box, offers the diviner a collection of signs that are the object of his interpretation.
The masculine figure placed on the side of the container probably represents the consulting person. While in other boxes of this same period the figure is limited to a simple relief, in this case, while being materially one with the others — we note continuity between the base of the container and the foundation of the statue — they assume autonomous sculptural relief, becoming visibly preponderant and making a seat of the receptacle.

17. Cup holder, Luba, Congo
wood; height 44 cm
This sculpture, collected around the turn of the last century, was attributed by Olbrechts in 1940 to the "master of Buli," a denomination that indicates a group of Luba sculptures that seem to belong stylistically to a single artist or laboratory. Among the distinctive characteristics are the curved posture that seems to indicate the advanced age of the represented subject, the elongated face, the prominent cheekbones, the drawn cheeks, the bulging forehead, the half-closed eyes placed within great orbital cavities and overhung by a wide, arched eyebrow.
The figure of the cup bearer is used in the context of royal rites for the custody of the kaolin, a sacred substance strictly associated with the exercise of power. In prophetic rites, it instead represents the diviner of whom the spirits have taken possession, and through whom they become the earthly spouse. Therapeutic and protective functions are also attributed to the statue. By virtue of the "medicine" inside, the statue exercises these functions through simple contact.

18. Anthropomorphic spoon, Zulu, South Africa
wood; height 57 cm

Spoons in Africa tend to take on a symbolic value that exceeds their immediate function, sometimes explicitly with a high degree of formal elaboration. In these cases, their use is only for rituals. The integration between utilitarian finality and the figurative motif makes a symbolic association between woman-spoon possible: the forms of one accommodate themselves within the forms of the other and vice versa. The tie is so strong that often women are buried with their spoon.

19. Plate for cola nuts (*okwa oji*), Igbo, Nigeria
wood; diameter 47 cm
Among the Igbo, the cola nut carries great symbolic importance. In myths, it appears among the primordial gifts bestowed upon men by the divinity Chukwu; as an offer, it opens the way to communication with gods and to social relations among men. The consumption of cola nuts during hospitality rites is equal to an act of purification. This explains the reason that plates reserved for the rites are often artistically elaborate. In the central part, sometimes decorated with figurative motifs, is the container for condiments, while the linear protuberance on the side acts as a cutting board. The figures do not appear to have great symbolic weight; in their refined nature they celebrate more the proprietor's well-to-do condition.

20. Water pipe, Hemba, Congo
wood; height 42 cm
In Luba and Hemba water pipes, the narrow tube is shaped like a feminine figure kneeling with her legs resting on the spherical base or wrapping around in an enveloping movement.

21. Anthropomorphic cup, Koro, Nigeria
wood, grains of abrus, height 47 cm
The Koro sculpt cups for palm wine that are used in sacrificial offerings and in second funerals (those that, after a certain period of burial, celebrate the arrival of the dead in the afterlife). In anthropomorphic versions, the containers correspond to the stomach of the feminine figure. The curvilinear form shrinks in the center, recalling the shape of pumpkins, commonly used as containers for liquids.

22. Toy, Luba, Congo
wood; height 75 cm
We are looking at a game widespread in a great part of the world. There are different versions: for two, three, and four rows of boxes. The version with four, however, is rarely seen outside of Africa, and only in Africa are all three versions contemporaneously present. The holes represent cultivated fields or village huts, such that the rules of the game become metaphors for the competitive spirit and interdependence of social relationships. Sometimes human or animal forms are represented in the shape of the table or appear on the sides.

23. Scepter with five heads, Chokwe, Angola
wood; height 66 cm
The element most aesthetically relevant is that of the hair styling of the Chokwe princes, winged and raised on the border, that, without a solution of continuity, overlaps on five faces, creating a circular fluid movement, a waving motion that is seen also in the lower profile of the eyes. The characteristic strong prognathism is also seen in Chokwe statuary.

24. *Oshe Shango*, Yoruba, Nigeria
wood; height 39 cm
The myth of Shango, god of thunder and light, makes a theme of the terrible ambivalence that is at the base of power and of authority which, if they are used wantonly, bring catastrophes and ill fortune. Shango is the legendary fourth king of the Oyo dynasty who, while being valorous, was a pitiless sovereign, dethroned and exiled from the capital; after his suicide, he was deified by his supporters and sacrifices were offered to placate his ire, which made itself apparent through storms and fires. His myth teaches that for energy to be productive, it has to be controlled: the concept of *ashe* (energy)

includes that of *iwa* (character)and *itutu* (mystic calm). The *oshe Shango* is a representation of the terrifying power of the god of thunder, tempered and balanced by feminine grace. Only Shango and his devoted know how to bring this balance on the head of two red-hot stones that constitute the hatchet of thunder, symbol of divinity.

25. The sign of *Ogo elegba*, Yoruba, Nigeria
polychrome wood, height 57 cm
We see a ritual staff used in the Eshu cult, a divinity tied to change, disorder, and the individual dimension of life. He is also responsible for the mediation that puts men in contact with gods, the public masculine sphere and the private feminine one. Ambiguity and unpredictability are his distinctive traits. Often, the figures associated with him have a phallic hairstyle or a razor blade; every now and then the divinity performs wonders.
When he is in a state of sexual excitement, the razor rises from his head. His uncontrollable sensuality and volubility are in this way symbolized by the hairstyle that hinders him from carrying weights in a balanced way on his head. In his hands, there is an object which appears to be a gun but is more probably the flute with which the Eshu play songs in praise of the gods to persuade them to enter the heads of the devout.

26. Top of a staff, Senufo, Ivory Coast
wood; height 28.5 cm
This is the representation of Katieleo, the "mother of the village." If the creator god Kulotiolo remains remote and inaccessible, Katieleo maintains contact with humans, regenerating the world thanks to the initiating association of *poro*. The face presents linear eyes with lowered lids, a long, straight nose that ends with a small transversal arch, an oval mouth with visible teeth and prognathism of the jawbone.

27. Male figure, Dogon, Mali
wood; height 26 cm
A figure used in agrarian rites, the face is absorbed in a priest-like composure.

28. Hermaphrodite figure, Dogon, Mali, 15th-17th century (?)
wood; height 132 cm
This figure, attributed to the so-called "master of Sanga," has hermaphrodite characteristics, having breasts and a penis at the same time. It is possible that it represents the mythological figure of the *nommo*. The articulation is a sign of the human; the *nommo* were not human but genies, anthropomorphic in the top half of the body with a serpentine appearance in the lower half. The suppleness of the figure can be explained precisely with the absence of articulation and with the undulating movement of the *nommo,* whose body is made from water. The sculptor would thus have followed the sinuous nature of the wood in as much as it was thematically pertinent to the object of representation.

29. *Nyeleni* figure, Bamana, Mali
wood and metal; height 53 cm
These figures are used by the smiths in performances that follow their initiation; representing feminine beauty, they manifest the males' matrimonial intentions. The human body is broken down into elementary geometric forms, emphasizing the separation of parts: the squared shape of the shoulders and the chest, the plane of the pelvis and of the buttocks, the broken line of the arms, the cylindrical element of the neck, the rising cones of the breasts. The face is rendered on a lightly concave plane, cut by the long and subtle line of the nose; the mouth is reduced to a slit, the eyes to two buttons.

30. Chair, Pende, Congo
wood; height 36 cm
The plane of the seat is supported by the pair of primordial ancestors. In the meeting of symbolic and functional elements, power makes the foundations of its own legitimacy visible: the ancestors that physically, historically, and spiritually sustain the weight of their descendants.

31. Chair, Luba-Hemba, Congo
wood; height 48.5 cm
An entire hierarchy of chairs gives form to the social stratification of Luba society. The caryatid thrones are the exclusive patrimony of the chiefs and famous members of society, and are the receptacles of components of those people. These are not objects intended for daily use: the chief sits on the chair only when he needs to attempt to mediate between the world of the living and the world of the ancestors. Generally, because the Luba society is matrilineal, the characters represented are feminine, recognizing women's role as founders of the society. The sense of order is plastically expressed in the equilibrium and the symmetry of parts. The fluidity of lines and the ample empty spaces suggest a total absence of effort, so that we understand the superior power of the ancestor. Contributing to the creation of that sensation are the composure of the face, the absence of muscular contractions, and the fingers of the hands that sustain the weight with the fingertip.

32. Headrest, Songye, Congo
wood; height 14 cm
The headrests allow users to maintain their elaborate hairstyles while they are sleeping. The figure of a man standing supports the lightly curved plane of the headrest; the enormous feet provide the headrest with stability. The measurements are massive, the forms angular, the jaw prognathic, the stomach rising.

33. Male figure, Bembe, Congo
wood, shell; 25.5 cm
These small statues are used among the cult of the ancestors to give favorable conditions for fertility and to ward off sickness. The figure, on its feet, with the legs slightly flexed, presents a long cylindrical bust covered with geometric inscriptions. The head is ovoid; the face is clean-shaven; the beard comes to a point. The white of the eyes is obtained by setting in shell fragments. The arms, very short, bend at right angles and lean on the chest; the left hand holds a staff. Holes are present at the base, on the buttocks, on the head, and on the ears.

34. Male figure, Magbetu, Congo
wood; height 48.5 cm
The elongated skull of Magbetu statues does not represent a "distortion" of the human body, but faithfully corresponds to it. The Magbetu, in fact, for aesthetic designs, alter the form of children's skulls by binding them tightly in raffia cords; women usually exaggerate this affect through the elaboration of tubular hairstyles. The linear pyrographed motifs on the surfaces of the statue recall the corporal paintings that mark ethnic identity.

35. Container with anthropomorphic plug, Zigua, Tanzania
pumpkin, wood, skin; height 27 cm
Everything seems to be pushed in the direction of the small circular mouth: from the movement of the jaw to the curved line of the ears. The plug extends internally in a pole that measures the level of liquid (medicine or sacred oils).

36. Figure of *Unil* ("the human person"), Bassar, Togo
Twisted and blackened raffia fibers; height 10 cm
Here is a figure that incarnates the spirit of a dead woman and represents her during her second funeral. The figurine is laid out on the stretcher of sugar cane that is destined to envelop it.

37. Funerary board *nduein fubara*, Ijo Kalabari, Nigeria
wood; height 155 cm
These funerary boards are destined for the cult of the ancestors. The tendentially two-dimensional representation of the figure of the dead within a frame echoes, perhaps, the influence of European devotional images. The Kalabari, stationed along the delta of the Niger River, did in fact have very close

commercial relations with Westerners, and they played a role in the first stage of the slave trade. The ascent, to the inside of the mercantile associations, of immigrants who did not have access to the objects of traditional cults, probably brought the adoption of a new manner of representation. The power of these people is indicated by the feathered head covering that they wear, by the carved tusk, and by the knife that they grasp. They are elements of ritual costumes that, however, in the funerary representations are without the mask that usually accompanies them.

38. *Efomba* anthropomorphic coffin, Ntomba, Congo
wood, pigments; length 218 cm
Despite the more widespread practice of burying the dead enveloped in raffia fabrics, sometimes the bodies are positioned in bars of wood. In that case though, the chest, created using two small canoes (one for the base and the other for the covering) would have served as the image of the dead and was conserved in the home as a memento. The human physiognomy did not completely reshape the container: the essential human traces are simply added, like protrusions, to the squared forms of the chest, perhaps hinting at the rigidity of the cadaver.

39. Funerary pole, Sakalava, Madagascar
wood; height 210 cm
The sculptural art of Madagascar, in which Bantu and Indonesian influences overlap, expresses itself essentially in funerary monuments. Human figures appear on the summit of the steles that commemorate the ancestors. The human figures, separately or in pairs, are sometimes united in a passionate embrace. The Sakalava figures have full and fluid proportions, their arms are attached to their body and they are without feet. The expression of the faces is seen in the ocular cavities and in the large and subtle horizontal cut of the mouth.

40. 41. *chi wara* helmets, Bamana, Mali
wood; height 101 cm; 130 cm
The masks of the *chi wara* initiation associations accompany the salient moments of work in the fields, inciting the farmer to work. The vertical projection of the antelope horn is associated with the growth of alimentary plants. The forms also recall the horse, unique among domestic animals in that it is linked to the sky and thus the rain. Among the diverse variations of the mask, this is the only one that demonstrates, in a non-equivocal way, the distinction between the sexes: the female carries the little one on her back, while the male, of larger dimensions, reveals his penis. The perforated decoration of the back symbolizes the sun, while the curve of the back recalls the celestial vault and the difficulty of work.

42. Buffalo mask, Nunuma, Burkina Faso
wood; height 45 cm
This represents a spirit of the *brousse*, a mediator between men and gods. The animal forms are represented in regular geometric shapes: the triangular mouth, the circular movement of the horn, the horizontal projection of the ears, the concentric circles of the eyes. The engraved geometric motifs reassert the angular lines of the jaw and repeat the scarring of men and women.

43. *Nwantantay* mask, Bwa, Burkina Faso
wood, kaolin; height 125 cm
Manifestations of the spirits of air and of water, they participate in initiation, agrarian, and funerary rites, and they dance on market days to entertain people.
The flat and circular face projects an axis with geometric motifs. The figurative and abstract signs and the forms that appear there are part of an initiating writing. The eyes, rendered through concentric circles, evoke the owl (a symbol of magic powers), while the hooked projection recalls the circumcised penis and the hornbill (a bird tied to divination). The opening of the mouth, like the concentric circles of the eyes, evokes the wells of water. The geometric motifs and the "X" are those of the scarring that men and women wear on

their foreheads, while the summit of the "moon of the masks" echoes the time of the ceremonies.
All of these elements take on, however, a plurality of meanings according to their combinations, the initiation level of reading, and the diverse families and villages.

44. *Nyanga* mask, Bobo—Fing (Burkina Faso)
wood, pigments; height 111 cm
Carved and used among smiths, it has the forms of an antelope (*hippotragus koba*), but in reality it incarnates Dwo, the son of the creator Wuro. It has a long snout that is curved in the front, a bulging forehead and large horns twisted back. The surface of the snout is covered in white, black and red geometric motifs.

45. Mask, Baulé, Ivory Coast
wood; height 45 cm
The mask unites the anthropomorphic lineaments of the elemental animal face to the horns. The subtle traces and the fluidity of curved lines and polished surfaces are the characteristic elements: the indentation that frames the face is of Yaouré origin but, given the reciprocal influences, is also diffused among the Baulé.

46. *Orere* sign, Yoruba, Nigeria
iron; height 114 cm
These poles are part of the equipment of the diviners. Signs of this kind are planted, with a protective function, at the entrance of houses and at the center of courtyards. Some small cones are used as containers for "medicine." Birds are tied to divination, to the figure of the king, to creation myths, and to the magic powers of women, who can transform the birds in the night.

47. Figure of a warrior, Bamana, Mali
beaten iron; height 49 cm
Sign of the chief. In the case of attack, it is placed at the entrance of a village to confront the enemy. His strength comes from iron (material used in the production of weapons) and from the energy imprinted on the figure from the blows of the smith's hammer. The style is extremely essential, reducing the human figure to its silhouette. The contained curvilinear movement of the legs responds to the linearity of the bust and the lance.

48. *Bansonyi* figure, Baga, Guinea Bassau
wood, pigments; height 240 cm
The Baga are a lagoon population of fishermen and rice growers. The mythic python is thought to be the element of connection between the world of water and the world of the *brousse*. These figures appear in pairs during circumcision rites; they are supported by a framework covered in raffia and fabrics in which many men are hidden, running confusedly among people, fighting among themselves and creating chaos, then returning to the *brousse*. It is in this fight, without winners or winnings, that two snakes, male and female, each representing a half of the village, seek to snatch the children from the other half, demonstrating the complementary nature of opposites.
The curvilinear development of the sculpture and the swelling and narrowing of volumes and decorations combine to suggest the sinuous movement of the snake.

49. *Ikenga*, Igbo, Nigeria
wood, pigments; height 61 cm
The *ikenga* are altars dedicated to the personal spirits (*chi*) of Igbo men, to the most individual part of the person, not limited by the moral order of relationships. They are the instruments and the representations of individual success; they are turned to for periodic sacrifices and to bring favorable results to endeavors. The seated position, the pole, the ivory trumpet, the facial scarring (signs of the titled *ozo*), the horns that are taken from the heads of animals that appear there, give the measure of social status of the proprietor. All of the elements exalt the strength and the firmness of hunters, warriors, and powerful men. The complex perforated super-

structure sees the horns turn around the head and end with the heads of serpents; among them are four ram heads, while on the summit there is the figure of a leopard.

50. *Tukum* crest, Widekum, Cameroon
wood, skin, nails, wicker; height 29 cm
This is the manifestation of the *mpoh* spirits and presides over the exit of the masks. The wooden body is covered in animal skin. The head takes on the appearance of a skull; articulated arms and legs are attached to the body with nails.

51. Emblem of the *Ekpe* association, Ejagham, Cameroon
wood, vegetable fibers, bones and animal skins, pumpkins; height 120 cm
The secret *Ekpe* association collects, in diverse initiation levels, men from the Ejagham society and plays a regulatory and judiciary role. The spirit protected by the leopard is an object of the cult. The emblems are built from a trellis of wood and vegetable fibers on which diverse objects that trace the symbolic coordinates of the group unity are placed. The surface of the support is cut diagonally by two brushes while a sacred drum is in the center; sacrificed animal skulls, pumpkins, ropes, necklaces, are distributed among the four portions in which the surface is subdivided.

52. Crest, Eket, Nigeria
wood; height 66.5 cm
Crest of the *Oghom* association that celebrates the cult of the earth divinity on whom the fertility of the fields and the fecundity of women depend.
Surrounding the head with a long ringed neck are two figures, one male the other female, that turn their shoulders to each other. An arch unites them, framing the underlying head at the same time. The sexual characteristics of the figures alter the bilateral symmetry of the combination. At the base of the crest, a series of holes is used to fix them to the costume.

53. *Ekeleke* crest, Igbo, Nigeria
wood, kaolin, raffia, hair; height 22.5 cm
Ekeleke crests are associated with the water spirits (*Owu*), whose cult probably originates along the area of the Niger delta. The dancing *ekeleke* masks (the face is hidden by the costume's fabrics) increase their own height, also using stilts. The dances finish with the killing of the "leopard" that celebrates the victory of good over evil. The masks vary stylistically according to the area.

54. 55. *Bundu* masks, Mende, Sierra Leone
wood; height 40 cm, 38 cm
Usually, the use of the mask is a male prerogative; among different populations in Liberia and Sierra Leone, however, there are masks tied to secret female associations (*Bundu* or *Sandé*) that prepare women for adult life. These masks express the ideal of feminine beauty: the subtle traces of the face, the shiny skin, the small rolls of fat at the neck and the elaborate hair styling suggest good health and a well-to-do social condition. On another level of meaning, these masks represent the water spirits that the form of the helmet has the power to attract. The wrinkles of the neck echo, therefore, the rippling of the water from which the masks emerge.

56. 57. *Karanga* masks, Mossi, Burkina Faso
wood, pigments, fibers; height a. 176 cm, b. 124 cm, c. 128 cm, d. 154 cm
Anthropozoomorphic elements frequently appear on masks that physicalize the spirits of the *brousse* and at the same time return to the ancestors. The Mossi clan are closely associated with totemic animals: the relationship that men and animals hold is of a reciprocal dependence and the disgraces or prosperity of one group is reflected also on the other. The masks appear during funeral occasions to accompany the dead to their tombs or, placed on familial altars, they are an instrument of communication with the dead. Their task is also to protect wild plants, whose use is collectively regulated. Under the formal aspect, an element common to all four of the masks is the vertical projection (decorated, pierced, indented), while they are differentiated, according to regional styles, in the form of the face (flat, concave, or convex) and eyes (slits, triangulated or circular).

58. *Nimba* mask, Baga, Guinea Bissau
wood, metal, pigments; height 143 cm
This is a mask that favors the fertility of women and of fields and the representation of the fecund woman whose breasts are flattened by the nursing. It is worn on the shoulders by a dancer whose figure is hidden by a raffia skirt; two holes placed between the breasts allow sight. The large, elongated head presents a hair styling of crests and decorations of brass knobs; the hooked nose and the small tubular mouth are characteristic traits.

59. *Satimbe* masks, Dogon, Mali
wood, metal, vegetable fibers; height 83 cm
On the facial mask, which represents an antelope and at the same time echoes the Dogon forms of architecture, a female figure sits with her arms open and raised to the sky. She represents Yasigui, the twin of the pale Fox, a transgressive character in Dogon myth; the Fox, like Yasigui, breaks all of the prohibitions and, castigated by the god Amma, dies pregnant. Despite her faults, Yasigui continues to occupy an important position in the great ceremonies of *sigi* that the Dogon celebrate every seventy years. The *satimbe* mask echoes the role of the discoverer of the masks, from whom men later appropriated the masks. For this reason, it is called the "sister of the masks" and as such participates in this dominion of male ritual. The red threads that appear on the mask celebrate her as a discoverer of red fibers and recall the lost blood on the earth as a consequence of the exsection of the clitoris, used by her as a hoe.

60. Mask, Grassland, Cameroon
wood, copper, iron, cowry shell fibers, beads; height 37.5 cm
In the kingdoms and *chefferies* of Grassland, the masks are used by associations with regulative and judicial functions as an instrument to exercise their own authority.
The wooden surface of the mask is covered by small plates of copper and is punctuated with nails that trace the arch of the eyebrows and then descend along the nose. Copper is a symbol of the power of the king (*fon*). The bilobate hairstyle of the cowry shells reprises the shapes of noble head coverings, while the strings of beads and cowry shells that frame the chin recall the royal ornament in beads (*mble*), a kind of artificial beard that is the masculine symbol of power. The mask is without holes for the eyes because it is worn as if it were a helmet, hiding the face with the costume.

61. *Batcham* mask, Bamileke, Cameroon
wood; height 67 cm
Although the precise purpose of these masks is not known, they seem to be closely associated with the figure of the king (*fon*), and it is thought that they made their appearance in the course of funerals of the monarch and in the occasion of the selection of the inheritor of the throne.
The human traits were selectively emphasized and altered in proportion, combining concave and convex forms: above the large almond shaped eyes, there are enormous vertically-projected eye brows, while below the cheeks and the mouth are rendered through protruding levels. In the center, the nose acts as an element of reconciliation between the two planes, vertical and horizontal, of the mask.

62. *Ngil* mask, Fang, Gabon (19th century)
wood, kaolin; height 65 cm
We are looking at a mask tied to the superclannish association of *Ngil*, who played judiciary and political roles among the Fang, assuring peace and hunting witches. The mask, whose apparitions in villages happened at night, had the task of punishing those guilty of vices and criminals. The characteristics of the face do not express, therefore, as perhaps one might think, a composed serenity, but in the deformation of anatomic characteristics reveal its superhuman and terrible

character. This character is also reasserted by the use of white, the color of death and of spirits. The accentuated vertical development of the mask is underlined by the long and subtle line of the nose in which the incisions of the arched eyebrow meet those that leave from the top of the head. The bulging forehead is followed by the convex and heart-shaped form of the eye sockets and the cheeks. Under the slits of the eyes, there is semicircular scarring. The mouth coincides with the lower contours of the mask.

63. Mask, Kwele, Gabon
wood; height 52.7 cm

The exact function of this mask is not known; we do not even know whether it was intended to be used for dance or if it was hung on the walls of cult places. It seems that in recent times they have appeared in funerals and in ceremonies initiating adulthood. The mask is principally rendered in its curvilinear composition. The form at the heart of the mask defines the concavity of the cheeks and the eye sockets and the movement of the horn that frames the faces is repeated; the two pairs of eyes inscribed on the summit of the horn metonymically echo the theme.

64. *Mhangu* mask, Pende, Congo
wood, pigments, vegetable fibers; height 26.6 cm

In this Pende mask, the intentional use of asymmetry serves to visualize the obscure action of witchcraft: the transgression of the ethical-aesthetic order of symmetry is thus well localized and aimed at reconfirming traditional values. It represents the sickness or misfortune of the one who is hit by the arrows of a witchcraft spell. The distortion of facial traits is the consequence of a facial paralysis. The bichrome of the face alludes to the scars brought back by falling into the fire because of an epileptic seizure, and more generally to the duality of health and sickness. The left side of the face is hit (the holes on the eyelid are from variola) while the right side conserves, in reality, a normal appearance. The costume and the movements of the mask during the dance reinforce the symbolism: it has an arrow stuck to its hump and it moves as if it wants to avoid other arrows, or it advances by leaning on a walking staff.

65. *Kifwebe* mask, Songye, Congo
wood, pigments; height 59.6 cm

Kifwebe masks are distinguished by their signs of a great dynamism and strong expressiveness, given their projection of the eyes, the nose, and the mouth, a movement that is returned by the forward push imprinted by the striation of the surfaces. These incisions carry symbolic value, recalling the underground from which the founding spirits of the *Kifwebe* society arrive, or, on another level of meaning, the womb of the cave from which the first men exited.

66. *Moshambwooy* mask, Kuba, Congo
fabric, vegetable fibers, skin, cowry shells, beads; height 40 cm

This is the most important of the royal Bushongo masks. It represents a threatening spirit, *Ngesh* and is used to maintain social order. Being a mask endowed with a terrible power that blinds the wearer, it is worn by people close to the king, and when it is exhibited the sovereign moves away from it, making believe that he finds himself on a trip.
Animal skins are sewn on the base of raffia fabric and threads of beads and cowry shells (signs of wealth) design the characteristics of the face and the large jaw. On the other side is an elaborate bead design. There are no holes for eyes.

67. *Ntshak* fabric, Kuba, Congo
raffia, pigments; 113 cm x 73 cm

Two well-defined decorative styles are present in Kuba art: one style based on the repetition and variation of geometric motifs combining and interweaving among themselves (Plate 68) and one style that works to juxtapose geometric motifs that are clearly separated and distinct from each other. This last style has a more limited diffusion and is seen in female tattoos, in the cups of buffalo horn, and in the ceremonial *ntshak* skirts worn in funeral occasions and ritual dances.

68. *Shoowa* fabric, Kuba, Congo
raffia, pigments; 52 cm x 45 cm

The weaving of canvases is masculine work, while the embroidery that covers them is feminine work. The needlepoint traces the design while the tufts of raffia, trimmed from the surface, fill the space, creating a "velvet" effect. The complicated aesthetic effect is a result of repetition, variation ,and combinations of various decorative motifs that overlap and brusquely interrupt each other; smokiness of tone, chromatic contrasts, variations in the density of the filling of the "velvet" effect contribute, often in an unpredictable way, to dynamize the composition. The surface is not rigidly divided but is a virtual line cut roughly in two halves.

69. *Tapa* fabric, Mbuti, Congo
beaten bark, pigments; 144 cm x 128 cm

The bark is beaten by men until it becomes a soft felt; the artistic work is instead the female prerogative. The designs are traced with the finger or through sticks using carbon from wood or vegetable juice. The pictorial design is not regulated by preliminary grids, but, while being part of repertorial motifs, is totally free in its composition. Generally, a multiplicity of motifs (rectilinear elements, curvilinear elements, dots, isolated figures) are distributed along the surface without establishing a clear focal point. Such motifs seem to allude to the entanglement of the forest and the presence of man, without creating a clean partition between the two camps: the human signs (hooks, ladders) mix with those of the forest (butterflies, birds, the leopard's maculation).

70. *Kente* cloth (*Oyokom Adweneasa Nsaduaso*) Ashanti, Ghana
silk; 138 cm x 200 cm

Kente is the fabric that the noble Ashanti wear as a tunic. It is the result of assembling multiple stripes of fabric separately on small pedal looms. The *asasia* are fabrics of royal monopoly. They exhibit the exclusively obtained designs with a loom of six heddles. In more elaborate fabrics. the motifs of the weave arrive at obscuring the underlying themes of the warp and annul the checkerboard structure. The use of color also follows precise restrictions, in particular yellow gold, which is associated with warmth, longevity and prosperity. The pattern of the warp of yellow, red, and green (*oyokoman*) stripes that constitutes the background was a royal prerogative.

71. *Kente* cloth, Ashanti, Ghana
silk, cotton; 325 cm x 208 cm

72. Fabric, Gambia
width 104 cm

The variegated effect is obtained by carefully crumpling the fabric before immersing it in a bath of dye in a method of offering variable resistance to the absorption of color. Although the process involves a clear intentionality, a high value is placed on the relative unpredictability and fortuitousness of the result. The technique of "resist-dyeing" changes according to the area, occurring based on the wrinkling, the sewing, the knotting of parts of fabric filled with small stones or seeds or on the covering with cassava paste. The design will thus appear in reverse on a tinted background.

tured and poisoned. Words can be manipulated like objects, and like objects, they can produce or induce certain behaviors.

It is on this basis that the practice of traditional therapy operates. Healing is in fact obtained through objects prepared by the healer that the patient carries, in which their interactive ties are "deposited". The construction of an object is seen as a material transformation of the world that preserves and strengthens its efficacy[110].

But if words make things, things can also make signs. Language is not seen as an exclusively human privilege: musical instruments "speak"; so too do certain animals of mythic importance and certain particularly marked symbolic objects, such as looms for weaving and atmospheric events.

The world offers men a silent word (what the Dogon call "word of the world") that they have to translate into their own code for it to have meaning.

Because of the possibility of their reciprocal transformation of the one into the other and because of the kinds of effects they can produce, words and object have an ambiguous character.

African metaphors that express the word are full of meaning. It is the double-edged sword, the vital water in which we can drown, the fire that scalds and burns, the conducting thread in which we can get entangled. The word, the carrier of order, is also a passage to disorder. It allows agreement and creates division. It is the bearer of truth and lies. And this is particularly true for the feminine word that shares the oscillation between order and disorder, life and death, with women and thus sometimes plants joy and other times inspires dispute. This is the reason that certain societies impose a ban against women expressing themselves in public. It is also the reason for the prophylactic role of rings in the lips or ears, tattoos on the lower lip, or the filing of the teeth.

Such ambivalence is also seen in objects, as much in their use as in their form. Magic statues are in and of themselves neither good nor evil, but subtract or increase the forces, both their own and others', according to the way in which they are manipulated. Ambiguity and reversibility – we have already seen – can become a specific iconographic theme, as in the Janus-formed images (the two in one, the coincidence or polarity of objects) or in the presence of cleanly discordant stylistic modules (realistic-abstract, for example).

Even if words and things fundamentally resemble each other and participate in the same reality, they remain forever distinct from one another, and we are well aware of this distinction. While we attach the sentiment of transience to the word, the sentiment of the irreversibility of the discussion, whose "good sense" we therefore need to guarantee in order to avoid the irreparable, objects and graphic symbols guarantee an element of spatial permanence. The plastic arts, say the Dogon, are invented by men to fight against death, providing an element of spatial permanence against the volatility of words.

Visible forms thus allow the spatialization of words, the recall of words to memory, and therefore, in the African perspective, the greater control of their force. Dogon pictures contain the *nyama*, the vital energy of the world; they stabilize it and render it more accessible[111].

From this point of view, in the introduction of an element of reversibility in words which allows them to be retrieved, the African visual arts have the character of "writing", even if we are very far from the servile relationship and the one-way direction that is established among the visible and utteral in phonetic writing. African graphic and plastic representation is thus multidimensional, coordinated and not subordinate to words, while linear writing holds the registration of visual representation in check.

Therefore it is senseless to look for *the* significance in the relationship of African art, forcing it to retrace the multiplicity open to the meanings of a coherent vision and without contradictions. The diversity of meanings in fact often does not allow for disciplining within a hierarchical scale of values that proceed from the superficial covering of the profound nucleus. What prevails is a simultaneous and contradictory multiplicity of symbols, equivalently-powered and differently-activated by interpretations. In effect, the community participates in the same ritual, but in the absence of written words elevated to dogma, it is experienced differently according to the expectations and scopes of each person[112].

This is also true for those Dogon who still see writing as a representation of words. A zigzag can be read as "water", but we are not talking about a traditional representation of this word, even though the same sign could be interpreted as "walking of the word", "weaving", "a sprouting of grain", "original vibration", "serpent", etc. in other contexts.

But even this – as we will see – is only one of many possibilities. It also happens that objects and designs act independently as an alternative to or against the word, since they are mute but efficient none the less.

61. Hypothetical progressive stylization of a motif of crossing crocodiles, Ashanti, Ghana

a. b. d. e. Weights for gold; c. Motif of adinkra *fabrics. The motifs of geometric weights, according to certain hypotheses, would be the result of a process of abstraction that would have figurative weights as a point of departure.*

126

For the most part, African writings are not representations of words but pictographs and mythograms, sedimentation of thoughts that do not necessarily pass through the tongue.

Words and things are two different ways to materialize thought, the one through an aphonic system, the other through a graphic or plastic code. However, one is not the substitute for the other[113].

Generally, African visual arts do not develop along a narrative dimension. Objects do not represent tales, fables, or myths. They are thus not representations of the word, just as they are not representations of an already-given external reality. The same interpretation of sculpture within a pre-defined mythic picture, abstracting the object from the operative context in which it appears, finishes with the arbitrary being[114].

The majority of African statues privilege the single figure. Sometimes the figures are juxtaposed or coordinated among themselves, but only rarely do they help the composition of the scene or their succession. Even when this happens – as in Yoruba or Benin bas reliefs – the scenes do not have a narrative development, and thus they cannot be interpreted as a sequence of actions carried out by a single subject. More than to the successive phases of a single cult or ceremony, they assist the scene of diverse cults or ceremonies. The unity is not narrative as much as it is thematic[115].

Even in puppet theater, for example, where the sculptures are integrated in such a way as to construct a beginning and an end from the vicissitudes that have a temporal passing, the "practice of bringing to the scene a mythic or an epic poem in its totality, similarly to eastern theater, seems rare in the theater of black Africans. These stories are evocations of the presence of marionettes who incarnate their heroes, and not through the chronological representation of their contents."[116]

62. Figurative weights, Ashanti, Ghana, bronze

Oil lamp; crossing crocodiles; leopard; chameleon
The weights for gold recall the proverbs and are thus the support in the transmission of traditional knowledge. The motif of "mixed crocodiles" — two animals with a sole stomach — recalls the clannish solidarity that makes a collective possession of individual entrances and at the same time puts them on guard from dangers caused by those who privilege their own throat while sharing the stomach with others.

63. The principal graphic signs of weights for gold, Akan, Ghana

The Akan graphic system includes nearly one hundred signs. The attempts to retrace a coherent system or to establish a correlation between graphic signs and ponderal value had no success.

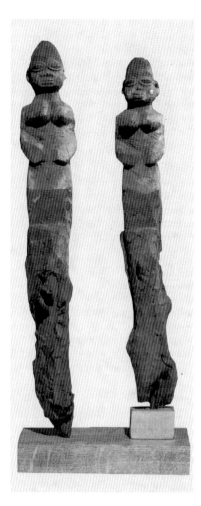

64. Bochio *figures, Fon, Benin; wood, height 43 cm, 38 cm*

These figures hunt witches, capture thieves, influence the weather. They are planted in the ground on the directions of the diviners and assume a different identity (known only to those they serve) according to the place in which they find themselves: house, village, intersections, river banks, forest.

65. Asen *altars, Fon, Ouidah, Benin*

If the figurative and visible part is the most striking, the most significant part is, however, buried: the ground in which they are planted, prepared with leaves, food and other materials, is the place of sanctification of the ancestors. The offers are not in reality offers to the asen but to the ground in which they are planted.

The image does not express itself directly in words but, at most, through concepts with which it has a symbolic relationship. The rapport between words and design or images can be more or less narrow and leaning towards on side or the other.

Let's take the case of Ashanti textiles (*Kente*). Even though the indigenous sometimes verbally embroider stories on the fabric as a favor to the ethnologist, it does not seem, despite the strong association with a regal power of sacred connotations, that the fabrics are depositories of any secret to reawaken and bring to the word. The nexus between visible and utterable runs along the surface and reveals itself intermittently, discontinuously, and in fragments. The individual name itself of each fabric seems to be derived from a combination of references drawn from the design, the name of the inventor, and a few other elements (images that can seduce the purchaser, proverbs ...). More than anything else, they act as a mnemonic aid for the weavers, who, associating a name with certain technical characteristics, are prepared to create a repertoire which can be handed down through time. At least in this case, it is not the visible that supports the word but vice versa[117] (Plates 70, 71).

In the *adunudo* fabrics of the Eve of Togo, whose social use is similar to that of the neighboring Ashantis, the relationship between design and verbalization is even more loosely granted multiplicities of discretional interpretations. The design is no longer exclusively geometric, as in *Kente* cloths. It presents figurative elements: there are figures of animals, humans, and objects (knives, guns, chairs, etc.) that generically refer to power[118]. To the weaver's eyes, such motifs are only part of a traditional repertoire that draws liberally and with the possibility of being enriched (hence outside of a prescriptive and binding order), leaving, though, the purchasers free to read what they most want in it, while referring to traditional proverbs.

The Eve and Ashanti fabrics – here, as in the Akan's gold weights – demonstrate how there are two large margins of indetermination among them even in the case of images that recall proverbs, in which the nexus between word and image is narrower. It is not that the proverb selects the image, but that it offers the words a point of anchorage; more words can be attached according to the situation. The proverbs themselves do not have an unequivocal meaning, but can be interpreted on various levels. There is no text that subtracts words from context and send them back unaltered. The relationship that sculpture, fabric, and graphic symbols establish with words is contextually undecided, from time to time, in the context of a strategic definition of the situation. The complex meaning of a "text" is the result of a combination of plastic forms, graphic trees, manipulations, sounds, odors in their exclusive echoes, metaphors, and evocations. However, this does not mean that the interpretation is totally arbitrary. In fact, the possible meanings, for as much as they are extended and changeable, are not boundless. Each symbol acquires a precise

identity only in relationship to the others, but, "Even taken individually, outside of any context, it contains a form, a name, and a nucleus of meaning that belongs to itself, that distinguishes it and confirms in its identity as a graphic symbol."[119] The text is read in relation to the context, but is not reduced to it. Moreover, in the reciprocity that the text echoes, it contributes to the definition of the context.

The weights for gold that are in the special little bag (*dja*) are strongly limited in number. The themes they evoke are recurrent, and the possibility of association, for as much as it is indefinable *a priori*, cannot be infinite.

In other cases, the interpretation is oriented not by formal differences but by positions occupied in space. The Fon statue, known as *bochio*, takes on different identities not by following their visual form but through the connection – house, village, forest – that is prewritten for them by the soothsayer on the basis of geomantic practices[120]. Similarly, the attractive appearance of Baulé statues do not allow them to individualize an identity. They can address friendly spirits (*blolo bla*) as much as evil ones (*asie usu*); only the behavior taken in their encounters allows them to be distinguished.

In the *asen*, commemorative altars of the Fon of Benin, the figures that appear there (people, animals, vegetables, objects) recall events from the life of the person to whom they refer. Nevertheless, only those knowing the deceased directly can reconstitute their life based on these forms. This would already be impossible for the relatives of following generations (Plate 17). Still, what counts does not come less: the togetherness of the *asen* materially certifies the history of the family. It acts as a testimony and guarantees its continuity. Based on what is seen, it is always possible to reconstruct a history, even if nothing guarantees its "veracity"[121].

The fleetingness and indeterminateness of the rapport between the visible and the utterable is clearly evident in the *shoowa*, "velvets" in raffia embroidered by the Kuba of Congo, whose linear geometric design is absolutely free as to composition (Plate 68). While drawn from the catalogued motifs whose names are often tied to Kuba mythology, the single motifs do not illustrate anything, nor do they take away from the development of their possible combinations, leaving the composition more or less to the sensibility and improvisation of the individual embroiderers. No less free is the interpretation that selects some motifs thought to be subjectively dominant that give the name to the complex design[122].

The fabrics therefore, in as much as they are carriers of design, images, or more simply color, do not mean anything but with their meanings always entertain relationships (we can speak of a fabric). Rather, they act without saying, constituting through their behavior. *Asasia*, a silk fabric of Ashanti sovereigns, is not a representation of royal power in its splendor but a manifestation of its existence, an expression of superiority through decorative excess. One is more sensitive to the strength it expresses than to the sense it implies. Power, like rites. is more legitimate for what it is than for what it signifies. Between power and ostentatious apparatus, the relationship is not one of ideological duplication (which would make of the second an overlapping element, an element that is derivative, a passive reflection of the first) but one of mutual generation: one is a king expressing his own grandeur[123]. Hereditary rights, in fact, only establish the possibility that a person has to exercise a role. The effective capacity of governance depends instead on the possession of those objects through which vital energy is transmitted and which reconnect the sovereign with those who proceeded him. Osei Tuto, the first king of the Ashanti, gave the kingdom its symbolic unity through the golden throne that contained the souls of the nation and by forcing local authorities to bury their own chairs.

This also remains true where the intersection between words and images is tighter, as

66. Récades (makpo), *Fon, Benin*

These are kinds of scepters, carved in wood and covered in metallic plaques. The images recall the "strong names" of the sovereign: the serpent is a symbol of the King Ghezo (1818-1858) while the shark is a symbol of the King Behanzin (1889-1894).

67. *Graphic* Nsibidi *signs, Cross River, Nigeria/Cameroon*

Approximately a thousand symbols are known in Nsibidi *writing. They were traced on the ground, mimed in gestures, painted on fabrics and masks. They include a collection of signs known to everyone that allude to human relations and domestic objects (of which there are examples among those reproduced here) and a collection of esoteric signs tied to dangers, to death, to the sanction of infractions, and to the hierarchy of the* Ngbe *initiating hierarchy.*
a. love, unity, compatibility; b. hate, dissension, divorce; c. word, conversation, assembly; d. mirror; e. table settings; f. travel, route.

in the royal fabrics with figurative *appliqués* of the Fon of Dahomey (Benin), in which the images and words do not meet on the side of representation of action. The name does not simply signify the strength of the sovereign, but is an integral part; the image does not illustrate (the name thus exposed remains a secret), but renders it present[124]. When a messenger brings the *récade*, the scepter on which there are carved figures associated with the sovereign, the same honors given the king are bestowed on the object because it is exactly as if the king had come in person to give the order. The *récade* is exhibited to publicly attest to the existence of a secret that will not be revealed. The visibility of the secret, obscured as much as its contents, sanctions and regulates the unequal distribution of knowledge that is the basis of power differences.

The relationship between image or graphic traces and words is more closely tied where there are existing forms of initiative writing based on interpretative codes divided by restrictive groups, as in the case of *nsibidi* writing of Nigeria and of Congolese cosmograms[125]. Nevertheless, outside of occult meanings, the most important aspect is really in their public side, where they reveal themselves, concealing their meaning. The text fascinates because of its power to signify meanings. In the apparent inalterability, it constitutes a space for the protection of ever-diverse meanings.

7. *Power and the Limits of Art: the Giving and Withdrawal of Images and Speech*

The operative dimension of fabrics and sculptures, what makes fabrics and sculptures elements which articulate a relationship of strength, does not only express the position of *one* of the contenders on the list in relationship to the others (in the ordered differences from esteem and prestige of each person's clothing for example), but is sometimes visible in a single object that then becomes the battleground between opposing forces in an ambiguous and unstable equilibrium.

The *jibbeh*, a Sudanese uniform worn by Madhist officials, offers us an illuminating testimonial[126]. Precisely because of the mass of followers of Muhammad Ahmed, called the *Mahdi* (the Prophet), who in the last twenty years of the last century fought Egyptian sultans and the English in the name of Islam, the *jibbeh* was a lacerated tunic, a result of the sewing of different bits of fabric. It demonstrated in a tangible way the attachment of faith and the virtuous life inspired by the ideals of poverty and equality of the *jihad*. The elements of the official uniforms, though, were different. The uniforms, very specific, presented rectangular *appliqués* of colored fabric and decorative motifs corresponding to the pockets and the collar, with effects of a certain elegance.

The distance between the refined uniform and primitive tunic is palpable, but the gap is not the consequence of a simple cancellation of the original inspiration, of the betrayal of the elite, as much as an attempt to compose exigencies and lines from contradictory pressures. The necessity of war demanded the formation of an effective and visible structure of command. The triumph of victory demands a paradoxical development of hierarchy. From this comes the birth of a new uniform that, through the decorative citation of patches, contemporaneously seeks to mark an identity of belonging and a diversity of function, to make old and new, movement and institution, all coexist.

The "the skin of the pangolin" costume of the dignitaries of the city of Benin (Nigeria) presents an analogous case to the clothes crossed with multifarious and divergent

(Facing page)
68. Fabric design, Fon, Benin

Here we see the "strong names" of twelve kings of Abomey. The "strong names" do not only express the power of kings but participate in their strength. The chronological order assumed here by the sequence —reading from left to right and from top to bottom — makes one think of the influence of alphabetic writing. For example, the first ideogram is that of King Ganhehessou, who ruled around 1620; a male bird, a drum, and two hunting clubs, also used as weapons of war at the time, appear here. The reading of these designs follows the principle of a riddle: "the head is a great male bird who makes himself heard by everyone as a drum."

69. Jibbeh, tunic of the Mahdist army, Sudan; cotton, height 189 cm

70. Jibbeh, tunic of an official in the Mahdist army, Sudan; cotton, height 84 cm

The refined appliqués of the tunics of Mahdist officials are a probable aesthetic and symbolic reworking of the patches of ordinary tunics, emblems of the ideal of poverty that inspires the followers of the Prophet.

71. Osuma chief, city of Benin, Nigeria

The ceremonial red dress of the chiefs of the city of Benin imitates, in the skirt, the scales of the pangolin; the symbolism that is associated with the color and the animal demonstrate the hierarchical dependence and the tensions that exist between the chiefs and the king.

valences[127]. On the one hand, the red of the fabric signals its belonging at the ceremony of court and is therefore an integrative element. On the other hand, it is associated with rage, blood, and war and is therefore viewed as potentially threatening and disruptive. The same holds true for the symbolic nexus with the skin of the pangolin. Used as medicine, the scales of the pangolin (imitated by the fabric) protect the pangolin and its own king from evil, but while the pangolin is considered the only animal that can resist the leopard (a symbol of royalty), they also protect *from* the king and allude to the potential conflicts between the sovereign and the city heads. The costume makes these tensions explicit without stating them, and it is really for this reason that they loosen the conflicts, exercising a cathartic effect.

The visual arts, besides celebrating power, can thus become the instrument of the opposition to power. In large part, Benin art can be read in this light. Many of the masks used in the villages of the kingdom are in fact associated with heroes opposed to central power and thus prohibited in the capital. At the same time however, they stabilize a tie with the center, announcing their annual ceremonies to the king and receiving his approval. Such duplicity is clearly seen in the *Ekpo* masks, in which not only rebel figures appear but also the figures of people who have mediated between the village and the court and who were lavished with the greetings of the king[128].

The emotional and intellectual experience generated by vision is only partly translatable into language, and any attempt to force it inside of words ends by destroying it or transforming it into something else.

Words and things can be interpreted as verbal and plastic strategies, alternative or complementary, finalized by the translation of the divine into the human.

Sometimes within a single ritual context, one can see the divarication and contraposition of verbal and visual registers. While the forms of certain *gelede* masks laud the calm gentleness of mothers, the song that accompanies them denounces the cold pitilessness that can hide behind the impenetrability of the face[129]. Analogously, in the cult of the thunder god Shango, while the song focuses on the god's hot, volatile, and destructive temperament, the ritual sticks demonstrate the composure of the devout who are possessed by Shango[130].

Often the word and image do not proceed in parallel, but show themselves as alternatives. This is the case of animals occupying a place that is much more relevant in the art of words, where they have a higher level than they do in sculpture. The spider, for example, which holds a role of the first importance in many African tales and myths, is instead nearly absent from all the visual arts[131]. In the art of the Edo of Nigeria, the tales address a togetherness of distinct animal symbols different from those that appear in the visual arts.

The presence of things can bring the necessary cessation of words, as is the case in the mask which, belonging to the kingdom of the dead, is generally silent and expresses itself only in gestures.

The same can be said of puppets, whose movement, at once mechanical and released from the limits of gravity, is often compared to that of the returning dead. Often, the puppets dance mutely or with a voice either deformed or rendered incomprehensible. When puppets recite a story, they do it more through action than dialogue: "That which they do dominates that which they say." Their visual signs and sounds do not reflect a language but suggest a thought[132].

This is where art finds its power and its limits. The surplus of the sacred that always exaggerates the forms used to try to enclose it makes art into an attempt that can be renewed, varied, or abandoned in order to gain from other strategies thought to be more fruitful.

With this knowledge of the limits, we can explain the syncretic, tolerant, and open characteristics of African religions, which, always looking for new ways of translating the sacred, extend the boundaries of the pantheon including external contributions. However, they also contract the limits, pragmatically thinning out the threads of the less favorable spirits or less industrious ancestors. The experience of the boundaries of words and things explains the continuous oscillation between them.

Art finds an impassable limit in inaccessibility, in contact, and in the image of the creator god, often distant and remote if not entirely indifferent to the adventures of humans, unrepresented in as much as he is unimaginable or because he is insensitive to representation or the sufferings of men.

In fact, if the populations of the Bantu language turn to the Creator as a provident father who continues to sustain His creatures even after creation, elsewhere God seems to

have created the world out of boredom and by accident, only to forget it afterwards[133]. The creator god is thus placed in the center by some, reducing the manifold figures of the spirits and divinities to hypostatis, a manifestation of a single god, while among others, he is instead suspended on the margins, a kind of limited idea, a negligible appendix of African conceptions of the world. On one side, He is a God close to humans who uses intermediaries; on the other side, He is a distant God, absent from the life and cares of humans, who started creation only to retreat from it.

We need to say that it is not completely clear how much of this diversity can be attributed to African conceptions and what can be attributed to the inclinations and the wish to reach an unequivocal clarity of those interpreting it, nor what is due to the overlapping of Islam and Christianity and what is due to traditional religions. This idea of the inaccessibility of the divinity to the image depends on the way in which the divinity is conceived. For some, in fact, the minor divinities are nothing other than refractions of God and do not have their own individual status. For others, on the contrary, the supreme divinity simply does not exist, and one must speak of a conception that is pantheistic or polytheistic if not outright atheistic. This way the non-representation of supreme divinity is, from time to time, thought to be indicative of the transcendence or spirituality attributed to Him or seen as a consequence of the fact that, if God is everywhere, it is not necessary to give Him an image, for one can look directly to one of His creations.

Things are not much clearer on the side of the word. The insufficient wisdom of the word is seen in the frequent absence of prayer. The absence that penetrates the word is, however, perhaps less radical than that inherent in the image, since a name is given to the divinity, and in myths, many of his gestures are recounted, portraying them in terms that are very, and even too, human. However, this does not mean that words come to tell things as they are, that they have been consented what is precluded form the image. In fact, it happens that we do not believe or we believe only half, and it happens at the lowest levels that words do not reveal but function as a screen or lentitive for a mystery that remains, in reality, intact.

God remains unknowable, outside of every image and word. What we can say *starting from art* is that God is omnipotent as a maximum concentration of force, of vital energy. He is not so much a being or person, the source of all things. Among the Bantu, God is not He who possesses the force, but the force itself: He does not have force, He is force[134]. When God is represented in a graphic form, He takes the shape of three concentric circles or a spiral. He is not directly represented, but is seen in His generative motion, like an ordered multiplication[135]. Such symbols are not specific to the Bantu area, but are found throughout black Africa. The Dogon represent God (Amma) not with a noun, making Him a being, but with a verb, expressing Him in dynamic character. They also represent Him as a spiral (the symbol of creative movement, of the motion of water and the rays of the sun), studded by a series of dots that indicate the created objects. According to the Dogon, such inscriptions are, for another thing, much more of a simple representative expedient, since God Himself started to create the universe writing a series of graphic signs where He then deposited the world[136].

It seems that this interpretation can also be extended to the completely particular case of Edo iconography in the city of Benin. Even here, we are in the presence of a creator god (Osanobua) far from the daily life of man, whose public cults are not reserved, and one would only turn to them as a last resort when all other contacts had failed. Nevertheless, we have representations of this god. Images of Osanobua appear in the cult masks of the *Ekpo* and as earthen statues in the altars dedicated to the son Olokun, father of the great waters. It is interesting to note that in these altars Osanobua sits behind Olokun in a clearly subordinate position. His grand status seems to consist in his generative capacity, in the act of having created something other than himself. As the Benin adage explains, "One can in truth generate a son greater than oneself, as Osonobua created Olokun."[137]

72. Olokun altar, city of Benin, Nigeria; earth, synthetic paints

The creator god Osanobua is a distant god for whom an organized cult does not exist: he is only sought as the last resort, when all the attempts through other divinities have failed. Differently, however, from what happens in other African cultures, he assumes sculptural shapes in Ekpo *masks and in the altars dedicated to the son Olokun, master of the great waters. Olokun is placed in the center while the father, in a subordinate position, appears on the right.*

73. Motifs of a ritual vase in terracotta, Ife, Nigeria, 13th-15th centuries

The three figures positioned in the center frame demonstrate that works of extremely diverse styles coexisted in the antique culture of Ife, side by side and in the same cult. On the sides of a realistic type head, there are two other heads leaning to a decisive geometric schematism. It is probable that, analogous to what happens at the same time among the Yoruba, the first would represent the visible head and the others the head's interior dimension.

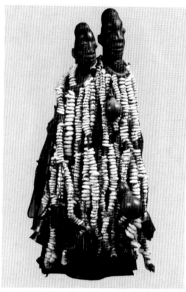

74. Couple of figures of Eshu (Ogo Elegba), Yoruba, Nigeria; wood, cowry shells, pumpkins, metal, height 25 cm

The aesthetic of African sculptures often leans on the partial concealment of the carved part. Eshu often manifests himself in the form of a masculine-feminine couple: this emphasizes his ambiguity and his power to mediate between opposites. The strands of cowry shells with their noise and movement during the dance allude to the world of extremes. Their white color is contrasted with the black of the statues. Eshu is one and the other. The pumpkins contain magic substances.

75. Woman with ceremonial Ntshak skirt

The fabric in raffia with the design and inserted appliqué is wrapped around the waist many times; for this reason, only a small part is visible. It is decorated on its entire surface; analogous motifs also appear in the ventral scarring.

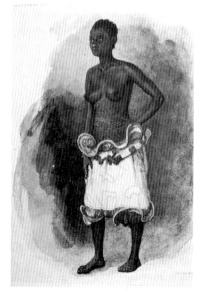

The understanding of artistic and stylistic typologies in terms of situational strategies, of choices occurring within a range of culturally defined possibilities, could allow the recognition of the reason behind the presence or absence of sculptural figures in nearby populations, behind the stylistic variability of time and space within the same culture or cult.

The Ogun divinity is seen this way in the art of the Benin kingdom, in a multiplicity of representations, abstract or anthropomorphic, which corresponds to the diverse ways of conceiving the divinity. Ogun is the protector of farmers, artisans, hunters, and warriors, all of whom use metal tools. Ogun, more than anything, is the creative and destructive force that lives in metal, that which cannot be directly represented, but which is active in all the tools in which he is present. Signs and ceremonial swords serve to underline this aspect. Ogun is, however, a character who appears in oral literature as a younger son of the creator god Osanobua and as such is then present on altars in an anthropomorphic state[138].

For as much as sculpture is conferred power, it exists deprived of shadows, deprived of the power to bring everything back into full light and the power to dissipate the enigmatic nature of existence, bringing it to a full transparency and visibility.

To the iconophilia, a variable measure of a certain reticence to representation that can sometimes translate in anti-iconic behavior (the production of handmade items whose efficacy does not depend on their formal and representative characteristics) and more rarely (under the influence of the religions of the Book) iconoclastic behavior is added[139].

The power of the image indicated by the prevalence of anthropo-zoomorphic sculptures over abstract sculptures is mined within the dynamic or formal orientation imprinted on the block of wood about which we are speaking. The wood is not a passive or resistant material waiting for the demiurgic intervention of man but the seat of a vital force that already finds its forms in the trunk and in the tree. This explains how the handmade artistic object can be effectively substituted by natural objects.

the African statue is therefore not the sketch bundled in the material because of the inexperience of the artist but the result of an encounter between diverse forms seeking a coexistence.

The aesthetic and practical efficacy of African sculpture really comes from the latent but noted presence of an unrepresentable force that expresses itself in the form and dynamic of the wood, seconded or contrasted but never suppressed. The artistic form develops or inhibits the force of the natural form, or simply signals the presence of hidden objects, functioning as a pole of attraction and diversion at the same time.

If wood possesses such force on the other hand, it is because it comes from a tree, from an autonomous life force that is symbolically invested.

The aerial and underground development of trees, their participation in the sky and the earth, makes them symbolic bridges between diverse parts of the world. It is this way for the Dan of the Ivory Coast, where the highest trees are those who sustain the sky, keeping it from falling to earth, and so cannot be cut down. Every new Ashanti king plants a tree that is seen as a potential dwelling place for his spirit. The shadow of a parasol under which he sits during public exhibitions is seen as a lengthening of the shadow of this tree; knocking it down would be the objective of his enemies[140].

Trees occupy a central position in the life of African populations; they are the seats of the spiritual and symbolic entity of the vital dynamism of the universe.

From trees come the materials for construction, textile fibers, medicines, food, and beverage. They are present in an underlying way in all spheres of life. In central Africa, the wearing of raffia fabrics signifies the marking of one's humanity through the technical element of the weave and the reconfirmation of one's ties to the forest at the same time.

This is true for the Nande from the north of Kivu (Congo), who proudly designate themselves "knockers-down of trees" (*aba-kondi*). They have provoked the destruction of the forest, which continues to exist, however, in toponymies and in their way of conceptualizing space. These are unavoidable terms of a cultural identity that finds its own reason for being precisely in the "knocking down and taking over" in the relationship of constant and polemic dialogue with the forest[141].

Even among the Ashanti, the king, on the occasion of the annual rites of purification of the kingdom, abandons his rich clothes of silk in favor of a humble cloth of bark. Temporarily leaving the fibers of importance, he reties his vital bond to the ancestors and the forest then returns to the present and the city[142].

The cutting of a tree to procure wood for carving is often preceded by sacrifices and rituals that attempt to obtain the consensus of the spirit who lives in the tree. The choice

of wood and the way in which it is worked do not respond in a priority way to considerations of a technical nature but to a symbolic nature. For the *gelede* masks, Yoruba artisans chose green instead of seasoned wood. What would be seen as a useless complication to a Western sculptor (the fresh wood is more difficult to carve and is subject to breaking with desiccation) would instead be an unavoidable point of departure for an African artist: the greater vitality of the freshly cut wood is in fact a guarantee of the efficacy and strength of the mask[143].

And yet, in a way that is rather surprising, the vegetable world is relatively absent from African iconography. Perhaps it does not need to be represented because it is directly present in the wood of the statuary and the fiber of the fabrics and masks.

Among the Bwa of Burkina Faso, the principal subdivision between masks is between the wooden mask and the mask of leaves. While in the north of the country this distinction is given in terms of a reciprocal hostility between associations of rival cults that present them as alternatives, in the south they are peacefully and simultaneously present, playing complementary roles. In the spring when the men leave the village to work in the fields, the masks of leaves help them integrate into the natural environment, while it is the masks of wood that welcome and reinsert them into humanized space when they return to the village after the harvest. The costumes of the former, composed of wild vegetables, and those of the latter, composed of the fibers of cultivated plants, demonstrate the opposition and connection between nature and culture.

Sometimes, it is the animal forms that carry vegetable symbolism, as in the *chi wara* masks whose function is to activate the ritual elements, indispensable to the growth of alimentary plants, reaffirming the communion between men and plants. In fact, the Bamana believe that men were born from millet, and they pool plants and human beings in the exertion of work and growth. These masks take on and combine the forms of diverse animals, associating them with locally cultivated plants. The type of vertical development, in the form of the long-horned antelope, echoes the aerial development of fonium and milium, whose shallow roots are indicated by the absence of excavators' claws. In headdresses whose compositions seem to touch the abstract, the parts of two or more animals (pangolin, aardvark, antelope) are combined and overlapped to echo the development, as much aerial as radicular, of sorghum, while in crests of horizontal development, the reference is instead to plants that grow in line with the earth[144].

The simultaneous recognition of the power of images and their insufficiency takes the form of a cautious economy of visibility. In the case of African kings, for example, the affirmation of the sacredness of their power is often obtained by subtracting their body from sight, not just isolating them in the palace, but also covering them in fabrics, crowns jewelry, and signs that, hiding their physical body, make the body politic visible. To miss publicly exhibiting himself but also to reveal himself completely, uncovering his own human character, are both equally dangerous and undermining extremes for the king. The signs of equipment isolate the figure, taking him away from ordinary life, establishing the indirect visibility that suits him. It happens this way during the Odwira ritual: the Akuapem king (Ghana) passes at night through the streets with the royal throne, but the subjects, who know what is happening, remain closed in the darkness of their homes[145].

76. Chi wara crest, Bamana, Mali; wood, metal, 75 cm.

The figure is played on two overlapping registers: the body of the aardvark and the horns of the antelope. The head is joined to the body by a metal joint. The symbolism of the mask is tied to agrarian rites: the upward curve of the horns, the opposite of what is natural, suggests the thrust of the plant towards the light; the aardvark, a digging animal, instead recalls the roots.

77. Chi wara crest, Bamana, Mali; wood, metal, height 58.5 cm.

Elements of different animals are assembled on many registers: the bottom figure is the aardvark also in this case; above him is the body of the pangolin whose twofold nature, terrestrial and arboricultural, provides an element of connection between the roots and aerial protection of the sorghum stele (the horns of the antelope). The arched shapes allude to the folding of the stele in the wind, to the growth of vegetables, and to the work of the farmer.

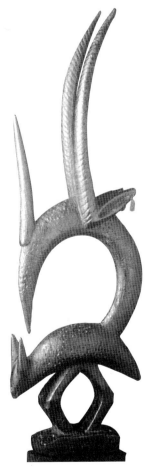

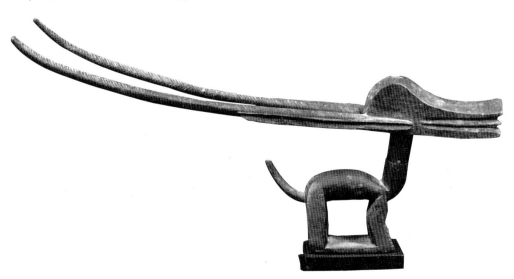

Analogously, a similar thing happens to the word that is always mediated. The often silent king speaks only through a spokesman who acts as a protective filter, avoiding all contamination, or rather he expresses himself through signs that refer back to proverbs. The indirect character of expression is reinforced by the equivocal way in which the forms recall the word and the ambiguous meaning of the proverbs themselves.

The recognition of the strength and weakness of man in the word takes the Bamana to an explicit valorization of silence and secrets as complementary opposites. The centrifugal and alienating push of words appears with the centripetal and intimate push of silence, a silence that is not the simple cessation of the word but the thing from which the word is born and that the word generates: "If the word constitutes the village, silence builds the word." The efficacy of words cannot leave out the shadow that envelops them: "It does not conserve its integral state, if not in proportion to its grade of deficiency."[146] Silence is the index of mastery of oneself; reserve, euphemism, and implicit meaning are ways in which words enrich themselves with significance.

There is an inseparability of giving and withdrawal that is also at the base of the aesthetic of the mask, clothing, and corporal incisions.

A sculpture is often taken out of view in order to preserve its strength and prevent dangerous dispersions. Its appearances are rare and calculated and its power much greater the less it is allowed to be seen.

Its own aesthetic efficiency sometimes depends on its intentional obscuration. Clothes and applied elements can "hide" the sculpture, and yet its forms, for as much as they are not seen, remain indispensable. The reliquaries and additive elements that appear on magic statues hide or change the body of the figure on the one hand, while on the other, arranging the "power", they underline the vital points (stomach, head, back). This simultaneous giving and withdrawal of something that remains hidden clearly expresses itself in the nocturnal masks of the Igbo of Nigeria. They are not really masks but voices dressed by obscurity[147].

Similarly, the design of ceremonial *ntshak* skirts remains largely hidden because, wrapped several times around the waist, one sees only the end part of the long wrapped fabric. The innermost part, which is not visible, is nonetheless designed; the efficacy of the design of this part does not hinge on the spectacle it offers but on the contact it establishes with the body[148].

Often the disclosure of a secret coincides with the acquisition of awareness that is not at all secret. To strip the secret from its wrapping (the object) does not allow us a direct grasp of the contents, but makes us lose one in the other so that, as in Chinese boxes, one is made of the other.

The secret of which the initiates are part is none other than the same procedure as the

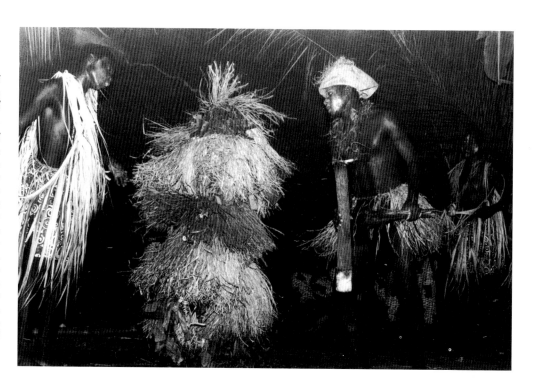

78. Apparition of the spirit Mohondji during the spectacle called Le malin sorcier *of the Matenga theatrical company, Libreville, Gabon, 1978.*

The spirit is brought on stage in total darkness so that his vision is reserved to the initiated; here we see him thanks to a flash. The director, wary of the photograph, seemed to be unnerved by the possible consequences of this unplanned event. The entrance of the spirit onto the scene does not respond to the requirement that it must be spectacular (it is in fact invisible) but — in the words of the director himself — to the wish to come as close as possible to reality. This comportment is very diffuse among authors of African theater who live in cities, some of whom also go to the villages to be initiated into cults and thus enrich their art (Denis and Olenka Nidzgorski).

initiation. It is not new knowledge but a different way of considering what is already known, a new interpretative key.

What is most important in a secret that is already public and known, as much the secret as the object consist in their exteriority[149]

8. Local Aesthetics

Generally following the principle of ethnic unity as a criterion in the individuation of artistic styles, ethno-ethnicists have produced a series of field work that seeks to individuate the local codes the preside over the creation and valorization of aesthetics.

To avoid undue overlapping on the part of the researcher, the adapted measures usually keep the discrimination phase (arranging, in a preferential order, a series of photographs that represent statues form diverse provenances) separate from the verbalization phase (the request for an explanation of motives that have led to a determined choice).

For as much as such procedures are linked to an objective valuation, they still produce a result that is inevitably that of an aesthetic created from the interaction between the indigenous people and the anthropologist. Anthropologists construct their field of experience selecting the presented objects, which, shown all together, create a relationship that precedes and influences the single valuations and their ordering. The judgements, moreover, are sometimes expressed on photographs and therefore on a two-dimensional representation of sculpture that is absolutely abstract from its context. This identification of a sculpture as an aesthetically privileged object is rather the consequence of a Eurocentric judgement of taste.

The attempt to produce a situation that is experimentally controllable, isolating determinant variables, produces an artificial object of the context. We privilege statuary because it is thought to be easily isolated in comparison to masks, more tied to music and dance, and because the axiom of departure continues to be that, Eurocentric, of the isolation of the object in context as a precondition of aesthetic judgement. This assigned work, that of "classifying", is not culturally neutral.

The verbalizations of the indigenous people are not spontaneous but a response to the more or less implicit requests of the anthropologist, who cannot then avoid translating them and making them meaningful to us, systemizing, in analytic and coherent principles, evaluations that are often holistic, semi-conscious, and only partly verbalized. The inferred aesthetic principles, in the end, do not seem to be able to be applied to other artistic forms developed by the same groups and therefore pose the problem of the validity of generalizations, particularly when they are applied to very numerically limited samples. These considerations do not mean in any way to diminish the weight of such research, which provides precious information, but want only to bring it back to its boundaries (and hence to its possibilities), revealing the character of its intercultural construction. Our "will for truth" moves them, the attempt to precipitate a visual form in the shapes of language and in writing that is probably in large part not verbalized and not meant for verbalization.

This research reveals how aesthetic appreciations follow basic cultural values, for as much as we try to isolate aesthetic judgement, decontextualizing objects, liberating them from the bonds of belief and the obligations of determining faith, the considerations expressed by the informants are not of a purely formal type but are inseparably aesthetic, social, and religious, tying visual quality and cultural values together. Sometimes considerations of non-visual orders are revealed as preponderant.

This research leads to the definition of a communal aesthetic code, a common base divided by artists and all people, deduced from the tendential homogeneity of the classifications. This is not without apparent internal contradictions, as in the case of the person who, after having emphasized the homogeneity of the judgement expressed by interview subjects, affirms that "nothing is good or evil forever and for every Baulé"[150].

Susan Vogel has individuated the principles of the aesthetic of the Baulé of the Ivory Coast in the "resemblance to the human being" and in "moderation", terms which in the Baulé culture, however, take on a meaning very different from what is familiar to us.

The resemblance is not intended in a purely physical sense or as a portrait but as a response to the generalized human type, the physical and moral ideal. The expression of this non-visual quality explains how it can lend resemblance even in the relative distance from the natural forms and proportions of the body. It is for this reason that the head of a statue

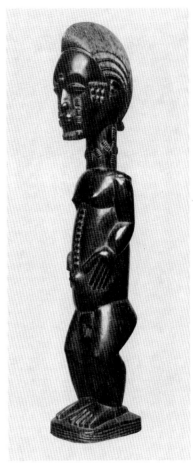

79. Male figure, Baulé, Ivory Coast; wood, height 52 cm

The Baulé figures of the "spouses of the afterlife" find their ethical-aesthetic criterion in moderation. The expression of the face and the posture express serenity and tranquillity: the legs, slightly bent, have rounded and curvilinear forms while the arms adhere to the body, grasping the stomach, and emphasizing the umbilicus. The head, in its dimensions and attention to detail, constitutes the center of attention: the small and closed mouth, the lowered eyelids, the fine nose, the accuracy of the hairstyle, the shiny and smooth surfaces confer a delicate beauty on the figures.

close to the natural proportions of the body can be judged as "too small". Thus, even if the Baulé turn to the paragon of photography to explain their conceptions, it is because they are aware of the manipulative character of photographic reproduction of reality, which becomes smaller, flattened, and altered in color.

Moderation (*sese*) is the principal criterion. It is what is deduced from the phrases that accompany positive appreciation: "neither too high nor too low", "neither too thin nor too fat", "neither too big nor too small" etc.. Such a principle that informs everyone else is to be interpreted, according to Vogel, as a search for harmony of the parts, appropriateness to the context. To this wish for equilibrium, the search for a moderated asymmetry that expresses itself in light twists of the bust or in different extents of the arts is also added. Vogel thus translates the Baulé aesthetic in the terminology of classical aesthetics, perhaps rediscovering the same disposition of souls in contexts that are culturally, temporally, and artistically extremely different.

The sculptures that displease are those called similar to "the things of the *brousse*"; those deemed pleasing are instead compared to the "village of the human beings". The complementary village-*brousse* opposition that is at the base of Baulé thought inserts an aesthetic valuation within a global, cosmological, social, and ethical order. As we have already seen with reference to other cultures, the things associated with the *brousse* (animals, spirits, people) are generally thought to be asocial, antisocial, arbitrary, dangerous, lawless, and non-human and therefore ugly. Things associated with the village are instead deemed social, orderly, controlled, law-abiding, human, and productive.

Consequently, the expressions used to express approval – "pretty" (*klanman*) or "good" (*kpa*) – refer to the physical dimensions as much as the moral ones.

Judgements are not made about sculptures as entire pieces but about single parts in their order of importance. While almost no attention is paid to the ears, shoulders, feet, and hands, the head is privileged. It is oversized and carefully detailed because it is the seat of freedom and intelligence and is associated with clairvoyance. For this reason, the eyes are generally large – but not overly so – and open. Particular attention is paid to the hairstyle, scarring (considered signs of socialization), and to the smoothness of the surface (a sign of cleanliness, purity, and health in opposition to sickness, a sign of disharmony in relationships with the world). The way in which the different physical attributes are rendered emphasizes the central values of work, fertility, and honor: the long and straight neck, the physical energy seen in the fullness of the calves, the erotic lure of the buttocks that have the better of the breasts and genitals.

These observations are, in many aspects, similar to those developed by Thompson in relation to the aesthetic of the Yoruba of Nigeria (Plate 3), whose sculpture, for one thing, is notably different from the Baulé's, and to the observations of Silver, who studied the Ashanti art of Ghana[151].

In this case as well, we would find ourselves before an art of measure. The Yoruba would be in search of equilibrium that would derive not from suppression or the neutralization of opposites – the "hot" and "cold" aspects of the cosmos and of character – but in the recognition of the complementary nature. It is an aesthetic that has its foundations in the relative mimesis (*jijora*) intended as a resemblance to the generic human type, an ethical ideal of behavior without excess or defect; in the relative visibility (*ifarahon*) for which

80. Agbogho mmuo *mask, Igbo, Nigeria; wood, kaolin, height 37 cm*

81. Mask, Igbo, Nigeria; wood, black-yellow-red chromatism, height 28 cm

Many Igbo masks are constructed on the base of an ethical-aesthetic polarity that juxtaposes the masculine and feminine elements. The white mask, in its subtle traces, in its smile, in its facial decorations, and in the elaborate hairstyle, represents the ideal of feminine beauty; the black mask, instead, with its tubular eyes and animal horns, recalls the power of elderly men. The first is gentle and benign, the second is aggressive and fearsome.

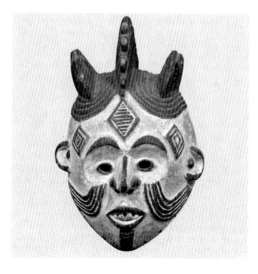 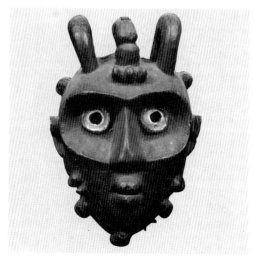

the immediate visibility of some details lives in the absorption in the background of others; in the discrete luminosity (*didon*) that favors blue indigo, index of controlled vitality; among the extremes of blazing red and gloomy black in the partial rectlinearity that is well understood in the outlines and panels of carved doors. Here too, there is a predilection for fluid forms and shapes full of youth, the strongest and most fertile time of life.

Silver underlines how among the Ashanti the socially shared preference for a moderate naturalism is not, however, a sufficient condition for obtaining a positive judgement. The images must also permit references to ideals and places from traditional and modern Ashanti cultures. Once more, the valuation of visible forms is undetermined by considerations of a non-visual character. The works are interpreted as representations of phenomena that can sustain or threaten local order. The most appreciated are those identified as figures of chiefs or priests. Conversely, the ones that are interpreted as figures of Muslims or evil spirits are unpopular. The categories that preside over aesthetic judgement are those of order and disorder as conformity or less to the values of the Ashanti.

Cole and Aniakor have instead highlighted the precise dualism that guides the aesthetic valuations and world vision of the Igbo of Nigeria[152]. On one side, we have the whiteness of the kaolin and *mma* masks associated with femininity, youth, weakness, benign spirits, purity, clairvoyance, and light of day and on the other the black and dark things, the masks with distorted marks that recall instead the night, mystery, masculine power, "evil" spirits, and death.

Such polarity leaves, however, ample space for gradations, going outside of appearances: the objects of the soothsayer are dark and weighty with a terrible power that is, however, put into the service of man; conversely, the fact that the elderly dress themselves up in the feathers of the white eagle does not exclude the fact that they can use their powers destructively.

Even the most luminous thing contains seeds of obscurity: a pretty girl can have a black heart, and an exquisite meal can be poisoned. This is also true for masks, which give multiple forms to the transition between extremes.

The masks however – as much "masculine" as "feminine" masks – in reality reflect a point of view and aesthetic that is that of men. It is the men who produce them and the men who wear them[153]. Among the Igbo in fact, sculpting in wood and metal is a male prerogative. By producing and using the ritual objects used in familial and communal affairs, the men control the decision-making centers.

The aesthetic sense of Igbo women expresses itself instead in an ephemeral art – mural pictures and body art – that they present outside of the sanctuaries and power. The sexual division of artistic work is stressed on an aesthetic level. On one side, there is the feminine design, curvilinear, with fluid and asymmetrical lines. On the other, there are the straight and symmetrical lines of masculine bas reliefs.

What emerges from the collection of these studies is the existence of an indigenous aesthetic criticism that values objects in relation to the use for which they were assigned (appropriateness) and to the recognizable intentions of the artist (technical competence and good taste), distinguishing the good artist from the bad, the professional artist from the dilettante, and so on. The aesthetic valuation of anthropomorphic images shares its precepts with judgements about the beauty of the person in a reciprocal echoing. The

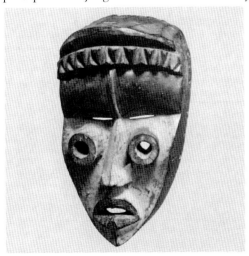 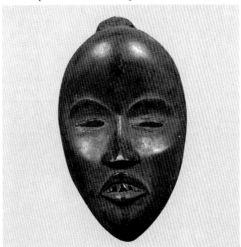

82. Bagle mask, Dan, Ivory Coast; *wood, pigments, height 26 cm*

83. Deangle mask, Dan, Ivory Coast; *wood, metal, height 23.5 cm*

The fine traces and smooth surfaces of the feminine masks are contrasted with the angular forms, the tubular eyes, and the coarse surfaces of the masculine masks, to which beards are often added. In this case, the bagle *mask seems however to unite feminine traits to the masculine ones: above the tubular eyes, in fact, there two other slit eyes open and the forehead, differently from the rest of the face, has a shiny surface.*

traits that make a mask beautiful are those prized in people and vice-versa, for we can say that a beautiful woman is like a statue.

The Dan feminine masks represent the ideal face for a Dan woman: oval with a pointed chin, vertical scarring on the forehead, a two-way hairstyle that emphasizes bilateral symmetry, eyes like slits (that the women make an effort to emphasize by not completely opening them or by painting a white strip from one eye to the other), and sharp and filed teeth[154].

9. *The African Aesthetic*

The possibility of defining the general traits of an "African aesthetic" plays between the two extremes of people who take the capacity of judgement about works that do not belong to their culture away from the Africans and people who instead interpret the positive judgement of the works of other cultures as proof of a yielding and shared African aesthetic sense.

In an intermediate position, there are people who maintain that if the Africans formulate significant judgements about the works of other cultures, they do not do it on the basis of a *corpus* of pan-African values but on the basis of local aesthetic criteria, judging on the basis of proximity to their own art and not examining the meaning that such works can have in the cultures of their origins.

The search for an African aesthetic is the object of a decision and a choice of interpretation. We do not discover an "African aesthetic" but construct it, we together with them. It is the result of a strategy that isolates common traits instead of differences.

Once we have accepted the "artificiality" of the object on which we base our analyses ("Africa" as an intercultural construction, as it is mapped by the foreign eye), it then seems that we can speak usefully, frankly recognizing the fictitious character of our own discourse. Thus we do not speak of outlining a transcendental aesthetic or a typical mentality but of establishing connections between objects, connections that can open to a foreign observer. The synthesis that pervades would not have a causal and explicit significance but a rhetorical one. It would not explain the genesis of the works, carrying them back to a common starting point, but would retrace a possible route, would suggest an itinerary that could be traveled from "us" to "them".

It is in the unity of the performance that the homologies that allow us to outline the general characteristics of an African aesthetic, which we can reach through the diversity of styles and modes of expression, appear. In the feast, in the rite, there is an interlacing of

84. Mbari *sanctuary, Igbo, Nigeria*

The argil sculpture, in its architectonic integration, finds a monumental dimension here. The mbari *are houses built for the divinity of the earth (Ala) and other divinities, with the aim of increasing the community's prosperity; they can include as many as one hundred statues. Their construction, accompanied by festivals and rituals, requires twenty or thirty people and can take up to two years. The finished work is left to decay under atmospheric and environmental events: the aesthetic and symbolic emphasis, in fact, falls not on the product but on the work of spiritual and visual renewal that occur during the building process.*

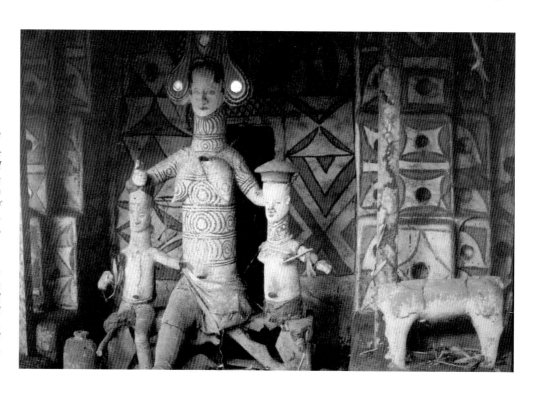

visual, auditory, tactile, olfactory, and gustatory sensations, making the visual forms part of a more ample complex of sensations.

In the same way, the erotic-aesthetic female scarring is addressed not only to the eye but to the sense of touch. Incised on the abdomen and hips, they make the lower stomach more attractive. Their essential scope it to be caressed by a man and to stimulate the couple's sexual desire.

Masks, in particular, take on a definite identity, as much as it is transitory, only in the polyphonic unity of ritual performance, in dance, in agreement or contrast with other expressive means. Their efficacy and aesthetic value take form only in movement: when the mask is not dancing it becomes a dead object, and only in seeing it dance can one identify it. Significantly, the same term is often used to indicate the carved part, the entire masquerade, the incarnated character, and the presented spectacle. This way, "the same mask" can take on sacred and dreadful connotations, canceling the identity of the wearer, or it can aim to pure entertainment, letting the participants maintain their own identity, according to the context in which it appears[155].

The aesthetic of the visual arts should be considered, therefore, in the more ample context of the production of events. It is what has led someone to say that a history of African art would have to be the history of danced art, inseparable from time and movement[156]. This importance given to the doing, to art as process more than to art as product, more than to the consideration of it, immobile and detached from any context, is clearly exemplified in the *mbari* sanctuaries of the Igbo of Nigeria. For them, in fact, "The completed building is probably no more significant than the richly orchestrated building process. '*Mbari* is a dance for our gods', say informants."[157] The construction of the architectonic structure and numerous earthen statues is accompanied by dances, songs, sacrifices, prayers, and the playing of drums. A poem of praise for the god of the earth (Ala), whose beauty is in his behavior and in his process of collective elaboration. When the structure is completed, it is then abandoned to time and severe weather conditions. What counts is the execution, the construction as a ritual renewing of the Igbo world; the product itself has an ephemeral character.

This centrality of movement, of the spectacular and dramatic performance, in which the borders between rituality and theatricality are not easily distinguishable, can perhaps justify an excessive use of the notion of puppets within which one can gather a great number of African plastic creations. If a puppet is the animated reproduction of a living being, such a definition applies not only to the figures that move behind the puppeteer's castle, but also includes the dancing masks, the statues that move in procession or are manipulated by soothsayers and therapeutists, the same men who, altering their normal way of moving, transform themselves into mechanical puppets in the dance. Some sculptures, like the Yoruba stomachs from which figures of dwarves or babies are delivered (Plate 2), are contemporaneously parts of the costume of a mask and inhabitable puppets. This facial mask, in addition, can carry a puppet with moving arms on its top. Some large-dimensioned Bamana puppets, supported by a pole, can equally be worn by the puppet player. "It also happens that a puppet could be masked, that a mask enters in his composition, that he represents a mask, or that someone holds a mask in his hand and moves it in the way that he would a puppet."[158]

In light of this centrality of action, the same relative expressive immobility of many figures reveals itself as the willingness to assume the most diverse identities in the scenic game. An overly defined emotional expression would reduce the possibility of assuming diverse identities.

For as much as a sufficiently marked distinction can be made between the formal structure of three-dimensional sculpture and design on flat surfaces (mural paintings, decorated textiles) to the point of delineating two opposing aesthetics [159] – the one centered on symmetry, the other on irregularity – it is nonetheless possible to individuate a common thread that connects them despite their differences.

The same opposition should probably be reduced. The "exceptions" seem numerous to the point that it is legitimate to ask ourselves whether we should not review the "rule" and ask ourselves to what extent the Western wish to find symmetry and order has inscribed itself on the selection and collection of African sculpture, rejecting objects that diverged from that Western interest. If symmetry can be visibly translated as the social and cosmic order of its being, asymmetry recalls the complementary aspects of disorder, mutation, and individuality.

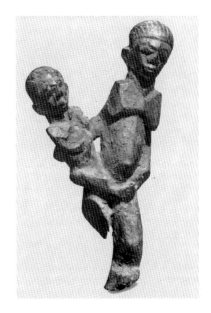

85. Maternity figure, Lobi, Burkina Faso; wood, height 15 cm

In Lobi statuary, an erect bust and bilateral symmetry of the body is only one of the possibilities within a wide ranging repertoire of poses: figures can lean to one side as in the propitiatory maternity figure, lift one arm or the other or both at the same time. We are looking at gestures of projection that distance witches or signs of mourning; in the latter case, the figures take upon themselves a sense of sadness, saving the proprietor from it.

86. Male figure, Fon, Benin; bronze, height 20.7 cm

The style of the bronze figure of the Fon is clearly differentiated from that of the wooden sculptures, for its fluid lines, the asymmetry of its forms, the representation of movement.

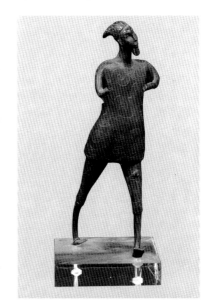

If in one instance some asymmetrical objects do not do anything but recall the rule in the intended transgression – as is the case of certain Pende masks (Plate 64) – in other instances it seems rather that the symmetry is only one of many positions within a wide variety of possible positions. In Lobi (*bouthiba*) and Bakongo (*mintadi*) statues, posture and the position of the arms vary strongly in relation to the situations that they are signaling. The arms can be at the sides, both can be raised to the sky, or the statues can have one arm raised and the other lowered. The absence of symmetry is particularly evident in many of the Fon figures in bronze and in the terracotta sculptures of Middle Niger.

On the other hand, we could cite many cases where the design on flat surfaces assumes a tendentially symmetrical direction.

Finally, it is the same contrast between surfaces and volumes that could be softened. In corporal paintings, volumes and designed surfaces interact in a reciprocal way. The painting conforms to the body on which it was placed, and at the same time, it modifies it in a perceptible way. Designs of thick outlines make it grow; delicate lines reduce it. The redrawing of corporal designs on flat surfaces, on the panels of a book, therefore signify the profound modification of their identity.

The same can be said of fabrics. Fabric becomes surface only when it is no longer worn and is hung under glass, attached to a wall. Thus included in the category of artistic objects, resembling paintings, it can be contrasted to sculpture. However, the three-dimensionality that the body gives to fabric is not an accidental factor; design and cut are considered precisely in view of this final effect. In their rotary movements, the motifs of fabrics with *appliqués* (*ntshak*) of the Kuba of Congo reprise and accompany the steps of the ritual *itul* dance. The *engunguun* mask, in its performances, whirls, swells, and overturns the fabric of its own costume, creating unexpected forms that demonstrate that things are never what they seem[160]. The volumes of fabric thus finish by going beyond those of the body, creating autonomous sculptural compositions. Sculptures and fabrics are closely tied: in the mask, the wooden face and the costume acquire a precise identity only in relationship to each other while fabrics often clothe the statues, becoming an integral part of the sculpture.

Even in the case in which we do not want to consider the fabric unitedly with the body that it covers, considering them only textiles, it is still possible to establish an entire series of gradual passages that connect the extremes of design to the sculptor, moving from embroideries, fabrics with *appliqués*, fabrics with beads, the interweavings of wicker, engraved wood panels, flat masks, etc.. The surfaces ripple, the volumes grow smaller, communicating among themselves.

The emphasis for the strategic importance that art holds in the transmission of the cultural values of African societies does not fall on innovation but on repetition. The forms

87. Seated figure, Djenné, Mali, 13th century; terracotta, height 25.3 cm

Approximately one half of the catalogued Djenné statues appear in kneeling positions, with the bust straight and the hands on the knees, but, in addition, another 65 types of postures have been discovered. In the asymmetrical poses, the body, while remaining the support of a symbolic expression, rediscovers its fluidity, ending up in acrobatic positions; they may be the positions prescribed from the divinities to the faithful in adoration.

88. Ntadi figure, Bakongo, Congo; stone, height 38.2 cm

These statues, placed on tombs and bound by precise religious prescriptions, often take on conventional asymmetrical poses; in this case, the figure is seated, with legs that meet at a right angle, the head inclined, and the hands leaning on the left knee, in a position that indicates sadness.

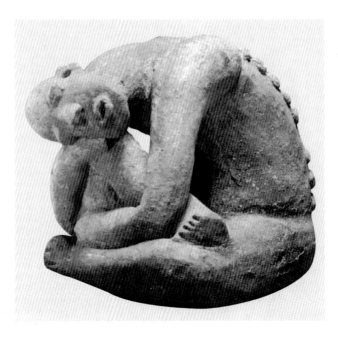
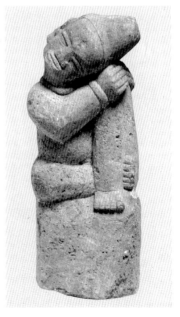

must allow the recognition and rediscovery of themselves, offering an element of stability. Yet, having said this, we must also underline that such reiteration of forms – from one object to the other, or on the same object – does not exclude, but, on the contrary, presupposes deviations and mutations.

Through redundancy, repetition guarantees the clarity of transmitted messages and allows elevation to the highest operative and communicative levels, inducing the trance that opens the path to the gods. Repetition is not, therefore, a simple reconfirmation of what has already been noted but an instrument of change.

The best narrators are not those who know tales that are different from the others but those who best tell the stories that everyone already knows. The most capable sculptors are those who make new details emerge from the variety of known forms, those who know how to graft mutation onto the stem of tradition. The ability of singers and dancers lies in their repeating the same verses and movements many times, introducing light variations in tone, corporal movements, or in the instrumental background music[161].

Morphological analysis of African tales demonstrates an analogous structure to that of the visual arts: the presence of a common canvas (an iconographic and narrative repertory) and the multiple changes that the narrator (or sculptor) more or less consciously brings to them[162]. The Akan weights for gold can be the occasion for tales that move from the interpretation of figurative symbols. Narrative order is established in the random extraction of weights from the bag and the ability of the storyteller to present them in connection, producing something unique on the basis of a togetherness defined by possible combinations.

The aesthetic effect is born specifically from the tension between the predictable and

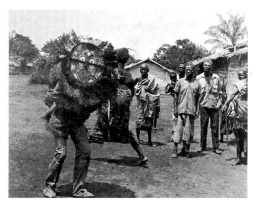

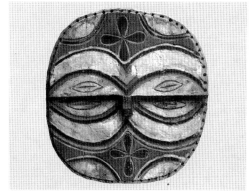

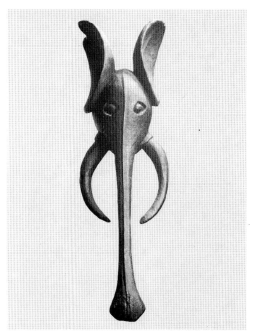

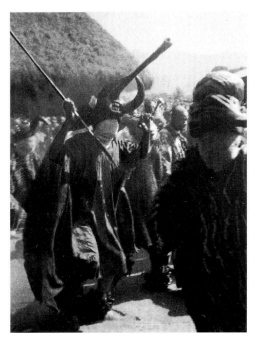

89. Kidumu mask that dances, Teke, Congo

90. Mask, Teke, Congo; wood, pigments, height 34 cm

91. Elephant mask, Grassfield, Cameroon; wood, height 114 cm

92. Elephant mask that dances

The aesthetic of African masks is inseparable from the comprehensive event of their exhibition, from the body, the costume, the dance, and the collection of relationships that each maintains with the other masks and with the spectators. We note how the elephant mask, which is placed in its position horizontally, in the out-of-context photograph is then reproduced vertically, guaranteeing "maximum visibility" but profoundly modifying the perception.

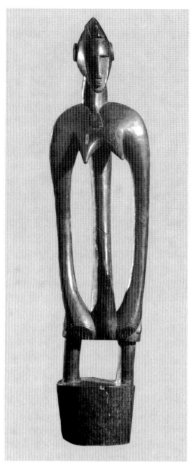

93. Deblé *statue, Senufo, Ivory Coast; wood, height 91.4 cm*

These statues are carried in procession during funerals that initiate the dead into the society of the ancestors; the movement was an essential component of the aesthetic experience associated with the figure, which was moved according to the rhythm of the drums. Rhythmically beating the ground prompted the assistance of the ancestors who lived there.

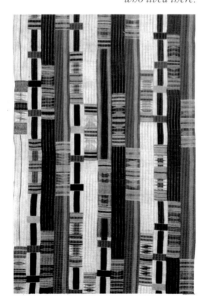

the unexpected. If, on the one side, the widespread knowledge of stereotypes restrains the variations, pushing towards conformity, the frequency of representation and interaction with the public solicit the mutations on the other.

Movement is not foreign to African art, but we are speaking – in musical terms – of an essentially rhythmic movement, shared by music, dance, words, and images in the unity of performance.

Thompson argues that this way the music that accompanies song, dance, and the exhibition of masks provides the structure for the entire African aesthetic.

Movement descending from African melody is comparable to that of a saw, whose tone starts high then delicately lowers and rises abruptly, an opposition between alto and basso, delicate and improvised, which would reconcile the African taste for combinations of high effect with the symbolic ordering of these cultures along a binary polarity (hot-cold, masculine-feminine, clear-obscure, etc.). Thus the movements of the body in dance would reprise the raising and lowering of sounds in the lengthening and contracting of the body. The kneeling and erect positions would be the sculptural equivalent.

The emphasis in African music and art does not fall on melody as much as in the West but on rhythmic structure. The soloist's voice is not the fulcrum of the composition but only an interlude placed between repetitions of the choral theme. The clapping of hands crosses through it without following the intervals between words[163]. The clapping of hands, the beating of drums, the ringing of bells, the sound of pestles in mortars, and the song itself are rhythmic. Such rhythm is present on the visual level in the pairing of contrasting colors, in the sculptural combinations of empty and full spaces, in the plastic proportions of anatomic parts, or in the fixed lines of engravings.

The composite richness of African arts comes from the adaptation of multiple criteria. In music, the effect of togetherness results from the assembly of diverse rhythmic combinations. The rhythms that are shared only at the point of departure are marked more with the clapping of hands. The drums follow diverse patterns in their own way, sometimes changing the pattern in the course of a single execution. The overall effect derives from the intertwining of these contrasting rhythms, which intersect without ever converging in the principal beats and therefore exhaust each one, following its own line without giving space to a unitary and dramatic finale. The movements of the dancer correspond to the music. In particular, the movements of the chest and pelvic area mirror the music, succeeding in following as many as four different rhythms at the same time. On the sculptural level, a parallel can be found in the segmentation of body parts, in the combination of rigid and fluid lines.

This dialectic of reproduction and variation is clearly perceptible in carvings and fabrics, in which the ordered repetition of design is often interrupted, modifying its dimensions or direction or introducing different motifs.

The *kente* of the Ashanti are rectangular fabrics that are created by the assembly of separate strips of fabric. Every band presents a succession of motifs that generally alternate between simple registers and more complex ones, with designs that are geometric and rarely figurative. The comprehensive effect is determined by the tension that is established between the warp (a homogenous color or in lines of different colors) and the greater or lesser overlapping of motifs along the weave with partial or total obstruction of the underlying design. In many of the oldest *kente* cloths – and in contrast with more recent ones – the accent does not fall on regularity but on the variations of the pattern to the extent that one hundred different motifs can be found within the weave. Beyond that, the composition can also be made dynamic by introducing diverse themes of the warp and intervening in the assembly of the stripes. In the latter case, the checkerboard arrangement is intentionally staggered to create a result that is nearly imperceptible, or else very showy, ending by eliminating the arrangement.

In the raffia fabrics of the Kuba (*shoowa*), although a repertoire of elementary traditional motifs are recognizable and certain practices of division on the surfaces are relatively constant (the preliminary subdivision of the surfaces in squares and rectangles), the final result remains unexpected. The motifs of one square could cross over into another and obscure every division, with the end result of virtually projecting themselves beyond the borders of the frame. The result does not correspond to a preliminary plan (it is not drafted on paper or outlined on the completed design), but demonstrates the evolution and definition of an idea in its realization. The tension between the mental anticipation of the finished product and the work that is carried out leads to a subsequent reorganization, to an improvisation that enhances the unpredictable elements and accidents of the course, like those due to the irregularity of the weave, which imprints a different direction on the embroidery. The fabric is thus the faithful account of this experience[164].

Often there are economic necessities that define, while not determining, the space within which the artist's creativity is expressed: the flexibility of the client, the limited economic possibilities of the artist. Weavers who acquire yarn a little bit at a time, so that the work proceeds, will find themselves using yarns that, coming from different dye baths, do not have a homogenous color.

The aesthetic enhancements of case and necessity also seem clearly present in other Kuba fabrics: the *ntshak* (Plate 67). The origin of these raffia fabrics with *appliqués* would be the utilitarian exigency of mending a tear, hiding it with a patch and then hiding the repair itself, organizing everything around a composition of pseudo-patches making necessity a virtue. The contingency of the rip would offer a primer, orienting but not determining the compositional procedure. The composition is without center, and these patches – when they exist - are indistinguishable from the "false" ones except for the tears that they hide. Additionally, the fact that the diverse panels that compose the long ceremonial skirt are separately embroidered by different women leaves a certain margin of unpredictability around the final effect of the assembly[165].

It is similar for fabrics painted with the tie-dye technique (Plate 72). The fabric, before being immersed in a bath of dye, is stitched, folded, or knotted at many points, creating pockets that are filled with rocks. The final design would be the result of the different absorption of color, only predictable in part. Sometimes the same preliminary needlework is executed without attention, turning one's gaze only to the final work[166].

In the lines and dots of the Pygmy tapa (*murumba*), we find an analogous combination of calculation, imagination, and coincidence. The beaten bark is painted, folded into halves or quarters, and each part treated separately. Logical progressions are brusquely interrupted by random variations or omissions, creating a visual rhythm analogous to that of the polyphonic Pygmy songs[167].

In this passage from same to same, the repetition surprises: statues and tales are the same but not identical; they are different but not new.

NOTES

[1] J. Pouillon, "Remarques sur le verbe croire", in Id., *Le cru et le su*, Seuil, Paris 1983

[2] M. Cartry, "Du village à la brousse ou le retour de la question. A propos des Gourmantché du Gobnangou (Hautre-Volta)", in M. Izard, P. Smith, *La fonction symbolique. Essai d'anthropologie* Gallimard, Paris 1979

[3] D. Dalby, "The Concept of Settlement in West African Savannah", in P. Oliver, *Shelter, Sign & Symbol*, Barrie & Jenkins, London 1975, pp. 197-205

[4] M.D. McLeod, *The Asante*, The Trustees of the British Museum, London 1981, pp. 20-40

[5] M.D. McLeod, "Aspects of Asante Images", in M. Greenhalgh, V. Megaw (editors), *Arts in Society*, London 1978, pp. 305-316

[6] M. Cros, "La production sacrificielle des territoires cynegetiques. A propos de 'l'ethnographie' des Lobi", in P. Claval (editor), *Ethtnogéographie*, L'Harmattan, Paris 1995, pp. 261-269

[7] E.T. Hall, *The Hidden Dimension*, 1966 (Ital. trans.*La dimensione nascosta. Il significato delle distanze nei rapporti umani*, Bompiani, Milan, 1968)

[8] M.D. McLeod, *The Asante*, cit., p. 57

[9] R. Bastide, *Le r êve, la trance et la folie*, Flammarion, Paris 1972 (Ital. trans.*Sogno, trance e follia,* Jaca Book, Milan, 1976, pp. 69-127)

[10] C. Riviere, "Représentations de l'espace dans le pèlegrinage africain traditionnel", in P. Claval, *op. cit.*, pp. 137-148

[11] L. de Heusch, *Le sacrifice dans les religions africaines,* Gallimard, Paris 1986

[12] H. Maurier, *Philosophie de l'Afrique noire*, Antropos Istitut St. Augustin, Bonn, 1976, pp. 51-67

[13] M. Augé, *Génie du paganisme*, Gallimard, Paris 1982, p. 54

[14] M. Rouayroux, "Et pourtant... ce ne sont pas des passeports", *Arts d'Afrique Noire*, 70/1989

[15] D. Frazer, "The Symbols of Ashanti Kingship", in D. Frazer, H.M. Cole, *African Art and Leadership,* University of Wisconsin Press, Madison 1972, p. 142

[16] C. Béart, "D'une sociologie des peuples africains à partir de leurs jeux", in *Bulletin de l'I.F.A.N.*, 1959; Id., *Recherche des éléments d'une sociologie des peuples africains à partir de leurs jeux*, Présence africaine, Paris 1960

[17] J. Fernandez, "The Exposition and Imposition of Order: Artistic Expression in the Fang Culture" in W.D'Azevedo, *The Traditional Artist in African Society*, Indiana University Press, Indianapolis 1973

[18] J. Fernandez, *op. cit.*

[19] M. Griaule, *Dieu d'eau*, Fayard, Paris 1966 (Ital. Trans. *Dio d'acqua*, Bompiani, Milan 1968); M. Griaule, G. Dieterlen, *Le renard pâle. La création du monde*, Institut d'ethnologie du Musée de l'Homme, Paris 1965

[20] G. Balandier, *Anthropo-logiques*, Librarie Générale Française, Paris 1985, p. 40

[21] E. Fischer, H. Himmelheber, *The Arts of the Dan in West Africa*, Rietberg Museum, Zurich 1984

[22] D. Zahan, *Sociétés d'initiation bambara: le N'domo, le Koré,* Mouton, Paris 1960, pp. 80-86

[23] M. Griaule, *Dio d'acqua,* cit., pp. 26-29, 84-94

[24] M.A. Fassassi, *L'architecture en Afrique noire. Cosmoarchitecture,* Maspero, Paris 1978, pp. 130-134

[25] H. Witte, *Earth and Ancestors: Ogboni Iconography*, Gallery Balolu, Amsterdam 1988, pp.25-26

(Bottom of facing page)
94. Kente cloth, Ashanti, Ghana; cotton and silk, 159.1 cm x 101.3 cm

These fabrics, the result of assembling multiple strips, sometimes make the interruption of rhythm their strong point: the regularity in the alternation of motifs in the weave undergoes interruptions that are more or less marked and that dynamize the composition, intervening on the predictability of the repetitive scheme.

26 D. Paulme, J. Brousse, *Parures africaines*, Hachette, Paris 1967; C. Meillassoux, "Modes et codes de la coiffure ouest-africaine", *L'ethnographie*, 69/1975

27 S.F. Nadel, *Black Byzantium,* Oxford University Press, 1965, pp. 91-92

28 G. Dieterlen, "La serrure et sa clé (Dogon, Mali)", in J. Pouillon, P. Maranda, *Echanges et Communications, Mélanges offerts à Lévi-Strauss*, Paris 1970

29 N. Nehaer, "An Interpretation of Igbo Carved Doors", African Arts, 1/1981

30 J.-P. Lebeuf, *L'habitation des Fali montagnards du Camerun septentrional*, Hachette, Paris 1961

31 F. Schwerdtfeger, "Housing in Zaria", in P. Oliver, *Shelter in Africa,* Barrie & Backliff, London 1971, pp.58-79

32 H.M. Cole, "The History of Ibo Mbari Houses – Facts and Theories", in D.F. McCall, E G. Bay, *African Images*, Africana Publishing Co., New York 1975, pp. 104-132; H.M. Cole, "The Survival and Impact of Igbo Mbari", *African Arts*, 2/1988

33 M.A. Fassassi, *L'architecture en Afrique noire. Cosmoarchitecture,* cit. pp. 135-143

34 J. Vansina, *The Children of Woot. A History of the Kuba Peoples,* The University of Wisconsin Press, Madison 1978, p. 22

35 J. Cornet, *Art royal Kuba*, Sipiel, Milan 1982, p. 129

36 A. Kagame, *La philosophie bantoue comparée*, Présence africaine, Paris 1976, pp. 157-158

37 P. Bohannan, "La terra in Africa", *The Centennial Review*, 4/1960, (Ital. trans. in E. Grendi, *L'antropologia economica,* Einaudi, Turin 1972, pp.187-188)

38 M.A. Fassassi, *L'architecture en Afrique noire. Cosmoarchitecture,* cit. Pp.76-85

39 A. Phaedon-Lagopoulus, "Semiological Urbanism: an Analysis of the Traditional Western Sudanes Settelement", in P. Oliver, *Shelter, Sign & Symbol*, cit. pp. 206-218

40 M. Griaule, G. Dieterlen, *Le renard pâle,* cit.

41 G. Dematteis, *Geografia come metafora. La geografia umana fra mito e scienza*, Feltrinelli, Milan 1985, pp. 30-31

42 P. Rollard, "La maison ba'mbenga: un champ sémantique? (pour une étude de l'espace pygmée)" in AA.VV., *Espaces des autres. Lectures anthropologiques d'architecture,* Editions de la Villette, Paris 1987, pp.155-176

43 M. Eliade, *Le mythe de l'éternel retour*, Gallimard, Paris 1969, p. 33

44 J.P. Raison, "Perception et réalisation de l'espace dans la société Mérina", Annales ESC, 3/1977

45 M. Griaule, *Dio d'acqua,* cit., p. 94; G. Calame-Griaule, "La parole qui est dans l'étoffe (Dogon, Mali)", *Cahiers de la littérature orale*, 19/1986

46 Y. Cissé, "Signes graphiques, réprésentations, concepts et textes relatifs à la personne chez le Malinke et les Bambara du Mali", in C. Cartry (editor), *La notion de personne en Afrique noire*, CNRS, Paris 1981, p. 166

47 A. Leroi-Gourhan, *Le geste et la parole. La mémoire et les rhythmes,* Albin Michel, Paris 1964 (Ital. trans. *Il gesto e la parola. La memoria e i ritmi,* Einaudi, Turin 1977, pp. 379-382)

48 M. Griaule, *Dio d'acqua,* cit.; G. Calame-Griaule, "La parole qui est dans l'étoffe (Dogon, Mali)", cit.

49 R.F. Thompson, "Naissance du dessin 'nègre': l'art mbuti dans une perspective mondiale", in R.F. Thompson, S. Bauchet, *Pymées?*, Dapper, Paris 1991, pp. 27-96

50 "In reality the same African agricultural societies, through the continual processes of segmentation, know frequent movements along lines of 'internal' frontiers that take them to colonize the physical and political interstices among their constructed societies, giving space to a true and precise 'frontier ideology.'" Cfr. I. Kopytoff, *The African Frontier: the Reproduction of Traditional Societies*, Indiana University Press, Bloomington 1987.

51 F. Lévy, M. Segaud, *Anthropologie dans l'espace*, Paris 1983; M. Douglas, *Purity and Danger. An Analysis of Concepts of Pollution and Taboo,* Penguin, Harmondsworth 1966 (Ital. trans. *Purezza e pericolo*, Bologna 1976)

52 A. Van Gennep, *Les rites de passage*, Nourry, Paris 1909 (Ital. trans.*I riti di passaggio*, Boringhieri, Turin, 1981); M. Douglas, *Purity and Danger,* cit.

53 D.P. McNaughton, "The Shirts that Mande Hunters Wear", *African Arts*, 3/1982

54 C. Lévi-Strauss, *Les structures élémentaires de la parenté,* PUF, Paris 1947 (Ital. trans. *Le strutture elementari della parentela*, Feltrinelli, Milan 1984)

55 M. Douglas, "Raffia Cloth Distrubtion in the Lele Economy", in G. Dalton, *Tribal and Peasant Economies.Reading in Economic Anthropology*, American Museum of Natural History Press, pp. 103-122

56 G. Balandier, *Anthropo-logiques*, cit., pp. 31-84

57 G. Beaudoin, *Les Dogon du Mali*, Colin, Paris 1984, pp. 177-182

58 L. de Heusch, "Le sorcier, le père Tempels et les jumeaux mal venus", in C. Cartry (editor), *La notion de personne en Afrique noire*, cit., pp.239-241

59 R.F. Thompson, *Black Gods and Kings. Yoruba Art at UCLA*, University of California Press, Los Angeles 1971, chap. 13.

60 D. Fraser, H.M. Cole (editors), *African Art and Leadership*, cit.; E. Beumers, H.-J. Koloss (editors), *King of Africa,* Foundations Kings of Africa, Maastricht 1992

61 P. Ben-Amos, "African Visual Arts from a Social Perspective", *The African Studies Review*, 2/1989, pp. 32-35

62 J. Maquet, *The Aesthetic Experience. An Anthropologist Looks at the Visual Arts*, Yale University Press, New Haven and London 1986, pp. 65-76

63 G. Calame-Griaule, *Ethnologie et langage. La parole chez les Dogon,* Institut d'Ethnologie, Paris 1987 (Gallimard, 1965), pp.476-501

64 G. Calame-Griaule, *op. cit.,* pp. 472-476

65 E. Gombrich, *Art and Illusion,* New York 1960 (Ital. trans. *Arte e illusione,* Einaudi, Turin 1965)

66 J.M. Borgatti, R. Brilliant, *Likeness and Beyond. Portraits from Africa and the World,* Center for African Art, New York 1990

67 C. Falgayrettes-Leveau, L. Stéphan, *Formes et Couleurs. Sculpturues de l'Afrique noire*, Musée Dapper, Paris 1993

68 H.M. Cole, C. Aniakor, *Igbo Art. Community and Cosmos*, University of California Press, Los Angeles 1984, p.216

69 D. Zahan, "Bianco, rosso e nero: il simbolismo dei colori in Africa occidentale", in AA.VV., *Il sentimento del colore. L'esperienza cromatica come simbolo, cultura e scienza*, RED, Como, 1990

[70] M.G. Mudiji, *Le langage des masques africaines. Etude des formes et fonctions symboliques des "Mbuya" des Phende*, Facoltà Catholique de Kinshasa 1989, pp. 77-79

[71] S. Vogel, *Beauty in the Eyes of the Baule. Aesthetics and Cultural Values*, Working Papers in Traditional Art, Institute for the Study of Human Issues, Philadelphia 1980; A.M. Boyer, "Miroirs de l'invisible: la statuaire baoulé", *Arts d'Afrique noire*, 45/1983

[72] M. Augé, *Le dieu objet*, Flammarion, Paris 1988; W. MacGaffey, "African Religions: Types and Generalization", in I. Karp, C.S. Bird (editors), *Explorations in African Systems of Thought*, Smithsonian Institution Press, Washington, 1980, p. 305

[73] M. Augé, *Le dieu objet*, cit., p. 57

[74] W. Abimbola, "The Yoruba Concept of Human Personality", in C. Cartry (editor), *La notion de personne en Afrique noire*, cit., pp.73-90

[75] M. Augé, *Le dieu objet*, cit., p. 66

[76] L.V. Thomas, "Le pluralisme cohérent de la notion de personne en Afrique Noire traditionelle", in C. Cartry (editor), *La notion de personne en Afrique noire*, cit., pp. 387 – 420

[77] R. Bastide, "Le principe d'individuation (contribution à une philosophie africaine)", in C. Cartry (editor), *La notion de personne en Afrique noire*, cit., p. 38

[78] A.F. Roberts, *Animals in African Art. From the Familiar to the Marvelous*, Prestel, Monaco, 1995

[79] D. Fraser, *African Art as Philosophy*, Interbook, New York 1974

[80] M. Douglas, *Purezza e Pericolo*, cit., Id., "Animals in Lele Religious Symbolism", *Africa*, 1/1957

[81] L. de Heusch, *Le roi ivre ou l'origine de l'Etat*, Gallimard, Paris 1972

[82] D. Fraser, *African Art as Philosophy*, Interbook, New York 1974

[83] L. de Heusch, *Le sacrifice dans les religions africaines*, cit., p. 312

[84] P. Ben-Amos, "Men and Animals in Benin Art", *Man*, 11, 1976

[85] T. Northern, *The Art of Cameroon*, Smithsonian Institution Press, Washington 1984, pp. 43-54

[86] W. MacGaffey, *Art and Healing of the Bakongo: Commented by Themselves*, Stockholm 1991

[87] J.P. Imperato, S. Marli, "Bokolanfini: Mud Cloth of the Bamana of Mali", *African Arts*, 4/1970; S.C. Brett-Smith, "Symbolic Blood: Cloth for Excised Women", *RES*, 3/1982

[88] R.F. Thompson, *Black Gods and Kings*, cit., chap.6, p. 2

[89] M.D. McLeod, *The Asante*, cit., pp. 112-116

[90] D. Zahan, *Religion, spiritualité et pensée africaines*, Payot, Paris 1970; V. Mulago Cwa Cikala, "Il Sacro e i popoli africani", in J. Ries (editor), *Le origini e il problema dell'Homo Religiosus*, Jaca Book, Milan 1985, pp. 245-246

[91] It is however possible that this centrality of the anthropomorphic element is once again a turn of the charge, at least in part, of the Western eye, to the process of selecting from handmade African objects that have accompanied their metamorphoses from instrumental objects into artistic objects.

[92] M. Augé, *Le dieu objet*, cit., pp. 29-35

[93] H. Pernet, "Masks and Women: Toward a Reappraisal" *History of Religions*, 22, 1, 1982

[94] J. Gabus, *Art nègre*, Les editions de la Baconnière, Neuchâtel 1967; G. Calame-Griaule, "Graphiques et signes africains", *Semiotica*, 1/1969

[95] G.R. Cadorna, *Antropologia della scrittura*, Loescher, Turin 1987

[96] H.O. Oruka, *Sage Philosophy*, Brill, New York 1990

[97] S. Battestini, *Ecriture et texte. Contribution africaine*, Les Presses de l'Université Laval, Présence africaine, Paris 1997

[98] P. Rollard, " La maison ba'mbenga: un champ sémantique? (pour une étude de l'espace pygmée)", cit.

[99] G. Calame-Griaule, *Ethnologie et langage*, cit.

[100] D. Zahan, *La dialectique du verbe chez les Bambara*, Mouton, Paris 1963; J. B. Danquah, *The Akan doctrine of God*, Cass., London 1968, pp. 28, 30

[101] W. Abimbola, "The Yoruba Concept of Human Personality", in C. Cartry (editor), *La notion de personne en Afrique noire*, cit., p. 80

[102] M. Cartry, "Le statut de l'animal dans le système sacrificiel des Gourmantché (Haute-Volta)", Part II, *Systèmes de pensée en Afrique noire*, CNRS, Paris, 3/1978

[103] J. Vansina, *De la tradition orale. Essai de methode historique*, Musée Royal de l'Afrique centrale, Tervuren, 1961 (Ital. trans. *La tradizione orale*, Officina libri, Roma, 1977, pp. 158-159)

[104] P. Tempels, *La philosophie bantoue*, Présence africaine, Paris 1949, p. 72

[105] J. Cornet, "Pictographies Wojo", *Quaderni Poro*, 2, 1980

[106] M.D. McLeod, "Aspect of Asante Images", cit.

[107] G. Dieterlen, "Signes d'écriture bambara. Signes graphiques soudanais", *L'Homme*, 3/1951

[108] E. Torday, T.A. Joyce, "Notes ethnographiques sur des populations habitant les bassins du Kasai et du Kwango oriental", *Annales du Musée de Congo Belge*, series III, II, 2, p. 216

[109] C. Fajik-Nzuji, *Symboles graphiques en Afrique noire*, Karthala-Ciltade, Paris, Louvain-La-Neuve 1992

[110] A. de Surgy, "*Bo* et *vodu* protecteurs du sud-Togo", *Nouvelle revue d'ethnopsychiatrie*, 16/1991

[111] M. Griaule, *Masques dogon*, Musée de l'Homme, Paris 1938

[112] H.J. Drewal, "Object and Intellect: Interpretations of Meaning in African Art", *Art Journal*, 47/2/1988; S. P. Blier, "Words about Words about Icons: Iconography in the Study of African Art", *ibid.*

[113] A. Leroi-Gourhan, *Il gesto e la parola*, cit. pp. 227-233

[114] W.A.E. Van Beek, "Functions of Sculpture in Dogon Religion", *African Arts*, 4/1988; J. Bouju, "La statuaire dogon au regard de l'anthropologue", in AA.VV., *Dogon*, Dapper, Paris 1994, pp. 221-237

[115] L. Stéphan, "La sculpture africaine, essai d'esthetiques comparées", cit., pp. 207-209

[116] O. Darkowska-Nidzgorski, "Tchitchili Tsitsawi. Marionnettes d'Afrique", *Cahiers de l'ADEIAO*, 13/1996, p. 40

[117] V. Lamb, *West African Weaving*, Duckworth, London 1975, pp. 128-136

[118] V. Lamb, *op. cit.*, pp. 197-204

[119] C. Fajik-Nzuji, *Symboles graphiques en Afrique noire*, cit., p. 109

[120] S.P. Blier, "Words about Words about Icons: Iconography in the Study of African Art", cit., p. 77

[121] S. Battestini, *Ecriture et texte. Contribution africaine*, cit., pp. 370-371

[122] J. Meurant, *Abstractions aux royaumes des Kuba*, Dapper, Paris 1987, pp. 129-130; E. Torday, *Notes ethnographiques...* , cit., p. 158

[123] P. Veyne, "Propagande expression roi, image idole oracle", *L'Homme,* EHESS, Paris 114/1990

[124] S. Preston Blier, "King Glele of Dahomé", *African Arts,* 4/1990 (Part II); M. Adams "Fon Applique Cloth", *African Arts,* 2/1980

[125] R.F. Thompson, *African Art in Motion,* University of California Press, Los Angeles 1974; Id., *Flash of the Spirit, African and Afro-American Art and Philosophy,* Vintage Books, New York 1983; K. F. Campbell, "Nsibidi Update. Nsibidi Actualize", *Arts d'Afrique noire,* 47/1983

[126] J. Picton, J. Mack, *African Textiles,* British Museum, London 1989, pp. 19-21

[127] P. Ben-Amos, "Royal Weaves of Benin", *African Arts,* 4/1978

[128] P. Ben-Amos, *The Art of Benin,* Thames & Hudson, London, 1980, p. 57

[129] H.J. Drewal, M. Thompson Drewal, *Gelede. Art and the Female Power Among the Yoruba,* Indiana University Press, Bloomington 1983

[130] H.J. Drewal, J. Pemberton III, R. Abiodun, *Yoruba. Nine Centuries of African Art and Thought,* Wardwell, Center for African Art, New York 1989, p. 162

[131] D.F. McCall, "The Hornbill and Analagous Forms in West African Sculpture", in D.F. McCall, E.G. Bay, *African Images,* cit., pp. 269-270

[132] O. Darkowska-Nidzgorski, *Théâtre populaire des marionnettes en Afrique sub-saharienne*, CEEBA, Bandundu 1980, p. 22

[133] J.S. Mbiti, *African Religion and Philosophy,* Heinemann, Oxford 1989 (1969), pp. 29-38

[134] P. Tempels, *La philosophie bantoue,* cit., pp. 34-35

[135] C. Fajik-Nzuji, *Symboles graphiques en Afrique noire,* cit., pp. 84-86

[136] M. Griaule, G. Dieterlen, *Le renard pâle,* cit.

[137] P. Ben-Amos, *The Art of Benin,* cit., pp.45-46

[138] P. Ben-Amos, *op. cit.,* p. 51

[139] J. Goody, "Icônes et iconoclasme en Afrique", *Annales,* 6/1991

[140] J. McLeod, *The Asante,* cit., p. 130

[141] F. Remotti, "Concetti spaziali nande. Un tentativo di analisi semantica", *La ricerca folklorica,* 2/1985

[142] R.S. Rattray, *Religion and Art in Ashanti,* London (1927), Oxford University Press, 1959

[143] H.J. Drewal, M. Thompson Drewal, *Gelede. Art and the Female Power Among the Yoruba,* cit.

[144] D. Zahan, *Antilopes du soleil. Arts et Rites Agraires d'Afrique Noire,* Schendl, Vienna 1980

[145] M. Gilbertt, "The Leopard Who Sleeps in a Basket: Akuapem Secrecy in Everyday Life and in Royal Metaphor", in M.H. Nooter, *Secrecy. African Art that Conceals and Reveals,* cit., pp. 123-139

[146] D. Zahan, *La dialectique du verbe chez les Bambara,* cit., p. 150

[147] H.M. Cole, C.Aniakor, *Igbo Arts. Community and Cosmos,* cit., p. 219

[148] AA.VV., *Au royaume du signe. Appliquées sur toile des Kuba,* Dapper, Paris 1988

[149] M.H. Nooter, *Secrecy. African Art that Conceals and Reveals,* cit.

[150] S. Vogel, *Beauty in the Eyes of the Baule. Aesthetics and Cultural Values,* cit., Id., "Baule and Yoruba Art Criticism" in J.M. Cordwell, *World Anthropology. The Visual Arts,* Mouton, The Hague 1979

[151] Thompson, *Black Gods and Kings,* cit.; H. Silver "Foreign Art and Asante Aesthetics", *African Arts,* 3/1983,

[152] H.M. Cole, C. Aniakor, *Igbo Arts. Community and Cosmos,* cit.

[153] S. Ottemberg, "Psychological Aspects of Igbo Art", *African Arts,* 1/1988

[154] E. Fischer, H. Himmelheber, *The Arts of the Dan in West Africa,* cit.

[155] L. Segy, *Masks of Black Africa,* Dover Publ., New York 1976, p. 13

[156] R.F. Thompson, *African Arts in Motion,* cit.

[157] H.M. Cole, "The History of Ibo Mbari Houses. Facts and Theories", cit., p. 105

[158] O. Darkowska-Nidzgorski, "Tchitchili Tsitsawi", cit., p. 72

[159] M. Adams, "Beyond Middle African Design", *African Arts,* 1/1989

[160] H.J. Drewal, J. Pemberton III, R. Abiodun, *Yoruba. Nine Centuries of African Art and Thought,* cit., p. 182

[161] I. Okpewho, "Letteratura orale dell'Africa subsahariana", in *Letteratura dell'Africa nera,* Jaca Book, Milan 1993

[162] D. Paulme, *La mère devorante. Essai sur la morphologie des contes africains,* Gallimard, Paris 1976

[163] A.M. Jones, "African Rhythm", *Africa,* 1/1954

[164] M. Adams, "Kuba Embroidered Cloth", *African Arts,* 1/1978

[165] AA.VV., *Au royaume des signs,* cit., P. Darish, "Dressing for the Next Life. Raffia Textile Production and Use Among the Kuba of Zaire", in A.B. Weiner, J. Schneider, *Cloth and Human Experience,* Smithsonian Institution Press, Washington 1989, pp. 125-127

[166] P. Bohannan, "Artist and Critic in African Society", in M.V.Smith, *The Artist in Tribal Society,* Routledge and Kegan, London 1961, p. 91

[167] R.F. Thompson, S. Bauchet, *Pygmées?,* cit.

Part two
THE CURRENTS
OF TRADITION

1. Tradition as Betrayal

The spatializing approach may have clarified the dynamics of art as a cultural system and as part of a social system. It still risks, however, reifying revealed oppositions and symbolic associations, subtracting them from historical processes and the individual realizations in which they appear. The meaning of an element, in fact, does not derive only from the position that it occupies in relation to the others but also from the strategic use that is made of it, in a plurality of contexts, by people who manipulate it in view of the ends that they arrange. It is therefore necessary to fluidify the outlined picture, paying greater attention to time and to change.

The polarization in the Western imagination between an "authentic Africa" subtracted from time and consigned to oblivion, to the roots, to the unconscious, to nature, and a "spurious Africa" reduced to the periphery of the West has taken African art out of history, blocking it in geographic divisions and the synchrony of ethnic styles for a long time.

The purity of origins was contrasted with the corruption of the present. In every contact, a dilution of identity and a contamination was seen: "tribal art" on the one hand, "tourist art" on the other.

Africa would be seen as the powerless victim of a process of deculturation that, annihilating traditional societies, would lead to the death of art. The loss of communal character, balanced and integrated in African societies, would bring the crisis of African art with it. The serial craftsman for hurried tourists and the work of art destined for the international circuit of galleries or museums would not be anything other than two sides of the same laceration. The appearance of the Other would lead to the alienation of the African identity in standardization and individualism.

If we make the opening of the Other a condition of its existence in the case of the European identity, when we pass to the African identity this opening seems to inevitably translate into loss. Derivations and loans mutate into dependence and debt[1]. Such is the way a great historian like Trevor-Roper, echoing Hegel, could still affirm in 1963 that "There was not history in Africa but only the history of Europeans in Africa ... the rest is darkness ... and darkness is not the subject of history."[2]

Africa remains itself as long as it continues to be a "closed vase". When it opens to the world, it cannot do other than passively welcome what was invented elsewhere.

This is a behavior that in the past has led to the negation of the "Africanness" of those forms of art that seemed too elevated to be African. In this way, the disconcerting "classicism" of Ife sculptures (Plate 78) led the German anthropologist Frobenius to sustain an Etruscan derivation, via Atlantis, for the Yoruba culture; the Englishman Talbot to see in them an Egyptian influence; others to hypothesize that their ancestors were Israelite or to individuate the initiators of this antique art in the Portuguese or mysterious Greek, Roman, or Renaissance artists[3].

For Africa often seems to stand again for a substantialist conception of identity, the idea that the Same and the Other preexist interaction, that they are who they are by virtue

of themselves and not from the relationship that one has with the other. The identity of art and of African civilization is thus defined on the basis of the ownership that is necessarily inherent in them.

The rewriting of African history that has, with apologetic intent, sought to present Africa as the center of the world, affirming the black character of Egyptian civilization and the derivative and dependent character of Greek civilization and the entire West, has remained within such a paradigm, operating a simple symmetrical overturning of it[4].

In the world of art, these positions have given place to a voluntaristic and romantic attempt to preserve or recover African stylistic traditions. When the French missionary Pierre Romain-Défosses founded the *Atelier d'art l'Hangar*, from which the pictorial school of Lubumbashi (Congo) would later be born, he was guided specifically by the proposition of enhancing African specificity against the intrusion of modern Western art. This was a design that leaned on the presupposition of a native "Nilotic" background placed at the heart of African identity, which had an unconscious that would need to be reawakened[5].

While the West throws itself into the storms of history, Africa is consigned to the work of preserving the archetypal foundation of human history, of which it is the cradle.

Cosmologies, mythologies, and African religion are inserted into the currents of history. Cyclical time and the time of beginnings do not exclude it from unwinding in linear time. All societies, even in variable measure, posses the notion of linear time. What changes is the emphasis that is placed on the object. Every culture lives, in fact, in the more or less resolved tension between the assumption of the permanence of its own identity in time and the recognition of change that it seeks to domesticate, the regularity of material rhythms and the irreversibility of time, stressed by death[6]. We think of the rites of passage that translate individual linearity into social recurrence, to the genealogies that justify the present through the past, to the same mythic cosmologies which are as inherently connected to change as narrations.

Cyclicality does not arrive at the closure of a circle. Composing itself with linearity, it instead designs a spiralform outline. We speak of the eternal return of the different and not of the self.

What is absent is rather the sequential linearity defined by phonetic writing that induces us to conceive time as progress, to explain mutation as abandonment and history as accumulation.

African societies have never lived in an atemporal limbo.

In reality, all societies and not just those that are Western have a problematic and dynamic character. The relationships that hey establish are, contemporaneously and contradictorily, the bearers of order and disorder. What they rest on is also, indissolubly, what makes them precarious, since there are differences (between men and women, fathers and sons, first-born and younger children, dominant and dominated) that establish relationships and are, at the same time, the bearers of tension at the origin of every social system[7].

Myth does not restore a pacified cosmos to us, but brings the chaos of the beginnings. In the creation, we do not see the static state of a perfect order but the mingling of chance and necessity, a moving forward for the successive approximations in the necessary alliance of order and disorder[8]. The myths of foundation tell of migrations, of provenances from elsewhere, of processes of dispersion, of overlapping, of struggles. The laceration is at the beginning because only in it is there life.

Rites work for order, but bring the excess of measure back only temporarily, the unknown to what is known. Ritual practice is not limited to reinstating the time of the beginning, but also opens to the future. The conclusion of the ritual act brings a risk to the one who commands and the one who carries out the order. Its efficacy has to be practiced to be symbolic. If the sense of the rite is not reduced to the problem of realization of its explicit scope, it nevertheless depends on it[9].

Traditional societies know disorder and change. Tradition, long something motionless and static, brings the capacity for treating the future. Its persistence is frequently only formal and hides a substantial renewal of contents. If it is in fact tradition to discipline the game of relationships, tradition is also, however, the fruit of that game and changes with it.

In Africa, the absence of writing in a narrow sense hinders the crystallization of an orthodoxy and renders tradition flexible enough to adapt itself to the present. The open character of reference to sculptured forms or the instituted word with graphic traces and the ephemeral character of many written forms and their supports (like the writing on sand or the divinatory writings that leave no trace) exclude archival conservation and fa-

vor a continual renewal of the past. This way, it is never all the dead who become ancestors but only those who count in the present. And thus it is the present that models the past and not vice versa. The genealogies of Yoruba kings are reconstituted and remodeled on the basis of the claims that the different kings wish to deem worthy. The memory of the usurping of populations, autochthonous and allochthonous, are conserved in the contrasting versions of the creation myths, and their compromises are realized.

The past thus becomes an object of choice. The value of a tradition is not in its having been but in its being reproposed. What decides whether it will be taken up again is the *strength* of the tradition, and that is not in its "venerability" but in its capacity to persist in the present.

It is precisely this plasticity of tradition at which the colonial powers take aim, making the community structures in tribalism rigid and fastening the tongue within the stitches of a fixed and verifiable vocabulary[10]. Codes and dictionaries contain tradition within the stitches of writing, elevating it to customary law and to grammatical rules of certain transitory periods of social and linguistic relations.

This crystallization also partly strikes the visual arts, whose "authenticity" becomes rigidly normalized by museum collections or stereotyped images of a past that probably never existed. "Authentically traditional" African art finishes with being the result of an arbitrary slice, a decision that takes the state of African arts from the end of the nineteenth century and projects it into the atemporal space of collections and museum taxonomies[11]. In reality, when we look at African art we do not have anything to do with points of departure and not even with points of arrival but with the diverse moments of an inconclusive becoming.

Art puts myth, rite, and history in relation; that which remains and that which changes.

This explains its viscosity (the long duration of certain terms and formal canons) as much as its changes (the enlargement of iconographic repertories, the evolution of styles).

Art has, for example, played a central role in the political affirmation and defense of the identity of diverse Yoruba kings fighting among themselves. The political and economic expansion of the Oyo empire in the eighteenth century was accompanied by the spread of cults and iconography of the thunder god Shango, and of the masks of the *egungun* ancestors[12]. And this same process probably explains, as a reaction, the appearance of the cult and masks of the *gelede* among the western Yoruba. The kingdom of Ketu, incapable of responding militarily to the Oyo, sought to affirm their own identity through the institution of the association of *gelede*, whose exhibitions, sanctioned by the power of "the mothers", defined socially acceptable behavior in a restraining way. Such masks therefore contrasted the influence of the Oyo, exercising an indirect authority on the territory dominated by them. A specific historic juncture and a base of common beliefs for all Yoruba countries (the cult of the "mothers") would justify the apparition; their political function would explain their diffusion. Crossing from part to part of history, the *gelede* masks thus contribute to the determination of the time that they saw born.

2. The Dynamic of Creation: Between Individuality and Ethnic Group

Tradition furnishes the environment with what is culturally acceptable, but it does not act as a constriction that is imposed on individual liberty.

Tradition is not the inert weight of an overarching past but a collection of bonds within which we move, a togetherness determined by possibilities that continually expand and contract because they are entrusted to the care of individuals, to their interpretation, brought to existence by them, and maintained in life every time a sculptor starts to sculpt.

At the same time, we should point out that if tradition is not as suffocating as it is perhaps thought to be, it is really because it is not contrasted with an individuality that would want to liberate itself from tradition. In reality, the problem of individuality, of originality and unrepeatability, of culture and people, and of their protection and development presents itself only within our culture, in which the individual-society relationship is thought of in terms of opposition[13]. What we have seen from time to time in African art is the expression of a wild spontaneity released from social conventions and its opposite, a collective representation in which individuals are reduced to simple executors.

Making the African work into an individual product does not have any more sense than seeing it as the immediate expression of a homogenous social group. The relational

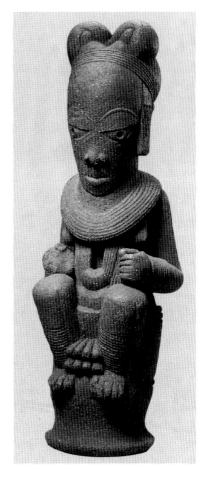

95. Seated figure, Nok, Nigeria; terracotta, height 58 cm

Nok statues, named for the village in which they were discovered in 1943, are evidence of an ancient African culture that farmed and knew how to smelt iron, developing between 500 BC and 500 A. D. Its artistic relations with the more recent kingdom of Ife (11th-14th centuries) are under discussion. The sculptures probably had a religious function. The figure, in a seated position, wears a loincloth, necklaces, bracelets, and ankle bands. The head is large, elongated, with a wide forehead; the face shows large eyes with pierced pupils, lowered eyelids and arched eyebrows, a nose with large nostrils and a full mouth.

153

field identity of the African person is rather thought of, as we have seen, in terms of participation differentiated to a multiplicity of groups and situations.

However, if instead of looking to "Africa" we want to establish another comparative grid tracing differences and resemblances between different African cultures, we would leave them in a more shaded square. Next to the society with a more "communitary" orientation, in which social and artistic innovation is hindered and feared, a society with a more "individualistic" orientation, in which innovation is instead sought after and followed would appear[14]. From Yoruba art and the art of Igbo, we would thus see not so much what they share but what makes them different: in the first, the prevalence of continuity with the dispersion of formal variations in regional differences within the canons of a shared aesthetic; in the second, the absence of an artistic form that is common to all, styles that can vary from village to village[15].

Identity and difference, in sum, are nothing in and of themselves but a function of the level of selected observation. If we were to leave the analyses of artistic forms conducted at the level of social or ethnic groups for a more restricted field of observation, significant differences would appear for the internal segments of each culture in relation to their specific typologies of objects and to the individual objects that they produce.

The figure itself of the "artist", the forms of selection, of apprenticeship, and of its position in the heart of society vary enormously from one place to another and in the relationship to specific artistic techniques. If in certain contexts the training comes informally and anyone can become a "sculptor" (as happens, for example, among the Kalabari, the Igbira, the Idoma, and the Tiv), in other cases sculpture is a specialized activity that requires a regulated apprenticeship (as is the case for the Senufo, The Yoruba, and the Dan), while the statuary is produced by smiths specialized in the sculpture of wood. The masks for initiation rituals are instead directly sculpted by the ones who use them.

Artists can work individually, or they can be united in guilds or castes. They may dedicate themselves to art full time or only during the periods when they are not busy with work in the fields. The craft may be inherited, or they may be called to follow the work by a god by whom one is consecrated[16].

Sexual difference is a determining factor also in this case[17]. Sculpture in wood and metal is a male prerogative, and women are often barred from assisting in the work of the sculptor and from touching the work, while terracotta and earthen sculpture is feminine territory[18].

Weaving in Madagascar and among the Berbers of the north is a feminine occupation. In western Africa, Congo and East Africa, it is instead exclusively masculine. Even where both sexes weave (Nigeria, Arab North Africa, and the Sudan), they take care to mark their respective spheres of competence: in general, the man takes care of the production of prestigious articles designed for foreign countries, while the woman is left with domestic production directed to self-consumption[19].

The term "artist" thus indicates a multiplicity of strongly differentiated situations. Often, a great part of the artist's work is directed at objects that we would not qualify as works of art. In other words, in many African societies artists, for as much as their works are well appreciated, do not possess an elevated social status.

In African art, individuality is in reality seen more markedly in the work and customer than in the artist, who, though known, is often institutionally forced to disappear. The visibility of the divinity and sovereigns in fact requires the shrinking into the shadows as a way of providing the them with the occasion to show themselves. It is for this reason – and not so much because of the "lack of writing" – that the work cannot carry the signature of the craftsman. Something that, for another thing, would not hinder the power of artists to ascend from the object they created nor the affirmation of the most capable artists, whose fame and name can be conserved even after their death.

What has been said of the Tiv of Nigeria can probably be extended to other cultures. African criticism looks more to the product than to the creative process and the author, just as their religions look more to the created than the creator[20]. Neither the artist nor the destined owners of the work see an expression of fantasy, of invention, or of the intimate personality of the artist in the work. In a large part of the cases, artistic activity is not thought of in terms of creation but in terms of transmission. We look to draw from traditional repertoires, from objects of determined efficacy, or to translate in forms that have been revealed in dreams or divinations. The work of artists is to demonstrate that they are of the proper stature for the situation, to correspond to it. This does not imply a motionlessness. To correspond to a reality in a state of change, to face it, brings a certain dose of

innovation while continuing to be thought of in terms of the continuity with what precedes.

The margins of autonomy which the artist can enjoy vary enormously in relationship to situations, to the types of objects, and to the context of their use. The possibility of innovation in particular seems to grow in the presence of systems of informal artistic apprenticeship, even in cases in which the customer is reluctant to change or in the presence of a customer who is well disposed to iconographic innovation, even in the presence of a rigid system of apprenticeship tied to the preservation of stylistic continuity[205].

Artists can produce for the "market" or on commission. The requests made of them can be vague or strictly bound, of a human or divine nature[22].

Among the Yoruba of Nigeria for example, the use of the mask of ancestors (*egungun*) is subject to specific institutional restrictions, and its connection with the past and ancestral authority makes great iconographic variations highly improbable, in contrast to the *gelede* masks that are in large part easily accessible and more tied to the present, more open to change and the formal and thematic innovations that can intervene as much because of the wish of the customer as the artist. In this case, the decision around the iconographic theme can be taken by the artist who would sculpt a certain variety of masks on his own initiative, seeking to encounter the taste of potential clients. In other cases instead, it would be the clients themselves to decide on the work, asking for the reproduction, in theme and often in style, of a certain mask brought as a model. Often though, it happens that the request is made verbally and very generically, leaving the sculptor with the job of translating, with ample space to maneuver, the words into visible forms[23]. The "freedom of the artist" is often situated precisely here, in the discrepancy and difference between words and things.

The African work of art is therefore open not only on the level of reception and use, with all the material modifications that this brings, but also on the level of ideation and creation, in the interaction between artist, customer, and other figures of the social context in which they belong. Among the Tiv of Nigeria, the critical evaluations expressed by the people who help in the work of the sculptor influence and modify the work[24]. Among the Mende of Liberia, the execution of the masks of the secret female society *Sande* (Plates 54-55) plays within the tension that the masks create among the women who commission them and the masculine figure who executes them[25]. Precisely this need to preserve a secret and the necessarily incomplete character of the directions given to the artist can provide him with a certain discretion.

Sculptures and tales, for as much as they are often the products of specialists, propose themselves thus as *open works* that invite, in different degrees and in regulated ways, participation. Public comment is an integral part of the work, making both the moral and what is unsaid explicit and soliciting artists to modify *in itinere* their own text or sculpture in relation to the reactions that they inspire. The intervention of multiple hands on the work often takes the form of a collaboration between many people even at the level of its conception. In the creation of a mask, there can be an intervention of multiple specialists (sculptors, weavers, priests, etc.), and at the creation there will also be participation from those who will use the mask through the periodic renovation of color, the production of sacrificial patina, and the use that will perceptively modify the aspect of the mask.

In the *ntshak* fabrics of the Kuba, the different panels that compose them are decorated separately by different women and then assembled. Bohannan refers to the fact that in the work of Tiv sculptors there can be the insertion of people who, finding the work unprotected during the course of being realized, engrave their own initiative of design on it[26].

Creation is thus dislocated in time and sees the participation of multiple generations, whose interventions are not purely conservative in nature even when they would want to limit themselves to restoring the initial state of work. Thus, the distinction between production and use, recitation and listening, "writing" and "reading", is obscured in an open conception of the art work as lacking a definitive status.

Conventions and stereotypes do not reduce the space of creation that, no matter what the culture is, is never born of nothing but in an environment of tradition in relation to which it takes position and on the basis of which it is silhouetted.

Stability and innovation should probably be connected on two different levels, tendentially stabilizing the "grammatical" and creative dimensions of that individual production. It is a distinction that does not signify exclusion. In analogy with what happens in language, in fact, the newness of the word can surpass the normative square of language

and in certain circumstances modify it. If the "freedom of the artist" or of the customer is often exercised on the margins, in the zones left free of symbolic bounds, we cannot however reduce individual innovation to variations lacking significance. As happens in the relationship of language to word, grammar and vocabulary are collectives, but the word, the act of selection in the togetherness of signs and their combinations to form messages, is individual.

"Individual liberty" inscribes itself on the intercises and the lapses of manifold determinism that constitute the person and the space of indeterminism between the religious, social, and functional bounds and the execution of the work.

But if it is true that we participate in the invention and construction of a culture at the same moment in which we seek to describe it – within a linguistic model for example – then the cultural basis which innovation will render perceptible will not only be that of the society in which the objects are produced but also that of the society in which they are seen. "Innovation", in sum, is not a material property of the objects but the effect of a cognitive relationship that is established with them. The innovations and permanence that Westerners and Africans place in the same objects are often not the same.

The perception of newness morphs in relation to the knowledge of the cultural codes within which it is set (to the eyes of a white person, all black people may seem equal) and in relation to time. The character of the innovation of a work collected in the moment of its appearance may be scaled down with time and vice versa; from a distance, we can gather changes that were produced unexpectedly.

The individuality of African works and the artist gain visibility when they become the object of an investigation, when there is an easing of the Durkheimian paradigm that enveloped African art, making it into a primitive art, replacing the anonymous collective mentality with concrete presences, informers, sculptors, and native critics called by name.

If at the aesthetic level the dichotomy of difference-repetition reveals itself as hardly relevant, it is similar at the level of the genesis of the works, because of the opposition of original-copy: every icon is contemporaneously a replica and an invention: never entirely original, rarely a mere copy[27].

In preliterate societies, as Marcel Mauss revealed, "It is useless to seek the original text: it *does not exist.*" The text is produced in repetition, taking from it what we call the variations of a tale or the different versions of the same story. Something similar – despite the material anchor of the work – happens for sculpture, in which repetition and variation end up coinciding. The horizon of expectation implied by the sculpted work is very much more indefinite with respect to that carried by the written work, and often recalls the orally transmitted word.

Even where one proceeds by imitation of a model, the replicas are never complete, the copies never exactly faithful, not because of a lack of skill but precisely because the idea of exact reproduction is tied to writing and in particular to the printing press. Often, because of the perishable nature of material like wood, the "prototype" is absent, and it must be made with replicas of replicas that deepen the discrepancy between the original that served as a real and mental model. The creation of something "new" thus dilutes itself over time and appears as the result of adding a series of small, more or less random, variations.

In this process, language intervenes, introducing discontinuity and distinctions. Newness is made perceptible through the name posted as a sign of a determinate object or design, conferring its own identity on what, until that moment, orbited in the sphere of tolerance of an object or design that preceded it[28].

Chance changes and individual inventions interact with the logic of formal development and socio-political strategies that imprint directional changes. The logic of a decorative motif is thus, for example, that of expanding and multiplying itself, saturating the surfaces[29] and yet, until such a purely logical possibility is realized, needing the presence of religious, political, and social exigencies in relationship to which it could act as a response and serve as a weapon.

Such a model of explanation could account for, as has been revealed, the evolution of bronze Benin sculpture and for the development of Kuba decorative art. In the first case, the military crisis of the monarchy with the arrival of the English could lead to an accentuation of its religious functions and a proliferation of iconographic symbols. In the second, a greater articulation of the hierarchy and of the competitions in the ostentatious symbols of social status would lead instead to a multiplication of decorative themes that would lead the symbolic motif that was once in the foreground to the background[30].

We do not speak here of sustaining a causal determinism that would reduce art to a

mere reflection but, on the contrary, of stressing the centrality in articulating the world. Art does not reflect history, but is a part of it.

Invention, as much as its contents and appearance, remains autonomous, not reducible, that is, to the context in which it is created, but to deciding to affirm itself in the giving of a place to tradition or, on the contrary, to its disappearance in remaining a unique work without followers; it is its capacity to be useful as a strategic weapon, to mutate, or to reaffirm the weave of its existing relations.

In this context, we can understand how the unique work in Africa would not then be the sign of inimitable genius but the confirmation of failure. Innovation pays, in terms of prestige, only when it *generates* replicas: not works of plagiarism but children, a web of relationships. Absolute individuality remains condemned once more.

The innovations, the changes and history of African art cannot be understood in their genesis and in their extensions, limiting us to analyses of the individual-society dialectic, thinking of them as internal routes to a singular culture.

If the identity of the person, cultures, and artistic styles always suggests the existence of a form that is synchronically coherent and endowed with temporal continuity and thus a particular trait that distinguishes it, this does not have to be seen as the consequence of the unraveling of a germinal unity. Time and the Other do not intervene only to confirm or negate, to allow or inhibit the development of an already-defined project, but are rather there from the beginning. Their intervention is not peripheral and successive but preliminary and constructive. If identity is always particular, this does not derive from the properties that are intrinsic in them but from a separation that is the fruit of the decision with which we distract ourselves from the continual flow of transformations, and it excludes a series of alternative possibilities: what the others are or what we could be and would never become, precisely to be able to be what we are[31]. The relationship, in terms of implication and opposition, exists before the separate existence of the parts. It defines itself only in relationship to the extraneous through the affixing of moveable borders and is subject to continuous revision.

It then becomes difficult to continue to think of African arts in terms of tribal or ethnic art, if not through the deconstruction of these analytical categories.

"Ethnic group" and "tribe" have in fact long been defined as substantial realities, resting on the intrinsic similarities of those of which they would be part, on the sharing of a cultural heritage transmitted by common ancestors. Homogenous entities for language, religion, art, costumes, territory, and governance, cultural totalities that, as a result of their integration, became very close to "races", whether they had been considered on the basis of a biological model of the organism or had been conceived of as a collective of "cultural traits" of which an inventory would have to be taken. Once compiled, the list of traits thought pertinent would tend in fact to solidify itself in a togetherness of propriety, with the result that successively compared variations would end up being considered extraneous and ascribed to the disintegrating eruption of acculturation[32].

This is how it happened that the classification of African art in "ethnic styles" had been, more than the result of an empirical observation, the product of the indebted assumption of some objects to the range of "typical" icon. The first objects that came from a

96. Evolutionary sequence of the styles of Benin heads in bronze, taken from W. Fagg and P. Dark

While in the first period (14th -15th centuries), under the direct influence of the Ife art, a pronounced naturalism would have been seen, it would then lead to a progressive stylization with the growing rigidity of facial traits and the multiplication of decorative and symbolic elements.
a. 14th-15th century; b. first half of the 16th century; c. end of the 16th-18th century: the collar rises to reach the height of the mouth; d. 18th century: added to the base; e. 19th century, added to the lateral wings

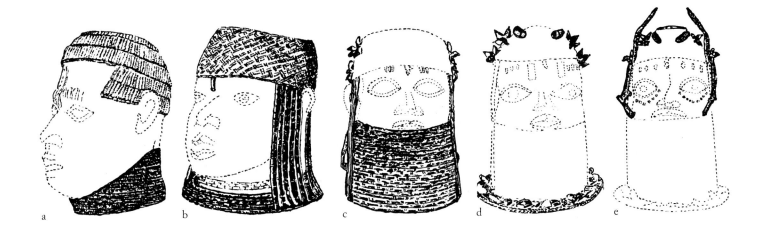

a b c d e

certain tribe ended up being arranged with a normative frame, so that the objects discovered later came to be considered "atypical" if they did not conform to the first objects, with the paradoxical effect that the "atypical" objects numerically surpassed and lasted on a much larger scale than the "typical" ones[33].

On the basis of these presuppositions, a viewer of African art could see "a multitude of tribal arts", concluding that "that which is not tribal is not African"[34]. Artistic style was thus considered as a part of the cohesive togetherness of a property that defined the identity of every ethnic group, affirming for each one of them the existence of their own distinctive style, homogenous on the inside and heterogeneous compared to the others.

The map of African artistic styles thus took the form of a juxtaposition of ethnic territories, demonstrating their coexistence but not gathering their interdependence. It is the conventions of writing which prescribe the ways of reading them and the sequential order of their treatment within the pages of a book: from high to low, from north to south, from east to west, from close to far.

In recent years, the notion of "ethnic group", and with it that of "ethnic style", has, however, been damaged by multifarious attacks[35]. The concept and reality of ethnic identity are no longer thought to be empirical *a priori* of research but the result of a historical and interpretive construction. Local realities are no longer thought of as discrete and impermeable entities, but are studied in relation to global phenomenon that constitute the matrix. The words which we use to describe them are recognized as having a character that is necessarily fictitious in the end.

Ethnic identity is no longer seen as the consequence of culturally objective differences but as a dynamic process of the acquisition of a subjective identity, a distinct identity that can be maintained even in the absence of shared cultural traits or, rather, existing in spite of the cultural homogeneity expected by the outside observer.

Thus a dissociation between the sense of belonging (the psychological, relational, and organizational aspect) and object cultural data that liberate African art from the axiom of a necessary and bijective correspondence between style and ethnic identity is realized. The inside of the same society can create multiple styles, and one same style can be shared by different societies[36] (Plates 76-79; 82-83).

Of course, this does not mean the assertion that art and ethnic identity do not entertain any kind of relationship. In fact, if ethnic identity is constructed in reference to a past that is shared and in large part invented, it cannot but recall the visual symbols on which to base collective "memory", symbols that do not simply express the sense of identity but that, articulating that sense, make it exist.

Symbols, however, in the measure in which they define limits, are not within the group if they do not indicate to it the margins that are contemporaneously turning toward the outside. "Ethnic styles" can then be better understood on the basis of the liminal and fluid spaces in which they realize their genesis and interaction[37]. The border does not constitute a foregone boundary, deriving from the isolation of the society, but a limit instituted and renewed by the behavior of the actors in their interactions, porous and mobile barriers that allow crossing and that move in relation to the choices effected and their results[38]. In certain cases, the masks tied to a group's system of beliefs can penetrate into another group and then be absorbed through a process of symbolic domestication that makes them compatible[39]. In other cases however, the passage of a mask from one group to another can bring with it the redefinition of its own sense of identity[40].

Borders are thus not reduced along a line of demarcation, but assume the thickness of a transitional space. The Dafing masks of Burkina Faso combine the sculptural traditions of the Mande group and the voltaic traditions of geometric design[41] (Plate 73).

Borders are crossed by merchants and pilgrims, itinerant people or single migrant or itinerant artists.

The itinerant Fulbe weavers travel from village to village, working on commission in many different styles. In Cameroon Grassfield, the court sculptors were recruited locally by the king or in other kingdoms, taking their aesthetic repertoire with them and modifying it in the interaction with then new patron[42].

Transfers of residence due to marriage introduce the styles of one lineage to another. For this reason, in the patrilocal societies of western Africa the process of constructing dwellings, masculine work, becomes modified very slowly, while parietal decoration, feminine work, changes much more rapidly: the women going to live in the community of their husband brought their own style to the community[43].

3. Spaces and Time in Black Islam

The presence of an Islamic civilization in Africa is not so recent. A large part of the area of Africa north of the equatorial forests and east of the Rift valley has known Islam for approximately one thousand years. The islamization of the Mediterranean side and the works of the Almoravidi in the eighth century were then followed in the next century by their penetration into the Sahara, while in the same period the Horn of Africa witnessed the installation of a community of Arabic and Yemenite merchants. In the tenth century, the Soninke, a black population of the Mande language who converted to the religion of Allah, reached the valley of the Senegal River and that of the Niger, where the vast Sudanese empires that constructed their fortunes on the trans-Saharan commerce connected Mediterranean Africa along the areas of the forests arose. The black islamicized merchants, Hausa, Diula, Ligbi, pushing themselves towards the coast, would later establish – particularly in the seventeenth century – a vast network of contacts and commercial points that extended from Liberia to Cameroon.

It would be foolish to think that this remote and continuing presence did not profoundly inscribe itself on African reality, nor would it make sense to reconstruct the past one thousand years of African history without including Islam, seeking a profound and original Africa under the veneer of foreign intrusions. Africa and Islam intertwine, reciprocally capturing each other. From one side, large zones of Africa become part of the universal community of believers, from the other Islam is transformed into *an African religion*.

The influence was reciprocal and gave rise to a large range of compromises between the needs of fidelity to the doctrine and that of its diffusion[44]. Transplanted in Africa, Islam was not passively collected but adapted to local needs, realizing a synthesis between the universalistic orientation of the Koranic religion and traditional beliefs.

It was a relationship that certainly included struggles, confrontations, forms of domination, and exploitation like treatment of slaves, forms of dimensions and consequences no less dramatic than the European situation, but which, however, also gave rise to a form of reciprocal cultural cooperation.

It is not through holy war (*jihad*) that Islam spread itself in western Africa. The practice of *jihad*, with it meager results, is limited to the seventeenth through nineteenth centuries. More than anything, the religious expansion follows the roads of commerce along the trans-Saharan caravan route, often reuniting the figure of a merchant and a religious man in the same person. Tolerance and accommodation seem to have been the prevailing behavior as much for one side as for the other.

The prestige of the Arabic merchants who brought unknown and valuable goods, the power attributed to Islamic magic, and the fascination exercised in writing as a way of communication among men and with gods seem to have been the motives at the base of many conversions. The syncretic character of polytheism and the presence of a kind of shared cultural substratum guaranteed its success[45]. Thus in the anti-colonial struggle, Islam was often intended as part of the African resistance against the foreigner[46].

It was a long cohabitation that gave rise to the formation of a multicultural, integrated community composed of Muslims and polytheists like those of the empires and the city-state of western Africa and to the unprecedented creation of mixed cultures like the Swahili culture of the eastern coast. Civilizations made borders (ecological, cultural, religious, economic) into the territory of their development.

The Swahili culture was born on the African coast that lies on the Indian Ocean, where the seasonal monsoon currents brought Arab, Persian, and Indian migrations and led to the birth of a thriving intercontinental commerce. It created a mercantile and urban society that had its base on the Arabic-Islamic contributions, but that grafted itself onto a preexisting African culture. Projected to the outside, it would decline with the arrival of the Portuguese in the seventeenth century.

In the Swahili language and culture of the eastern coast, which had its apogee around the fifteenth century, Arabic and Bantu elements competed to realize an urban society and merchant economy that opened itself towards Asia (Arabia, Persia, India, and China), while the autochthonous cults of the ancestors merged in the Muslim religion.

The originality of the culture is easy to see on the artistic level, in the inventiveness with which they assumed heterogeneous elements, integrating them into the construction of an autonomous and recognizable identity. We can thus find boxes of wood produced in Bombay expressly for eastern Africa and decorated according to local taste, using the Indian technique of lacquering, while in the decorations of carved wooden doors in cities

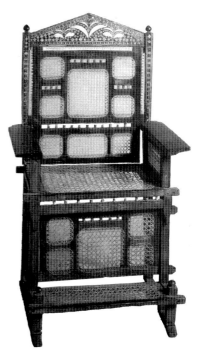

97. Kiti Cha Enzi chair, Swahili, Tanzania; wood, ivory, cord, height 126.5 cm

The colonial model of the Anglo-Indian country chair is locally transformed until it transforms the chair into a throne; its dimensions increase and its preciousness is augmented, using ebony and inserting ivory.

98. Door, Swahili, Tanzania; wood, height 200 cm

The tradition of carved doors of the eastern coast had its greatest development during the nineteenth century; the door has two shutters that open towards the inside. There is carving on the interlacing and the central pilaster, on which there appear motifs of local origin (the date palm, the incense tree, the movement of the waves) and others of Indian derivation (the rosette and the lotus flower).

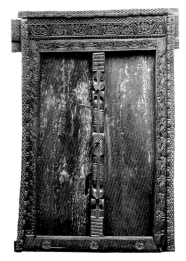

Color Plates

73. Mask, Marka Dafing, Burkina Faso
wood, pigments; height 70 cm
This is a mask that represents the face of a genie; on the superstructure, jagged and curved to the back, there are two pairs of eyes that recall the capacity of being able to see the invisible. The style of the Dafing mask — overlapping Mandé and Voltaic elements — registers the migratory history of these people who, with the fall of the empire of Ghana (1076) and the decline of the empire of Mali (fifteenth century), were progressively moved, pushed until they reached what is now Burkina. The oval of the face with the flattened cheeks, the rectangular projection of the ears, and the perpendicular traced by the intersection of the nose and the superciliary arch present strong resemblance to the masks of the Bamana (Figure, p. 12). The sense of color and geometric motifs that are triangular, linear, and in concentric circles, are instead precisely a part of the Voltaic decoration.

74. *Ndop*, statue of the Bushongo king Mabiintsh ma-Mbul, Kuba, Congo
wood; height 72 cm
The dynastic statues of the Bushongo kings (an ethnic group that holds power in the Kuba kingdom) seem to have constructed a sort of "double" of the sovereigns, later performing a commemorative function after their death. The transfer of power to the successor was transmitted through them, ensuring the continuity of legitimate authority. The sculpture of these statues probably dates from the second half of the eighteenth century and is contextualized in the process of the centralization of the Kuba kingdom.
The statues are put on a squared base that echoes the form of the flat headpiece typical of Bushongo kings. The figures present full and rounded shapes, heads of large dimensions, one arm on the knee and the other holding a sword facing towards the back; at the center of the anterior part of the base, a regal symbol appears, specific for each king, which would allow for recognition.
During the reign of Mabiintsh ma-Mbul, the Kuba were the first contact with the white men. The figure that represents this constitutes, from a stylistic point of view, a strong innovation compared to previous statues. While preserving the traditional position on crossed legs, the bust is lengthened and the head shortened, nearly bringing it to natural proportions (at least in the upper part of the body). There is another unusual element in the position of symbolic objects of the king, the ceremonial fly swatter in the right hand and the "basket of wisdom" on which his left arm rests.

75. Figure of a warrior, Bena-Lulua, Congo
wood; height 74 cm
This is a figure of a head of the group who has reached the highest level of initiation, that of the "leopard" (*nkahama*). The indications of this are the numerous emblems that he carries on himself: the leopard skin apron, the helmet, the sword, the necklace, the bracelets. It is likely that such statues were used to insure protection to the head of the group and to contribute to the well-being of the kingdom. There is a particular importance given to the head, both in the dimensions and in the accuracy of the execution; the elaborate facial scarring is the distinctive sign of local belonging in a society in which power is rarely centralized. The concentric circles around the rising of the navel instead recall the generation of life.

76. *Alusi* figure, Igbo, Nigeria
wood, earthy patina; height 169.5 cm

77. *Alusi* figures, Igbo, Nigeria
wood; height 113 cm; height 111 cm
The *alusi* are the protective divinities associated with elements of nature (the rivers, the earth) or social elements (markets, ancestors). They are gathered in sanctuaries on the model of familial Igbo groups, and — in the hairstyles, the scarring, and the ornaments — they present the status symbols of influential people. The statues of the center-north Igbo (Plate 77) reflect a moderate realism in the proportion and representation of body parts. Conceived for frontal vision, they have a symmetrical appearance, with the legs slightly parted and the arm pointed away from the bust. The volumes are full and rounded, the shoulders robust, the neck vigorous. There is a recurrent element in the palms of the hands, turned one to the other to indicate frankness, the openness to giving and receiving, the relationship of reciprocity that exists between men and gods. The attention to detail is concentrated above all on the head, while the hands and feet are intentionally sculpted in a more or less summary style.
For as much as the cultural function is the same, the sculptural style of the southern Igbo (Plate 76) is clearly differentiated by its marked geometric schematism, which privileges strongly angular lines and flat surfaces. The face has a rectangular form, the shoulders are squared, the arms run parallel to the bust; the fingers and the toes are indicated by simple vertical incisions. The swelling of the penis, navel, and hands stresses the verticality of the figure, limiting the horizontal projection.

78. 79. Head, Ife, Nigeria (Thirteenth-fourteenth century)
terracotta; height 15.2 in.
The style of Ife sculptures, in bronze or terracotta, is marked by an idealized naturalism (Plate 79). Heads and whole-figure statues were probably placed on altars that were consecrated to an anthropomorphic divinity through which the king (*oni*) could be placed. The striations on the face represent scarring or facial paintings.
However, next to the faces inspired by a harmonious composition are the strongly expressive and grotesque faces (Plate 78). Here, the representation of deformed people, consecrated to the gods for their extraordinary aspects and destined to the sacrifice, is seen. There is a ritual dimension confirmed by the monkey skull that the figure wears around its neck and by the jewel that is bound around the head. The alteration of the customary style would thus respond, more profoundly, to the same rules of appropriateness of representation: an aesthetic that would take into account their differences, modulating the canons of "beauty" on the essence (*iwa*) of the individual.

80. 81. Plaques of the Palazzo of Benin, Nigeria
bronze; height 45.5 cm
These bronze plaques, fused with the technique of lost wax, decorated the wooden columns of the palace of the kings of the city of Benin. Their rectangular shape inspired thoughts of a kind of sculptural transposition of the illustrations of European books. The scenes and subjects that appear on the plaques probably refer not to singular events but to the diverse phases of court rituals. This seems to be confirmed by the lack of elements that allow a specific spatial-temporal connection. They lack a line that demarcates the ground, and the background, in floral motifs, remains undifferentiated.
In the plaques that are reproduced here, though, there is an absence of the relative rigidity that appears in other plaques: the accent falls on the fluidity of the movement and there seems to be an attempt at perspective. In the hunting scene, there is also the representation of a tree, something that is very rare in African art.

82. 83. Seated figures, Komoland, Ghana (Fourteenth - seventeenth centuries)
Terracotta; height 26 cm; a. 17 cm, b. 18 cm, c. 15.5 cm
The rediscovery, in the middle of the 1980's, of these figures in the funerary chests of a vast complex of tombs in a burial

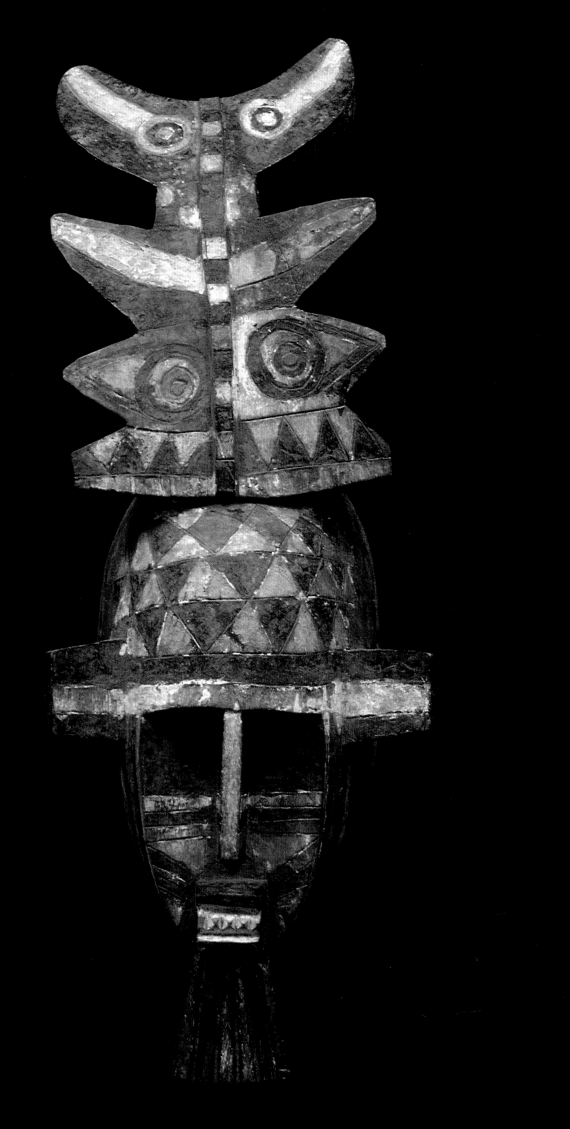

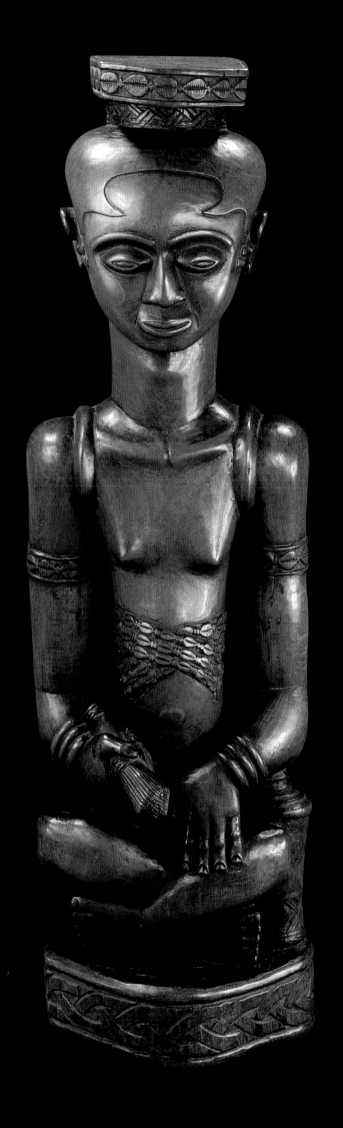

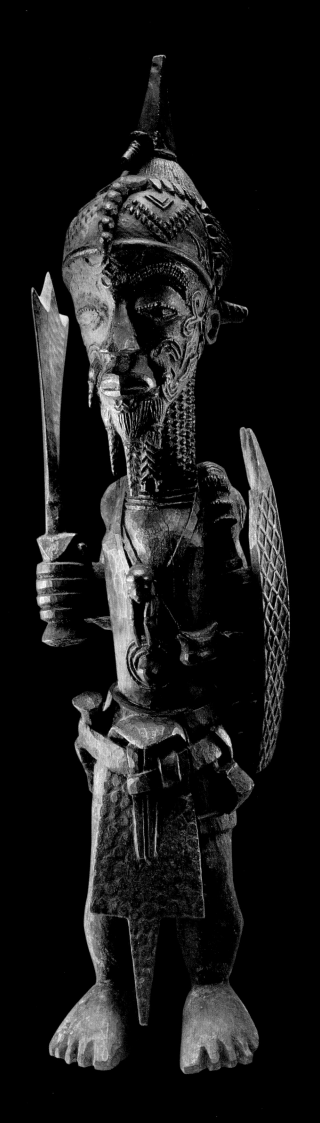

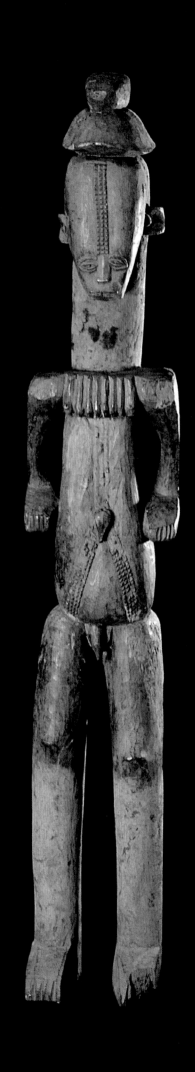

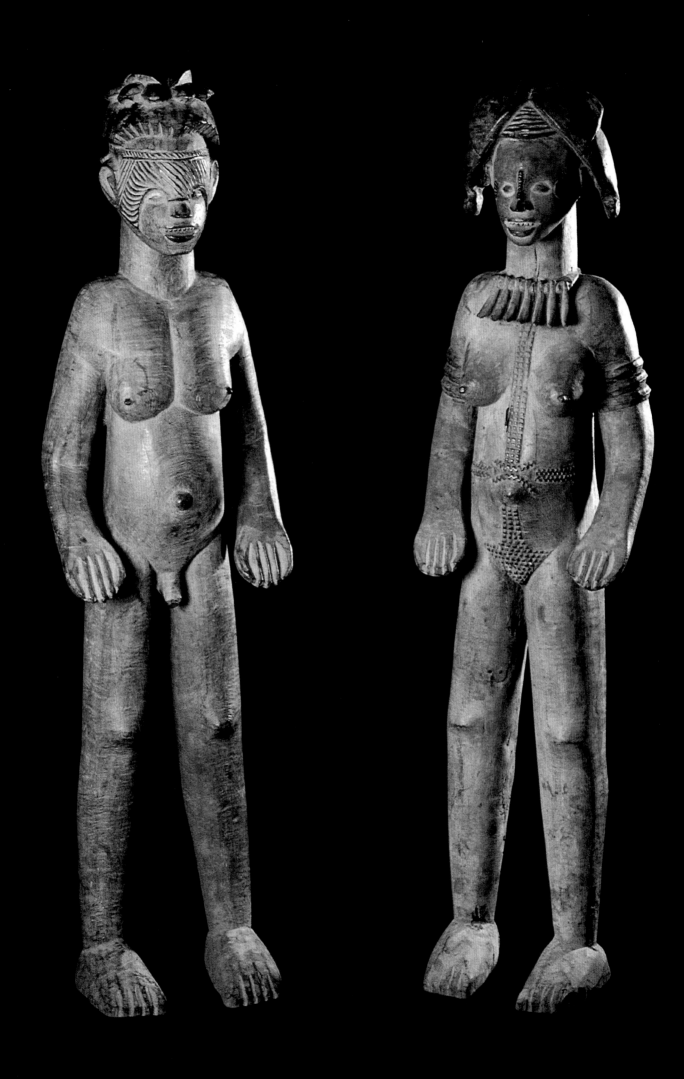

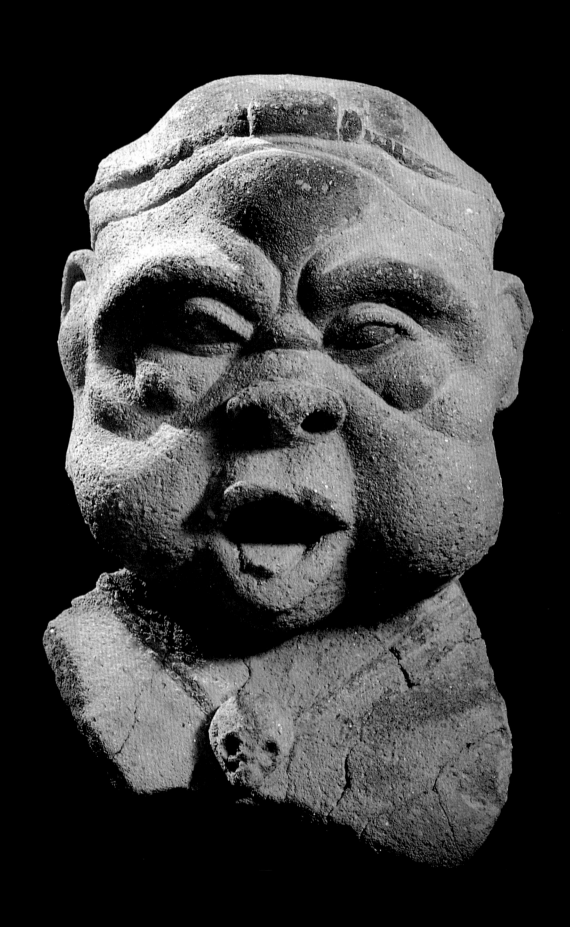

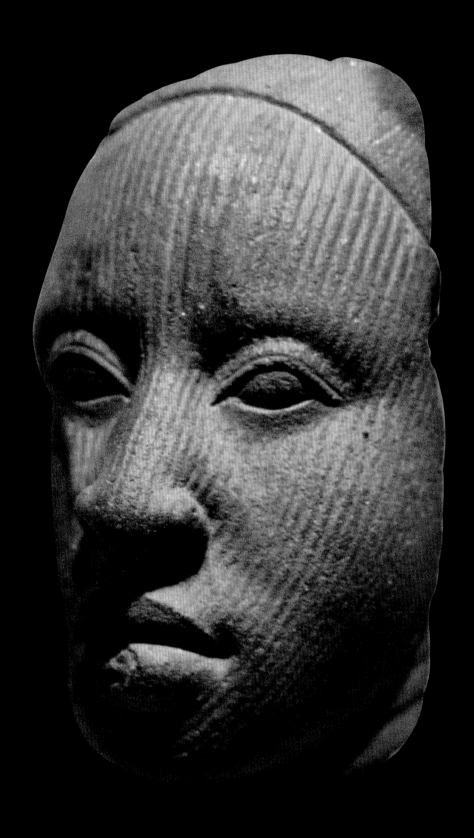

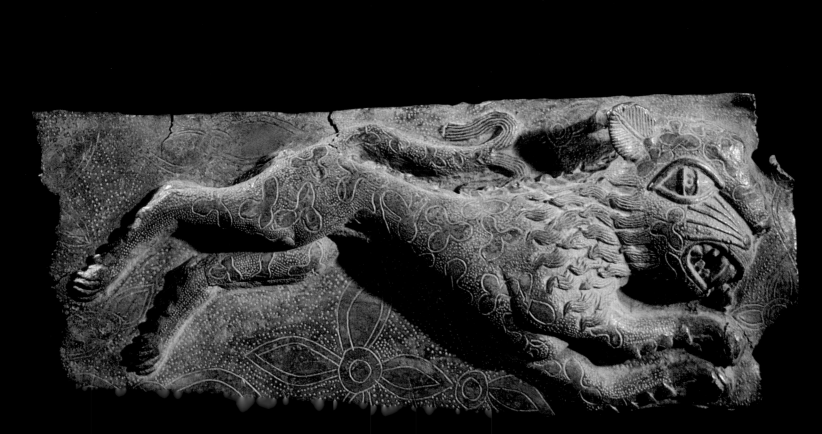

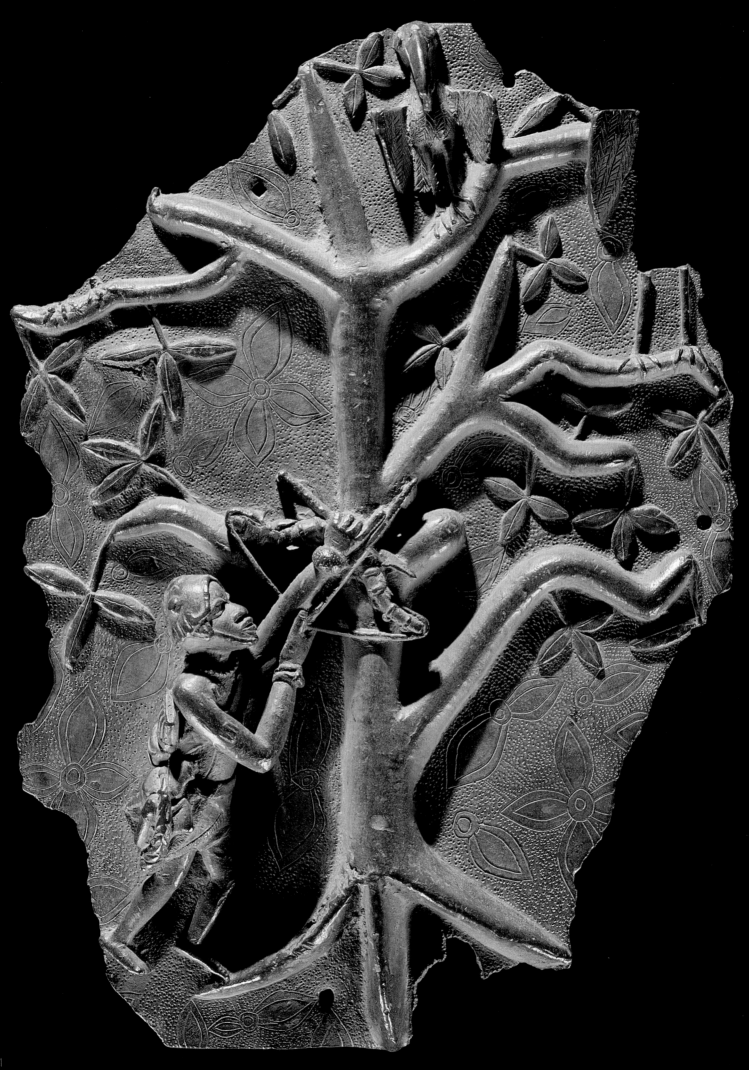

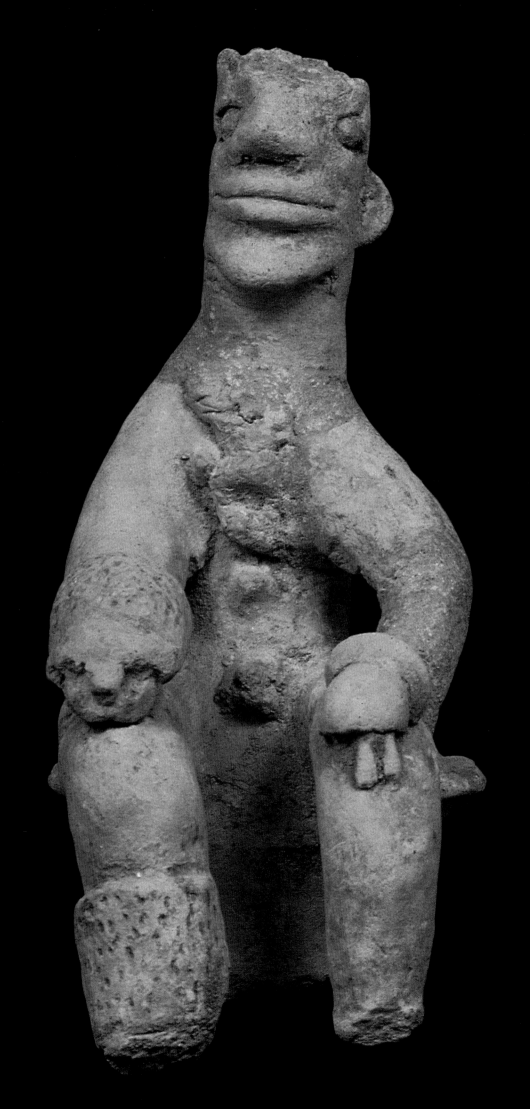

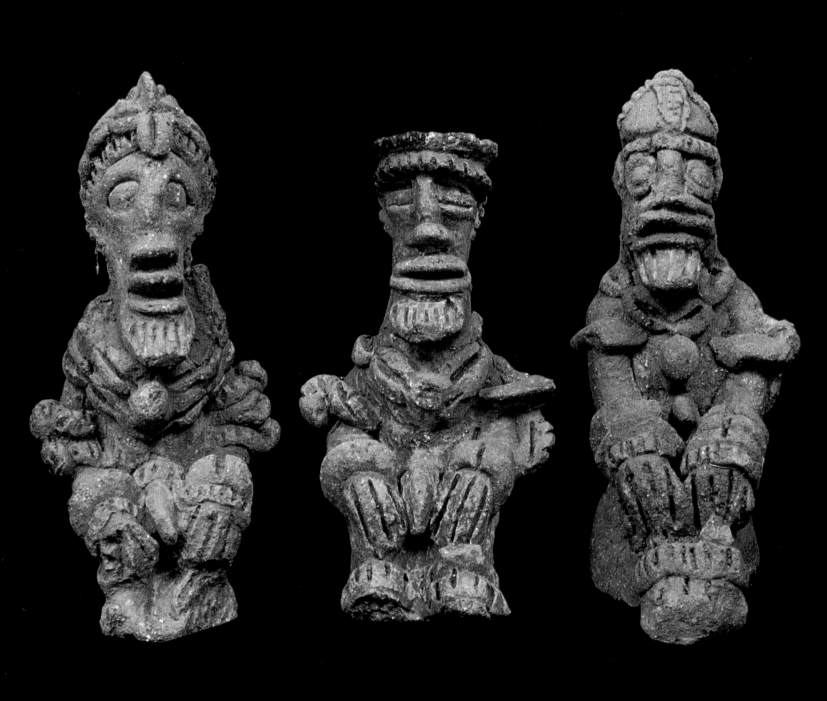

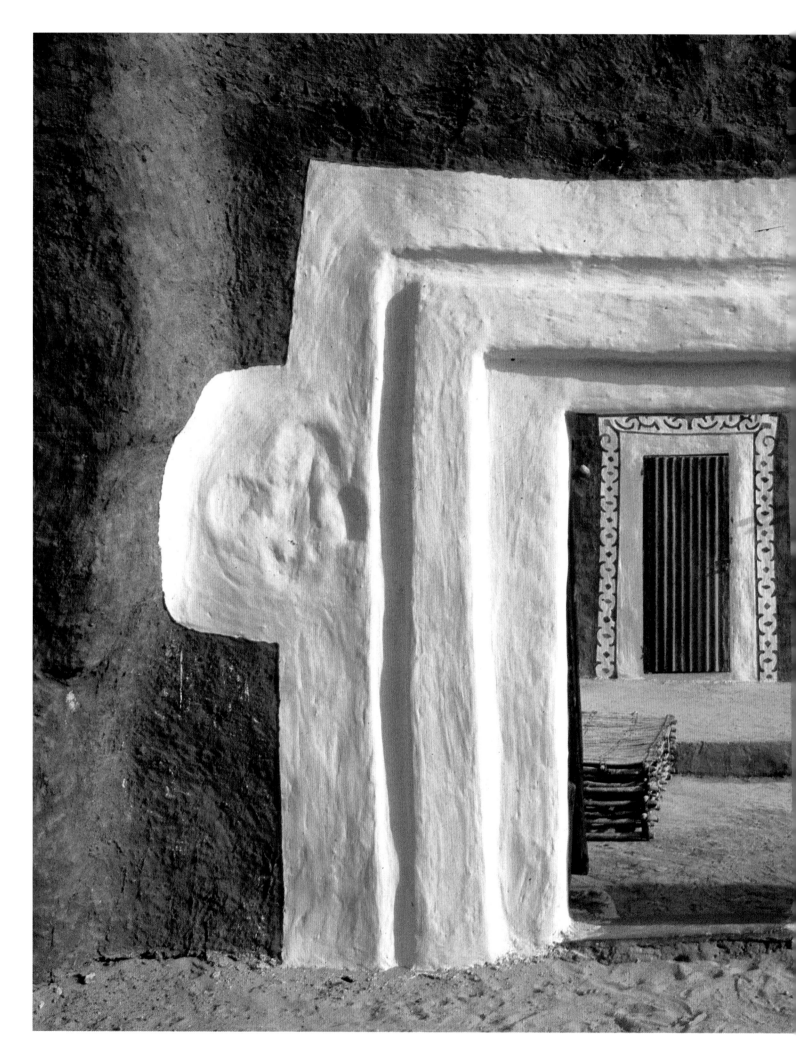

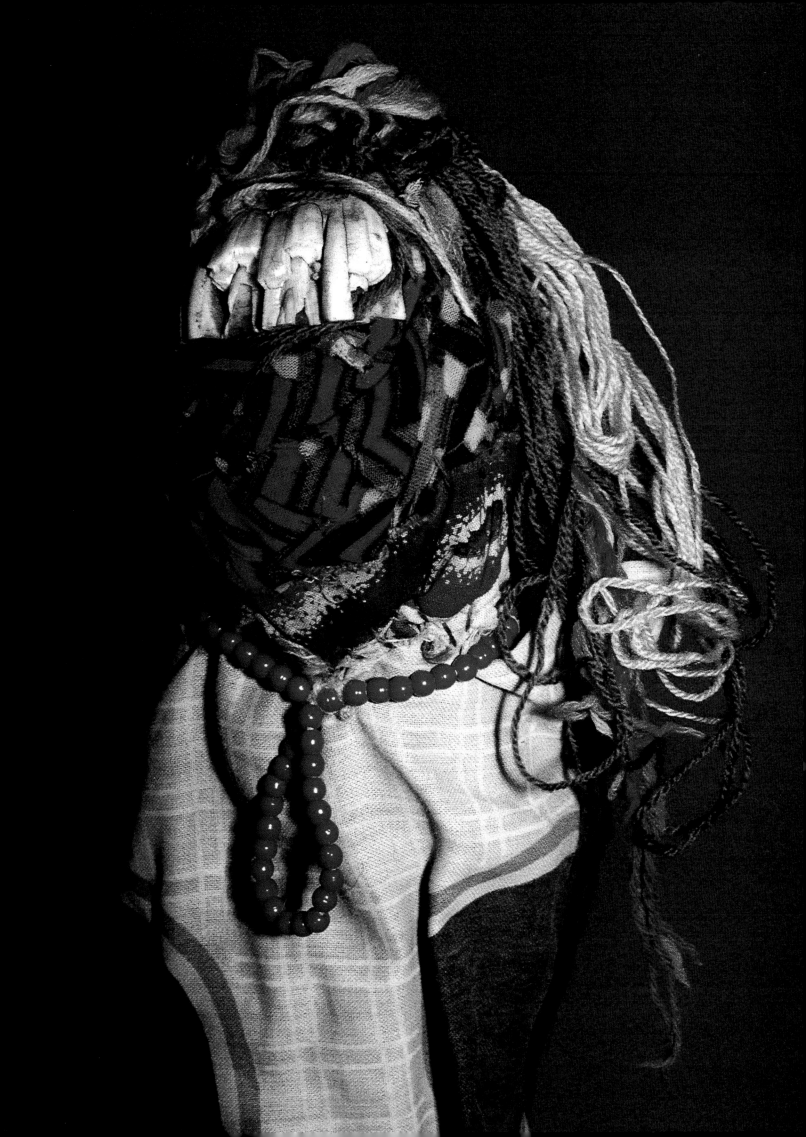

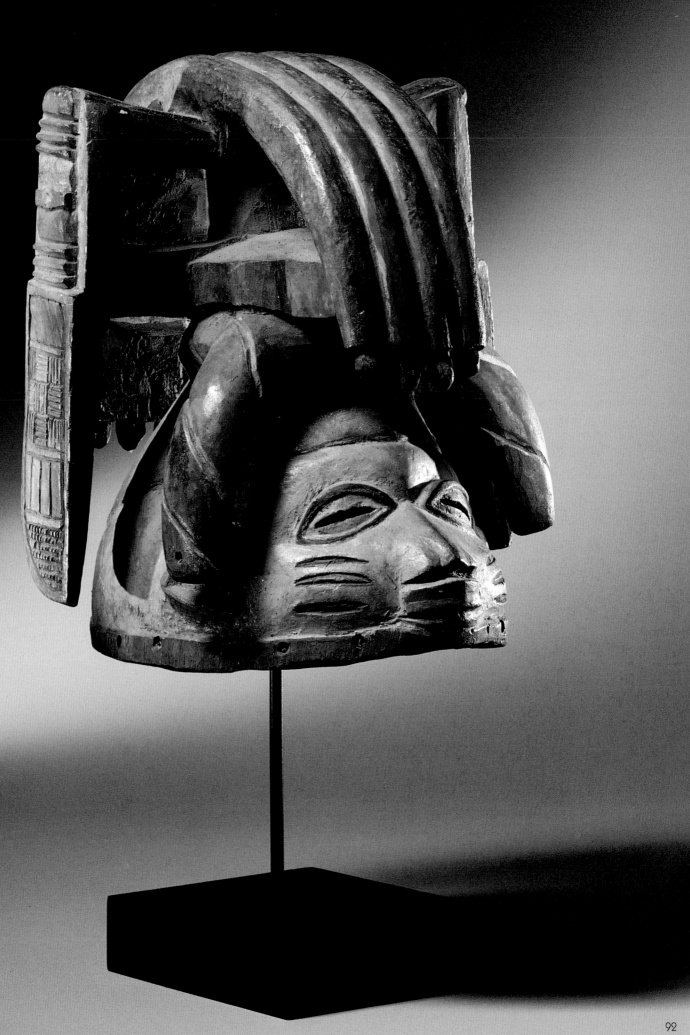

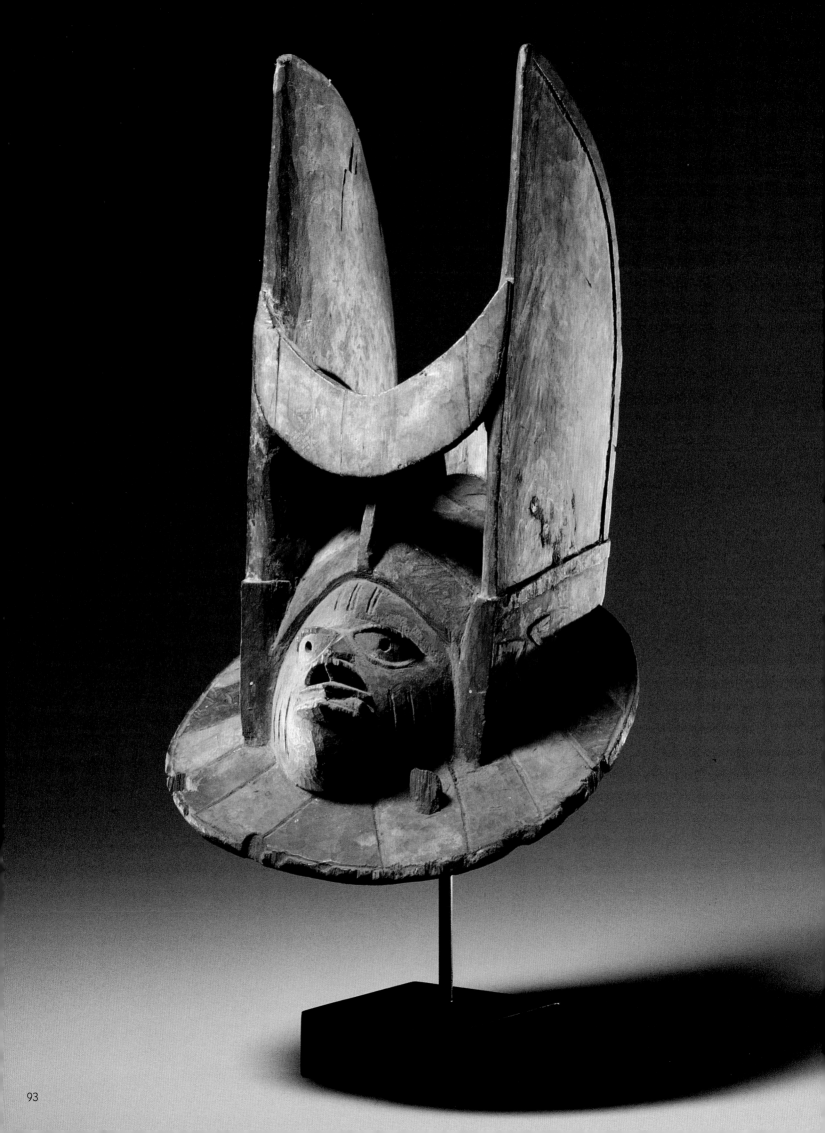

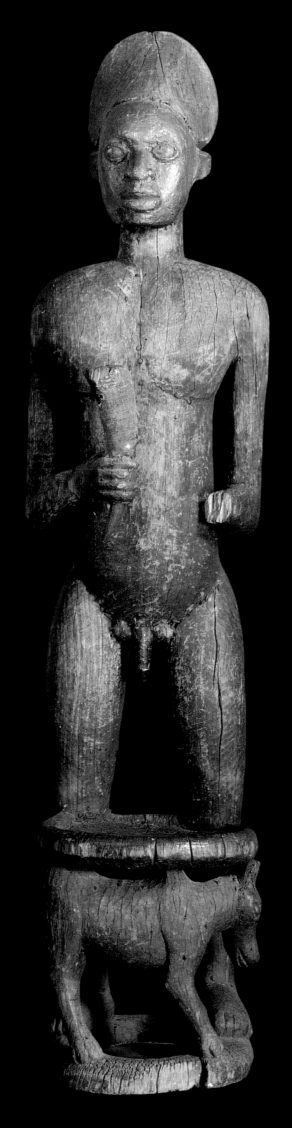

94

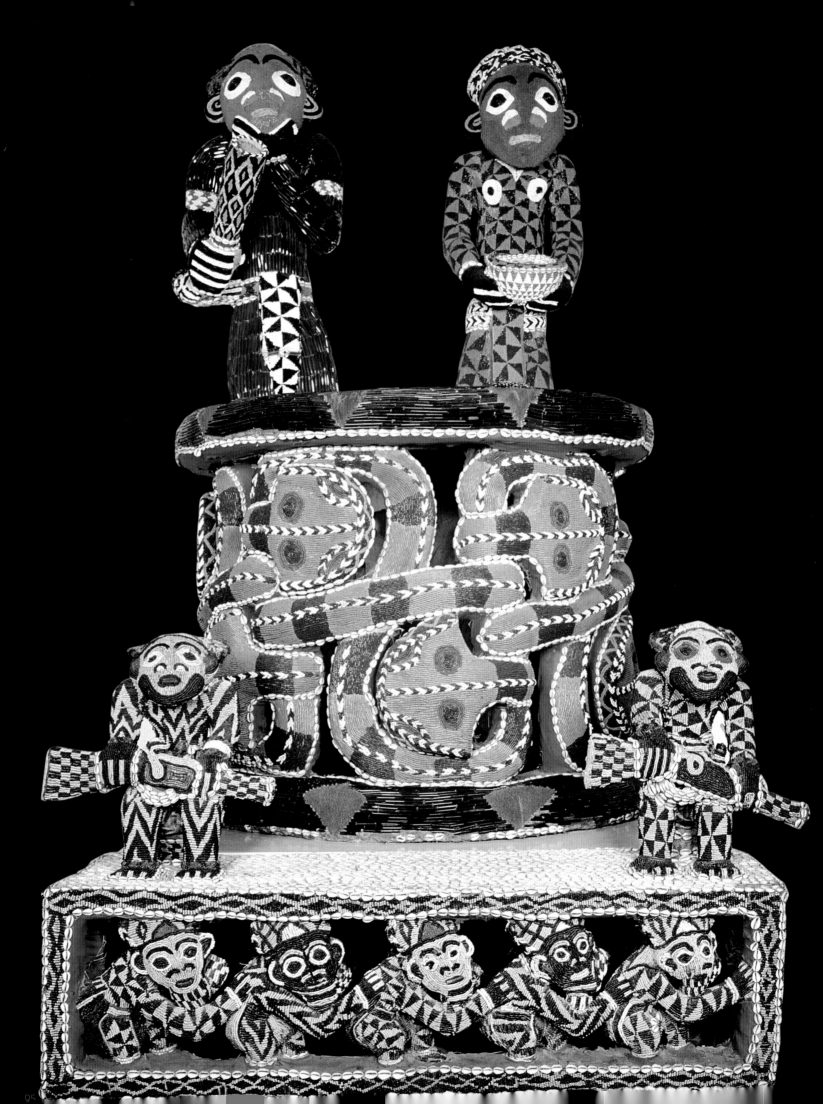

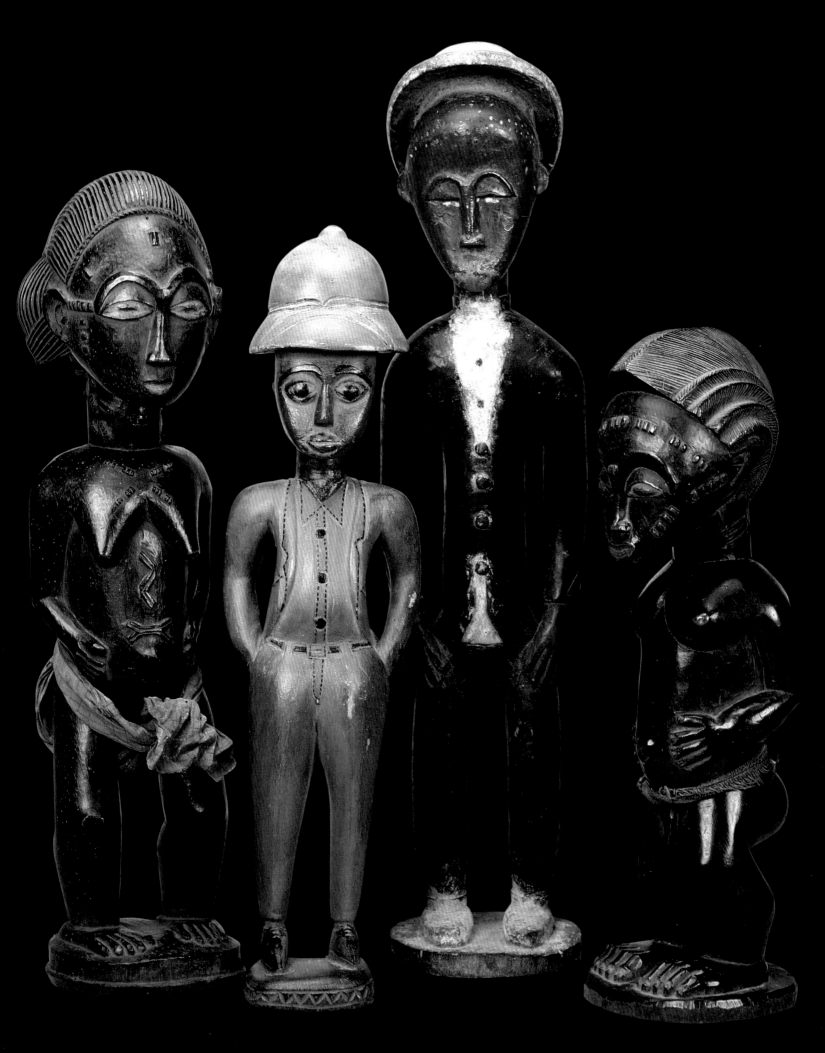

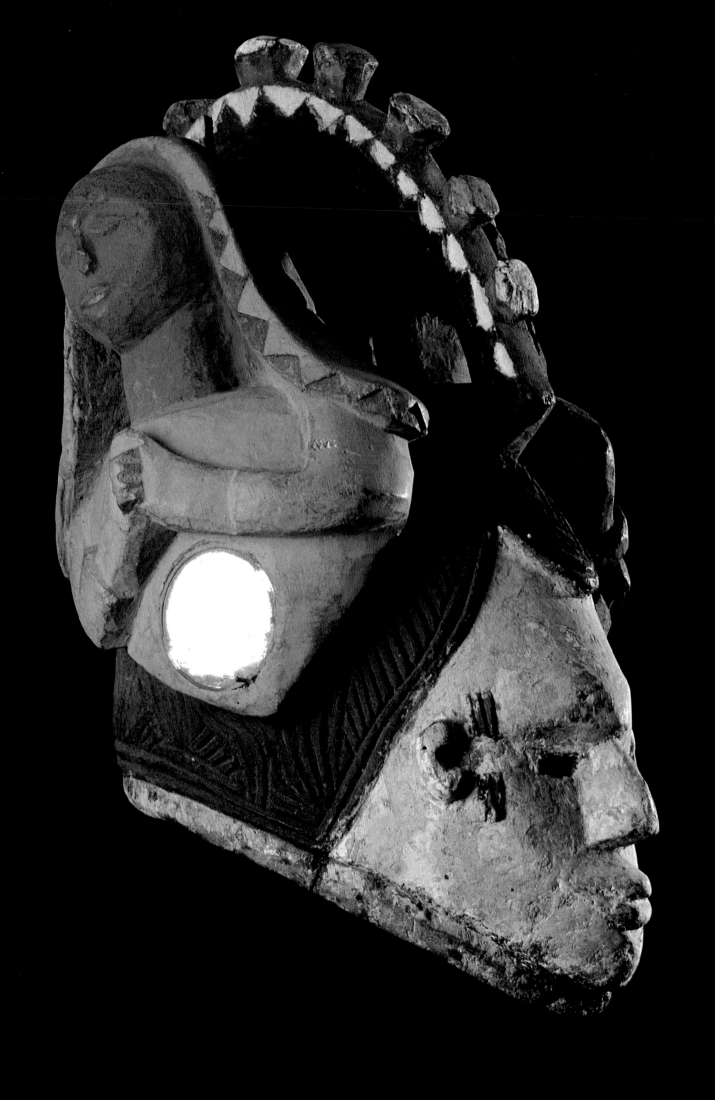

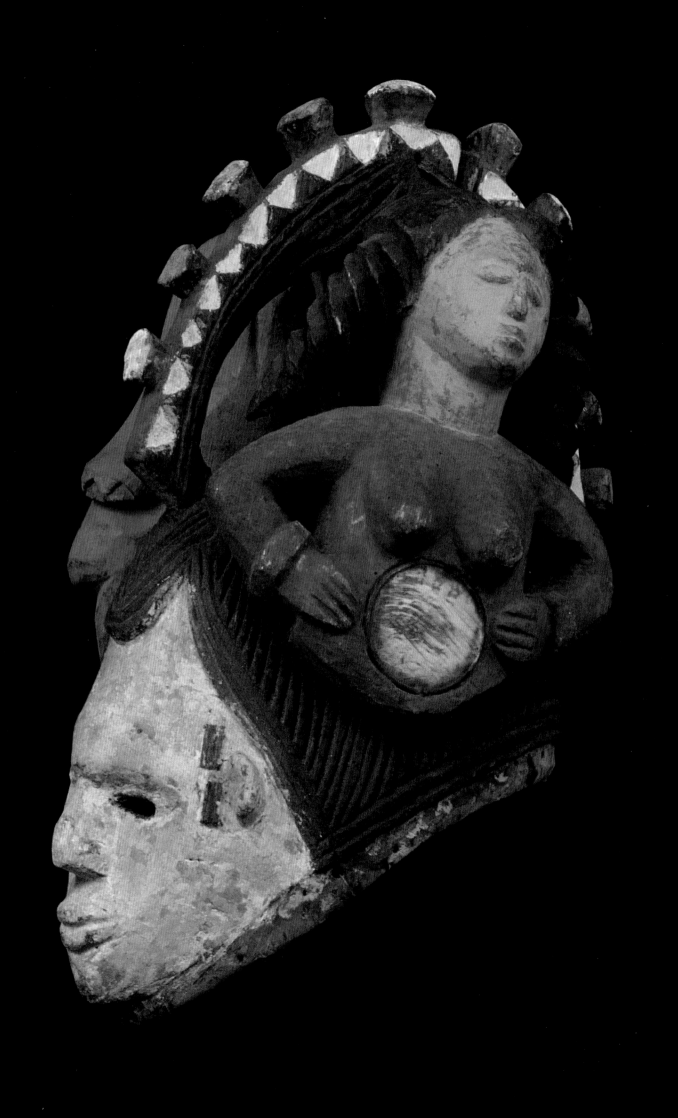

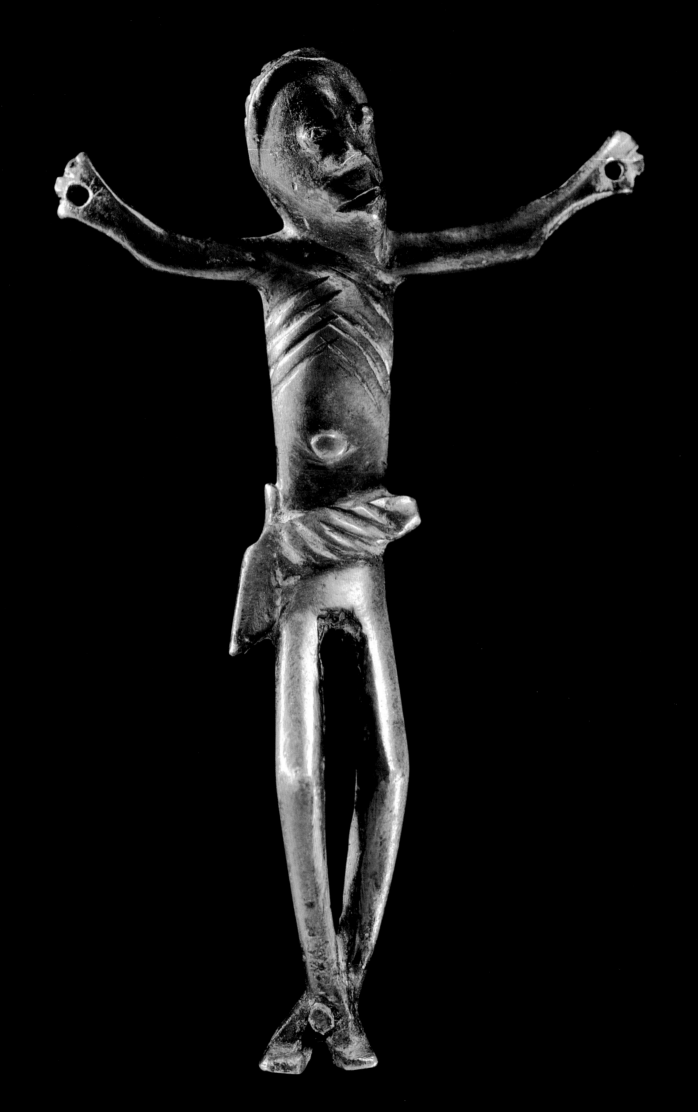

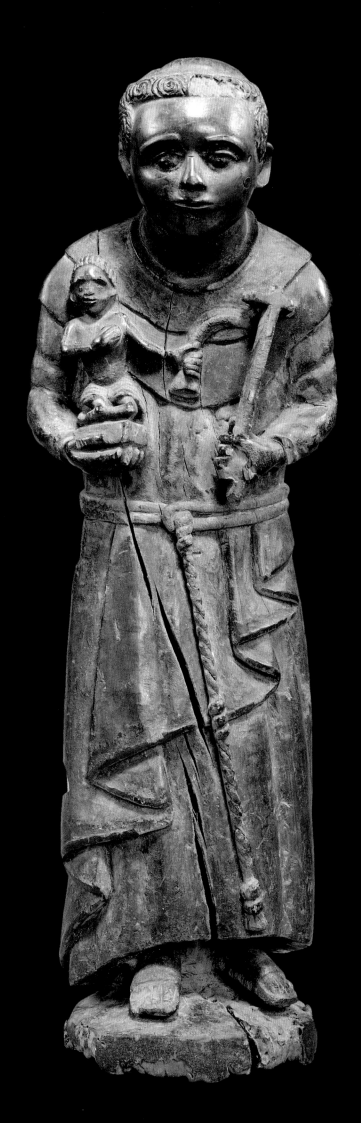

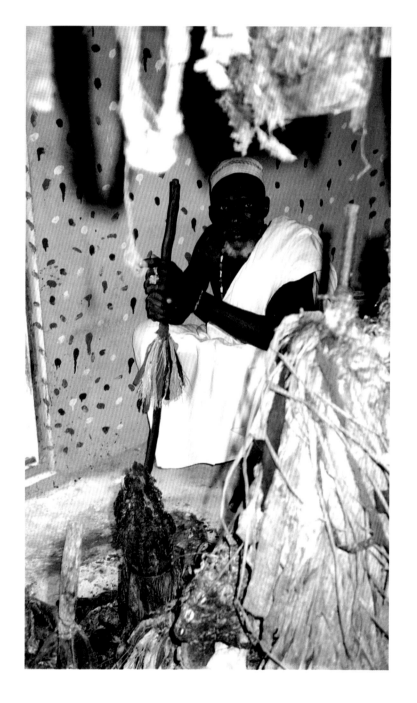

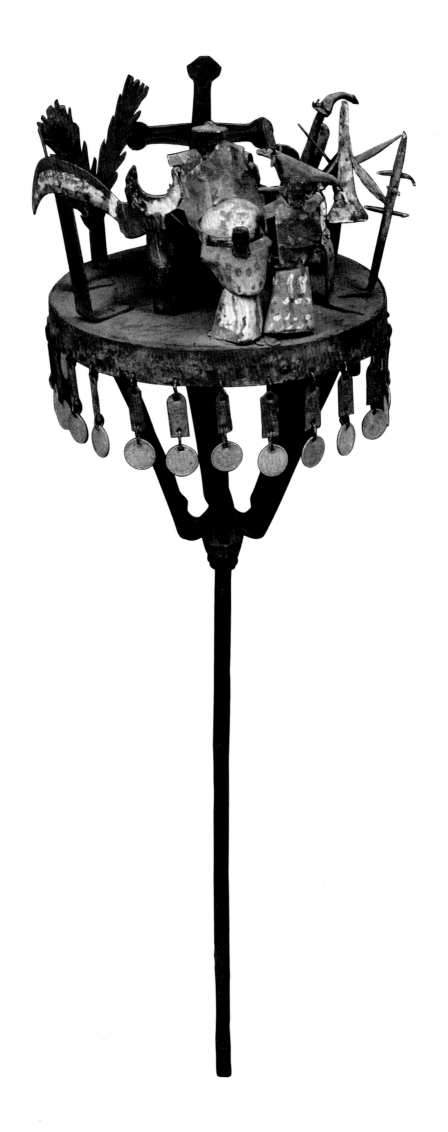

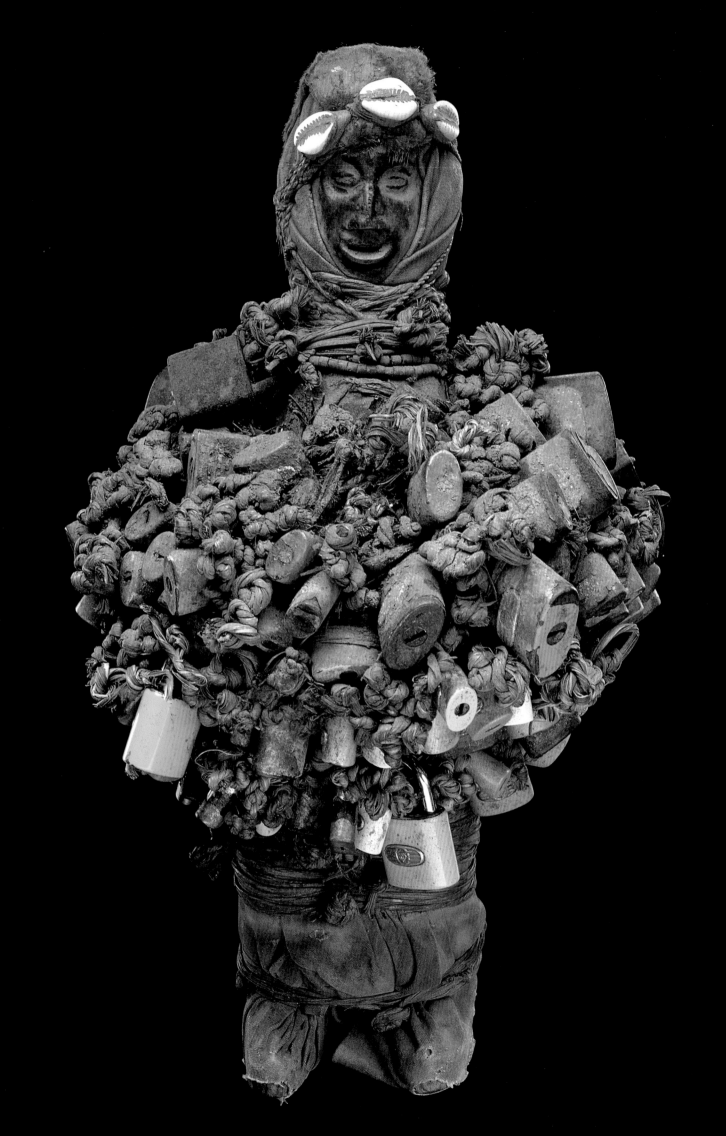

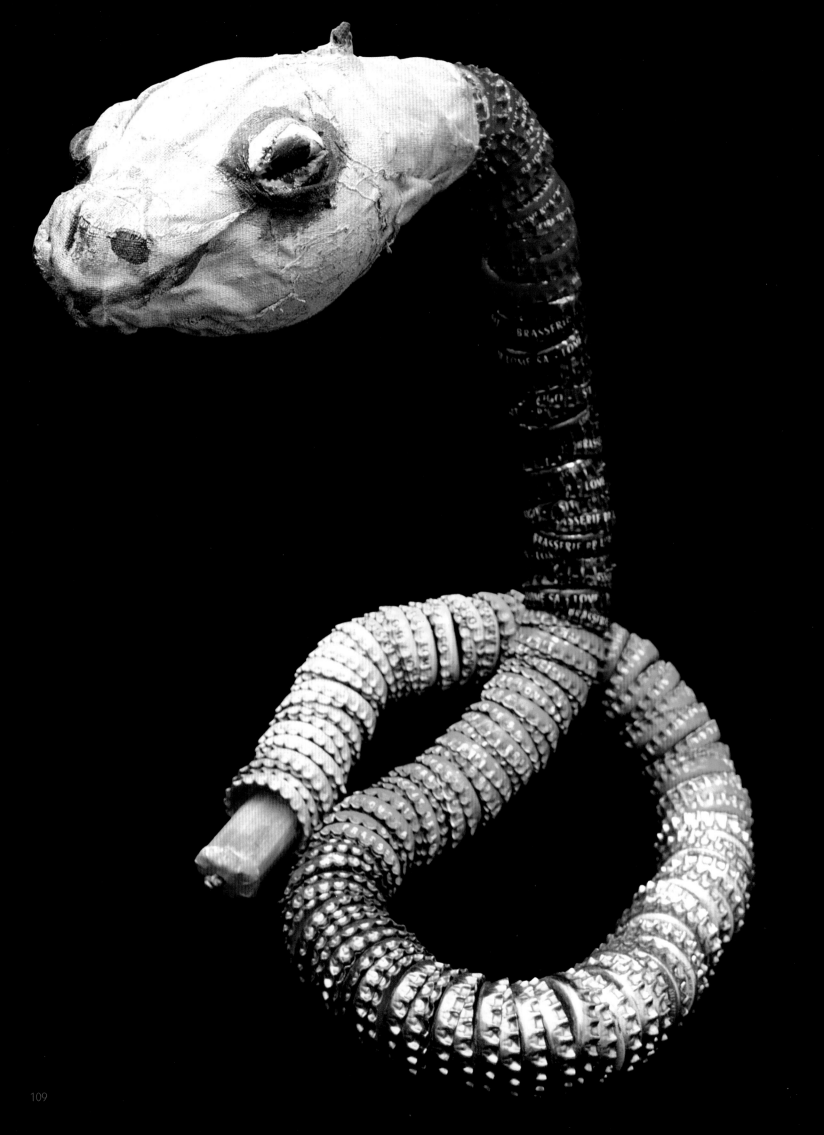

ground north of Ghana made one think of a kingdom that flourished along the caravan routes that connected North Africa to the Gulf of Guinea. This hypothesis is supported by the richness of the vestments that appear on the anthropomorphic terracotta, among them necklaces of cowry shells, indigenous shells from the Indian Ocean that arrived in western Africa through the Sahara and were used as money in trading.

Variations that are clearly distinct from each other are seen in the diversity of the mixture and in the styles of the statuary. In the first (Plate 82), the accent is placed on frontality, symmetry, and the fixity of the glance that reinforces the iconic element and the authority of the figures: seated, hands on the knees, the elbows attached to the bust and the body indistinct from the seat on which it rests, they realize a strong, intense concentration in the decided reduction of dispersive empty spaces. The other variation (Plate 83), numerically limited, instead presents supple and curvy members, one separated from the other, of the seats and of the body, while the face reveals a sort of smile. Empty spaces and dynamic lines introduce a partially extended element.

Two figures present flared heads with openings in the center.

84. Great Mosque of Djenné, Mali

Built with the patronage of the colonial French administration on the ruins of the preexisting mosque in 1909, it echoes the original forms but with altered sensitivities. It is possible that it runs along the place of the tomb of the first Djenné king and that the enclosing wall corresponds to the borders of a pre-Islamic cemetery; here African and Islamic traditions overlap with colonial visions.

85. Mausoleum of Muhammed of the Askia, Gao, Niger

Gao, the capital of the Songhay empire (fifteenth-sixteenth century), has seen the overlapping of Berber, Arabic and black African traditions. Askia Muhammed, who took power in 1493, favored a reinforcement of orthodox Islam. His mausoleum, probably built in the enclosure of the ancestors of the pre-Islamic epoch, presents a pyramid structure on three levels of terraces that seem to reproduce the form of the minaret of the Great Mosque of Kariouan (Tunisia) and at the same time develop the conical form of traditional African altars.

86. 87. Mural paintings of dwellings of Oualata (Mauritania)

Oualata was an important caravan center in the seventeenth century. The wall paintings of the houses draw inspiration from Islamic calligraphy and then give rise to a unique aesthetic, produced by a cosmopolitan environment in which Berber nomads, sedentary and islamicized black Soninke, merchants, and religious Arabic men all mixed. They are the work of women and cover the internal spaces of dwellings (private and feminine), contrasting with the bare geometry of the exteriors (public and masculine space). The designs, which grow denser primarily near the doors (in this case the motif of the "ears"), symbolically recall female fertility or masculine virility. They propitiate the prosperity of the house.

Motifs illustrated on the side (from top to bottom): "the young girl" (tfaila), " girl, 20 years old " (mra sghira), "the woman with long tresses, 30 years old" (m'soulfa), "older woman, 40 years old" (mra kbira).

88. Tunic with Arabic inscriptions, Togo

cotton, ink; 124 cm x 123 cm
The name of Allah, Koranic verses ,and proclamations of faith written in ink on the entire surface of the fabric guarantee divine protection to the wearer.

89. Embroidered tunic, Hausa/Nupe, Nigeria

silk and cotton; height 137 cm
Among the Islamicized Hausa, the technique of embroidery is strictly associated with the art of calligraphy. Taught by Koranic masters to the students, it is a masculine prerogative. The design that appears on the tunics responds to symbolic and protective exigencies. The isolated spiral that appears on the left side of the body (the side that is considered noble) recalls the spiritual path that leads to God (placed in the center of magic squares). On the left side, there is instead, among others, the motif of the eight-pointed star and that of the "knives" (also in eight), motifs that would be echoed by the banners carried by pilgrims to Mecca. The togetherness of designs is enclosed by, from top to bottom, a long line that ends at the two extremes with motifs termed "lizard-like" that recall the pre-Islamic symbolism.

90. Bozou girl, puppet, Hausa, Niger

fabric, cotton tufts, wool and acrylic fiber threads; the head is made from a pumpkin and covered by fabric; height 56 cm
A puppet that represents one of the ethnic groups of the Dagamaran region. This character is a reminder of the duty of teamwork and of the complementarity that have to reign among the inhabitants of the village, even if their ethnic origins are different. It is an homage to the beauty and seduction of youth. The absence of a face is an example of Islamic influence: through this elision, the puppeteer bypasses the religious prohibitions on figurative representation.

91. Abssatou puppet, *sumbala* seller, Hausa, Nigeria

wood, fabric, cotton tufts, necklace of glass beads, animal teeth; 42 cm
Sumbala is a condiment used in the preparation of a sauce whose strong odor attracts flies. The odor of the sauce and the clearly visible teeth of this character, used in Hausa puppet theater, are very probably similar to the representation of death. While the *sumbala* seller is very ugly, she is considered to be of an irresistible beauty: she is lavished in caresses, flaunts her fascination, draws all the men to her...

92. *Oro efe baba ako* mask ("Father of the Masculine Images"), Yoruba, Nigeria

wood, pigments; height 35 cm
A stereotypical representation of the head constitutes the sculptural and symbolic base of a complex superstructure. Two large tassels pointed towards the base depart from a ring-shaped head covering; above it is a radial structure on whose extremities two sheathed knives are placed. In the center, there is a group of pythons. The knives suggest the male prerogative (one of the same terms indicates the snake and the penis) and recall Ogun, the god of war and of metal. The sheaths of skin and the head covering recall the influence of the Hausa population and the importance of Islamic forces. The serpents are an echo of the vigilance which inspires the saying associated with them: "It could be that the snake is sleeping, but he continues to see."

93. *Oro efe* mask, Yoruba, Nigeria

wood, pigments; height 38 cm
This is a mask that affirms male leadership, tying it to the power of the Mothers, who are at its source. The face, bordered by a circular, segmented, and polychromatic protuberance that represents a beard (a symbol of wisdom and old age), is framed by large ears in the shape of swords that recall masculine aggression and the god Ogun. Between them there is the motif of the half moon that, like the head covering in the form of a crest, recalls the influence and power of Islam and echoes the nocturnal time of the ceremony.

94. Throne, Bamun, Cameroon

wood, beads, cowry shells, fabric; height 175 cm
The throne of the king Nsa'ngu was given in 1908 to the German emperor William II by his son, the king Njoya, as a sign of friendship and in recognition of his authority. The carved throne is based on a single block of wood and is covered in a cotton fabric on which colored beads and cowry shells are sewn that, through their chromatic contrasts, delineate the traits of different figures. Iconography and materials attest to the power and wealth of the sovereign: beads of extra-African origin, shells used like money, warriors who cradle firearms, the motif of a two-headed serpent that indicates the capacity to confront attacks on several fronts.

The figures placed on the summit represent twins, tradition-

ally carried to the court to serve the king, while the line of figures on the base are those of advisers.

95. Chair with male characters on their feet, Kom, Cameroon
wood, copper; height 190 cm
This chair, used for ceremonies and originally covered in small glass beads, was publicly exhibited for special occasions. It is attributed to King Yu, who reigned in Kom between 1865 and 1912 and became famous, beyond his political abilities, for his artistic gifts.
The human figure is an idealized representation of royalty and does not constitute a portrait of a specific king. No one is allowed to sit on the chair, not even the one king who occupies the royal office. The symbolically central element is that of continuity of the monarchy; for this reason every king (fon) sculpts, or has sculpted, a chair during his reign, placing it next to that of his first wife. For the same reason, these chairs were presented at the sovereign funerals, guaranteeing the permanence of the royal functions during the interregnum period.

96. Chair, Luguru, Tanzania
wood; height 109 cm
While the footstool, as archeological data has attested, has a long history in Africa, the chair seems to have made its appearance following contact with white people. Taken from outside, it was however transformed to respond to local aesthetic and symbolic needs. Luguru art was only recently discovered; among the major works are chairs with anthropomorphic designs. The chair is made from a single wooden block and presents a circular seat and a long arched back, finely inscribed with geometric motifs in the posterior section; on the summit rises a head with a crest-shaped hairstyle, while jutting out immediately below are two small breasts. On the base, there are three feet pointing towards the outside.

97. Vase for water, Magbetu, Congo
terracotta; height 30 cm
The Magbetu vases constitute an example of court art with a political function released from all religious significance. Their appearance is contextual to the arrival of the Belgians, and they were shown to the Belgians to prove the splendor of the Magbetu court and to suggest the Magbetus as interlocutors. The elongated form of the head recalls the cranial deformations as an aesthetic finality of Magbetu women.

98. Ntadi (ntumba) funerary stele, Kongo, Congo
stone, cement; height 39.5 cm
The funerary statues that commemorate the dead on tombs date at least as far back as the early years of the 1500s. This statuary, not being regulated by precise religious bonds, traditionally leaves the artist a certain liberty in the choice of the subject's pose. The knowledge of writing, with the professions it allows one to reach, confers an elevated social status.

99. "Traditional" and "colonial" figures, Baulé, Ivory Coast
wood, pigments and synthetic paints; height 35 cm - 51 cm
The figures of a colonial subject that the Baulé call sondjia ("soldiers") may be from the eighteenth century, from the period of their migration from Ashanti countries (A.-M. Boyer). They represent the whites or blacks as they adapted their customs. They may be a manifestation of the "spouses of the afterlife" (blolo bian) or perhaps of asie usu, spirits. From the times of the first contacts, in fact, the whites were exchanged — because of their formidable character, their unusual clothes, their long hair — for spirits of the brousse.
The "colonial" style and the "traditional" style do not simply follow each other, but coexist; in the mutation (the tapering of the figures, the amplification of the chromatic palette, the clothing directly sculpted and not added on), one can collect the continuity of style (traces of the face).

100. 101. Agbogho mmuo mask, Igbo, Nigeria
wood, pigments; height 46.5 cm
The whiteness of the face, the fineness of the markings, and the hairstyle in the crest form are typical of agbogho mmuo masks, which are used among the Igbo to celebrate the physical and moral beauty of young girls and to honor the spirits of the mothers. In this case, the reference to femininity is syncretically empowered, including an image of the Madonna and one of Mami Wata, the divinity of water in which iconographic elements of European and Indian origins converge. The two figures placed on the sides in oblique positions become, from a compositional point of view, integral parts of the hairstyle, taking from it also decorative motifs. The mirrors, often present in costumes of mmuo masks, increase its beauty and splendor.

102. Crucifix, Kongo, Congo, Sixteenth century (?)
copper alloy; height 51 cm
The spread of Christian iconography in the Bakong territory stems from the conversions effected by the Portuguese in the sixteenth century. The pose and proportions of the figures recall European tradition, while the markings of the face are typically African. These crucifixes, distanced from meaning and from their original function, were then used as figures to favor hunting and as such are enveloped by a medicinal sheath similar to other magical statues (nkisi).

103. Saint Anthony with the baby Jesus, Kongo, Congo
wood; height 51 cm
The figure of Saint Anthony of Padua, patron saint of Portugal, enjoyed a great reputation among the Bakong starting in the seventeenth century; however the statues that represented him were used outside of the intentions of the missionaries who spread them as talismans against evil spirits (Toni malau, "Anthony good luck charm"). Their presence endured even after the European missionaries left in the eighteenth century. This statue, carved in the nineteenth century, imitates European models, introducing African adaptations (the fly swatter that the saint holds in his right hand).

104. 105. Priestly hangings, Studio of liturgical art of Yaoundé, Cameroon
The Catholic church in Africa tried to privilege a renewal of the liturgy that would integrate symbols and forms from African traditions. On these hangings, we thus see the three base colors of the African shades of color, a symbol of the human condition, and a series of geometric and figurative motifs that trace a continuity between Christianity and African cosmology: the man and the "cosmic circles", the ovals and the small shells, a symbol of fecundity and of life, that are associated with cross are "the symbol of the redemption of our salvation" (Mveng).

106. 107. Priest and voodoo altar, Lomé, Togo
The voodoo cults diffused among Togo and Benin are full of Afro-American, Christian, Hindu, and Islamic syncretic elements. The divinities have characteristics that are at once human and non-human; the sacrificial offerings that have to placate or attract them and that must feed them, go to the blood of sacrificial animals, to perfumes, tobacco, and bottles of whisky.

108. Npungu figure, Nkanu, Congo
wood, fibers, herbs, small shells, animal skins, cola nuts, padlocks, pigments; height 26 cm
The traditional protective functions of statues of this type, receptacles that enclose forces, preserving them from outside attacks, explain the inclusion of modern padlocks among the materials that they envelop. The wooden figure acts on a functional and aesthetic level as a support for the applied elements. The only part that is still visible is the face.

109. Puppet of a sacred serpent, work by Danaye Kanlanféi, Lomé (Togo)
pumpkin covered with glued on fabric, bottle caps, wood, iron and nylon threads
This is a string puppet whose scenic contortions are accompanied by musical instruments played to evoke the spirits;

the material of recovery is regenerated within a new aesthetic and symbolic identity.

110. Coffin in the shape of a cocoa pod; coffin in the shape of a Mercedes-Benz, works by Kane Kwey, Ghana
wood, synthetic paint; length 266.7 cm, length 265 cm
The cultivation of cocoa was introduced in Ghana in the last quarter of the nineteenth century, establishing an economic development that made Ghana, beginning in 1910 and continuing through the 1950's, the world's largest cocoa producer. The economic importance of this cultivation made it into a symbol of social status. The use of coffins in the shape of cocoa pods to celebrate the economic success of the dead and the elevation to the level of the ancestors began after the Second World War. The cocoa pod, a fruit that contains the seeds of the plant, allows, on another high level, the allusion to the succeeding generations and to the permanence of their relationship.
The Mercedes is seen as the highest symbol of the achievement of economic success. The number of the license plate generally corresponds to that of the automobile effectively owned by the dead person, which is often flanked by the coffin during the funeral ceremony. Differently from the great part of traditional African art, the work is not based on a single wooden block but is the result of a work in iron. The line of separation between the base and the cover of the coffin passes above the doorkeeper.

111. Man in a coat and tie, work by Sunday Jack Akpan, Nigeria cement, acrylic colors; height 192 cm
S. J. Akpan (1940), a wall builder, sculpts life-sized statues in cement for funerary monuments, publicity signs, and gardens. Prominent Nigerians are celebrated through these figures. The hyperrealism of these statues does not have precedents in the artistic tradition of the Cross River (eastern Nigeria), and Akpan himself — for as much as he was not an inventor of the genre — presents his art as a radical innovation, a "gift of God," placing the accent on "fidelity to nature." Other Nigerian artists sculpt in a similar way: we are seeing the beginning of a new tradition that has extended the use of funerary monuments into areas where they were previously absent.

112. *Pelete-bite* fabric, Kalabari, Nigeria
cotton; height 88 cm x 131 cm
The aesthetic of this fabric rests on the manipulation of industrial products, generally imported from India and from England. The lined or checked design of the initial fabric is modified and dynamized by removing, in a selective way, a certain quantity of threads of the weave and the warp. Names deriving from the construction of "traditional" repertoires are attributed to the designs obtained this way. They are used by men and women as skirts, wrapping around them in life and funeral rites.

like Zanzibar and Mombassa, we see animal and vegetable motifs of local origin (the fish, the date palm tree), Arabic inscriptions, rosettes, and the lotus flowers of an Indian origin.

In the *kita ka enzi* chairs ("chairs of power"), there may instead be an indirect reflection of European models, on the basis of the exotic nineteenth century versions produced by English colonialism in India. They share with European chairs the squared form, the high back, the foot rest, the technique of interlacing, the insertion of wood and ivory, but they are distant at multiple points, as much from a visual aesthetic as a functional use[47]. It is interesting to note how the other hypothesis evoked to explain the genesis of these chairs, while retracing a different origin, also delineates a grid of wide-ranging influences. Constructed from the sixteenth to eighteenth centuries, inspired by Egyptian models, they would then be brought to the United States by American travelers in the second half of the nineteenth century, where they were known as "Mississippi boat chairs"[48].

It was instead on the confines between the savanna and the desert, in a wide open space that communicates easily with the outside, that the medieval empire of western Africa was born, where the camel gave way to the ass or the canoe of the Niger River, door and hinge in the commercial exchanges between the forest belt and Mediterranean Africa. Salt, fabrics, utensils, beads, and manuscripts arrived from the north; from the south came gold, slaves, cola, rubber, ivory, and animal skins[49].

These empires, sometimes of notable dimensions and incorporating thousands of villages, demonstrate the existence in pre-colonial Africa of vast intercommunal and incorporated spaces, of which local society would be not the point of departure but the effect.

Ethnic identity would not therefore be the consequence of isolation from society, closed on itself, but the result of participation differentiated by a series of relational spaces (economic, political, religious, linguistic)[50].

Permanent urbanized populations or populations disseminated in the countrysides, nomadic animal breeders, itinerant merchant communities who, based on their differences, formed symbiotic relationships in a network of economic, monetary, and matrimonial exchanges, a web of relationships of strength in which the position of each one is de-

99. Principal commercial Trans-Saharan passages between the fifth and eighteenth centuries

The desert has never constituted an impenetrable barrier; in the Sahelian zone, along the caravansary paths that connected the Mediterranean to tropical Africa, great kingdoms and commercial cities were born.

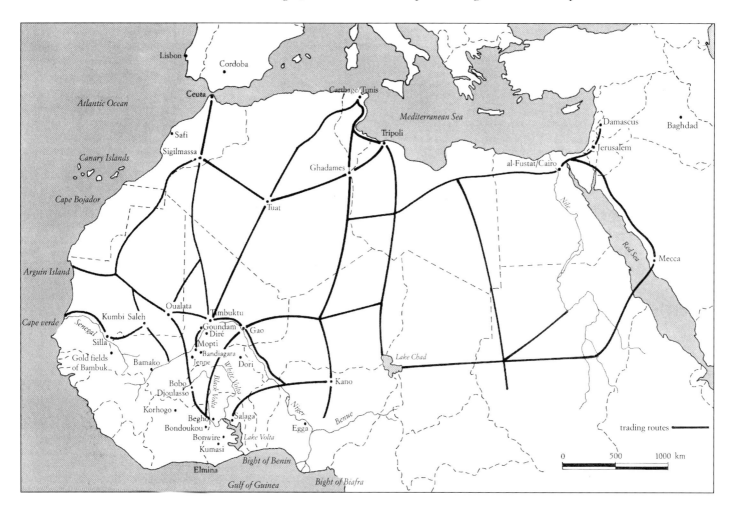

termined by the diverse capacities of making itself valued, of proceeding in a delimitation of space prevailed over by great political and warrior institutions that press down on the weakest groups, reducing them to tributaries and slaves or pushing them to emigrate, a space, therefore, in which coexistence is not the "harmonious" one of lost villages, but which was tied to open and complex societies.

In a city like Timbuktu, the seat of an Islamic university and a great center of commerce that reached its apogee in the sixteenth century with the Songhay empire, there were North African and Tuareg merchants and diverse black populations (Soninke, Fulbe, Mandingo, and Songhai).

An intertwining of languages, cultures, and religions made the Sahelian cities into great cosmopolitan centers and explains the vast iconographic variety of terracotta statuaries that came to be produced in the internal delta of the Niger between the twelfth and seventeenth centuries. The hypotheses that have been used to explain their appearance share this same base. Some see them as an act of symbolic instrumentation for resolving the emergent ambiguities of ethnic and social belonging in a phase of urban development[51]; others see them in a contrary way, attributing a trans-ethnic function to them, reducing the differences to the internal articulations of the same, broadly shared animist cult[52]. In the first case, we see a differentiated sign function. In the second, we see a unifying element, diverse exigencies which share, however, a presumption of the same level of cultural complexity.

100. Scene of childbirth, Djenné, Mali; terracotta, height 21 cm

The sculptural art of the Djenné (12th-17th century) developed in a cosmopolitan and multi-religious environment; the statues operated in a cultural context. In the figure reproduced here, a rare case in African art, the figures interact to compose a scene: the male figure leans over the woman in labor, and supports her body and her head.

The arrival of Islam modifies the African conceptions of time and space, the relationship between words and things and images.

Islam brings with it the formal time of the lunar calendar, a histographical time defined by a precise chronology, a liturgical time scanned by religious festivals, prayer, and the long pilgrimages to Mecca.

This diverse conception of time intervenes to remodel the myths of creation. In the areas most strongly impacted and in periods of particular pressure from Orthodox Islam, the African populations – as in the case of the Mandingo – thus redefined their identity, changing names and reworking the stories of their own origins, giving themselves another connection in time and space. Affirming their Arabic provenance, they tried to draw themselves closer, not only geographically but also *temporally*, to the center of irradiation of the Islamic religion, to occupy a space of greater importance, here and now, within the community of believers (*umma*)[53].

The changes that Islam induces diversify not only in relationship to the different societies they touched but also within each society, producing an overlapping and a coexistence of different places and times.

Before 1900 in the kingdom of Gonja, situated to the north of the Ashanti kingdom, the activities and perspectives of the rulers, common people, and foreign Muslims were clearly distinct[54]. While the space and time of autochthonous populations were cyclical and circumscribed by agriculture, a local and parental space and time, defined by the matrimonial practices and the spaces of the cult, those of the rulers were a political space that placed the kingdom within a web of friendly and hostile states, among whose interstices were connected the acephalous societies, objects of raids. Muslim society, in the end, was even more extensive and crossed over the borders of the kingdom to look to the entire Muslim community of western Africa, a space conceived more in terms of lines of communication (those of commerce and pilgrimages) than in terms of local units opposed among themselves, a space crossed according to the times of a calendar marked by salient episodes in the life of the prophet.

In this variegated situation, the power of the rulers was expressed in the capacity to mediate between diverse conceptions. Their time is thus that which ensures the continuity and pervasiveness of power within the society: dynastic time and ritual time stressed as much by the principle of Islamic feasts as by agrarian ones.

This exigency of commutation and translation from one "place" to another pushed, at times, the creation of conversion tables like those in Benin which allow the passing of the traditional calendar based on the four-day week to the Islamic one of seven days and to the European one, correlating the polytheist celebrations with the Muslim and Christian ones[55].

This duplicity is visibly traceable on the ground. Villages and cities are constructed around two diverse religious, cosmological, social, and urbanistic centers, one represented by the ancient ancestral altar that allows the connection of familial and clan relationships and the other defined by the oratory of the *Ka'ba* which indicates the religious and geo-

graphic center of Mecca, imposing it in a manner tied to the dispositions and orientation of the buildings.

Thus around the tenth century, the Soninke dynasty of the Ghana kingdom, which made use of the services of ministers and Muslim merchants, assigned to itself a part of the city in which it placed its palace headquarters and where it placed the statues of the ancestors. It reserved the opposite side, where the Mosques grew, for the followers of Islam, but it also allowed a mosque to rise in the vicinity of the royal palace to accommodate the Muslims waiting to meet the king[56].

Separation was not, however, the only residential model: in the city of Oulata (Mauritania), the north African Muslims often united in marriage with local women. Black people from different populations, Berbers, and Arabs were intertwined there.

Islam assisted in "the institutionalization of a different set of prescriptions concerning behavior in space, to the transposition of hodological space into Euclidean space" that was mathematically defined[57]. It is the order of the faithful in prayer, positioned behind the *mama* in lines that parallel the wall of the *qibla* to whose center the niche of the *mihrab* opens through the perpendicular line that ties the devout to Mecca.

Sometimes, the figure of the architect coincides with that of the mathematician and ties itself therefore to a written geometric knowledge through which a more uniform reproducibility of buildings was derived.

African space is occupied in the stitches of alphabetic writing and arrives there in a certain stiffened measure. The obligations are not those tied to the plasticity of oral tradition but those of Koranic law deposited in the books of commentators (the *Kitab-al-Muwatta* of Malik of the ninth century and the *Mukhtasar* of Kahilil ibn-Ishaq in the fourteenth century). The constructed space begins to turn to monumental buildings – the mosque first among them – that would have to utilize materials that guarantee them permanence. The construction of the black islamicized dynasties corresponds to the development of a monumental architecture that brings it to a more marked visibility of signs impressed upon space, emphasizing duration and a stronger separation of construction from the natural environment: the sacred tree is added to or superimposed on the minaret.

This geometric space is not, however, the instrumental space of mathematics applied to modern technology as much as the space of a symbolic numerology. The number seven is not thus a simple quantitative index but recalls a cosmological symbolism of seven skies, seven hells, and seven planets, while the number five echoes the five pillars of faith[58]. This way, the inside of the houses with a rectangular lay-out in Timbuktu is subdivided by walls in nine quadrants that form the rooms and the courtyard, tracing the magic quadrants whose numerical combinations tend to ensure the protection of Allah, at the same time es-

101. Mosque of Kawara, Ivory Coast

The forms of the clay mounds which create altars to the ancestors and constitute elementary architectonic modules of fortified Sudanese dwellings echo the constructed elements of the mosques that represent the same conical shape to the fences, walls and pilasters. The protruding lines that, in addition to ensuring the cohesion of the constructions, recall the vegetable symbolism of germination and renewal of life are typical of Sudanese architecture.

tablishing an anthropomorphic symbolism in which each of the rooms corresponds to a part of the body; the door to the head of a man, the vestibule to the head of a woman, the courtyard to the stomach, the man's bedroom on the eastern side to the right arm, and the woman's bedroom on the western side to the left arm[59]. It is an anthropomorphism that also involves the interpretation of mosques, which were seen by the marabouts themselves as representations of a man or a woman in prayer, whose head corresponds to the minaret[60].

With the insertion of a long-distance commercial network and more accentuated urbanization brought on by the arrival of Islam, there was a growth of social differences and divisions of work.

The city is more cleanly distinguished from the villages and countryside, architectonically opposing the square to the circle: rectangular buildings with flat roofs on one side and circular constructions with conical thatched roofs on the other.

More than anything, the form of the mosque, and thus the shape of houses, must be "squared", in imitation of the *Ka'ba* of Mecca.

Although there are many exceptions in areas where circular constructions with internal courtyards prevail, the homes of the islamicized Mande merchants have rectangular plans. In areas where the most diffused model is quasi-rectangular with cumulative and labyrinthine development, that among the Diula distinguishes itself by the positioning of spaces around a central internal courtyard[61].

The institution of private property reduces common spaces and introduces a clearer difference between public and private, individual and communal. The streets of cities like Timbuktu demonstrate a sequence of continuous walls interrupted only by a few doors or windows placed on the higher floor to prevent any visibility from the street. Doors and windows never face each other in order to prevent the penetration of a glance into the space of others.

The carving out of private and individual spaces does not however exclude moments of high visibility. Muslims do not pray only in the mosque but wherever they find themselves, simply isolating the prayer space with the matting on which they kneel. The streets, in particular during *Ramadan*, often become theaters of collective celebrations. From this point of view, their visibility is perhaps greater than that of Christians, who tends to close themselves in churches, and this may have been an influence on the diverse capacity of diffusion of the two religions in western Africa[62].

102. Plan of a Hausa dwelling, Zaria, Nigeria

The Islamic dwelling decisively marks the separation between internal and external and between masculine and feminine spaces. Beyond the entrance to the compound, fenced by high walls, an initial circular construction indicates the limits beyond which foreigners of the male sex cannot proceed: here the head of the compound receives friends, dedicates himself to tailoring or embroidery, teaches the Koran. Access to internal courtyards and residential units is covered by matting that distances them from indiscreet eyes.

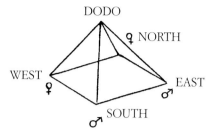

103. Religious symbolism of the domes of Hausa buildings, Niger

In the spatial symbolism of the domes of Muslim Hausas, we see the pre-Islamic divinities: on the summit of the celestial vault is Dodo, a kind of man-eating monster, while at the four cardinal points, according to a sexualized polarity, there are the sons and the daughters. The relationships between the four cardinal points are seen on a model of relations between couples, space thus appears as a field of convergent and divergent forces that separate and maintain the unity of the group.

104. Mosque of Doumga Ouro Thierno, Futa Toro, Senegal

Built towards the end of the nineteenth century and reconstructed in the 1930's, it was replaced in the 1980's by a cement mosque. The squared plan and the three entrances recall the model of the house of Muhammed and Medina; the wish to remain faithful to the simplicity of Islamic origins leads the Toucouleur of Futa Toro to refute the minaret as a blasphemous innovation.

(Facing page)
105. Mural decorations of the entrances and windows of a Hausa dwelling, Zinder (Niger) and Kano (Nigeria)

Magic virtues are attributed to Arabic writing; the virtues intervene on the writing, disassociating the writing from its meaning and manipulating the forms of writing to increase its power. The inscriptions placed in correspondence to the openings (doors and windows) protect the home. The "knot of wisdom" is a recurring element, probably of North African origin; sometimes the geometric and abstract design transforms into a figurative one.

The public-private distinction particularly touches the sexual divisions of labor and spaces. Islam is accompanied by a strong push towards making things sedentary and towards the passage from matrilocality to patrilocality. If the tent of the nomads was built by women and though of as being under their jurisdiction, the fixed habitation is instead a masculine property. If first the men built homes and the women dedicated themselves to the outer surfaces, with Islam this assignment finished with the reentrance of the process of building, and the work of women was confined to the decoration of internal walls[63] (Plates 86-87).

Between these two different conceptions of space, there are not only oppositions but also continuities: the east indicates the origin of the rising sun before it signals the direction of Mecca.

The Hausa of Niger, despite intense islamization, conserved an anthropomorphic and sexualized conception of space that dates back to pre-cosmologies and in which the criteria of demarcation respond to the complementary idea of opposites[64]. For as much as the Hausa kingdom of Gober is formally Islamic, the king, to be able to reign, has to forge, even against his personal convictions, alliances with pre-Islamic clan divinities that continue to influence his reign.

"The flux and reflux of the *brousse* around the islands formed by villages" continues to regulate the rhythms of human activity. When the dry season nears and the brushwood invades the fields, obscuring their borders, it is again the hunters' turn to ritually "open" the *brousse* to be able to penetrate it while the divinity of the fields (*iskoki*) pulls back into the granaries. With the return of the rainy season, it will be the spirits of the *brousse* (*iskokin daji*) to draw back while the men and agrarian divinities leave the villages and granaries to go to the fields and "close" the *brousse*, suspending the hunt.

Such representation of places does not limit itself to surviving the geometric conception of space from an Islamic derivation, but brings it with itself.

Hausa architecture, with a cupola on a squared base is an emblematic case. On the summit of the cupola, as in the pre-Islamic celestial vaults, there is Dodo, the divine female man-eater, and on the four corners the children, male (south and east) and female (north and west), a marriage stressed in the building techniques in which the North African Islamic influence would be seen as much as the traditional cupolas of branches and bushes in the dwellings of the Fulbe nomads. The building becomes solid, but, because of the absence of stones and bricks, under the cover of clay there are vegetable materials interlaced according to traditional techniques. The result is that of a "visible synthesis of multifarious, contradictory aspirations within a unified image: mobility, identity with Islam and a state of becoming sedentary"[65].

Sometimes, the modifications intentionally brought to Islamic North African architecture through the revival of local traditions aim to realize a more coherent fidelity to the Koran. The mosques of Futa Toro (Senegal), built between the seventeenth and nineteenth centuries, take the house of the Prophet as a model, making the squared plan and three entrances their qualifying elements while disregarding the minaret, seen as a blasphemous innovation and in contrast to the simplicity of the origins of Islam. In its place is a chapel that is limited to serving as a refuge from intemperate weather conditions on the stairs used to reach the roof, allowing the light to filter to the underlying floor[66].

The architecture of the Songhai empire is exemplary for its syncretic nature and, in particular, the mausoleum of Askia Mohammed in Gao, whose formal and symbolic analo-

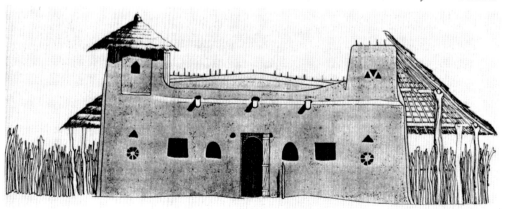

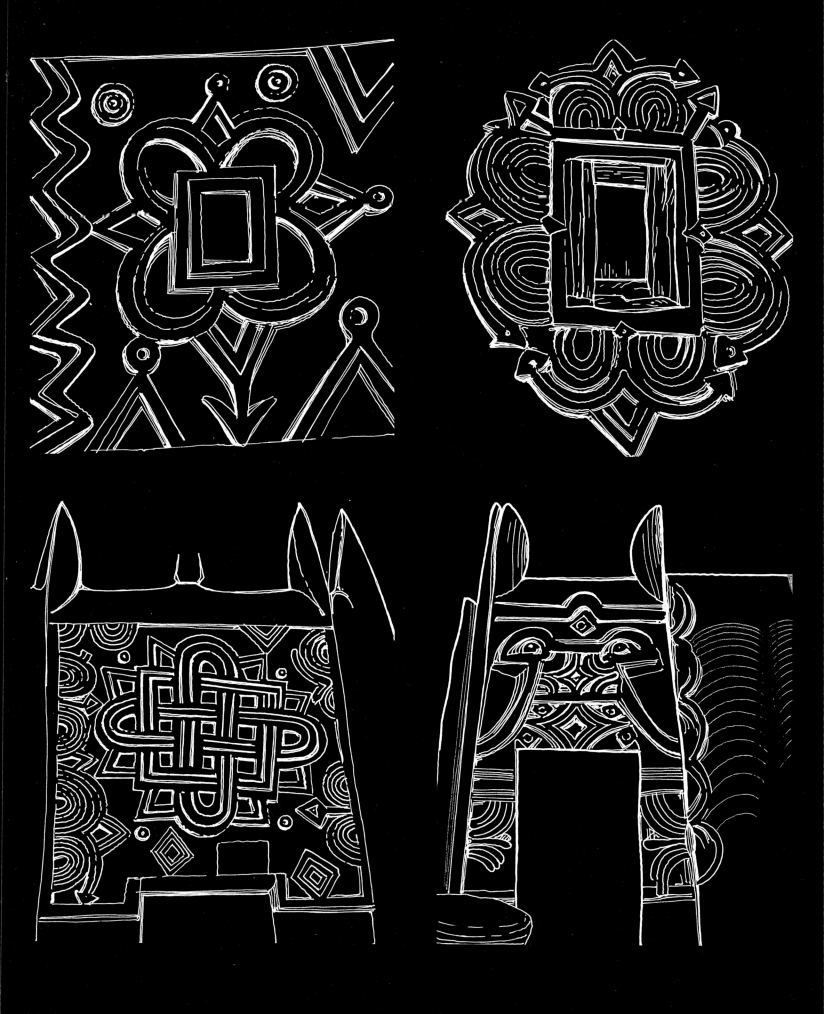

gy with the *ziqqurat* of Mesopotamia bridges the earth and the sky and which provides an entrance for bold speculations (Plate 85).

The building reprises the conical form of popular architecture and of ancestral tombs, developing it into a pyramid with four sides and three levels. The space on which it rises was probably that, delimited but not constructed on, already destined to the cult of the ancestors in pre-Islamic times. The monument inherits the symbology of the center from it, projecting it vertically and placing it within Muslim numerology.

The religious and architectonic influence of Ibadite Islamic sects appears with the traditions of Mandingo constructions. The supports (*toro*) that are projected horizontally from the walls of the building constitute a peculiar stylistic element of the Islamic architecture of western Africa. They reinforce the structural capacity of the edifice and symbolically recall the branches of a tree, suggesting the germination and rebirth that are associated with them.

But if monuments and Islamic mosques can make certain elements of architecture and black African plasticity their own, and the conical altars of the ancestors transform into minarets, it is also true that the traditional sanctuaries sometimes mutate their forms into mosques.

106. Alekwuafia mask, Nigeria

The spread of this mask is likely due to the movements of populations caused by the Fulani Jihad *in the nineteenth century.*

107. Mask of the do *cult, Jimini, Ivory Coast, wood, black with details in white and blue, height 39 cm*

The masks of the do *cult are, in the circle of Bondoukou, strictly associated with Islam: their use is restricted to the Mande Muslims, and the rituals in which they appear are strictly tied to the Islamic calendar.*

4. Images of Islam

In general, it is believed that the spread of Islam acted on African arts, developing a tendency towards abstract decoration and bringing it towards the disappearance of figurative art[67]. These considerations certainly contain a partial truth, but, becoming stereotypes, sometimes end up with the hiding of a reality that is much more variegated. If figurative art decreased in certain cases with the advance of Islam, in other cases it seems by the same rights to have been encouraged[68].

Paradoxically, precisely the iconoclast *jihad* launched by Fulani in the nineteenth century may have been, with its moving of provoked populations, the vehicle for the spread of pagan masked cults, as in the case of the *alekwuafia* masks in the area of lower Benue and its confluence[69].

In addition, Muslims (Hausa, Mande, Wolof) account for many of the contemporary merchants of African art. Their extraneousness from the cults with whom the objects are associated privileges their commercialization. If this certainly constitutes a dissolving factor, it nonetheless contributes to the maintenance of the life of the arts and encourages, if not resuscitates, the traditional arts, while the growing mobility of objects brings a growth of the variety of styles with which African artists come in contact.

There are, however, more profound reasons that explain the persistence of traditional sculpture in the areas reached by Islam. For as much as its influence was widely extended, it did not supplant traditional religions. The Muslim religion, in fact, permits the rising of an eschatological hope of an otherworldly salvation, but does not respond in a satisfying manner to daily terrestrial problems: the absence of rain, the fertility of the soil, defense from witchcraft.

If the universalistic religions seem better equipped than autochthonous religions to deal with the dangers and dilemmas of globalization, allowing Africans to insert them-

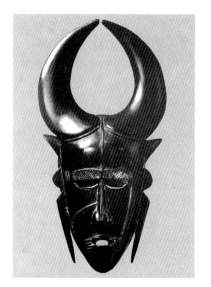

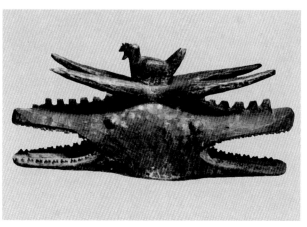

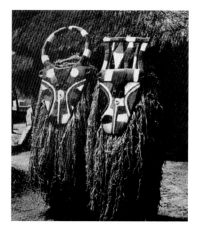

selves in a planetary context, they do not, however, seem to be able to substitute in local questions that demand a rooting in the earth. Sometimes, on the other hand, the polytheist religions seem to be able to expand victoriously. If among the Badyaranke of Senegal *ufann*, the spirit that adores palm wine and cannot bear the smell of gasoline in trucks, withdrew into the forest, leaving the field free to Allah[70], in Nigeria Ogun, the Yoruba god of iron and war, instead made himself the protector of truck drivers as well.

Masks and statues can thus continue to exist, exercising a distinct and complementary function with respect to Islam, even drawing from magic and demonologic foundations of Muslim culture. Islamic amulets and magic squares thus find a place in the pagan cults, while masks sometimes appear in Muslim celebrations[71]. The cohabitation of Islamic and pagan practices is therefore explained with a functional division of roles, with their diversity and with the presence of a shared background – beliefs in witchcraft, magic, divinatory practices – and thus with a certain perceived proximity.

Mutual exclusion and conflict are not the only possibilities in the relationships the Muslims and followers of traditional religions create around the masks: they also find a wide variety of positive ties.

In the circle of Bondoukou (Ivory Coast) and in center-western Ghana, such relationships are signaled by connections and distinctions on multifarious levels.

Bedu masks are the expression of traditions clearly outside of Islamic religion, but they are tolerated by the Muslims. Even the Muslims assist in the performance that goes towards the benefit of both religious groups, and very often it is precisely the Muslim artists who carve them. *Ghain* masks instead see the active cooperation of both, and as much as their compatibility with Islam is a subject of controversies and is not accepted with unanimity, it seems that their origins are precisely from Mande Islamic groups (Diula, Hwela), and that only later did they spread among non-Muslims. Finally, *do* masks are the exclusive patrimony of Muslims, and their presence honors the *imam*, the highest religious authority.

The presence of masked cults in other areas of Africa with strong Islamic presence – areas of Kong and Gonja, of Bobo-Dafing and Mossi of Burkina Faso, Bozo and Marka of Mali, the kingdoms of Nupe and of Ilorin in Nigeria –demonstrate that we are not speaking of an exceptional case but of a relatively widespread situation.

The vitality of African visual arts is not limited to simple resistance, but is expressed in the capacity to evolve with the changing situation. Not only have the traditional arts survived the wave of Islamic influence, they have even integrated and reinterpreted motifs, themes, and figures, while artists of black Africa have given their original contribution to the religious art of Islam, figuratively treating themes like the life of the Prophet that are normally excluded from representation.

From this point of view, we find exemplary cases in the portrayals of Mohammed's voyage from Mecca to Jerusalem and his ascendance to heaven through the representation of his winged mount Al-Buraq. It is a representation that in an indirect way allows an allusion to God, to whose presence Mohammed was driven.

The Koran refers to this creature but without giving her a name or describing her. It was the commentators who later gave precise outlines, conferring on Al-Buraq a legendary prominence that made her one of the preferred themes for poets and miniaturists. The

110. *Performance by the puppeteer Agola Mamane, Zinder, Niger, 1991*

Satire and social criticism are expressed through the puppets. The "saint-man", who is also a diviner, proposes his attractive males to the young girl who consults him to discover the name of her future husband.

(Facing page)
108. *Ghain mask, Ghana, wood, length 78.7 cm*

The mask intervenes in the hunt for witches. For as much as its appearances do not follow the calendar of Islamic liturgy, the rituals that renew its power are celebrated in the Mande Muslims' most important magic day of the year: the san ielema seri, *the day in which the waters of the flood begin to subside. The mask's power, on the other hand, is guaranteed by amulets with Koranic verses and by offerings of food eaten on the occasion of important Islamic festivals.*

109. Bedu *mask, Nafana, Ivory Coast*

The origin of these masks is attributed to the Mande Muslims, but their use is widespread even in non-islamicized groups; they propitiate fertility, prevent epidemics, heal children. They make their appearances, in pairs, at the death of the most influential elder.

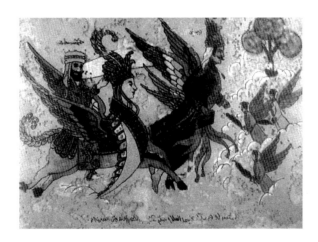

111. *The nocturnal ascent of the Prophet, anonymous, Senegal; painting under glass, 33 cm x 54 cm*

Al Buraq, the fabled mount allied with Muhammed, is one of the favorite themes of African Muslim artists. In the paintings under glass, there are fewer prohibitions on the figurative representation, and Muhammed himself is painted with an exposed face.

112. Throwing weapon of the Mahdist army, Sudan, late nineteenth century; iron, crocodile skin, leather, height 34 cm

The form recalls that of the throwing knives of the non-Muslim populations in central Africa. However, the fluid lines of the original model surrender their place to angular lines that render the weapon more functional in hand-to-hand combat. The curvilinear element returns to the surfaces, entirely covered in pseudo-Arabic inscriptions. Such flourishes cannot be read, and yet it seems unlikely, seeing the care with which they were executed, that they were mistakes: if an analytical correspondence between word and sign is missing, it is, however, probable that the writing had to capture the Word of Allah in such, insuring the presence of God at the side of the fighter.

113. Slit drum, Sudan; wood, length 271 cm

This drum, which belonged to Mahadi Khalifa, was brought by Kitchener, commander of the Anglo-Egyptian forces, to Queen Victoria. On the figurative drums of African tradition, there are geometric and floral designs of Islamic derivation whose regularity expresses unity and the presence of God: the voice of authority that pushes towards battle comes from the drum.

African artists renewed this traditional motif, creatively inserting it in their expressive forms.

Al-Buraq thus assumed not only a sculptural form, but was made into a mask. In Sierra Leone, in the capital of Freetown, her mask appears for celebrations at the end of *Ramadan* in which not only Muslims participate but also Christians and followers of polytheistic religions. The sculpted image of Al Buraq also appears among the non-islamicized Baga of Guinea as part of their traditional initiation; when she appears on doors it is instead to protect the house from witches[72].

In non-African images, Al Buraq is represented without her rider or without allowing the face of the Prophet to be visible for fear of idolatry deviations, but in Africa this prohibition is not always affirmed with the same rigor, and thus it can happen that in the glass paintings of Senegal Mohammed makes his appearance with a revealed face[73].

In Africa, the high consideration for images, more than contaminating Islam with extraneous elements, seems to have allowed it the exploration of its repressed possibilities with the margin of liberty that can only be enjoyed on the peripheries. As we cannot talk about Africa without pluralities, without a multiplicity of differentiated realities, so we can say of the Muslim *umma*: "There are not but those *of* Islam, the results of perpetual negotiation between universal and ideal norms and those who appropriate them."[74] Some African Muslim artists will thus bypass the suspicion that the production of images is a challenge to the power of God the Creator, presenting their works not as an imitation of the omnipotent but as one of His "sparks"[75].

In the history of Islam, there are, on the basis of the unity of Koranic text, different culturally and temporally distinct behaviors in confrontation with the image[76]. The iconoclastic attitude is not directly traceable to the Koran but to the *hadith* (the collection of thoughts and sayings attributed to the Prophet, reunited after his death and systematized by commentators during the tenth century) and to the juridical interpretations that were given of them.

In fact, as much as the ban on the portrayal is already seen in the Old Testament (Ezek. 20.4), the Koran does not prohibit the image as much as its drawing nearer to God. Only the Word is appropriate to the unity of God, while in the multiplication of images there is the danger of idolatry. In this perspective, it is sculpture even more than painting that appears threatening because of its physicality. The image takes on an ambiguous status: from one side it is admitted in its playful valence as one of the licit pleasures of earthly life. The seduction exercised by the image is condemned as it interferes with the Word, presenting itself on the vertical plane of communication between men and God. Its threatening nature is neutralized by moving it to a horizontal plane, relegating it to the margins of the communal order.

"It is not thus the act of the vision that makes the community but that of *reading* and of the collective *listening* of a *voice* whose power produces the united being."[77] Differently from Christianity, in which with Christ the Word is made flesh and the community is built around the vision of His body, in Islam the attention is placed on the essentiality of the Word to which the person of the Prophet provides only a communicative support. The Word of the Koran is not in fact a testimony but the Word of God itself.

The word does not completely cut off its relationship with the visible, but finds its stability and visibility in the writing that does not limit itself to preserving the meaning of the word, but visibly stresses it through a refined graphic and aesthetic elaboration.

In Africa, Arabic inscriptions appear on a large quantity of supports: on the matting for prayers, on fabrics, on amulets, on containers, on dwellings. The word thus acquires a physicality. The man who clothes his own body in the fabric on which the name of Allah is written innumerable times realizes an intimate contact with divinity and places himself under His protection (Plate 88). In this saturation of the surfaces of the fabrics, through the geometrically ordered repetition of words, one can find a graphic analogy in the litanies of the Sufi confraternities of western Africa in which the repetition of the name of God thousands of times is the method of uniting oneself to Him[78].

The introduction of Arabic writing in Africa undoubtedly brought great changes, but its diffusion did not coincide with the formation of a literate minority. In fact, it came about in great part irrespective of the knowledge of the Arabic language and of the capacity to read it. Its spread outside of a literate minority was verified in the continuity with the traditional conceptions of writing, untying it from the word.

This can clearly be seen in the wrapping, very widespread in western Africa, of amulets that contain Arabic inscriptions. Constructed from diverse materials (wood, paper, fabric, leather, etc.), they generally unite writing and design: Koranic verses, citations

from books,, astrology, divination, numerology, a great variety of geometric figures, magic squares, images of planets and their movements. This is a custom in which Africa renews and encounters the magic conceptions that already fill Arabic writing[79].

For the Muslim believer, the force of these heterogeneous elements is derived not from their intrinsic power but from the word of God, who is the primary source. Such a sedimentation of words allows people to intervene, exercising their analytic and manipulative abilities. In different writing styles, in the separation and recombination of letters, words, and formulas, in their geometric distribution, the word is used as a defensive shield to protect the person or the house. When the signs within the squares refer to an evil force like the evil angels and *Jinn*, the squares often have reinforcing borders. It happens differently for the word of God, which cannot be contained in the borders that encircle it[80].

Often, the inscriptions of these amulets are neither read nor seen nor understood without this being seen as a limit. The conditions of their efficacy are precisely the secret and silence that envelops them. Their incomprehensibility, in fact, predisposes them to being filled with esoteric and sacred implications. Their power is thus thought of as stronger the more that there are sheaths that hide the word.

The use of these otherworldly amulets does not necessarily imply the conversion and obedience to the sayings of the Prophet, and even non-Islamic populations use them. The strength that is attributed to the writing in its materiality protects the disregarding of their meaning. For this reason, it can happen not only that stanzas of children's nursery rhymes also appear next to Koranic verses, words, letters, and isolated numbers but that the inscriptions lack any complete sense, conserving only a certain graphic resemblance to Arabic writing[81]. In fact, often not only the person wearing the amulet but also the person preparing it are illiterate. The circuit within which the writing is taken thus is no longer linguistic, and what counts is the presence of the writing in and of itself[82]. The writing does not demand that it be read to spread its effects; it is enough that it be worn or that it be drunk. A decoction of verses can guarantee them the most complete assimilation.

Arabic pseudo-writings can also appear in the interior of masks, seeking to connect different traditions synergistically, and phylactery can be added to them or directly carved in, as happens in certain Mende, Baga, and Yoruba masks (Plate 92).

This use of writing that privileges the visual aspect to its significant connection with discourse is tied to the African predilection for geometric design. Also in this case, more than in a unidirectional influence, one has to see it as an encounter between diverse cultures on which common ground can be constructed. Islam changes Africa, acting as a lever for something that it already possesses. Geometric design extends its presence, becomes more regular, and acquires new motifs.

Dispositions and attitudes present in African traditions like the recourse to allusion, elision, and indirect and cautious expression in the artistic field as much as in social relationships are renewed and bent by Islam into a new direction. The geometric design, through repetition and continuous variation of its shapes, can suggest immanence and at

114. Ashanti, Peul and Berber textile designs

The design of carpets of Upper Atlas is filtered through the mediation of Sahelian islamicized populations in the area of the forest: they share the checkerboard structure and the subdivision of squares into diamonds and triangles.

ASHANTI PEUL BERBER

115. Adinkra *fabric, Ashanti, Ghana; printed cotton, height 271 cm*

The adinkra *are worn as a sign of mourning. In these fabrics, the Islamic influence would be present both in the subdivision of surfaces into squared forms and in the signs that cover them. The motifs, arranged within a geometric grid created through stencils, recall the Kufic writing of North Africa and the decorative motifs of Islamic architecture.*

116. *Alphabet of* tifinar *writing, Tuareg*

117. *Signs of* bogolan *fabrics, Bamana, Mali*

The signs of bogolan *fabrics carry symbols. The design reproduced here is known as "the war between Samori and Tieba", a warrior* imam *and the king of Sikasso, respectively (nineteenth century). The continuing line is that of the walls of Tieba, the capital of Sikasso; inside are the pillow of the Maure women (a sign of nobility), the house of pumpkin flowers (dwelling of important people), and the drum of the king's minstrel. The zigzag lines outside the wall instead signal the trajectories of the attack of Samori soldiers. The circles with the point in the middle recall instead another event: the battle in which the Samori were defeated by the French.*

the same time the intangibility of the divine presence on the one hand while on the other it recalls the reserved approach that characterizes interpersonal relationships[83]. The problematic state of translation of the divine, which is already present in African religions, takes on a more decisive aniconic orientation, while privacy assumes a greater importance in social relations, as is clearly recognizable not only in the architecture of houses but also in clothing.

The fabrics clearly testify to this grafting.

For as much as the presence of weaving and the cultivation of cotton in western Africa can be seen as precursors to the arrival of Islam[84], it is certain however that their continual spread took advantage of the expansion of the Islamic religion. Islamic morality brought an exterior respectability that cotton helped realize, and commerce profited from this consequence of morals[85]. Sometimes, the newly converted, with a certain pragmatism, saw in their religion the possibility of acceding to the luxury goods that came from the North. In the thirteenth century, the sovereigns of the Mali empire joined Islam and fabrics became the visible sign of their power over their subjects.

The advance of cotton brought a decrease in nudity nearly everywhere (there was, however, often decorated, tattooed, or painted nudity, thus another form of clothing) and the reduction in the use of animal skins, beaten bark, books, and raffia. Their duration is often limited to ritual contexts within which they perform functions of great importance.

The development of weaving will be such that in the city of Timbuktu in 1591 there were twenty-six tailoring *ateliers* employing from 1,500 to 2,000 workers[86], while the hundreds of strips of fabric found in the cliff of Bandiagara in Mali provide evidence of a well-installed local production and active currents of exchange as early as the eleventh century[87].

In black Africa, fabrics from the Middle East, Indian cottons, and Chinese and Yemenite silks arrived and went to enrich the magnificence of the court.

It is interesting to note that if religious discriminators hampered African sculptural traditions from influencing the northern part of the continent this did not involve fabrics. In the fifteenth century, materials in blue indigo cotton from Gao and Djenné were sold to Berbers in the Sahara, the Arabs of the north wore fabrics form Guinea, and the Bornu (to the south east of the river Chad) exported cloth dyed with saffron[88].

The influence exercised by the design of the Berber rugs of North Africa on the fabrics of western Africa is traceable in the checkered compositions (possible multiplications of magic Islamic squares), in the placement of diamond-shaped geometric motifs on horizontal lines. The design of the multi-striped blankets of the Peul, materials on the narrow horizontal looms of western Africa, reveals the effort of conserving the motifs of the rugs

of the North. The design is developed along long horizontal lines transversely to the assembled stripes, restraining the vertical orientation impressed by the loom[89].

In western Africa, the spread of Islam is accompanied by that of the technique of embroidery, which can be considered a from of writing. Embroiderers in fact are part of the small literate Islamic minority, and there are often words or graphemes to be embroidered. The geometric shapes are retaken from Koranic texts or tablets (Plate 89).

Kufic writing would instead be at the origin of painted motifs on the *adinkra*, fabrics used by the Ashanti in funeral ceremonies, while some of the signs that appear on the Bamana *bogolan* seem to be able to be traced back to the writing on sand (*tifinar*) of the Tuareg.

5. *White Skin and Black Masks: From the Space of Discovery to the Construction of Territory*

It is from the end of 1200 that Europeans began venturing along the coast of western Africa. The first direct contacts with the *oba* of the Benin kingdom were established in 1486. the following year, Bartolomeo Diaz would touch the southern tip of the continent. Relationships with sub-Saharan Africa are thus anything but recent, and contacts were established as early as Greek and Roman times.

The interest in Africa of late medieval and Renaissance Europe moves more than anything from the strategic relevance of an anti-Arabic function. The objective is that of bypassing the Muslim antagonist, finding a new route to the Indies or an access to African gold deposits that would avoid Arabic mediation. If in his explorations the Portuguese Prince Henry the Navigator (1394-1460) was moved by the desire to reach the Christian empire of Ethiopia to establish an alliance against the Muslims, the trading of gold, ivory, and the slaves of western Africa would later become the principal objective.

For as much as the European presence in internal Africa became determined only after the First World War, direct and indirect contacts between elite, indigenous, and European emissaries date back many centuries and are clearly seen, in particular, in the evolution of court art that constitutes a large part of African art.

The arrival of the Europeans along the Atlantic coast created a profound restructuring of African space.

The Arabic-Muslim penetration in western Africa came on the basis of the presuppositions of Ptolemic geography that defined the Mediterranean as the center of the world and consigned places that were inaccessible, uninhabitable, and surrounded by a limitless ocean to the margins. Between the tenth and fourteenth century, there was the creation of a great unified space which ran from east to west, from the Atlantic to the Red Sea but only marginally touched by the southern forest, which would remain inaccessible until the arrival of the Europeans in the sixteenth century. The Portuguese, reaching the mouth of the Conger river, instead introduced even the Atlantic equatorial part of Africa into the world economic circuit. Bartolomeo Diaz and Vasco da Gama (1498) would later trace the outlines of Africa, placing the Ptolemic conception in crisis.

With the conquering of the new continent, Africa took on a strategic position, and to the trinomial Africa-Islam-Europe, built principally around the exportation of slaves and gold and hinging on Arab mediation, there would arise the Africa-Europe-America triangulation centered on the exportation of slaves and functional to the industrial development of the old continent.

Western Africa thus saw the addition of a passage towards the north through the desert to an opening of its own space towards the south. The Gulf of Guinea opens to the ocean, which is transformed from insurmountable limit to frontier[90]. A progressive moving of the economic barycenter would derive that would move from the end of the great medieval empires of western Africa to the birth or affirmation of new kingdoms.

From the European side, such a "discovery" of Europe will not simply be the arrival of the knowledge of something that until that moment was ignored but an active taking of possession that would construct Africa as an object of knowledge (giving it a place in Western wisdom and geography) and a place of expropriation.

African space will be formally annulled, proclaimed *terra nullius*, to be instituted *ex novo*. It is what Pope Alexander VI sanctified with the *Inter Coetera* bull in 1493, affirming the right and duty of Christian Europe to exploit the territories left uncultivated by indigenous populations and given by God to all humanity: in the political and economic appropriations of others' lands, the introduction of pagans in the history of salvation was in-

troduced. The treatise of Tordesillas (1494) would later define the spheres of Spanish and Portuguese conquests, assigning Africa to the Portuguese, while in 1499 Pope Sisto -VI would entrust their patronage over all discovered African lands and those lands waiting to be discovered.

In these treatises and proclamations, the writing reveals itself in its founding and institutional functions. The word and the writing ritually mark the new spatial order not just in the seats of diplomatic Europe but also on African soil. For as much as the indigenous people did not understand the language and did not know how to read, there would often be the celebration of a mass and the reading of a document that proclaimed their own right to conquer to define the transference of authority.

A new territorial definition of power and a new religious cosmology made their appearance in Africa. Colonial and missionary politics, while having different ends (economic exploitation, the salvation of souls), would overlap for long stretches in a project of reconversion of space which would aim at the conversion of souls.

Part of the assimilatory strategy would be the substitution of African names for places and people with European and Christian names. When Livingston reaches the falls of Zambesi, he does not welcome the indigenous name of *Mosi-oa-Tunya* (Smoke-that-Booms), but mutates it into Victoria Falls.

As if reaching an uninhabited land, the explorers baptized the places they found, bringing a new life to them. That of the words inscribed in space is a new web of power relationships. It is thus that the lacustrine geography of central Africa – Lake Victoria, Lake Albert, Lake Edward, Lake George – would host the entire British royal family. These onomastic and baptismal politics acting on words did not leave things unchanged. They regenerate the people and profoundly transform the memory of places and the system of social relationships that take place there. They spread the imposition of monogamous families and the system of patrilinear succession, a new concept of landed property and territorial state. They establish a new economic, administrative, and road grid.

The ways of representation oriented by space change, the seats of colonial administrations and the metropoli – Lisbon, Paris, London, Berlin – will become the new points of reference.

Such principles were visibly written on the ground. First, there will be piles of stone, clearly visible from the sea, which often take the name of the king in whose stead they take possession of new lands and castles which had been built with defensive and commercial

118. T. And J. Bry, The Portuguese render homage to the king of Congo (from the Latin edition by F. Pigafetta, Relazione del Reame di Congo..., *1598)*

The Africans in the sixteenth century were not yet seen as objects of disdain, which would happen later: the king of Congo is here represented with the dignity of a European sovereign. The Portuguese emissary bows slightly and doffs his hat in the king's presence; in the background a Portuguese man shakes the hand of a Congolese man. The soldiers in the foreground, on the other hand, seem more or less distracted and disorderly, and the difference of attitude is evident when compared to the native population prostrated on the ground. Among the gifts lifted from a bag and leaned on the stage, one can see a crucifix and a chalice.

functions between the fifteenth and seventeenth centuries. Later, there will be European-like cities.

These designs will only find a partial and gradual realization passing from the mercantile colonialism of the sixteenth century to the systematic slave trade of the seventeenth and eighteenth centuries to the territorial partition of Africa in the nineteenth century.

The history of African arts would again feel the effects, for better and worse, of the evolution of this relationship and the modification of European perceptions of Africa tied to the deepening of economic and technological distances.

In the epoch of initial Portuguese colonialism, Europe had not yet known the scientific and industrial revolutions or the literacy of the masses. What the Europeans found in Africa was not completely foreign to them. Beliefs in magic and witchcraft and the centrality of the extended family in the organization of society seem to offer a common ground[91]. The African is not considered as radically Other.

The Portuguese presence, for strategic reasons and for the material impossibility of doing otherwise, is primarily limited to the commercial control of preexisting production activities, with small settlements in coastal ports. They created alliances with local rulers and exchanged embassies on a level of apparent equality.

The principal diversity seems to be found in religion, and yet even this obstacle seems resolvable. Conversion, always thought of as a one-way course, is possible and demanded.

These relationships also explain the behavior taken in encounters with African artists. They burned their idols though at the same time they appreciated the capacity of African artists. They imported local fabrics, while salt cellars, spoons, and horns in ivory, commissioned by the Portuguese from Sapi, Bini, and Kongo artists, appeared on the tables and in the *cabinets de curiosités* of Renaissance courts.

As much as these Afro-Portuguese ivories were probably created based on designs furnished by the European customers, the role played by the Africans was not limited to simply acting as executors. In the shapes and decorations of these objects, there is in reality an extraordinary cultural syncretism that will make certain zones of Africa a meeting point of iconographic traditions and European, African, and Oriental stylistic approaches in the first half of the 1500's. Images of Asiatic origin – as in the Indian elephant with the palanquin on its back – and mythological images of European and Oriental derivation – like dragons, sirens, harpies, unicorns, and centaurs – appeared[92]. The African aesthetic sensibility seems to emerge in the recourse privileged to the human figure and geometric design (where Europeans would have used floral motifs) and in the clear articulation of the parts of objects that separate themselves from the European propensity for the fluidity of forms[93].

These ivories are proof of a fertile and possible encounter between Africa and the West on the territory of art, even if the level of opening and availability that appear here are not overvalued.

In the absence of documented sources, it is difficult to say exactly what repercussions this kind of production had on the local use of African arts. As far as European reception is concerned, on the other hand, it appears that these handmade items were seen as a kind of culturally neutral object. Appreciated for their exotic origins, the preciousness of the materials, the refinement of the execution, they constructed an image that was undifferentiated and generic from the Other. It was an Other of which one would know nothing and thus would remain under its spell.

The discovery of American gold and the needs of trade would change things. In the European perception, Africa would then become the place of barbarians, images of a corrupt humanity that would act as a counterbalance to the uncontaminated purity of the primitive American. The provenance of the Afro-Portuguese ivories would be forgotten, and they would be reclassified as Indian or Turkish[94]. In Africa, they would be absent by definition.

And yet, precisely this trade, which was devastating for many African populations, would be the occasion for development for others in western Africa, even if conditioned by and dependant on the outside[95]. Not only would the acephalous societies be hit by trade but also the webs of mercantile cities that in western Africa, thanks to a system of indirect and filtered contacts, were established in the hollow spaces between the northern islamicized zones and the coast on which the European castles were rising[96]. To be favored instead were the more centralized societies, the Ashanti, Fon, Benin, and Oyo monarchies, whose fortune and decline had been tied in large part specifically to the role of mediation exercised in the slave trade.

119. Afro-Portuguese salt cellar, Sapi, Sierra Leone, beginning of the sixteenth century; ivory, height 23.5 cm

A fusion of European and African elements was probably realized in this art form, developed with the patronage of Europeans. We can suppose an African foundation for this salt cellar, for which we have not seen any European prototypes. They appear to respond to African aesthetic conceptions: the subordination of decoration to structure, the anthropomorphic and geometric (instead of floral) character of the ornament, and the absence of a scenic space. The figurative elements do not have an independent development, but coincide with the functional parts of the object.

These kingdoms assisted in the creation of a magnificent art of the court which has its historical, political, and material conditions of possibility in the meeting with the West, in the growth of the availability of materials (metals, silks), in the spread of American cultivation, which allowed an increase in agricultural production (corn, cassava, green banana, peanuts, etc.), and in the introduction of firearms.

The same development of the royal apparatus (signs, thrones, flags) would imitate, at least in part, the iconography and ceremonies of European courts of which the whites of the coast offered a deformed replica. What would come out of it would not be the dogmatic imitation of the existent but a chain of invention and reinvention in which the different actors present would seek to exploit their own strategic representation of reality.

On this ground, the Africans were not alone. The signs of the noble "tradition" in which they would be appropriated, in reality invented in the successive period after the industrial revolution, were already objects of appropriation of the Westerners living in Africa. Often coming from the lower classes of European societies, they constructed a new social and racial identity imitating the styles of noble life and adapting them to African reality. The white farmers in Africa thus transformed themselves from peasants into "country gentlemen"[97]. The Africans would intervene on this symbolic apparatus in their own time to seek to turn it to their advantage.

In the second half of the nineteenth century, European colonialism assumed characteristics of territorial occupation, and with the Berlin conference of 1885, Africa was remapped on the basis of a new political geography. Political and administrative borders which sanctioned the partition between European powers appeared and traced the new coordinates of Africa's economic exploitation.

The mercantile geography favored the coastal margins, and when it pushed to the interior it followed the river axis or brief road of earthly penetration. Its geography was a territory made of a few recognized lines and great unknown spaces. On the basis of these new exigencies of the political management of space, this indeterminate complexity would become an emptiness to fill. Cartography, with its effort of total denomination, would then

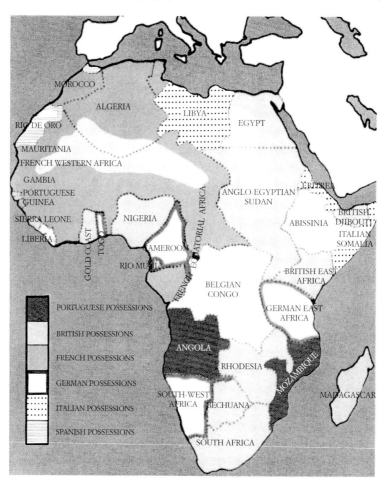

120. The colonial partition of Africa (1914)

The territorial occupation of the continent, its economic exploitation, the redefinition and growing rigidity of the borders, considerably modifies the space and African society.

respond to this desire to construct a useful and transparent space in which it would be impossible to become lost[98].

In this process of the reconstruction of African space, the strategies of denomination would register a significant movement of the accent. In the passage from mercantile colonialism to territorial colonialism, the symbolic-religious toponymy loses ground while the scientific-classificatory toponymy advances. We are speaking of a rationality which responds to a principle of the economy. Instead of submitting local names with Christian ones, they used those which were there and invested their energy in the great mass of spatial elements which local knowledge left undiscovered[99].

Everything has to be denominated and collected exactly: natural elements, social groups, artistic styles. Writing takes on the face of bureaucracy: that of the identity card, of travel permits, of vaccination certificates. Each individual is identified in terms of residence, occupation, fiscal status, state of health.

The migratory floods were blocked and the populations fixed within the arbitrarily defined space, giving space to the process of ethnic segmentation which brought it to the tribalization of contemporary Africa. People who possess very different customs, religions, political and social institutions, would all be gathered under an amalgamated denomination. The Igbo, Tonga, and Baroste thus become conscious of creating a unity only when they are identified as such by foreigners who perceive in them shared characteristics, despite their demonstrated differences. "The foreigners gave the Igbo their name and, treating them as if they were all the same population, encouraged them to become thus."[100]

Even in this case, despite the violence and the drastic nature of the changes, colonial penetration did not see the passivity of the Africans, nor can it be reduced to the sole imposition of a foreign order. If the Europeans would often equivocate and, believing that the Africans were organized in tribes, introduce in fact an exogenous element, it would however be in part the Africans themselves – in their struggles for the definition of new balances of power – to construct those tribes to which they were presumed to belong[101].

Art played a role in this contested and negotiated process of the construction of identity.

A particularly interesting case, in this context, is that of the terracotta vases in cephalforms by the Magbetu of Congo (Plate 97). The European presence acted upon them as a catalyst, stimulating the recombining of shapes and preexisting themes and giving space to unprecedented developments[102]. For as much as the "Africanness" of the forms hides the signs of contact at the point of creating a "classic" of African art, we are in reality looking at an artistic production tied to economic conditions, which is born and falls in the context of the relationships between the Magbetu king and Belgian colonialists between the end of the nineteenth century and the Second World War. We are facing a political art tied

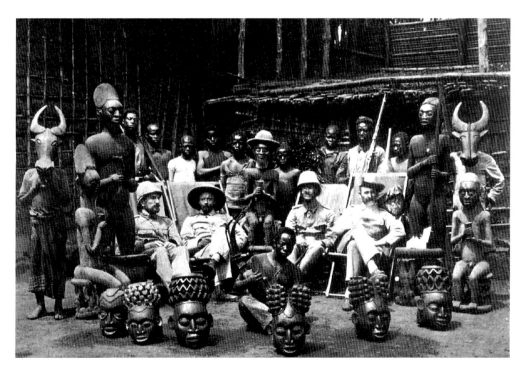

121. *Officials of the colonial German troops after the conquest of the Kom (Cameroon) kingdom, 1905*

The masks and royal chairs, arranged symmetrically, are demonstrated as trophies of war: objects and people make a frame for the four military officials seated in the center. The position of two of them, legs crossed and sunken in the chaise-lounge, is typical of colonial iconography: in the ostentatious and informal relaxation they affirm the superiority of the victor and the smallness of the defeated. In a significant gesture, a European head covering has been placed on the central statue. In the background, there is the palace of Laikom.

122. Staff, Ashanti, Ghana; wood, ivory, height 100 cm

With the arrival of the Europeans, the key becomes one of the symbols of power and as such appears in the iconography of the court. The control of keys implies the management of freedom of other's movements and the protection of one's wealth; this was even more true in the case of the Ashanti monarchy which based a great part of its power on the slave trade. The Ashanti kings possessed bundles of pseudo-keys in gold or silver, whose efficacy was not functional but symbolic; the key appears also in motifs of signs of court and lineage: "the king is the key of the state."

to the celebration of the grandeur of Magbetu kingdoms, in competition with each other to earn a good reputation among Europeans and be able to hold a role in the political readjustment of the region.

Precisely for this reason, art would decline with the affirmation of a colonial bureaucratic administration directly managed by the Belgians.

The Afro-Portuguese ivories showed us how in Africa contact did not necessarily bring degradation, addressing a creation, one presumes, of exclusively foreign use. Now, the Magbetu vases show us not only how their production to foreign ends does not signify the decay of African art but how it can coincide with the production of internal ends. These vases, destined for the Belgian residents of the Congo and Europe, aim at the same time to make an impression on their own people and on other Magbetu kings. The political function they play remains openly "traditional" if only for a changed, unprecedented context.

In other words, if contact provided the stimulus and determined the strategic use of these objects, the formal resolution – differently from the Afro-Portuguese ivories – draws exclusively on local traditions, synthesizing the two separate paths of the anthropomorphic sculpture of wood and the non-figurative sculpture in terracotta, something which is reconciled as much with the desired image to be projected on the outside (the solidarity of a preexisting situation) as with its internal function (the capacity of leaders to affirm themselves in the new situation).

In many case and in particular with the British system of indirect rule, the West did not destroy African traditions with a frontal attack, but transformed them, reformulating them in a unitary and systematic way, purging them of the ambiguities and contradictions which had rendered them plastic and mobile and making them rigid in the schemes of a coherent and controlled folklore. The fetishism of the past and authenticity would be the product. The nostalgic countertrend of modernity which followed is, paradoxically, the instrument of its realization. The process of territorial fixation with the closed mental space of the village would proceed, in fact, at the same rate with the new forms of economic emigration towards the city.

The religious geography of Belgian Congo, for example, saw the repartition of the territory between diverse ecclesiastical orders which would redefine the space on the base of its own rule, following the model of medieval European monasteries, religious centers which led to the colonization of entire areas[103]. Hospitals, schools, and artisan workshops were created around the church and the mission. If in one sense they aimed at reproducing ways of European life, in another these constructions sought to adapt themselves to local customs, maintaining, for example, the traditional construction in mud but substituting the round plan for a rectangular one.

The reorganization of space is – as we have already seen – functional to the reconversion of mentality. The village which extends among the extremes of the forest and the mission allows the material building of the route which goes from the past to the future. It indicates the distance that separates them and the road that would allow them to surpass the passage. The division between the residential spaces of white people and those of blacks confirms racial and power differences, but also reveals the ideological lines of a development situated as an unrealizable meta ideal.

These are practices which, on the side of knowledge, find expression in the evolutionist anthropology which, interpreting cultural differences in terms of temporal distances, connects them on a single evolutionary line which goes from the simple to the complex, from the primitive to the civilized. Moving in this space would then be equivalent to travelling in time[104].

In African territory, the disciplinary transformation of spaces proceeds at the same pace as a redefinition of time. The raising of the flag, the firing of the cannon, the ringing of bells, and then the hands of the clock begin to mark time. Thus, disciplined military time, the eschatological time of the church, the accountable time of the merchants, and finally the narrow time periods of capitalist production appear.

The Africans quickly learn how the control over new forms like time has so narrowly assumed the function of control over men. The clock thus becomes a symbol of power and finds a place in African iconography. Its spatial equivalent could perhaps be retraced in the image of the key which represents the European power to close and open spaces. Clocks and locks with keys become the objects of goldsmiths and, often lacking a mechanism, become functional on a symbolic level.

This passage to a quantitative conception of time – while not completely absent in Africa in brief periods and within a cyclical frame – does not however implicate the aban-

donment of traditional "qualitative" conceptions. Time conserved its own weight; it is not divisible into instants lacking measure, into homogeneous, mathematically exact pairs, but continues to be perceived as a duration. The scheduling of an appointment for a certain hour in Africa does not imply a precise position for the hands of the clock but a certain time slot.

This process of the redefinition of spaces and times could count on complicity, but does not arrive without resistance. The "local mentality" of the residents sometimes remains permanent, despite the disruption of physical and visible spaces, even in situations of complete uprooting[105].The attempt to plant the panoptic model of an integrally visible space without zones of shadow – rational space, planned and measurable by disciplinary power and capitalist production – in Africa reveals itself to be in great part illusory, as demonstrated, here as elsewhere, by the continual spontaneous rearrangement of urban centers as much as by the failure of development projects[106].

In this context, an emblematic example is seen in the way in which the populations of Maradi and Tsibiri, capitals of the Hausa principalities of Katsina and Gobir, confronted the transfer of these urban centers, run by a French administration, in 1945. The measure was taken to remove them from the dangers of floods during the storm season. The cities would thus be rebuilt on a higher elevation on the basis of functional and modern criteria and without taking local customs into account. The Hausa reacted to this grave laceration in their own historic-cultural fabric by inscribing in the weaves of this secularized space its own religious topography, reaffirming their own identity in continuity with the past. To the urbanistic plan with radial development in a fan shape, the only visible plan, they overlapped their traditional sacred grid with the four "doors" oriented according to the cardinal points. The magic-religious power which existed even before the material of the doors of the walled city disappeared was thus preserved by talismans buried in the four poles of the city and in the point of axial intersection. Analogous ritual delimitations also re-established the space protected by the market, the house, and the cultivated fields taken away from the *brousse*. The total rupture with the past is thus only apparent. In reality, two diverse cities overlap and are composed of the same physical space[107].

This profound memory seems in part to have also resisted the profound lacerations brought by the slave trade, the rupture of community and familial ties and the melting pot of traditions and provenances resulting from deportation. Haitian voodoo and Brazilian *macumba* and *candomblé* attest to the vitality of African religions across the ocean. Despite the uprooting and the interruptions that came from the process of cultural transmission, it

123. Afro-American patchwork quilt, Alabama; cotton

In the decultured context of the slave trade, the Afro-Americans lost the possibility of weaving; they then procured blankets by sewing scraps of old fabrics. The fortuitousness of the parting materials was not, however, only a limit: assumed with awareness, it was transformed into a resource. Sometimes the remnants were even casually fished out of the box, combining a planned nature with the unpredictable. The overall design, as in African tradition, comes from the flexible repetition of opportunely varied base motifs, appreciating the improvised deviation.

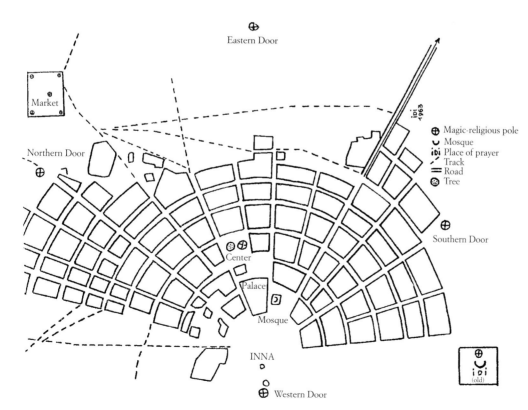

124. Visible and invisible plans of the city of Tibiri, Hausa, Niger

The European urbanistic plan, in which the streets converge in a fan shape around the palace, is overlapped by what is traditional, invisible, and unknown to the secular people: the space then takes on the form of a quadrilateral in which sides are directed in the direction of cardinal points. The center and point of intersection between the axis and sides (the "doors") are the religious poles marked by buried talismans and by trees that are planted there.

125. Magbo *mask, Yoruba, Nigeria; wood, pigments, height 72 cm*

In the spiral and floral elements that sometimes appear on the headdress of the Oro association, we can see the influence of the Brazilian baroque. Such motifs, which are also present in the architecture of Lagos and Ibeju, were introduced to Nigeria by the Yoruba returning from Brazil at the end of the nineteenth century.

is also possible to see a substantial continuity of aesthetic perceptions. Beyond that, as has been noted in the musical field, this is also clearly seen in textile compositions. If the impossibility of weaving in slavery led to the loss of knowledge of technical traditions, it did not however cancel the criteria of aesthetic valuation that clearly reemerges in Afro-American patchworks. These fabrics, realized through the assembly of scraps and remnants of various provenances, opportunely modeled, respond to the taste for the unpredictable and the approximated, for the rhythmic repetition and asymmetrical deviations that inspire African fabrics. That these compositions are the fruit of a conscious choice and not simply ordered by necessity seems to be confirmed by the fact that when new fabrics became available in the twentieth century they were not used as they were but cut, with stripes of different fabrics being assembled later on the basis of their contrasting chromatics, recalling in this way the aesthetic of the multi-striped African fabrics of the Mande and Akan[108].

And yet, the result, while in profound continuity with African traditions, is not the overseas repetition of an immutable archetypal background but the invention of a new Creole culture, which also incorporates European influences, in the frame of an inter-African syncretism[109].

The currents of the return of the African Diaspora, with the re-entrance, beginning at the end of the 1700's, of the liberated slaves, revealed the produced cultural distances, introducing new ideological, religious, and aesthetic stimuli into Africa. Brazilian architecture was thus able to appear on the African coasts, and "Brazilian quarters" were born in Porto Novo, Ouidah (Benin), and Lagos (Nigeria).

The territorialization of African cultures and the exasperation of the conservative particularism moved at the same pace as the intensification of globalization that brought it into a system of intercontinental relationships, not only with Europe, America, or the Arab world but also with East Asia[110].

Eastern and southern Africa – thanks to navigation along monsoonal currents – had already developed commercial relationships with India and China and had known immigration from Indonesia and Persia, while in western Africa, through Arab mediation, cowry shells from the Indian Ocean and silk from China had already arrived. The insertion of the planetary currents of European commerce and colonial empires, however, intensified and extended such direct and indirect relationships with the Orient.

In the sixteenth century, besides European textiles and Indian and Chinese silk fabrics, more than anything, dyed and printed Indian cottons also arrived in Africa. Their success would be such that the French and English in the eighteenth century would try in vain to substitute them with their own industrial imitations.

The Africans were enlisted in the colonial troops to fight European wars all over the

126. Chromolithograph, India; 51cm x 40 cm

127. *Figure associated with the cult of* Mami Wata, *Togo; ivory, wood, height 27 cm*

In Africa, Indian lithographs are a source of artistic and religious inspiration; in Togo, the image of the Hindu spirit assumes the identity of Densu, a masculine spirit associated with Mami Wata. The reproduction closely recalls the Indian model but the landscape elements disappear and the face, in particular the lips, is rendered in African style. The multiplication of arms and of valuable objects that are held between the hands makes the statue a talisman that propitiates wealth.

world, and in returning to Africa the veterans brought memories of far-away countries back with them. The spread of Javanese batiks in Africa, traded by the Dutch and later industrially reproduced by the English, may have been started by African soldiers. Between 1810 and 1862, the soldiers fought in Indonesia and returned bringing fabrics as gifts for their wives[111].

From Asiatic countries, there came not only commercial products but also new forms of religion. The presence of Indian merchants on the African coasts, in particular staring with the First World War, led to the spread of ritual elements of Hindu origin: religious images and sacred texts, the use of incense and perfumes, *bindu* on the forehead.

Modern technology – the press, photography, Indian cinema (widespread in Africa) – became the vehicle for the spread of new cults.

Among the cults of Indian ascendance, the most diffused, from Senegal to Tanzania, was that of the water goddess Mami Wata (Plate 101), in whom, syncretically, rites and images of African, European, and Hindu origin are all intermingled[112].

The name derives from the English *Mother of Water*, while the semblance of the siren echoes the figureheads of European sailing ships from the fifteenth century. She certainly recalls the lithographs of Hindu divinities or Indian snake charmers whose posters, printed in Europe or in Cairo, were widely distributed in Africa beginning at the end of the 1800's[113]. Curiously though, the European images of a fabled Orient, once they were translated in Africa, ended up becoming exotic images of a fabled Europe. In fact, it was said that Mami Wata was the white woman who came from the sea.

And yet, if these external stimuli took root it was also because they were grafted onto a preexisting cult of water spirits and snakes which allowed a renewed continuation. Thus, for example, the cult of Mami Wata found fertile ground in that of Oshun, the Yoruba spirit of rivers, and that of Yemoja, the divinity of salty waters. Even on this more strictly iconographic level, it is possible that the image itself of beings with a human bust and head and a bottom section formed like a fish had autochthonous roots that could indicate the Benin example to which we referred in preceding pages[114].

This continuity between the past and the present also concerns the contents of the cult. The African divinities of water are in fact associated, like Mami Wata, with fertility and prosperity. The divinities of the sea, in particular, recall the wealth that comes from elsewhere. First, there were the cowry shells and coral from the Indian Ocean, to which magical-symbolic values were attributed and which functioned as a means of exchange, then there were the goods that came from Europe.

Economic-material development did not erode or oppose religious-sacred development, but it provided historicized modes of expression. And thus in 1983, the mask of Mami Wata appeared among the Bwa of Burkina Faso, brought by a young man who had worked for several months at a petroleum plant in Nigeria[115].

6. The Dynamic Places of the Interweaving

As we have already indicated, textiles, objects of heavy trading, were in particular one of the principal means through which commercial and cultural relationships were launched and interwoven between Africa, the West, and the rest of the world.

If in writing (travel tales, administrative, military, and missionary reports) the European image of Africa often seems tied, in a strongly ethnocentric manner, to literary clichés of the "black continent" or the "old mother Africa", on the surfaces and in the weaves of the textiles one could read another history: the European wish to make Africa into a market for the European textile industry, forcing entrepreneurs and merchants to identify themselves in the mentality of the Africans, to anticipate their aesthetic taste, to find a plain of understanding[116]. Paradoxically, precisely the absence of an ethical choice, the presence of a purely economic calculation, seems to allow a drawing nearer, as limited as it may be, of sensibilities.

In western Africa, the arrival of the Europeans did not have, as a first effect, the supplanting of local production. Coastal commerce, at least through the end of the 1800's, did not substitute or achieve the depth of the continental African trade, and more than anything it constituted, at least in part, a factor of productive stimulation[117], so that Benin textiles, for example, reached Brazil through the French[118]. The Europeans inserted themselves into the local market, selling and acquiring fabrics to resell elsewhere in exchange for ivory, gold, slaves – something that demonstrates the quantitative importance of autochthonous production as much as the maintenance of local taste: the price of African fabrics was in fact as expensive as that of the most costly European fabrics[119].

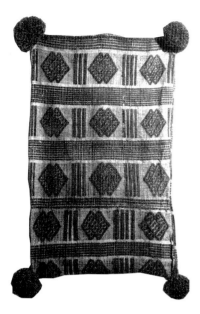

128. Fabric, Kongo, Congo, seventeenth century; raffia

The presence of these fabrics in European collections of the epoch (approximately forty have been conserved), is evidence of the appreciation that collectors had for the skills of African weavers. The proximity of these designs to European heraldic motifs and liturgical clothing suggests a possible Afro-Portuguese syncretism.

Competition did not revolve around the products of European sales as much as European imitations of African textiles. The so-called *lambens* sold by the Portuguese and probably produced in Morocco were composed of stripes of bright colors in imitation of Sudanese traditions. Desired for their exotic origins, they became accepted for their familiar design[120]. Part of their success can also be explained by the fact that they were often taken apart later so that their threads could be used in local weaving (especially for silk or cotton dyed in red, a color that is difficult to obtain with natural dyes). We are evidently very far from a passive acceptance. The European product is integrated as a base material to improve the quality of a local product that was thought of as altogether superior.

From another perspective, the same European production of fabrics destined for the African market and whose designs were conceived in Europe can, in a certain sense, reenter the history of African textiles. In fact, starting at least as far back as the seventeenth century they were modeled on African tastes, following the mutations and modifications on the basis of replies, differentiating them regionally. The Africans attributed a name to these industrial products – a name that was often the reason for their success – integrating them into their context of meaning. Time – some designs that are still used today have precursors in the First World War – later rendered them "traditional", in the eyes of Africans as much as in the eyes of Europeans[121].

A history of African textiles should not be limited to explaining only weaving. Even when the European industrial production of the nineteenth century in large part supplanted local production, African creativity had no less of an area in which to express itself. Many of the "typically African" materials in fact used imported pieces as a support for the decoration (painting or resisting dyeing) or recut them to use the pieces in fabrics with *appliqués* (like the celebrated pieces by the Fon of Benin) or again created completely new designs for the removal of the threads of the warp (Plate 112)[122]. The most prized ones were often local fabrics that were presented as insertions into precious European materials. The component contrast (between center and border or in the alternation of checks) emphasizes the diversity of their provenance. The insertion of exotic objects into the local culture sometimes came from diverting them from their original finality to make them take on a new finality. It was in this way that Bowdich came to see the British flags donated to the Ashanti king as a sign of allegiance sewn together to make a suit for the monarch[123].

In some cases, otherness and alienness are a value in themselves, demonstrating the history of a group and its provenance from outside. The populations of the Niger delta work within a system in which the importation of fabrics is not only an economic fact, but is symbolically necessary. The successive use of diverse textiles in different phases of a ritual, each one coming from a different outside source, visually recapitulates the history of these populations[124].

European intervention sometimes implied a more direct intervention in local production, as is the case of the so-called Cape Verde school[125]. In 1461, the Portuguese colonized the island of Cape Verde, along the Senegalese coast, transferring Wolof slaves and slaves of other ethnic groups to cultivate cotton and indigo there and to weave. The process was also repeated on the coast with Mandingo weavers. The Capeverdian fabrics enjoyed an impressive reputation until the eighteenth century (arriving at the level of being commercialized even in Europe), and if the Lusitans later abandoned them, or they were absorbed by the indigenous people, it is probable however that they provided the inspiration and a common base for the collective Senegalese textiles. The fact that the design of these fabrics was very similar to the Spanish-Moorish designs of the twelfth century lets us understand their intercultural depth[126].

Even in central Africa, the building of an Afro-Portuguese culture, that of the Christian kingdom of Kongo, directed by the fervent black sovereign Alphonse, seems to be among the principal sources for the iconography of raffia fabrics. The linear geometric pattern of Congolese fabrics echoes, in fact, the design of liturgical hangings of the seventeenth century and certain medieval heraldic motifs that should be excluded from a random phenomenon of convergence quite closely[127]. The European design would have been inserted into a preexisting tradition, creating space for the creation of a new *corpus* of African motifs.

According to a Portuguese report of 1611, between twelve and fifteen thousand pieces of superior quality and forty to fifty thousand medium-quality pieces were produced annually in the Congolese city of Loango. Used locally as money, clothes and funeral chests came, however, to be to be acquired mostly by the Portuguese, who exchanged them in Angola for slaves being sent to South America.

The European interest in these fabrics was not purely instrumental however; it was ac-

companied by sincere appreciation. In fact, the Portuguese Duarte Pacheco Pereira wrote in the beginning of the sixteenth century: "In the kingdom of Congo they make cloths of hairy palm that seem like velvet ... they are so beautiful that even the best in Italy cannot make better ones." In the following century, the curator of the Settala collection of Milan, referring to Congolese fabrics, said they seemed to him like "a work worthy of being observed for the rarity of the weave that is ordinary in that country, and in the city of Milan is practiced by only two people, who are experts"[128]. To these alluring judgements, there was probably a base "commensurability" which allowed for the making of a comparison between African and European fabrics using homogenous terms. On one side, the absence of figurative references allowed a more relaxed appropriation. On the other, in the same typology of design they breathed the air of family.

The monetary use to which objects were put and the prestige that surrounded them also explain their spread within central Africa. Technique, design, and linguistic terms allowed them to be associated with the most recent fabrics of the Kuba of Kasai. Kongo materials would have reached the Kuba kingdom between the seventeenth and eighteenth century. In the eighteenth and nineteenth centuries, the same Kuba, who had become unrivaled masters, would export fabrics, entering, even if just marginally, the web of Euro-African commerce[129].

It is of great interest to note the profound iconographic mutations that came in the transmission. While the search for balance and symmetry is predominant in Kongo fabrics, Kuba materials in large part assist in a knowing deformation and rupture of regular grids. This seems to have been influenced by the great liberty of Pygmy painting (*Mbuti*) on "fabrics" of beaten bark in which there is a complete absence of geometric bounds and repetitions of the weave (Plates 68, 69)[130]. Once more, the process of borrowing reveals itself as a contextual reinvention.

7. The Uproar of Battle and the Elision of Encounter: Strategies of Art

Profound continuity happens with the assumption, as selective as possible, of elements taken on loan from the West in which power, if not superiority, is recognized.

The dynamic of acceptance in the Ashanti kingdom demonstrates the existence of a system of selective discrimination given to great flexibility[131]. The strongly structured and hierarchized character of the Ashanti allowed them to prepare filters in advance for a filtered and controlled absorption of Western influences, channeling them to the peaks and preventing them from reaching the base where they could have had disruptive effects. For this reason, the teaching of writing was prevented. Writing was thought to have "magic powers", and its practice in the management of the state was addressed through the use of foreign copyists, carefully avoiding the spread of writing among the people. The Bible and the Koran appeared next to traditional "fetishes", but the books remained closed, acting through the force they emanated and not through their contents. This was similarly true for Western medicine, which did not supplant the traditional practices, but was included

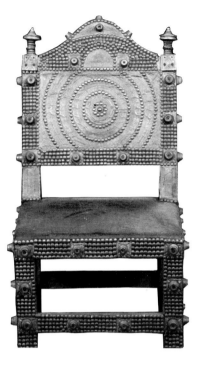

129. Asipim chair, Ashanti, Ghana; wood, brass, skin, height 67 cm

While stools made from a single piece of wood predated the arrival of the Europeans, the wooden assembled chairs recall the European models of the seventeenth and eighteenth centuries. The dimensions are, however, reduced, and the height of the chair is close to that of the benches.

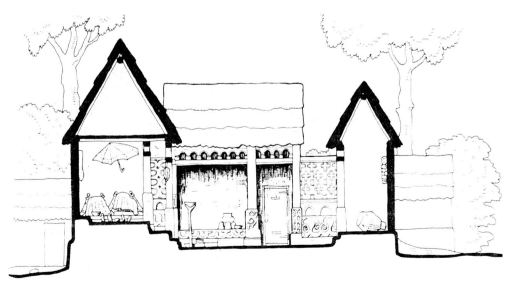

130. Section of the abosomfie sanctuary of the Bawjwiasi, Ashanti, Ghana

In the room to the left, hidden by fabrics, there are places for sacred chairs. The external walls are decorated with raised arabesques. The surface of the walls is subdivided into sections, each of which echoes a motif that is connected but autonomous with respect to the others.

among them in a conceptual sense: the mere possession of a medicine was thought to be a sufficiently strong antidote to sickness as to obviate the need that it actually be taken.

The evolution of Ashanti visual art demonstrates the way through which this kingdom was able to prosper for more than two centuries, assimilating or encircling in its own orbit other African peoples, looking as much to Europe on the coast as towards the islamicized north while maintaining its traditional polytheism[132]. This behavior cannot simply be qualified as a receptive availability, but more than anything proves an intentional research of innovation as an instrument of dynamic preservation[133]. Ashanti architecture offers a chart of these multifaceted contributions, integrating elements of Islamic-Sudanese origins and others of European origins.

From the Islamic influence, we see the use of Koranic amulets, which are added to warriors' tunics (*batakari*), the development of a system of weights for gold, fabrics, umbrellas with figurative tags, leather pillows, the shape of ceremonial swords, and probably the design of *adinkra* fabrics that would be the local answer to Islamic fabrics painted with magic squares[134]. From the Fulani, the islamicized nomads of the north, also come the coverings (*Kasha*) that enveloped the drums of state and ancestral chairs and that were used for the sovereign's litter and bed. The extraneous, once again, is not simply external, but is present within the heart of power itself as one of its conditions of functioning. From the other side, the spread of these wool fabrics in a tropical forest cannot be understood except through their symbolic exoticism.

The same happens for objects and themes of European derivation. Paradoxically, precisely the inclusion of symbols of white power reveals itself as functional to the affirmation of its own independence. The signs used by the king's spokesman as an instrument for transmitting messages, giving them an authority, would be a development of walking sticks used by Europeans on the coast, first employed in communication between whites and autochthonous people to qualify the messengers, then given to local heads and exhibited by them as proof of their capacity to accede to the goods brought by white people[135]. Chairs, until recently a monopoly of the court, echo, in their conception and style, European prototypes of the seventeenth and eighteenth centuries. Even cannons, guns, keys, and watches found a place in Ashanti iconography.

Probably, Western influence was not limited to technical objects, but also acted upon a preexisting animal symbolism, strengthening and modifying elements. The exclusive symbolic association between king and elephant that we find among the populations of Cameroon, for example, could be placed as a result of the economic value assumed by ivory in economic transactions with Europeans in the nineteenth century and to the subsequent establishment of a royal monarchy. Similarly, the Ashanti lion, more than part of a forest, seems to be a son of the British lion[136].

These symbols are the subject of a struggle between antagonistic representations of reality: an instrument of affirmation in the intentions of African sovereigns, the Trojan horse in the designs of colonial powers.

Imperial ideology found application, becoming elaborated in Europe between 1870

131. Lion emblem of the King Behanzin, Fon, Benin; copper alloy, length 23 cm

132. Leopard figure, Benin kingdom, Nigeria, 16th-17th centuries; bronze, length 74 cm

Behind typically African animals, like the lion and the leopard, there is sometimes a formal revision that draws from the iconography and emblems of European monarchies. The Benin leopards recall, in their shapes, medieval aquamanile, *while on the Fon "lion", whose pose seems to recall the Eastern heraldic form, there is instead a European type crown.*

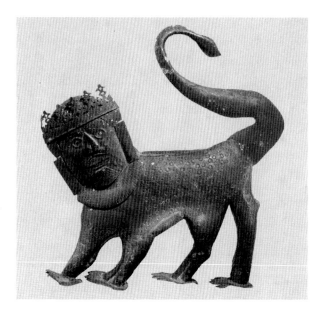
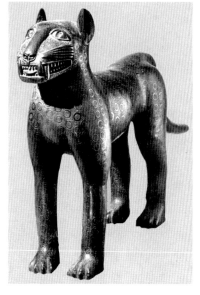

and 1900 and then becoming extended in Africa, taking off from the presupposition that the "civilized" and "primitive", separated by everything, would at least share the idea of monarchy. In reality, African monarchies were in good part shaped precisely by this encounter. The figure of the British sovereign or the German Kaiser would take on a "theological" dimension that was thought consonant with African conceptions and would then vaunt its omnipotence, omniscience, and omnipresence, presenting them as solicitous patriarchs attentive to the problems of the children of the empire[137]. Objects, portraits, photographs, and appearances in full splendor furnish the icons of this cult that the African arts have in various ways echoed and transmitted through to the present day. This, for example, is the case with Queen Victoria, who reigned from 1837 to 1901 and still appeared – crown on her head, cross at her throat, watch at her wrist, and bare breasted – on Fante drums in the 1920's, while the prints that portrayed her exerted an influence on Yoruba sculpture that would last until at least the Second World War[138].

The Africans adhered to this cult (it is not known with what conviction), probably offering themselves to the game, seeking to manipulate it to their own advantage. Local claimants to the throne would take their symbols to affirm their own authority and would pay homage to the British monarchy to obtain its favors. Once more, power found material for its own edification in tangible symbols. The symbols, in their polysemy and in the changed context of their application, were the object of a struggle in which different contenders pushed in opposite directions. The Europeans used them to establish their own power. The "traditional heads" individuated by the colonial administration saw them as an instrument of affirmation or conservation of their own authority. The young acculturated ones made them a lever of modernization.

On the popular level, the seemingly caricatured resumption of the panoply of colonial power united with the magic appropriation of signs, the criticism and satire of colonial society, and the expression of conflict among diverse local groups. In Kenya, the dance associations that proclaimed their own fidelity to the English throne passed in opposition to the infidel "Scottish" in kilts and bag pipes[139].

The jubilee celebrations of the British monarchy, well orchestrated, were certainly among the ceremonial events that had the greatest resonance in Africa and that left traces on the arts.

The jubilee thus becomes a traditional iconographic theme in the *oloba adire* fabrics of the Yoruba[140]. Born in imitation of the fabrics called *georges* or *africans* produced in Amsterdam or Manchester with the batik technique (resist dyeing), they reproduced in a central medallion – probably inspired by the souvenirs of the jubilee of 1935 – King George V or Queen Mary I, whose names were written, even if incompletely, on the fabric. The presence of the British lion on the same fabric reinforces the association of royal power that is also sanctified in the name of the fabric (*olobo*, in fact, means "property of a king"). On the surfaces, one can see the signs of the history of the empire and of African attempts to manipulate it. George V was followed by George VI then the visit of Queen Elizabeth in 1956, independence , elections, self-celebration of local chiefs who had their own per-

133. Drum design, Fante, Ghana, circa 1920

The figure that towers like a giant in the middle is Queen Victoria: the crown, her garments, and watch emphasize her European origins, but the large, exposed breasts insert her into the African context. To her left, in a subordinate position, there is the figure of an Akan chief. Above her are the figures of colonial soldiers with emblems of their power; one notes in particular the key and the handcuffs. Many other objects provide evidence of an English presence: a tea set, a kerosene lamp, a pair of scissors, a razor, a comb, a saw, etc. Next to the emblems of modernity are the traditional animal figures with their proverbial echoes.

134. Adire fabric, Yoruba, Nigeria; specially printed cotton (detail)

In the center medallion, the figures of King George V and Queen Mary are reproduced from souvenirs of the 1935 Jubilee; to the sides there is Muhammed on his winged mount.

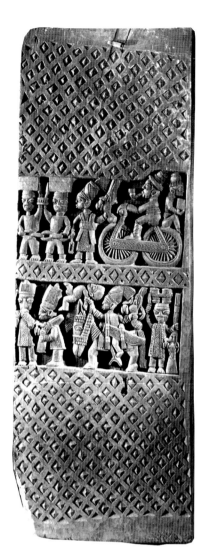

sonal *george* fabric made[141]. Other motifs though, contributed to a significantly more complicated chart of intercultural relationships constituted by the Yoruba identity. The image of Al-Buraq (the winged mount of Mohammed), minarets, birds, elephants, guns, and trees appear, and sometimes the royal couple is substituted by the biblical couple of Adam and Eve, of whom the prototype is found in Islamic prints that come from Cairo. The phrases that are repeated in them – "God knows everything.", "A rich man is no more powerful than a man of medicine." – synthesize values and beliefs of a world that changes. This probably could also be said of other motifs which are more difficult to identify. Some of the graphic signs may in fact echo the geometric motifs of fabrics in raffia and of traditional sacrifices that were later banned by Christian missionaries. The *adire* – an eminently feminine fabric – would thus have been granted the safeguarding of the new sense of modesty while reaffirming continuity with the past[142].

Not only court ritual but also new military, scholastic, and European bureaucratic traditions were exported to Africa.

"Many Africans, educated in the missions, would enter in the inferior levels of the bureaucratic hierarchy. The African employees would learn to attribute a precise value to rubber stamps and to the line of pens in the jacket pocket; there were associations of African dance that used rubber stamps to authenticate their correspondence, and that danced clothed in the uniforms of bureaucratic dress, more formal than those of the military uniforms." (Plate 98)[143] In the 1920's, the Bakongo responded to the identity cards imposed by the colonial government, giving them their own sacred version: the "passports for the sky" (*Kalite mazulu*)[144].

Under the slightly gray face of bureaucracy, they could thus peek at their gods. Ifa/Orunmila, a divinity that presides over Yoruba divination rites, is often indicated as a "scribe" or "office worker" because like modern clerks and secretaries, she "writes" for

135. Door of a palace (ilekun), *Yoruba, Nigeria; wood, height 180 cm*

On this bas relief, attributed to the school of Aerogun (c. 1880 - 1956) we find signs of both Islamic power (the cavalier and the slave) and Western power (technology); placed on the doors of influential Yorubas, they are the indexes of their social status. The character on the bicycle, with the pipe and, on the rear wheel, the character of the administrator with his paper, could be figures of Eshu.

136. Posuban, *military altar from the second* Asafo *company, Kormantine, Ghana, 1974; cement*

Within a structure whose colonial fort form has mutated, there is a collection of cement sculpture of European and local inspiration. The figure at the bottom center wears the warrior's tunic with amulets (batakari), *while the figures at the sides wear military uniforms.*

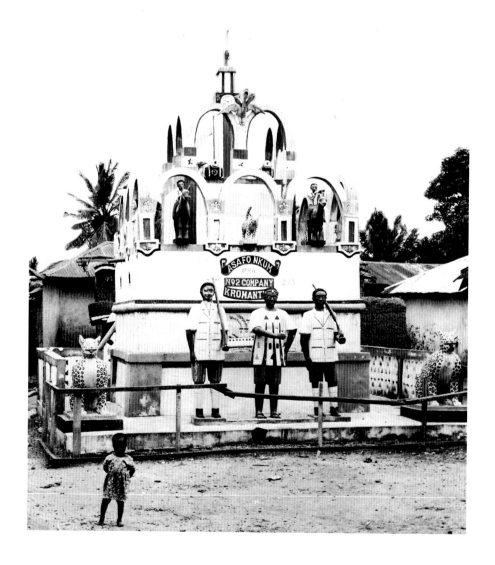

228

the gods. This approach does not imply any debasement and actually suggests the contrary. The invention of writing is attributed to Ifa, and the Christians, Muslims, and diviners learned it from her[145]. In these clothes, with a notebook or book under her arm, Ifa can reappear in Yoruba bas-reliefs. If thus European neo-traditions were the instrument of the selective assimilation and subordination of Africans in colonial European society, they did however furnish the ideological and symbolic basis of its opposition.

Among the Fante of Ghana, the iconography of the *asafo* companies is born of the confluence of traditional pre-colonial warriors and of those of the European military. These groups, organized on the patrilinear base and in a military mode, once constituted a counterweight to the royal bureaucracy and guaranteed the defense of the city. Destitute of their function, first by the English government and then by the Ghanaian, today they are civic associations. The pride of belonging, which opposed diverse companies in competitive ways, is expressed in the exclusive use of uniforms, emblems, flags, and in the edification of monumental altars[146].

The artistic elaboration of military altars (*posuban*) arises in the 1880's. Originally, they were constructed simply of a mound of earth and a tree placed behind an enclosure of branches. Their architecture is detached from local context and echoes, rather, the forms of European coastal forts and the architectonic details of Christian churches of the last century, depriving them of their functional destination and religious origin while the military symbolism is reinforced by the presence of cannons (or their simulacrum) and of statues of officials in traditional costumes or colonial uniforms.

This process of the intercultural and negotiated redefinition of "autochthonous" traditions finds one of its maximum expressions in the so-called Neo-Sudanese architecture[147], in which the Islamic-Sudanese amalgam of western Africa is revisited by French architects of the colonial period. We are speaking of a process of coming and going, from Africa to Europe and vice versa. Neo-Sudanese art is born in fact in colonial exhibitions that celebrate the splendors of the empire and reaffirm the principle of the indivisibility of the national territory, including therein the colonial dominoes[148]. One of the ways through which they seek to create this sense of extended citizenry of *la plus grande France* is that of widening the imaginary world of the French through the reproduction of the life contexts and architectonic structures of *France d'outre-mer*. The universal exposition of Paris in 1899 would thus see the creation of a Senegalese village which even had mosques, while the colonial exposition of Paris in 1931 would lend itself to the reconstruction of the streets and mosques of Djenné.

Ideological, commercial, and touristic intents empty these constructions of their symbolic weight, reducing them to the seductive exteriority of a simulacrum and redefining their aesthetic. Architectonic elements of diverse provenance are assembled in an ideal synthesis that aspires to be representative of "western French Africa".

This canonization of Sudanese architecture will, however, have its application in African territory in the building of edifices that see a European planing based on the reading of African-Islamic traditions and the work and technical skills of local workers and masons. The result would not be an exotic scenography of papier-mâché but an architecture that is "truly African as much in its history as its forms" and that places it back in the

137. *Flag of the sixth Asafo company, Fante, Ghana; cotton, length 218.4 cm*

Probably the creation of this flag was stimulated by the formation of auxiliary indigenous troops in the colonial era; the presence of the British banner, at the top left, is a recurrent motif. They flaunt the strength of the company and recall memorable episodes of its history.

138. *Detail from the design of an ivory tusk commissioned by the* oba *Ovoranmwen around 1889.*

139. *Plaque from the Benin palace, representing a Portuguese man, 16th-17th century; bronze; height 45 cm*

The figure of the Portuguese man in clothes from the sixteenth century is an iconographic theme that is transmitted, nearly unaltered, through the centuries; the figure on the right holds in his hands what could be a knob of copper, a coral necklace, or a piece of fabric, all objects brought by European merchants. The figure on the left, similar but with crossed arms, appeared more recently in Benin iconography; it would indicate instead a transformation in the identity of the represented subject: its transformation from a European merchant to a Benin priest. The central figure, finally, would be that of a high dignitary and the cross that he wears on his neck could recall Christianity as much as the Yoruba origins of the reigning dynasty.

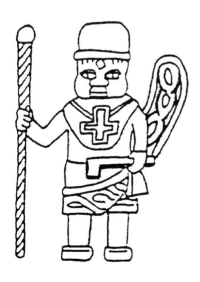
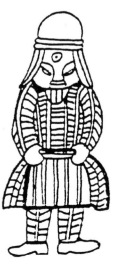

229

currents of tradition[149]. Among its major examples are the Great Mosque of Djenné which, built in 1909, echoes but also, in not small ways, modifies – in dimensions, in the organization of spaces, and in style – the precedent construction. The Islamic-Sudanese tradition is accommodated to be able to reconcile it with the needs of touristic development and police controls. Differently from the original construction, the principal façade that looks onto the market plaza (the one turned to the east and in which the *mirhab* is situated) coincides with the entrance, offering tourists and military personnel the wide perspective vision that they demand[150].

Inhabited spaces also change. The tendential moving from the extended family to the nuclear one, the introduction of Western furniture, and the changing of relations between the sexes leaves the morphology of houses with the internal courtyard unchanged, but profoundly alters the topological relationships between inhabited environments: the doors get bigger, the walls become straighter, the masculine and feminine spaces are no longer rigidly separated[151].

The so-called *colon* statuary of the nineteenth and twentieth centuries and, even earlier, the sculptural representations of white gods that are given at the beginning of the fifteenth century, prove both the thematic and stylistic level of rejection or imitation and revision of ways of Western life.

Whites are presented but, at least until recent times, through traditional aesthetic canons. Innovation is not stylistic nor functional but thematic and iconographic.

Images of Europeans and their activity appear in the first half of the 1500's on the ivory salt cellars that came from the Benin kingdom – and were exported to Portugal, later to reach Renaissance courts. Europeans were not, however, the only commissioners or receivers of these works. Representations of Europeans also appear on the bronze plaques of the fifteenth to seventeenth centuries that cover the pillars of the palace of the king (*oba*) of Benin and on the carved tusks placed on the altars of the ancestors.

A recurring theme in Benin art is that of the Portuguese merchant, whose iconography changes little during the centuries, but in whose apparent continuity of appearance there is in reality a change in identity, with the modifications of relations between the Benin kingdom and the different European powers that arise along the African coasts[152].

In the period in which the fortunes of the king were strictly tied to the slave trade, the figure of the "Portuguese" indicated one of the elements of strength of power. Recognized in his foreign origins, he found a place as such in Bini cosmology. As a liminal being, he moves freely, on a ship, through the borders between the kingdom of spirits (*erinmwin*) and the kingdom of the mortals (*agbon*), carrying to the *oba*, the king of the earth, the richness of Olokun, the divinity that rules over the oceans. The head of the Portuguese thus appears as a motif with a probable apotropaic or propitiatory function in the ornament of the belt of the *oba*, on the bronze plaques, and in ceremonial fabrics. While Lusitanians were succeeded by the Dutch and then the English, such a figure – for its closely-

140. Changes and continuity in the treatment of parts of the body in the Baulé statuary, Ivory Coast

While the head maintains its importance, a clean discontinuity is established in relation to the stomach, which tends to be flattened. To emphasize the place on the oblique of the pelvic line, which the traditional costumes underline with strings of beads on the loincloth, the horizontal lines of the waist take their place, evidenced by the European garments directly carved on the statue: the bust that was originally constituted as a single piece now becomes segmented into stomach and chest. The transformation in the fashion of clothing is thus shown to be determined in the same perception of the body: one has only to think that in the Baulé language there does not exist a term to designate the "waistline."

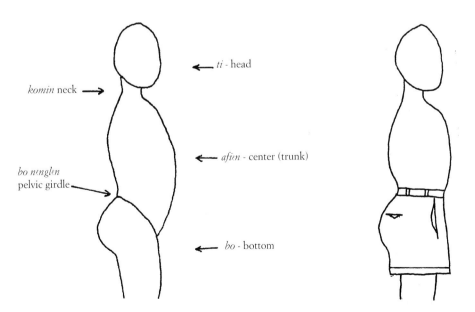

ti - head

komin neck →

afen - center (trunk)

bo nenglen pelvic girdle

bo - bottom

230

tied association with a sacred power that is legitimized through tradition – continues to cover Portuguese cloths of the 1500's, but its identity changes, ending with the representation no longer of a European but of Bini priests, continuators of Christian rites of the first conversions.

The end of the profitable slave trade imposed in the nineteenth century by the English, the weakening of the kingdom, and then the destruction of the palace itself hampered the maintenance of the customary symbolic relation. Of the plurality of positive valences connected to the foreigner, only the valence tied to the power of Christian religion is conserved. The *oba*, whose strength diminished on the military plane, reacted by accentuating his sacred functions, following Christianity and at the same time intensifying human sacrifices.

The ambiguities that marked the relationship with the West are traceable also in the more recent *colon* figures that, at least in some cases, seem to indicate more a danger from which to defend oneself than a model to imitate. The white appears with the face of the oppressor or as a figure lacking dignity, often in the clothes of a drunkard with a bottle in his hand. In the Ivory Coast for example, the *colon* were placed at intersections or at the entrance to the village to warn the populations of the passage of white people, and they were used, in the period of anti-colonial struggle, as weapons through which harm could be magically done. These same statues however later finished with representing no longer the white man but the black men who embraced them or, hoping to share with them, the style of life. They became symbols of the new social type of the urbanized African man, and they were then placed on familial altars[153].

Figures of the *colon* type also appear on the Baulé statuary dedicated to the lovers of the afterlife. Despite (though it would be better to say *because of*) the intervening changes on iconographic and stylistic levels, the Baulé statues continue to perform their traditional

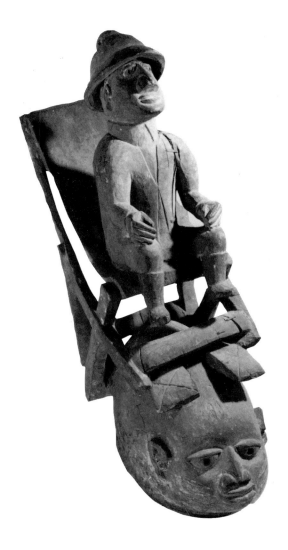

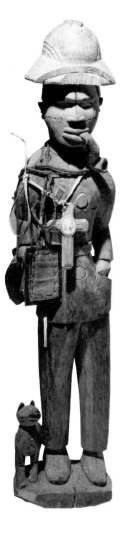

141. Gelede *mask with* Colon *figure on chaise-lounge, Yoruba, Benin; wood, pigments, 68 cm*

142. Colon *figure, Teke, Congo; wood, fibers, pigments, height 45 cm*

Gelede *masks in the forms of a head are repeated in a relatively uniform way, but they frequently change in their upper parts, learning from the changing times or making them into an object of social satire: the European man is here depicted in a typical pose, recurring in designs and photographs of the colonial era. In the Teke figure, we see instead the African man who has adopted the customs of the white man and carries them as emblems: the helmet, the pipe, the cross, the little dog.*

231

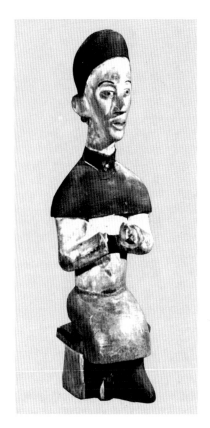

functions. Modern lovers of the afterlife, like their predecessors, continue to exhibit the socially recognized signs of success, with the difference that they are those of an Africa that is looking towards the West[154].

This continuity is clearly found on the aesthetic level (Plate 99). A singular "*colon* style" does not exist: these figures share the theme, which is then treated in stylistically differentiated ways. The style then becomes more "realistic", but is presented more as an anecdotal realism than an anatomical naturalism. Particular attention is given to fashionable clothing and to certain "typically modern" elements and behaviors like hands in pockets. If the traditional loincloth emphasized the turn of the hips, modern clothes instead move the barycenter towards the summit in the direction of the waist, while the stomach significantly becomes flat. The emphasis though continues to fall on the head, which in most cases is, as usual, oversized in comparison with the rest of the body. Even the use of color does not follow realistic conventions but symbolic ones. The adoption of synthetic paints may itself be motivated based on traditional beliefs: the greater duration that recalls vitality and superior luminosity that increases its power.

These aesthetic transformations however do not arrive in a pacific and uniform way, but are often part of the expression of interregional conflicts tied to historical changes. The introduction of the clothes that for the young constitute a social affirmation is instead seen by the elderly as a symbol of degeneration. If for the young clothes put the body on display, for the elderly they seem instead to hide possible physical defects[155].

Colon statuary, like certain masks and puppets, adheres to the time that passes, taking on a historical dimension, proposing ideals for the future and exercising a social criticism in the present. The style of the clothes or the objects that appear there allow them to be connected in time, to work as vehicles of memory. Often, the past and the present are dramatized through caricature and irony: the figures of executives or the colonial soldier are replaced by the international cooperator or the foreign advisor.

143. Figure of a missionary, Kongo, Congo; wood, pigments, height 62.6 cm.

8. Spaces and Times of Christianity in Africa

The presence of Christianity, like Islam, dates far back in African territory and also ended with the gathering of a great variety of religious beliefs, ritual practices, and organizational forms under the apparent univocity of the terms, from the different European de-

144. Abjuration of King Joao I of Congo, engraving by J.-T. and I. de Bry, 1598

The conversion, at least on the exterior, is signaled by the abandonment of "fetishes" that are thrown into the bonfire: their shapes are not, however, African, but recall Western demonology. The king of Kongo helps the bonfire in the company of a Portuguese official: on his head, he wears a crown given to him by the Portuguese, but on his shoulders he wears the skin of a civet, a symbol of power of traditional priests. In the background, a native man persists in the adoration of the deposed divinities.

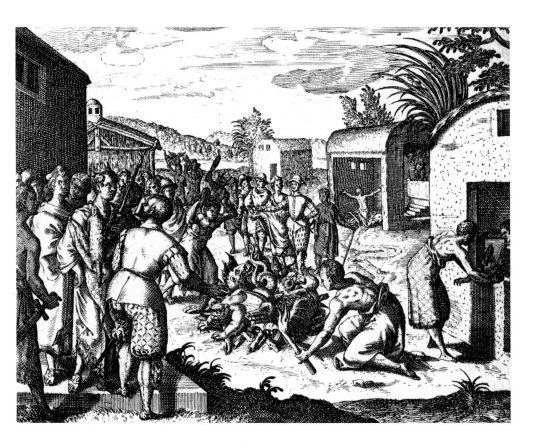

nominations transplanted onto African soil to the independent African churches, for a total of approximately seven thousand churches and religious movements.

The arrival of Christianity in western Africa dates from the first half of the fifteenth century, while its presence in Egypt, Tunisia, Ethiopia, and Nubia goes back to the first century AD. A Christian art has therefore been represented in certain zones of Africa since the dawn of Christianity, as is the case with Coptic art.

The relationships that Christianity entertained with African cultures and arts demonstrate ambiguities similar to those we have seen in regard to Islam and reflect the contradictory perception that Europe had for this land: Africa was made both the kingdom of idolaters, the cursed descendents of Cain, and at the same time the country of the legendary priest John and terrestrial paradise.

The relationship that Christianity formed with pagan populations has historically oscillated between two paradigms: that of polytheism as an aberration, a perversion of an original, primitive monotheism based on a universal revelation and that of polytheism as a premonition which waits and seeks its proper completion in the truth of the Scripture.

Different perspectives brought different thresholds of tolerance and acceptance of the cultural and artistic diversity of the African populations. On one side, there was total rejection, the creation of a *tabula rasa* of indigenous cultures to reintroduce the virgin space that would allow the welcoming of Christianity in its completeness and purity. On the other side, there was the attempt to screen the African religions and value systems, to trace on them the possible continuities and convergences with Christianity and make them grafting points for missionary activity[156].

The first behavior brought the decline of African religions to forms of superstitions, the bonfire of "fetishes" and the importation of European lifestyles and aesthetic codes. The second, while reaffirming the incompatibility of traditional cult figures with Christianity, did however bring a cautious retrieval and recycling of expressive modes and traditional aesthetics in the context of a Christian iconographic renewal. If thus on one side Christianity, no less than and perhaps more than Islam, brought a gust of iconoclasm to Africa, then on the other side it encouraged the renewal and prosecution of traditional figurative aesthetics rather than simply driving them to their end. From this point of view, we see a clear difference with respect to the Islamic suspicion in the face of representation as a blasphemous imitation of the creative power of God. In fact, Christianity – differently from Islam – can find a theological justification for iconophilia, for the representation of

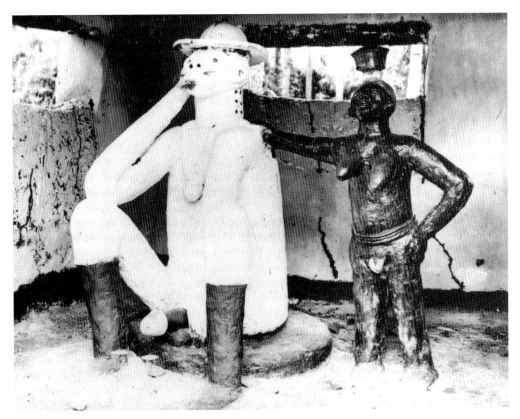

145. Altar of Eshu/Elegba, Adjara, Benin

Eshu/Elegba is on the threshold between the world of the living and the world of the gods; in sacrifices and divination, it opens the paths to their interaction. A figure tied to change, to the individual and transitory dimension of life, it is signaled by an irreducible duplicity that inseparably ties order and disorder. For this reason, it can appear both as male or female or as a couple: its ambiguity is the guarantee of communication between the sexes. The Christian missionaries, in the impossibility of finding a figure analogous to the Devil in the Fon/Yoruba pantheon, identify Eshu/Elegba with Satan, insisting unilaterally on its "negative" aspects.

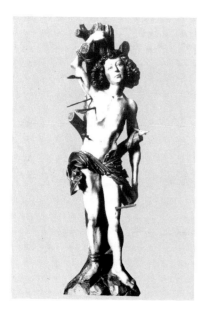

146. *The martyr of Saint Sebastian, P. von Kleinwallstadt, 1500.*

147. Nkisi *statue, Kongo, Congo, wood, nails and iron points, height 67.5 cm*

According to some hypotheses, Kongo nail statues could have been an unplanned development of Christian iconography brought by the missionaries and the availability of blades and nails that came from Europe.

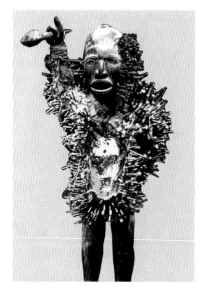

divinity in anthropomorphic forms, in the incarnation of Christ, who is made visible to man by assuming human forms. The image, pushed away in as much as it is an idol, is however assumed as a memory and prophecy of the encounter between God and men.

If Protestantism, because of its reticence in the face of sacred representations, acted substantially as a curbing influence, Catholicism, with its cult of the Madonna and the saints and its rich figurative tradition, instead allowed the passage of African aesthetics within the new religion, offering, despite even multifarious points of anchorage, the syncretism of the local religions at the same time.

Images in Africa were thus also the ground and the object of a struggle between competing religions.

Thus the fact that Europeans, until the beginning of the twentieth century, did not value the aesthetic importance of African arts is not simply due to their distance from commonly accepted canons of beauty. If African sculptures were not included among works of art, it was not because they were undervalued but because, on the contrary, they were taken terribly seriously. While to the Greek and Roman divinities, by this time without believers and strength, the path of art, the path of pure aesthetic contemplation devoid of religious significance, opened in the fourteenth and fifteenth centuries, African statues still represented hostile forces and as such were opposed. Not simply reduced to the object of superstition – a belief difficult to answer but in the end inoffensive – but replaced in the Christian universe as negative and demonic entities. Thus a process that brought the reinvention of traditional religions on the part of Europeans, and the reabsorption of Christianity in local conceptions on the part of the Africans was triggered. If the missionaries sought to make Eshu Elegba – the divinity of the Yoruba and Fon pantheon – into an analogy for Satan and Yemoja, the god of oceans and rivers, the correspondent of the Madonna, the Africans saw in Santa Barbara a manifestation of Shango, god of thunder, and in the face of Saint James Ogun, the god of iron and war. As much the African iconography, which would be destroyed, as Christian iconography, which would be diffused, became the weapon and the terrain of a contest between opposing interpretations, one tendentially exclusive and the other syncretic. If on the African side the image carried a stratification of equivocal and polymorphic meaning, on the European side they tried instead to regulate the meanings, make them univocal, reducing them to the sayings of the Scripture and to their didactic function, making them a book for the illiterate.

It is a struggle that not only touches the images, but revolves around the practice of writing. At the beginning of the twentieth century, Protestant missionaries in Belgian Congo drafted dictionaries in the Kikongo language, translating the Bible and publishing collections of customs and habits in the local language. This operation, either intentionally or unknowingly, modified the outlines of the Bakongo language and culture[157].

In the passage from the spoken to the written, which would synthesize some dialects thought to be central, the language becomes more homogenous and grammatically disciplined, generating standard Kikongo. The traditions become synthesized (eliminating silences, variations, and contradictions) and partly reformulated, attributing to the Bantu Egyptian origins or making them descendents of Adam and Eve. The search for terms of the Kikongo language that allow the expression of Christian conceptions brings a drastic revision to those words, which become deprived of the magic components. Thus, for example, the term *sumuna*, which originally indicated the contamination of a priest within a specific ritual, was made into the equivalent of the Christian notion of sin, transforming it into an ethical concept that covers almost every kind of imperfection and refers to an inclination of human nature.

Literate Africans responded by making the Bible into a type of *nkisi*, a sacred medicine. The chiefs would elevate genealogical papers and written traditions into new emblems of power which could mysteriously produce, in the courts of the white man, more powerful effects than things expressed orally. The traditional healers appropriated the herbal books compiled by the missionaries who intended to remove the people from the hands of "witches" in order to make them the texts of their art. Many literate Africans catechists reacted to the frustration of their marginality, as much in relation to the white man as to the black, elaborating the myth of their access to sacred texts hidden from the missionaries and creating the origin of the prophetic Kimbanguist movement.

The result was not complete homologation, but the creation of an ambiguous space in which misunderstanding would become possible. The written language, not drawing the tonal inflections of the spoken word, finishes with the preservation of flexibility and ambiguity. The words, passing from Africans to Europeans, carry a multiplicity of different meanings that remain in great part obscured the one from the other. It had an undesired

and unexpected effect that would push Catholic missionaries to spread Christianity through the introduction of French and Latin terms.

The results of this struggle were not decided in parting, and their conversion was not always a one-way process. At the midpoint of the eighteenth century in Senegambia, it was more frequent that French residents converted to African religions than that Africans converted to Christianity[158].

A particularly meaningful example of the struggle enacted around images is the celebrated case of the conversion, as precocious as it was ephemeral, of the Bakongo population at the end of the fifteenth century. Equivocating on the nature of powers of African kings, it was thought that a collective conversion could be ensured through the agreement of the sovereign. But the Bakongo king was not a despot, and his power was narrowly bound to traditional religious practices. The conversion could not include an abjuration that was fictitious, and the new god was simply added to the others. This explains how the bronze crucifixes and the statues of the saints that, under the influence of the missionaries, the Bakongo began to sculpt later became reintegrated into their traditional cults. While Christian iconography put down roots in order to arrive in the present day, the conceptions that supported it rapidly lost ground, and the forms took on new meanings (Plates 102, 103).

The influence of Christian iconography would even be recognizable in the objects which we would initially consider as the most profoundly "African" and far from our way of thinking: the magic *nkisi* statues. Their appearance would be contemporaneous with the arrival of the Portuguese and with the availability of blades and nails imported from Europe, whose use could have been suggested by the nails of the cross or the images of Christian martyrs pierced by arrows[159].

Precisely the need to preserve the purity of the Church in a "hostile" territory, and to offer exemplary models, brought the abandon of superficial collective conversions and the search for more convincing individual conversion.

The Church thus accentuated its character as a foreign institution, implementing an assimilationist policy in which becoming Christian was in the long run one and the same as the adherence to the customs and lifestyles of the West. The image of the good Christian that guided the preaching of Protestant missionaries, who in the last century operated among the Grebo of Liberia, was that of an African educated in Western fashion, who sanctified Sundays, who did not use talismans, who rejected traditional sacrifices, who had only one wife, who dressed in Western style, who built European-type houses and cultivated flowers in the garden[160].

The prevalence of this rigidly hostile behavior towards African religions and cultures probably explains the scarce capacity of the penetration of Christianity in lands in which it had to compete with Islam. While the Muslim religion was seen as autochthonous because of its accommodations, Christianity came to be perceived as foreign and an organic part of colonial domination. This was the situation that then generated the development of Christian separatist and independent churches, declared hostile to colonial authority and aspiring to the integration of African practices and beliefs into Christianity[161]. Even in this case, the process of assimilation would have to be realized through a profound disintegration and reconstruction of spaces, uprooting individuals from the society of belonging and separating Christian communities from the surrounding environments. It is in this view for example, that in the second half of the 1800's the Swiss evangelical missionary students in Ghana were banned from participating in dances and in political and economic local affairs, while Christians who lived with non-Christians were discouraged from eating with them[162].

The seminary where the native clergymen and "Christian village" were formed was called to operate in this process of transformation.

A construction isolated in the forest, the seminary escaped as much the rhythms of rural life as those of urban life, constituting an all-absorbing space lacking the cultural references of the outside world[163].

The "Christian village" instead often collected the ex-slaves whose freedom was purchased by missionaries and who were then placed in contexts completely foreign to their original culture. This was a practice of explanation and transplantation that found particular application with the ex-slaves who had returned from the new continent and who, in their position as black people raised as Christians in the West and reinjected into Africa, would seem to be able to propose a model to imitate, a concrete image of the future Africa, a lever with which to penetrate among the indigenous cultures. Instead it happened that for the most part – when they did not return to Islam – in these Afro-Ameri-

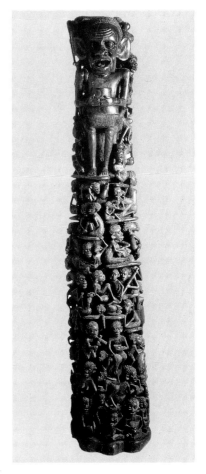

148. Ujamaa *sculpture, Makonde, Kenya; wood, height 159 cm*

The Portuguese, Indian merchants, and missionaries were identified in the evolution of Makonde sculpture of the 1950's. Ebony replaced light wood; the isolated and static figure was replaced by a group and movement. Thus, the "trees of life" sculptures that take the name Ujamaa, *referring to the project of communitarian socialism of the Tanzanian president Nyerere, were born. Here, we find the ideology of the village diffused in Africa by Christian missionaries and by English colonialism.*

149. *Church of Saint Paul, Lagos, Nigeria*

The church was built in 1956. Before then, of the public buildings in modern Lagos, only the television station was inspired by traditional African art. The building is constructed on a European plan, but the arabesques that cover part of the facade are those of the northern Muslim Hausas. The doors to the entrance are carved in the traditional Yoruba style.

cans a sense of "otherness" in the rediscovered African culture prevailed, with the tendency of constructing themselves as a separate body and of making Christian faith not a doctrine to spread but an element of exclusive social distinction[164].

It is interesting to note how even in the rare cases of approaches sympathetic to African reality, as in the cases of Christian villages run by the Basilian mission of a Pietist inspiration, the perspective remained decidedly ethnocentric: the idealized models of the farming community of pre-industrial Germany were transplanted onto African soil. The idea was to propose to the Africans "a mission *by* the village *in* the village" that would permit conversion on the basis of a continuity of values. The result was instead the introduction of a European mechanism of authoritarian control, tied to economic innovation. If the Pietist model was in fact the transfiguration of a past that had never had organic coherence attributed to it, as it already was as far as Germany was concerned, "In Africa, 'villages' of these dimensions and that solidity never existed."[165]. This was a reinvention of African tradition inspired by a European tradition, no less invented, that would then be inherited by contemporary Africa, ending up inspiring the African way of communitary socialism. What was in origin not African would end, at least on an imaginary level, with becoming so.

Similarly, the affirmation of independent black churches would be, more than a revenge of deep Africa against acculturation, the expression of its insertion in the currents of globalization. The claiming of its own particularity would be made concrete in the fact of the assumption of the mentality and rites of American fundamentalism in the deep South[166].

For its part, the Anglican church introduced into Africa the festivals of the harvest and the processions in the fields that were used in the homeland to create a "communitary" spirit against the social tensions that were turning the countryside around. For its part, the Catholic church disciplined the proliferation of cults and altars, erecting its copies of Fatima and Lourdes and channeling religious pilgrims into the few sanctuaries of the authorized Marian cult according to a scheme already tested in Europe[167].

The Africans reacted on the same ground, appropriating from historical narration and Christian geography and substituting with an imaginary topography. At the beginning of the eighteenth century, Kimpa Vita, a Congolese native who was thought to be possessed by Saint Anthony and otherwise known as Donna Beatrice, proclaimed Congo as the true Holy Land, affirming that the founders of Christianity belonged to the black race, substituting the sacred places of Congo with those of Christian revelation and preconizing a golden age in which "the objects of the white people" would belong to all the believers of the new faith"[168].

150. *Portal of the Catholic church of Ibadan, Nigeria*

This work was realized by the sculptor Lamidi Fakeye in 1954. Scenes from the New Testament are represented here. The framework of the door recalls in the overlapping registers the traditional carved Yoruba doors, introducing, however, a narrative and didactic intention that was absent in the Yoruba works.

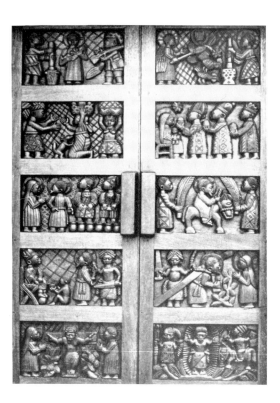

9. The Domestic Art of African Christianity

The continuity between present and past, between African religiousness and Christianity is not only expressed in syncretism, in the formation of independent churches and messianic sects, but also with the birth, in the post-war period, in the breast of Catholicism itself, of an African Christianity that claims its own peculiar artistic and cultural patrimony.

In the 1950's, with the continuation of the process of decolonization, there was in fact the affirmation of a process of making the Church native that guided, in an ecumenical optic, a revision of the relationship between paganism and African Christianity[169]. A particular face of common and universal wisdom begins to be seen in African religions, while the idea of an original African monotheism hidden behind apparent polytheism takes form. The process is duplicitous. If on the one hand we are talking about inserting Africa into the common current of universal humanity, on the other hand we are seeking a definition of orthodoxy in terms of historical and cultural differences, separating Christianity from the history of the West[170]. These were aspirations that at the end of the 1950's took form in the theology of the incarnation, in which the grafting of Christianity onto the traditional culture was tied to a program of African political liberation.

The Second Vatican Council would grant recognition to these expectations and give them a solid frame within which to express themselves, affirming, when "faith or the general good was not in question", the wish not to impart " a rigid uniformity" but to respect and favor "the qualities and gifts of the soul of the various races and various peoples" considering them with benevolence, and if possible, maintaining them unaltered and admitting "even in the liturgy" what in the customs of the people would not be "indissolubly tied to superstitions or errors"[171]. This was an opening that involved sacred art in an explicit way so that the "Church has always thought itself of good right to judge, choosing among the works of the artists those that responded to faith". It did not, however, "ever have as its own a particular artistic style, but according to the disposition and conditions of the people and the needs of various rites, had admitted the artistic forms of each period"[172]. Thus, a process of revision of Church behavior in relation to missionary art and to the art outside of Europe that had its beginnings in the 1920's and looked to the medieval Church and to the origins and echoed the lines of the Instruction of *Propoganda Fide* of 1659 came to a conclusion[173].

This perspective, if in one sense it could not but continue to hit the forms of art that risked favoring polytheism, did however also create a ground on which the selective retrieval of African artistic traditions becomes possible and desirable.

Thus, the idea of a widespread and spontaneous "African philosophy" that was affirmed with the writings of Belgian missionary Placide Tempels – and that would have its continuators in many African priests – arrived to isolate a profound nucleus of African wisdom that would anticipate and tend towards Christianity, but would seem to make African sculpture the precise sacrificial victim of this alliance. The process of the distillation of an "African philosophy", which is in large part unconscious, not formalized but settled in the structures of the language and in social practices, implicates in fact, with its systemization in the marks of writing, the distinction between an existential base (religious, moral, and intellectual) and a veneer of magical superstitions, dangerously close to materialism. African art thus ends between the dross and discards of "fetishism"[174].

In the practice of many missionaries however, the problem of art as indispensable to the high decorum of the church and the success of the preaching is presented:

"An ugly church, whose forms are foreign and unnatural to the place and contrasting to the tastes of the natives, is destined to sustain an unfavorable impression by the same native people. . . . A pretty and dignified church, responding to the sensibility of the natives, would prepare the soul to the curiosity and love toward a religion, which presents itself to them as something sympathetic and noble."[175]

On African land, it is thus possible to uncover a range of positions that go from the romantic conservatism of a Romain-Défosses, who sought to preserve African spirituality against Western materialism, to the project of Kevin Carrol, who aspired to reconcile European ideas with African forms[176].

In Carrol, we find an attentive scholar of Yoruba art and a convinced patron of Christian African art. In his opinion, the neo-Gothic African churches from the last century, as much as the "modern style" churches that followed, remain completely foreign to the Africans who do not feel at home in them.

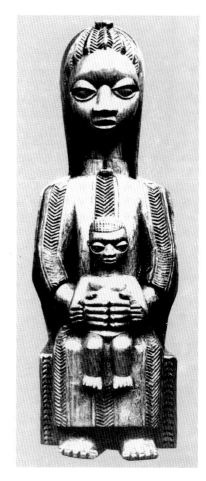

151. Madonna, work of the sculptor Bandele, Nigeria, 1954

Among the works by Bandele (1915), the son of the sculptor Aerogun, there are pieces of Christian art and traditional masks. Themes strongly rooted in maternity merge in the African Madonnas. In the facial details, the Madonna and Child recalls the traditional Yoruba style that is, however, sweetened; even the proportions between head and body change, becoming closer to anatomical proportions.

The recourse to local traditions – to the technical skills and formal repertoires of African artists – thus moves from the exigency of stripping Christian art of its communicative conventions, markedly European, to translating the universal Christian message in symbolic African forms. Depicting Christ with long hair, in traditional Western ways, in a culture like the Yoruba, where neither men nor women but only crazy people have long hair, could have created more than a misunderstanding. It affirms the right of Africans to portray the figure of Christ within their own aesthetic canons so that He physically resembles them, not very different from what Europeans had done for centuries.

Carrol's vision of Yoruba culture however is not static. He knows how to make a lever of the symbolic shared elements (the polarities of white-black, light-darkness, old-new, death-resurrection), for as much as they are dropped in profoundly different contexts and he demonstrates himself attentive to cultural transformation. If the symbol of the Sacred Heart is foreign to Yoruba culture, which does not locate the heart as the seat of affection, the influence of Western culture and the means of communication may have rendered the association at least somewhat familiar.

This encounter between Christian and Yoruba symbology arrives through an active reinvention of a language in disuse but of which the native people would continue to be unknowing carriers. In the "humanism" of Yoruba art, there would be the possibility of disassociating sculpture from pagan religion so that the lesser arrival of the latter does not bring death to the former, but brings its passage into Christian religion[177].

This reconversion of expressive forms presupposes, though, a vigilant and selective eye, in particular when we are speaking of the return of sculpture, which is more susceptible to being animated because of its three-dimensionality. If the return to Hausa arabesques for the façade of the Church of St. Paul in Lagos (1956) inspired only amused comments on its resemblance to Islamic mosques, the presence of the African Madonna (1961) instead raised the fear of idolatry. Carrol, who, though he does not see a form of polytheism but a way, certainly unorthodox, of addressing oneself to God through intermediaries in the Yoruba decoration of the *orisha*, admits the risk and to address it, in this case, looks to the iconographic tradition of the West. Against the emphasis that the Christian art of recent centuries has brought to isolated figures and personalities, there needs to be the renewal of a narrative art, of a Biblical content, that knows how to bind and discipline vision. From this comes the preference for the architectonic integration of sculpture, for didactic cut panels in which characters and scenes are placed in a narrative sequence and whose meaning becomes transparent in connection with the liturgy. From this also comes the choice to concentrate on the principal themes, allowing the peripheral ones to fall away so that the Madonna would be underlined in the title of "Mother of Christ", in continuity with the importance that the Africans attribute to maternity, and others would

be allowed to fall, averting an uncontrollable proliferation of images and Madonna figures[178].

This is the approach that is echoed and deepened in African Christianity.

The traditional iconography is thus passed through the sieve of the Christian message. The universality of the Christian message, the sacredness of the revealed Word, fix the criteria of judgement and thus the margins of compatibility. But if conversion inevitably implies a rupture, a separation, and as a result the collection and preservation of the pre-Christian tradition cannot but be selective, we would not speak of "an emptying, nor of a *tabula rasa*, even less of a surrender. The Son of Man has come to complete, not to abolish." Conversion also has the character of a "*recapitulation*, thus an arrangement, under a single head, of an entire inheritance."[179].

154. *Chair, Ashanti, Ghana; wood, red enamel paint*

In the Ashanti chairs of the nineteenth century, the caryatid often took on animal forms, like that of the leopard or the elephant, associated with the exercising of power. In the twentieth century, their place is sometimes taken by new emblems of power: in a world that changes, the iconographic transformation is rendered indispensable precisely to reaffirm the symbolic continuity of the object.

The possibility of a resumption of iconography, of symbolism, and of African artistic traditions is founded on the faith in the universality of natural revelation, of its seminal and anticipatory character with respect to the revealed doctrines. The open character of African art and prayer, which never arrives at annulling the distance between God and man in the identity of mystic union, is reinterpreted as availability to the welcoming of a revelation that fills that void. The silences and absence of images that surround the African God are not seen as an interruption or negation but as a moment of dialectic development[180]. Christianity would thus respond to the profound feeling of Africa, giving to life, with eternal salvation, the definitive victory over death, tearing humanity from eternal return. The necessity of such a resumption is motivated not only by the pragmatic adaptation to local realities indispensable to proselytism but distinguishing, more deeply, between the universality of revelation and the historically cultural rooted in forms through which Christianity is expressed. From this perspective, it is not only Christianity that interrogates African religiousness; Africa also interrogates the bound contents of Christianity.

This nexus provided a connection between Christianization and the adaptation of ways of Western life that in Africa had imposed the renunciation of cultural dignity as the price of conversion. In the effects of this process of depersonalization, we see a threat to this Christianity. When in Africa the Word is deprived of the flesh that could hold it, the total experience of the Church remains unrealized precisely because it is missing the distinctive black-African reading of the Book[181]. It is thus not an issue of remaining Africans *yet* becoming Christians, but of bringing to the Church, and to humanity with its own Africanness, its own irreplaceable contribution to the understanding of the revealed message.

African art can now contribute to the rearticulation of Christian liturgy through its own music, its own dance, its own graphic repertoire, its own architecture, its own sculptural style (Plates 104-105)[182]. Between Christianity and African tradition, a hermeneutical circle, a dialogue that, for as much as it is not equal, is not however predetermined in the results is thus established. If there are the Scriptures to indicate what part of African culture is inheritable, it is also true that the Scriptures reveal a part of their meaning only by taking African traditions as a point of departure.

We are addressing the retracing of this widespread symbolism that can function as a revolving platform, introduced from one context of meaning to another on the foundation of a sensitive and sensed continuity. African Christianity does not thus appear irreducibly the enemy of pagan religions, but seeks their domestication.

10. Beyond Disenchantment: Deculturation and Neo-identity Strategies

The lacerating discontinuity following Africa's insertion into the world capitalist system cannot in any way be undervalued. It would, however, be a mistake to see it simply as the disenchantment of the African world under the blows of rationalization brought by modernity. The superficial sharing – other than drastically unequal – of the gadgets of industrial society covers the persistence of profound distances, as much economic as cultural.

The process of the Westernization of the world does not seem to lead to the eclipse of the sacred and the establishment of a mono-culture. Economicism, utilitarianism, individualism gain ground, but their dominion is far from complete[183]. The models of development based on the presupposition of cultural assimilation are no less failed than the relativistic utopias that aimed at the preservation of a spectral original identity. The globalization of the economy extends contacts and occasions of contamination, but does not give a

(Facing page)
152. Pillar of the church of St. Michel, Libreville, Gabon; work by sculptor Zephirin Lendogno

Scenes from the Old and New Testaments are depicted on fifty pillars of the church of St. Michel carved by Zephirin Lendogno.

153. Church of St. Michel, Libreville, Gabon, 1977.

155. Tuareg slave merchant, puppet of Alassane Doundou; India rubber, wood, fabric, threads of wool.

Objects of European fabrication can be diverted from their native destination and, modified in their appearance, take on new and unpredictable identities. The puppet was abandoned by his creator with this explanation: "Slavery has been abolished, this no longer serves any purpose!" (D. And O. Nidzgorski).

place to any society or global culture. It exacerbates material inequalities and does not produce any shared sense. The differences, for better and for worse, rather than becoming reduced grow larger.

The outlined horizon does not seem rigidly uniform. Fragments of past traditions are composed in an unstable and precarious manner with the bringing of modernity to give space to new and multifarious identities. Post-modern eclecticism, with its practice of *pastiche* through time and space, thus finds a consonance in the *bricolages* of the post-colonial situation[184]. In Africa as much as in the West, identities are constructed and expressed assembling heterogeneous and composite materials.

And yet, the analogies cannot hide the profound differences. Africa and the West intertwine and then proceed on divergent paths. In affluent societies, the construction of identity proceeds through fashion and masks, interchangeable disguises of ephemeral duration. In this context, the acceptance of arts and outside cultures is often accompanied by their being rendered banal. "Ethnic fashion" moves to the search of ever-new and epidermic sensations, reducing symbols to simulacrums. It does not produce a sense, but hides, temporarily, an empty space. The aestheticization of the works and other lives seems thus to provide a dulling and anesthetizing function in our society: the mask does not reveal, but conceals. In African society instead, suffering and pain that do not allow cosmetic treatments contribute, perhaps, to the maintenance of a greater rooting of the corporal experience and of the earth, as much the one lived as the one promised.

Diversity also surfaces in the cases in which mimicry seems more extreme. Among the inferior social classes of Bakongo of Brazaville (Congo), the so-called *sapeurs* appeared (from the French *se saper*, which indicates the art of dressing oneself with elegance). These *sapeurs* constructed their public image and individual identity around the possession and ostentation of designer European clothes. We are seeing a process of gradual elevation that passes from the purchase in Brazaville of *prêt-à-porter* clothes imported from France and Italy to then land in Paris, where, living in misery, the *sapeurs* sought to acquire the greatest possible number of designer clothes on an installment plan. The return to their country would later be the occasion to display the result of their Parisian adventure, giving place to the so-called *dance des griffes*: the *sapeurs* parade through the streets of the city with the labels sewn on the lapels of the jackets so that they are visible to everyone.

Despite appearances, in this way of behaving there is not so much the renouncing of self in an obtuse submission to consumerism or the mere simulation, through objects of luxury composition, of a lifestyle that they cannot afford. We are looking, rather, at a cosmopolitan strategy that attempts to renegotiate its own identity within local society. The modalities can subvert the organization, but they still draw from the traditional ways of thinking. We are not speaking of a demonstration of aestheticized dandyism; there is no reduction from "being" to "appearing". If the clothes make the person, it is because, once more, individuals increase their vital energy by drawing from the external[185].

The flux of commodities, capital, and information triggers processes of deterritorial-

156. "Two horses", South Africa, 1994; metal, length 20.3 cm

A toy constructed using metal recycled from cases of concentrated milk.

ization that annul spatial-temporal spaces, but also deepen the remoteness of those lacking access to the resources.

The marginality of Africa with respect to economic circuits and global geopolitical strategies relegates it to underdevelopment, but also opens spaces of autonomy. In Africa, this helps to produce a spatial-temporal *multiversum* in which the life of great urban reality and the life of villages coexist and intertwine, metropolitan anomie and neoclanical solidarity.

The task of saying and showing, visually and through narratives, this heterogeneous reality seems today to be assumed in particular by African cinema, which in its best expressions seems precisely to have "the power to give a geographic face to the words"[186], recounting the difficulties of urban life or reinstating territory in the context of myth, perhaps reformulated on the basis of visual suggestions offered by the cinematography of science fiction.

Paradoxically, it is precisely the deculturation generated by the West that develops the question of sense, thus creating the conditions for a reinforcement of religious sentiment. The growth of competitive individualism, and of the sense of uncertainty that accompanies it, defines an intensification of magical beliefs, of divinatory and apotropaic practices. The continual expansion of prophetic and syncretic cults responds to the loss of meaning. The African *bidonvilles* react to the crises of state, of the formal economic system, and of technological development with the creation of new networks of solidarity and reciprocal help that echo and reinvent past communitary forms, looking more to relational needs than to profit. The uncertain and fragile outlines of an open society, and a society in formation, are thus delineated next to these signs of a continent adrift[187].

If Africa becomes the dump of the West (where obsolete technologies, expired medicines, discards, and refuse are exported with devastating results), it is also true that on this rubbish pile new forms of marginal economies were created, enough small works to allow the poorest part of the population to survive[188]. What one society pushes to the margins another reintegrates, ripping it from no man's land, from the refuse heap, and replacing it in the world of men.

Recycled materially and symbolically, this refuse becomes a resource. The remnants of industrial and consumer products are changed into the ingredients of a useful handmade object or a sometimes aesthetically elaborate cult object[189].

European dolls, opportunely transformed in their clothes and appearance, are thus used in voodoo cults, or cults of twins, and in puppet theater. The rubber from old tires, the inner tubes of bicycles, shower tubes, bottle caps, Coca-Cola cans, and boxes become materials for the construction of toys, suitcases, puppets, altars (Plates 107-109).

157. Lutte contre les moustiques, *work by painter Cheri Samba, Congo, 1990*

The generation following decolonialization placed social, political, and moral themes at the center of its own works. The starting points are taken from news events; the didactic concerns lead to the introduction of writing in pictorial works. The comic in this case urges personal responsibility in the struggle against malaria (which "in Africa kills more people than AIDS") without passively waiting for the intervention of authority.

158. *Funeral celebration, Ghana*

The coffin, a work by sculptor Kane Kwei, is in the shape of a Mercedes-Benz. The ceremony occurs outside because official Christian confessions prohibit these coffins, which are often accompanied by animist rituals and animal sacrifices from entering the church.

Sometimes, what is retrieved is used as a simple material, and then its transformation is radical, canceling out every formal and functional trace of the original objects. Another result instead comes from an intercultural object of an intentionally symbolic assembly in which, ironically, the memory of the old object shines through the new one. This is the case of kerosene lamps that use burned-out light bulbs as tanks, thus satisfying the need for illumination and at the same time alluding to the electric energy that they cannot afford[190].

Many art forms in the course of the twentieth century vanished with the crisis of political and religious structures in which they were used, but new forms of artistic expression took their place. Next to the "international art" of the African artists of an academic formation, and that for the tourists, there were new forms of functional, religious, and popular art.

Thus an art that was perhaps less unitary and harmonious than preceding forms, or much less than that collected and rendered "classic" in our museums, was born, an art that is more lopsided and rich with visual contrasts, which works on shards and fragments so as to be able to express the tensions and complexity of the contemporary world. The severe sobriety of sculptural volumes often thus leaves the field of a painting that privileges burning colors, strident approaches, while in the sculpture itself a montage of heterogeneous material replaces the compactness of the wooden block. All of the transformations, however, rather than constructing the innovation, present themselves as a selective accentuation of already existing selective models[191].

Thus the social and didactic function traditionally entrusted to African art also explains the recourse to alphabetic writing, which accompanies images with increasing frequency. On the paintings that the urban middle class hang in their homes, there sometimes appear captions or comic strips that render the messages more univocal, marking at the same time the social sphere of belonging (that of schooled Africans who own a living room in which to be able to hang a painting). Writing thus establishes the right of citizenship of the artist and the client in the space of modernity, the legitimacy and authority of their conversation. However, the writing on the image does not exercise a complete dominion. In representing facts of news, social problems, or episodes from recent or colonial history, text and image are often rather divergent, if not contradictory. The inscription transmits the official version, that taken from newspapers, exercising or parodying writing's function of social control. The image, which despite its pictorial language is also rooted in modernity, refers instead to what is learned through other channels, the voices on the street, and thus offers an opportunity to challenge constructed power[192].

Paintings, resuming their didactic use of illustrations made by the missionaries, can al-

159. *Cement tomb, work of sculptor Agoudavi Komlan, cemetery of Davié, Togo, 1978; cement, paint*

The date of death is written in the anterior part of the tomb. The finger pointing upwards to indicate the sky alludes to the omnipotence of God but also to a kind of challenge in his confrontations: "Dieu seul peut me (le) vaincre!". The photograph was taken in September of 1978; in 1996 a "crazy" truck reduced the cemetery to a heap of ruins. Economic crises hindered reconstruction; Komlan himself had left Davié to find any kind of work.

160. *Funerary monuments (aloalo), Mahafaly, Madagascar, 1970*

The emblematic figures that appear on Mahafaly funerary posts retell the biography of the dead and are thus modified in time, collecting signs of modern life. Planted in the place of the honored sepulcher, the dead exercises, perhaps, a function of mediation between the world of the living and the world of the ancestors.

so become episodes of the same story, but their narrative connection, instead of becoming rigidly prescribed, is left to the interpretation of the receiver.

The association between writing and image can also become an instrument of religious preaching and the spread of new cults. For example, in the designs of Frédéric Bruley Bouabré, founder of a 1950's solar cult that united African traditions (Beté) and Christianity (the cult of the Madonna), images and writing are composed in the translation of mystic dreams in which the divinity reveals itself and in the launching of a message of peace[193].

The development of collectionism and mass tourism brought African art into the international economic circuit. The demand for objects of African art in the West and the emergence of new needs and emblems of social status in Africa certainly created a series of disruptive pressures. And yet, if the marked growth of economic motivations changed the creative process, it did not define the final product, nor did it necessarily conclude in an aesthetic or semantic impoverishment of the object.

We take the case of the Ashanti. The artists, with the decline of royal patronage, increased their degree of dependence on the market. Immersed in a more competitive context and placed before fluctuating demand, they found a way to anticipate and meet the changing tastes of African and European buyers with a more accentuated stylistic and iconographic innovation. Such transformation, however, arrived in a regulated way that was socially differentiated, producing aesthetic niches and clearly distinct markets. Sculpting, with little success, objects that were purely fantastical, inspired by a vision of Africa bearing a Hollywoodesque imprint, for the tourist market were the most mediocre sculptors, often dilettantes waiting for other work. The better artists instead continued to seek the innovation that could confer their prestige: that which could reenter the channel of tradition, could affirm itself as a tradition becoming an object of others' imitation[194].

The impact of the market is not simply translated into a loss of traditional symbolism but into its intentional change when not absolutely in a "retrieval" of its own past. Paradoxically, precisely the value attributed by the Europeans to African masks made it such that in certain cases the Africans returned to believing in their power[195].

The aprioristic devaluation of contemporary African art on the base of its opening to the outside is not a solely empirical fact but the product of a judgement of value consequent to the tribalization of African society, operated by the ethnological gaze. The criteria of "authenticity" that are at the base of "ethnic art" presume in fact that the circulation of objects happens within an integrated community; that artist and patron share the same language, values, beliefs, and aesthetic principles; that the ritual character of this art and the absence of missionary spirit on the part of African religion hamper their spread outside of the group that produces them. These are axioms that clash with each other. With

161. Altar of Mami Wata, Igbo, Nigeria, 1978

The statue of the divinity is rested upon bottles of Coca-Cola, placed in a basin of water; the glasses and the mirrors that decorate her are the sign of modern feminine seduction but also, for their capacity to reflect the light, the symbol of the waters to which Mami Wata is tied, the element of conjunction and separation between the divinity and her devout.

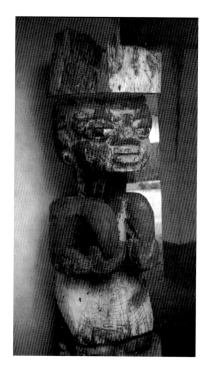

162. Pole of a verandah, work by the sculptor Osejman Adefunmi, USA.

The rediscovery of their "own" religious and artistic traditions on the part of the US descendants of the Yoruba brought the appearance of a neo-Yoruba style to American territory. In 1970, a Yoruba village was founded in Sheldon, North Carolina, by Oyotunji that was proposed as a pole of attraction for the rebirth of a religious Yoruba art purged of any Christian influence.

the presence of long-distance commerce – of artistic objects as well – come the traditional components of many African societies[196].

In reality, many contemporary African artists work in a highly variegated urban context whose economy involves as much barter as money and has its clients as much among working classes as the local elite, in tourists passing by and in buyers on the international circuit. The fact that the artists could produce for galleries all over the world does not stop them from continuing to create ceremonial pieces for local use. The two levels overlap, rather than exclude each other[197].

Growing individualism and the assumption of Western models of consumption changed African style as much as the iconography. Often, the portraiture is made more realistic and adopts Western canons of naturalism, even through photographic hyper-realism. For example, this is seen clearly seen in the cults of the dead in certain zones. The funerary statues in cement carry the name and dates of birth and death of the person who is thus distinct and remembered as an individual and accompanied to the afterworld by his/her material success and unique biography.

Such a development did not however bring a withdrawal of the sacred from art under the push of commercialization, both because the economic, functional, utilitarian aspect has never been foreign to African arts and because expressions of the sacred can inform in a concealed and latent way even handmade objects destined for Western consumers. Even the apparently more lifeless and serial objects can assume valences and multifarious identities according to their interlocutors.

The coffins created by the Ghana artist Kane Kwei (1922-1992) staring in the 1970's are "comic", "kitsch", or "surreal" only when they are acquired by museums or Western collectors (Plates 110,111). In Ghana, they are intended for sepulchers, to accompany the dead on their voyage to the afterworld. The subjects represented draw as much from symbols of modernity (Mercedes, airplanes, villas, cocoa) as from those of tradition (throne, leopard, elephant, eagle), constituting a conventional repertoire from a couple of dozen models, among which clients choose what best represents them. The use of the coffin is the consequence of the affirmation of Christianity, but, in the reuniting of the extended family within which the expense is subdivided, and in the animal sacrifices that accompany the rite, there is a continuation of the way of traditional feeling[198].

The development of the iconography of the cult of Mami Wata is also significant. For as much as the pictorial refigurations can sometimes be brought in the *naif* style of touristic art, they cannot in any way be reduced to an empty commercial product. Sacred and profane are mixed in them indissolubly, associating past beliefs and the desire for material wealth. We are not talking about mere representations but of amulets that conserve the propitiatory function of traditional icons. The duplicity connected to the image of the mermaid, half woman and half fish, which accompanies that of the snake, allows it to express, in its ambiguity, the hopes and fears that are tied to a time of great change. In them, the destitute man as much as the businessman can thus be found.

Mami Wata is also the image of modern femininity, unconventional and seductive. The woman is always at the center of attention, but the values with which she is connected change. The hieratical maternities collect in their procreative and communitary functions;

163. Iledi Ogboni house, Oshogbo, Nigeria; cement, clay, wood, vegetable fibers

In this sanctuary of the ogboni association, built in 1975, traditional Yoruba sculptures coexist with others, no less religious, by the Austrian artist Susanne Wenger, who herself practices the orisha religion. The two sculptures that project onto the outside of the sanctuary are thus manifestations of the Yoruba divinities Obatala and Alajere.

Mami Wata instead discovers the instinctual passions and individualistic desire of self-affirmation[199]. Traditional fecundity is converted into material prosperity. While she is called "mother", she does not have children and the relationship that she has with her devout, more than of a maternal type, has an amorous nature.

A precarious combination of past and present can explain how the Catholic Santa Maria who dominates the snake can appear on the voodoo altars dedicated to Lasiren (the Haitian transposition of Mami Wata) together with Barbie dolls and posters of Nastassja Kinski, naked between the coils of a boa constrictor[200].

Mami Wata is comfortable with Western technologies. She makes use of European boats, communicates with her devout by telephone, and perhaps we will see her use the Internet. Mami Wata carries the signs of the West on her, but these do not, however, signify the secularization of the African mentality. The sunglasses placed on the statues are not only the sign of a fashionable woman; they also find justification in traditional symbolism. Their property of filtering and reflecting light echoes, like the mirror that the mermaid clasps in her hand, the surface of the waters, the threshold that separates and unites the divinity with her devout.

Religious African art seems to give signs of resuming even in the breast of the West itself, where the push towards globalization is more advanced and the neo-communitarian revival is stronger. Among the North American descendents of the Yoruba, who have conserved the cult of traditional divinities (*orisha*), transfiguring it into Christianity, the need for a sculptural art that would retie the thread with the past seemed to manifest itself. Next to the porcelain or papier-mâché dolls that came from Europe in the nineteenth century appeared ritual objects imported from Nigeria or products, in particular in New York, from local artists. More than a transposition of Yoruba art onto American soil, we are in reality looking at an eclectic art, politically directed, that looks to the multiethnic character of American society, a neo-communitarian movement that collects among the followers of *orisha* not only African Americans from diverse origins but also white Americans[201].

From this point of view, an interesting experience in African territory was that in Nigeria which in the 1970's gave a space for the school of Oshogbo, which dedicated altars and consecrated sculptures to the cult of the *orisha*. In these realizations, Austrian scholars living in Nigeria, like Ulli and Georgina Beier and Susanne Wenger, had functions of stimulus and promotion. It was not only a politics of cultural preservation but of the creation of an unprecedented and living Euro-African production. Wenger, an artist and scholar of Yoruba thought, embraced the ways of life, becoming a priestess of the Obatala cult and taking the Yoruba name of Iwin Funmike Adunni ("For the Grace of Iwin, the Spirit, a Gift That Has to Be Appreciated and That We Truly Have"). Thus, the priests of Oshogbo would commission altars for the *orisha* Oshun. Their forms drew on European artistic traditions, modulating themselves, however, on Yoruba mythology. They also appear on sculptures of Yoruba artists like the statues and caryatids of Gbadamosi, Muslim and at the same time follower of the cult of the ancestors (*egungun*)[202].

The decline of traditional political structures and the affirmation of new national

164. Court of Ketu, Yoruba, Benin, 1992

The kings and traditional chiefs, deprived of their power, play administrative functions on a local level. The wealth of their courts is notably reduced compared to the past. In Ketu, the ancient palace is in ruins and the king lives in a very much more modest construction. In the foreground is a pillar with military figures; on the walls, European calendars.

165. Workshop of sculptor Sunday Jack Akpan, Nigeria

Among the figures of well-known men in coats and ties, in uniforms, and in traditional clothes, there is the figure of Saint Anthony with the baby Jesus. The style of the statues is naturalistic; the dimensions are life size.

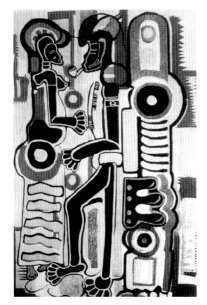

166. Couple, weaving by Bacary Dieme, Senegal, 1978, 200 cm x 292 cm
In many artists who possess an artistic training, the traditional forms are revisited in the light of European avant garde, transferring the style of sculpture to the flat surfaces and adding the rhythm of colors to the rhythm of the shapes.

167. Shoowa fabric, Kuba, Congo; raffia
In this fabric from the 1950's, ruptures and continuities in the Shoowa aesthetic are clearly seen. The overall articulations between different motifs are eliminated: a single magnified element is repeated with regularity; the design, as is shown in the "rest" on the margins, still continues to project itself outside of the frame. The embroidery disappears, but the chromatic contrast maintains the distinction between lines and refilling; fringes make their appearance. The perception of the persistence and changes is however culturally rooted: if for the Western eye the fundamental difference passes between rhombus and squares, the base of Kuba classification is not the shape but the orientation of the lines, with the preference for the development of the diagonal.

states, inheritors of political-administrative structures and colonial borders, changed the ways of clients and the social functions of art.

African art is "reborn" in the forms of a "neo-traditional art" through the demand of the layers of the middle and urbanized working classes.

The same post-colonial states sought to turn art to their advantage, promoting workshops and cooperatives in order to give a "national" cultural base, and at the same time to recall international tourism. Tradition is thus remodeled to serve as a support for the political and economic objectives of the modern state through the creation of national icons that retake and supplant the local ones. The objective was to break the old ties of loyalty and belonging, to call on a patriotic mobilization[203]. The toponymical politics worked in an analogous way, reknotting the ties with the ostentation of the ancient kingdoms (Ghana, Benin, Mali, etc.) while being clearly little linked, from a geographic and cultural perspective, with the new states and ancient formations. Delimiting the symbolic space of a mythic history, it tried to develop a sense of belonging that was functional to the realization of a political project.

In this context, the museum, a part of colonial inheritance, functions as a machine producer of memory. Only apparently devoted to mere conservation, it is in reality tied to the production of identifying images and stories and to the neutralization of their active religious dimension. Still-living art forms are placed under glass while archeology discovers forgotten arts and offers to the national consciousness emblems given to historical millennial weight: old deconsecrated icons that become objects of a cultural and political fruition. Temporary expositions become cut to the measure of the states in order to demonstrate unity in diversity, the harmonious convergence of the multiplicity of ethnic groups in the national identity. Thus the "art of Zaire" or the "art of Nigeria" is born. The African arts become ambassadors of African culture to the world, instruments of a politics of recognition within the economic and cultural relations with the West.

In this context, the circulation in Africa of Western books on African art, whose images form the text for the very native definition of African art, becomes relevant. What Westerners *believe* were the emblematic icons of African art finish in effect by becoming so.

Traces of a shared pan-African identity are hung over the single national identity. The "typical icons" of the ex-colonial French, where the archeological treasures of ancient Nigeria were added, are reunited on the banknote and spread through the area by the CFA franc. The silhouettes of the best-known masks appear as logos for airlines, banks, commercial enterprises. Objects in all African styles are found in African capitals. Handmade objects that earlier had a localized production are now reproduced through commercial means throughout the continent, thus becoming symbols of a shared belonging. It is thus that the use of *kente* cloth beyond the cultural and political context that saw its birth (the Ashanti kingdom) allowed the African bourgeois to demonstrate their own Africanness, escaping local traditional ties and developing an identiary sense on a continental scale that opens to relations with other parts of the planet.

From this point of view, the return to "traditional arts" in the assertion of an African "authenticity" and the adoption of international artistic languages were nothing if not an alternative or complementary strategy for the same attempt to find a dignified position that would be recognized within the global village, arms of a politics of identity that is played as much internally as externally, on individual and collective levels. In the so-called "Dakar school", we thus find the search for a national aesthetic ideologically inspired by the *négritude* of Léopold Sédar Senghor, an intellectual and the president of the Republic of Senegal: European abstractionism is combined with African iconographic tradition to improvise a new cultural history[204].

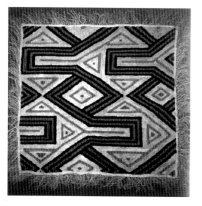

This vituperated tourist art, far from being a simple degeneration of traditional art, can be seen as an attempt to mediate the present and the past, identity and otherness, in a way of dynamically composing continuity and transformation, tradition and modernity.

The changes induced by the growing dependence on the consumer are undeniable: the creation of pieces of small dimension that can be put in a suitcase easily but also, in the opposite direction, the production of large-dimensioned pieces that meet the Western taste for monumentality, the transposition of traditional themes and stylistic features on new objects (paperweights, forks, hand-painted postcards, etc.), stylistic changes that generally move in the direction of growing naturalism in the proportions and psychological characterization of the characters or that search for grotesque effects in order to stimulate an improbable *sauvagerie*.

A purely economic or aesthetic analysis, however, does not exhaust the meaning. Semiological analysis has also shown the construction, in reality, of a complex system of intercultural communication in "tourist art". The aesthetic and cultural intentions of the creator and the expectations of the consumers are combined in the object, and these act as reciprocal influences in the attempt to guess the respective intentions they both share. The result is the construction of a *shared space* – as limited, ambiguous, and ephemeral as it can be[205]. The work takes on an open and stratified identity that is the result of a negotiation of meanings, expectations, and projections in which artists, tourists, and local and foreign dealers all intervene: travelers who tried to capture the authentic fragments of others' lives and give material support to their memories; the natives who seek to predict which Africa the foreigners want, which they will show them and at the same time,. subterraneanly and indirectly, reveal messages of the other type to members of the same group, on the basis of aesthetic codes that are not in any way determined by the response of the consumer.

In Kuba fabrics from the 1950's, we can thus retrace elements that mark a clear discontinuity compared to previous ones, and which we explain with an interlocutor's degree of extraneousness. In the presence of a less-needy buyer, the fabric becomes plainer and the embroidery disappears. The needs of comprehensibility bring a simplification of motifs that become larger, more simple and regular, while the addition of fringe, generically "primitive", seeks to respond to what is thought to be the tourist's expectation. No less revealing however is the sense of persistence. Most past designs continue to be reproduced, thus remaining the fundamental aesthetic characteristics, those of chromatic contrasts and the line-solid[206].

A similar thing seems to also happen in the "traditional" masks that dance for tourists. Among the Dogon, who in the last decades have seen the arrival of organized tourism, the masks made their appearance with the patronage of the tourist agency, exhibiting masks for the use and consumption of Western visitors. The exhibitions, from the formal point of view, are sufficiently close to ceremonial performances, constituting a kind of abbreviated version of them that conserves the most spectacular moments, those able to make an impression on outsiders, and allowing the other moments, those that could bother outsiders, to fall away. The formal proximity however does not generate confusion. Such spectacles

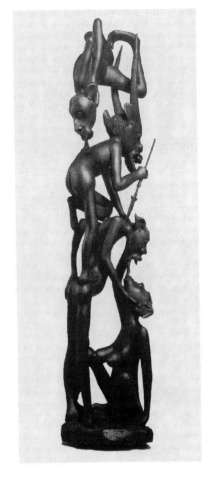

168. Shetani *figure, work by the* Makonde *sculptor Lamizozi Mandaguo, Mozambique, 1988; ebony, height 86.5 cm*

In the development of shetani *figures, commercial interests, exoticism, and religious conceptions overlap to create a space for an uncensored iconography. A narrative dimension is inserted in this representation of the "evil spirits": returning from the hunt with his son, Lipilie surprises his wife who kisses Ntangodi. Furious, the husband slams the rival with a spear while the son implores the father not to kill him.*

169. Puppet of Niikpel (the sacrificer), work by the puppeteer Danaye Kanlanféi, Togo, 1985; polychromatic pumpkin (synthetic paints), vegetable fibers, bamboo, fabric, iron threads

This is a string puppet created for the production Dieux fétiches. *It represents the head of the village, who offers libations to the ancestors. In puppet theater, the borders between sacred and profane are often ephemeral, and entertainment does not exclude religious implications.*

170. Gelede mask, Yoruba, Lagos, 1978, Nigeria.

The appearance of airplanes on gelede masks alludes to the technological and spiritual power (ase) of the Europeans, a clear continuity with traditional symbolism; in fact, we attribute to mothers the power to fly, transforming themselves into birds. The image of the biplane is a kind of entreaty directed to them so that they utilize their power in a constructive way.

do not seem to elide the sacredness of the rite through theatrical and profane representation, but they rather signify the birth of a new genre that coexists with the traditional ones, remaining separate and clearly distinct in its ends. In ritual celebrations, the masks, under the control of the elderly, appear on the occasion of funerals, creating a space for competition among different lineages in the celebration of the ancestors. In exhibitions for tourists however, masks would give young men the occasion to affirm themselves individually *within* the group and then to propose themselves as husbands and represent their own culture *towards the outside*, assuming a prerogative once reserved for the elderly[207].

The vision of a tourist art turned to the outside and opposed to a local art turned to the inside thus reveals itself to be overly schematic. More than the categories that refer to distinct objects, we see the different levels of reading to which every object is susceptible. The separation of traditional and tourist objects draws on the use to which they are put to use more than from the objects themselves. The handmade objects for the tourist market can in fact be acquired locally for ceremonial use. The boundaries between traditional, popular, and tourist art are thus anything but stable and definite.

In the process of turning towards the outside, "tourist art" defines the confines of the group through the projection of an "ethnic" or "African" image that is the result of an intercultural negotiation of meanings. It is not a fictional representation of purely external use but an image that references, reinforces, and modifies the sense of its own identity.

On another level, the work permits internal communication within the group of which the outside interlocutor remains unaware. Thus in the images of the fictionalized and idealized past, Western exoticism is as fixed as African nostalgia for a lost world.

In such images, seemingly decorative and lacking in political content, there is actually the hidden insertion of a polemic in comparison to the present, a reinvention of the past that offers new ideals for the future. Such images create a dialogue, in fact, with the representations of modernity that, carefully evaded by the Europeans, find diffusion instead among the urban working class expressing, in an often ironic form, the anxiety of change and the opposition to injustice[208].

The image of a burned village can thus echo the traditional practice of seasonal migrations and at the same time the destruction of village life under the blows of colonialism. While local buyers identify these various levels, Western buyers are only aware of the second interpretation.

Similarly, in the Makonde sculptures intended for the tourist market (*shetani*), the collective memory of the spirits of nature (*nnandenga*) persists, while their unusual shapes permit the Makonde sculptures that emigrated from Mozambique to Tanzania to redefine their own cultural identity within a foreign context[209].

The process is in many ways analogous to what brought about the creation of creole languages (*pidgin* or *patois*). These are languages that were developed as instruments of communication between groups without a common language as a consequence of intercultural contact brought about by colonization, a complex of syntactic and lexical alterations of standard French or English that end up being made indigenous, that no longer work only as a bridge to a foreigner but also, in the multilinguistic context of the African states born from decolonization, as a bridge for Africans themselves. "Once left by colonialism, the *pidgin* languages, in the same way as tourist art, became a source of cultural innovation and local pride."[210] To the simplification process demanded by the cultural distance of the interlocutors, a process of increased complexity that made an original and versatile creation out of an impoverished substitute followed. It cannot be included in the negative terms of a deviation from the norm, but must be interpreted as a new form of expression whose appropriateness is measured in the correspondence to a changing context.

Terms, stylistic traits, and local and foreign themes combine, creating polysemous and multifaceted objects. Thus in the *pidgin* term Mami Wata (from Mother of Water), the Africans recognize the otherness of divinity and at the same time her assimilation into an African context. Through the prolonged contact with the foreigner which presents the basis of a shared African experience, and the use of *pidgin* as the lingua franca in exchanges among the Africans themselves, the cult of Mami Wata acquires a transcultural dimension to become an element of a pan-African identity[211]. Her provenance from elsewhere and her pretext of European origin make her a wild spirit, not bound by specific places, open to change and accessible to the assumption of a new African identity: that which is derived from looking at each other with eyes that *consider themselves to each be* of the Other, assuming the same look on themselves.

If Mami Wata in her ambiguity and versatility can be assumed as a symbol of contemporary Africa, what is demonstrated is not, however, radically new: the definition of her

identity in the opening and the relationship with the Other, in a religious as much as socio-cultural sense. Contemporary *métissage* and creolization are the signs of permanent historical dynamics. In reality, every culture, while having different levels of opening and maneuvering spaces, defines itself on the basis of an intercultural horizon[212]. The apposition of borders, their regulated crossing, and the eruptions from the outside provide the supplying of material and formal series through which one's individual identity, expressing the sacred, tracing limits and paths of communication between the human and divine, is built.

Along our route, it has seemed that we have been able to retrace in African arts an openness to welcome that is not an uncritical acceptance but that, within the limits defined by relationships of strength in action, works for the selection of external contributions on the basis of their congruity to the situation. The opening of the Other, elaborated and not just modified, is revealed on all levels as a lasting and widespread availability. It is an attempt to construct a dialogue but also to mark boundaries, to grow and to preserve itself, playing on misunderstandings, double meanings, and the spaces of vagueness that make inhabitable spaces from the border lines. The resistance, continuity, and renewal are hidden behind the concessions and settlements, while the space of transformation is found in the reintroduction of traditional forms.

From this point of view, the possibility of misunderstanding that accompanies intercultural relationships, the polysemy of images and words, can be seen not as a defect of communication but as a means of coexistence, of order, in which unresolved ambiguity allows a reciprocal tolerance. In it, appearances "deceive" – in the sense of letting one thing be interpreted as another – but they also let appearances leak out. Appearances function there as a time and indissolubly as a trap and a condition of the relationships[213]. Images and words appear and disappear, always indispensable and always insufficient.

African arts have thus had a history, diverse histories, many of which have probably not left traces and thus will never be known. And African arts, despite periodically being declared dead, will also have a future: the stories that will result from the relationships in which Africans find themselves involved, that result from the reinvention of traditions that will spring from them.

"Africa" will, with difficulty, become in the near future a simple index of geographic provenance, of all that is unbound of its own artistic traditions and thought. Certainly, the crises of ideology and of the "great narrations" have not left it unscathed. The postulate of a unitary Africa in confrontation with a monolithic West crumbles in front of the circulation and contamination of cultures, and "Africa" reveals itself as a product of Africanism and modernity[214]. In the intellectual deconstruction and political failure of unitary projects, Africa "rediscovers" its plurality, as there are many "Africas", in which borders of meaning and ways of life do not extend to the territorial limits of the continent, or that instead cross it, proceeding in different directions (towards Europe, towards America, towards the Islamic or Hindu world).

The future of African arts will presumably be developed even more than it was in the past in a way of relating to otherness in its own contemporaries and that in its own ancestors, in the attempt, which is really part of all of us, of surpassing one's own boundaries without losing one's way, making a place for the other without losing oneself, finding a dynamic and precarious equilibrium among the need for coherence and openness.

NOTES

[1] Es. L. Segy, *African Masks*, cit. "As soon as new religious and material values were introduced in Africa, removing the fundamental, ancient need for religious ritual, the quality of African art declined. The contemporary production consists, for the most part, in the production of copies of authentic pieces. We can simply say that the sculptor puts his hand, not his heart, in the work, which consequently has become lacking of a soul" (p.22).

[2] Cit. In J. P. Créthien, "Confronting the Unequal Exchange of the Oral and the Written" in B. Jewsiewicky, D. Newbury (ed.), *African Historiographies,* Sage Publ., London 1985

[3] W. Bascom, *The Yoruba of Southern Nigeria*, Holt, Rinehart and Wiston, New York 1969, pp.2-4

[4] C. A. Diop, *Nations négres et culture*, Présence Africaine, Paris 1955; Id., *L'unité culturelle de l'Afrique noire*, Présence Africaine, Paris 1959; T. Obenga, *L'Afrique dans l'antiquité*, Présence Africaine, Paris 1973; M. Bernal, *Black Athena. The Afroasiatic Roots of Classical Civilization/ Vol. I: The Fabrication of Ancient Greece*, Free Association Books, London 1987 (Ital. trans. *Atena nera. Le radici afroasiatiche della civiltà egizia*, Pratiche, Parma 1991)

[5] V. Y. Mudimbe, *The Idea of Africa*, cit. pp. 156-159

[6] C. Pignato, "L'esperienza del tempo", in AA.VV., *Pensare altrimenti. Esperienza del mondo e antropologia della conoscenza,* Laterza, Bari 1987; F. Remotti, *Contro l'identità*, Laterza Bari 1996

[7] G. Balandier, *Anthropo-logiques,* cit., pp. 55-58

[8] G. Balandier, *Le désordre. Eloge du mouvement,* Fayard, Paris 1988, pp.17-39

[9] M. Augé, *Symbole, fonction, histoire,* Hachette, Paris (Ital. trans. *Symbolo, funzione, storia,* Liguori, Naples 1982, p. 63)

[10] J. Fabian, *Language and Colonial Power. The Appropriation of Swahili in the Former Belgian Congo, 1880-1938,* African Studies Series, 48, Cambridge University Press, 1986

[11] J. Clifford, *I frutti puri impazziscono. Etnografia, letteratura e arte nel XX secolo,* cit., pp. 249-288

[12] H. M. Drewal, M. Drewal Thompson, *Gelede,* cit., pp. 232-237

[13] C. Taylor, *Multiculturalism and the Politics of Recognition,* Princeton University Press, 1992 (Ital. trans. *Multiculturalismo. La politica del riconoscimento,* Anabasi, Milan 1993)

[14] D. Biebuyck, *Tradition and Creativity in Tribal Art,* University of California Press, Berkeley 1969

[15] S. Ottemberg, "Igbo and Yoruba Art Contrasted", *African Arts,* 2/1983

[16] W. D'Azevedo (edit.), *The Traditional Artist in African Society,* cit.

[17] "Male and Female Artistry in Africa", *African Arts,* 3/1986 (special edition)

[18] M. Berns, "Art, History and Gender: Women and Clay in West Africa", *African Archeological Review,* 11/1993; B. E. Frank, "More than Wives and Mothers. The Artistry of Mande Potters", *African Arts,* 4/1994

[19] J. Picton, J. Mack, *African Textiles,* cit., pp. 19-21

[20] P. Bohannan, "Artist and Critic in an African Society", cit., p. 88

[21] S. L. Kasfir, "Apprentices and Entrepreneurs: the Workshop and Style Uniformity in Sub-Saharan Africa" in C.D. Roy, *Iowa Studies in African Art: the Stanley Conferences at the University of Iowa* 2, University of Iowa, Iowa City 1987; cit. in M. Adams, "African Visual Arts from an Art Historical Perspective", *The African Studies Review,* 2/1989, p. 79

[22] "Patron-Artist Interactions in Africa", *African Arts,* 3/1980 (special edition)

[23] H.M. Drewal, M. Drewal Thompson, *Gelede,* cit., pp. 258-270

[24] P. Bohannan, "Artist and Critic in an African Society", cit., p. 89

[25] W. D'Azevedo, "Mask Makers and Myth in Western Liberia" in A. Forge, *Primitive Art and Society,* cit.

[26] P. Bohannan, "Artist and Critic in an African Society", cit.

[27] J. Vansina, *African Art in History,* Longman, New York 1984, pp. 136-158

[28] D.K. Washburn, "Style, Classification and Ethnicity: Design Categories on Bakuba Raffia Cloth", *Transactions of the American Philosophical Society,* Philadelphia 1990, pp. 57-91

[29] E.H. Gombrich, *The Sense of Order. A Study in Decorative Art,* Phaidon Press, Oxford 1979, pp.80-83

[30] P.J.C. Dark, "Bronze Benin Heads: Style and Chronology", in D.F. MacCall, E.G. Bay, *African Images,* cit., pp. 25-103; J. Vansina, *The Children of Woot,* cit., pp.218-224

[31] M. Foucault, *Histoire de la folie à l'âge classique,* Gallimard, Paris 1972 (Ital. trans. *Storia della follia nell'età classica,* Rizzoli, Milan 1973); F. Remotti, *Contro l'identità,* Laterza, Bari 1994

[32] E. Leach, "Cultura/culture", *Enciclopedia,* IV, Einaudi, Turin 1978

[33] J. Vansina, *Art History in Africa,* cit., p.175

[34] W. Fagg, "The Yoruba and their Past", in W. Fagg, J. Pemberton III, *Yoruba. Sculpture of West Africa,* Holcombe, New York, 1982

[35] P. Poutignant, J. Streinn-Fenart, *Théories de l'ethnicité,* PUF, Paris 1995; U. Fabietti, *L'identità etnica. Storia e critica di un concetto equivoco,* La Nuova Italia Scientifica, Rome 1995

[36] S.L. Kasfir, "One Tribe One Style? Paradigms in Historiography of African Art", *History in Africa,* 2/1984; G.I. Jones, *The Art of Eastern Nigeria,* Cambridge University Press, Cambridge 1984

[37] R.A. Bravmann, *Open Frontiers. The Mobility of Art in West Africa,* University of Washington Press, Washington 1973; AA.VV., "African Borderland Sculpture: Liminal Space in the Study of Style", African Arts, 4/1987

[38] F. Barth (edit.), *Ethnic Groups and Boundaries,* "Introduzione" (Ital. trans. *I gruppi etnici e i loro confini,* in V.Maher, *Questioni d'etnicità,* Rosemberg & Sellier, Turin 1994, pp. 33-71)

[39] K.L. Green, "Shared Masking Traditions in Northeastern Ivory Coast", *African Arts,* 4/1987

[40] C. Roy, "The Spread of Mask Styles in the Black Volta Basin", *African Arts,* 4/1987

[41] C. Roy, *op. cit.*

[42] T. Northern, *The Art of Cameroon,* cit., p. 61

[43] L. Prussin, *Hatumere. Islamic Design in West Africa,* University of California Press, Berkeley 1986

[44] J.S. Trimingham, "The Phases of Islamic Expansion and Islamic Culture Zones in Africa", in B. Lewis, *Islam in Tropical Africa,* Oxford University Press, 1966, p. 41

[45] B. Lewis, *Islam in Tropical Africa,* cit.

[46] V. Monteil, *L'islam noir,* Seuil, Paris 1964, pp. 49-53

[47] R.A. Bravmann, *African Islam,* Smithsonian Institution Press, Washington 1983

[48] J. De Vere Allen, "The *Kiti Cha Enzi* and Other Swahili Chairs", *African Arts,* 3/1989

[49] E.W. Bonvill, *The Trade of the Moors,* Oxford University Press, london 1958

[50] J.L. Amselle, "Ethnies et espaces: pour une anthropologie topologique", in J.L. Amselle, E.M. Bokolo, *Au coeur de l'ethnie. Ethnies, tribalisme, et état en Afrique,* La Découverte, Paris 1985, pp. 23-34

[51] R.J. McIntosh, "Middle Niger Terracottas before the Symplegates Gateway", *African Arts,* 2/1989

[52] B. de Grunne, "Le ultime ricerche sulla scultura in terracotta del Mali", in B. Bernardi, B. de Grunne, *Terra d'Africa, terra d'archeologia. La grande scultura in terracotta del Mali,* Alinari, Florence 1990; B. de Grunne, "An Art Historical Approach to the Terracotta Figures of the Inland Niger Delta", *African Arts,* 4/1995

[53] J. Devisse, "Islam et ethnie en Afrique", in J.P. Chrétien, G. Prunier, *Les ethnies ont une histoire,* Karthala-ACCT, Paris 1989, pp. 103-115

[54] J. Goody, *The Interfaces between the Written and the Oral,* Cambridge University Press, Cambridge 1987, pp. 134-138

[55] M.P. Marti, "Les calendriers dahoméens", *Objets et Mondes,* 4/1964

[56] A.O. El-Bekri, *Description de l'Afrique septentrionale,* Adrien-Maisonneuve, Paris 1965, p. 328

[57] L. Prussin, *Hatumere, Islamic Design in West Africa,* cit., pp. 66-67

[58] K. Critchlow, *Islamic Patterns. An Analytical and Cosmological Approach,* Thames & Hudson, London 1976

[59] L. Prussin, *Hatumere, Islamic Design in West Africa,* cit., pp. 144

[60] L. Prussin, *op. cit.,* p.153

[61] L. Prussin, *op. cit.,* p.177

[62] P.B. Clarck, *West Africa and Islam,* Arnold, London 1982, p.261

[63] L. Prussin, *Hatumere, Islamic Design in West Africa,* cit., pp. 43-48

[64] G. Nicolas, "Essai sur les structures fondamentales de l'espace dans la cosmologie Hausa", *Journal de la société des africanistes,* 1/1966; G. Nicolas, "Fondements magico-religieux du pouvoir politique au sein de la principauté hausa du Gobir", *Journal de la société des africanistes,* 2/1969

65 L. Prussin, *Hatumere, Islamic Design in West Africa,* cit., p. 202

66 J.-P. Bourdier, "The Rural Mosques of Futa-Toro", *African Arts,* 3/1993

67 E. Elisofon, W. Fagg, *The Sculpture ifi Africa*, Praeger, New York 1958

68 R.A. Bravmann, *Islam and Tribal Art in West Africa*, Cambridge University Press, Cambridge 1980, R.A. Bravmann, *African Islam,* cit.

69 S.L. Kasfir, *Art in History, History in Art: the Idoma Ancestral Masquerade, an Historical Evidence*, African Studies Center, Boston University 1985

70 W. Simmons, "Islamic Conversion and Social Change in a Senegalese Village", *Ethnology,* 18/1979

71 R.A. Bravmann, *Islam and Tribal Art in West Africa*, cit., p. 31

72 R.A. Bravmann, *African Islam,* cit., pp. 79-81

73 L. Albaret, R. Renaudeau, *Peintures populaires du Sénégal*, ADEAIO, Musée National des Arts Africains et Océaniens, Paris 1987

74 S. Hammami, "L'obscur regard des autres. Pour une problématique désoccidentalisée de l'image", *Xoana* 4/1996

75 A.A. Mazrui, "Islam and African Art. Stimulus or Stumbling Block?", *African Arts,* 1/1994, p. 57

76 G. Beaugé, J.-F. Clément, *L'image dans le monde arabe,* CNRS, Paris 1995

77 S. Hammami, "L'obscur regard des autres. Pour une problématique désoccidentalisée de l'image", cit., p. 20

78 R.A. Bravmann, *African Islam,* cit., pp.26-27

79 A.M. Piemontese, "Aspetti magici e funzionali della scrittura araba", *La ricerca folklorica*, 5/1982

80 R.A. Bravmann, *African Islam,* cit., pp.39-41

81 D. Heathcote, "A Hausa Charm Gown", *Man*, IX, 4, 1974

82 G.R. Cardona, *Antropologia della scrittura,* cit., pp. 175-177

83 O. Grabar, "What Makes Islamic Art Islamic", *Art and Archeology Papers,* 9/1976, cit. in R.A. Bravmann, *African Islam,* cit., p. 93

84 G.P. Murdock, *Africa. Its Peoples and their Culture History,* New York 1959, p. 70; R. Boser-Sarivaxevanis, *Les tissus de l'Afrique Occidentale,* Krebs, Bâle 1972

85 C. Monteil, *Le coton chez les Noirs,* Paris 1927, p. 12

86 C. Monteil, *op. cit.,* p. 20

87 R.M.A. Bedeaux, R. Bolland, "Medieval Textiles from the Tellem Caves in Central Mali, West Africa", Textiles Museum Journal, 19-20/1980-1981; R. Bolland, *Tellem Textiles. Archaeological Inds from Burial Caves in Mali's Bandiagara Cliff,* Tropenmuseum/Royal Tropical Institute, Amsterdam 1991

88 M. Coquet, *Textiles africains*, Biro, Paris 1993

89 M. Coquet, *op. cit.*

90 R. Mauny, "Le déblocage d'un continent par les voies maritimes: la cas africain", in AA.VV., *Les grandes voies maritimes dans le monde*, Sevpen, Paris 1965

91 P. Mark, "European Perceptions of Black Africans in the Renaissance", in B. Fagg, E. Bassani, *Africa and the Renaissance*, Center for African Arts, New York 1988, pp.21-31

92 E. Bassani, B. Fagg, *Africa and the Renaissance: Art in Ivory*, cit. Pp. 102-105; E. Bassani, "Additional Notes on the Afro-Portuguese Ivories", *African Arts,* 3/1994

93 S. Vogel, Introduction to B. Fagg, E. Bassani, *Africa and the Renaissance,* cit., pp.16-17

94 E. Bassani,*La grande scultura dell'Africa nera*, Artificio, Florence 1989, p. 67

95 J.D. Fage, "Slavery and the Slave Trade in the Context of West African History", *Journal of West African History,* 10/1969

96 C. Coquery-Vidrovitch, "Villes africaines anciennes: une civilisation mercantile pré-négrière dans l'ouest africain, XVI et XVII siècles", *Annales ESC,* 6/1991

97 T. Ranger, "L'invenzione della tradizione nell'Africa coloniale", in E.J. Hobsbawm, T. Ranger, *The Invention of Tradition,* Cambridge University Press, Cambridge 1983 (Ital. trans. *L'invenzione della tradizione*, Einaudi, Turin, 1994, p. 203)

98 "Domande a Michel Foucault sulla geografia", *Hérodote*, 1/1976 (Ital. trans. In M. Foucault, *Microfisica del potere,* Einaudi, Turin 1977, pp.147-161)

99 A. Turco, *Geografie della complessità in Africa. Interpretando il Senegal,* Unicopli, Milan 1986, pp.254-261

100 E. Colson, "African Society at the Time of the Scramble", in L.H. Gann, P. Duignan, *Colonialism in Africa,* Cambridge University Press, Cambridge 1969, pp.28-30

101 J. Iliffe, *A Modern History of Tanganyika*, Cambridge University Press, Cambridge 1979, p. 324

102 E. Schildkrout, J. Hellman, C. Keim, "Mangbetu Pottery: Tradition and Innovation in Northeast Zaire", *African Arts,* 2/1989

103 V.Y. Mudimbe, *The Idea of Africa,* Indiana University Press, Bloomington 1994, pp. 105-153

104 J. Fabian, *Time and the Other: How the Anthropology Makes its Objects*, Columbia University Press, New York 1983, pp. 15-16

105 F. La Cecla, *Mente locale. Per un'antropologia dell'abitare*, Eleuthera, Milan 1993

106 J.F.C. Turner, *Housing by People*, Boyars Publ., London 1976 (Ital. trans. *L'abitare autogestito,* Jaca Book, Milan 1978); A. Kabou, *Et si l'Afrique refusait le développement?,* L'Harmattan, Paris 1991 (Ital. trans. *E se l'Africa rifiutasse lo sviluppo?,* L'Harmattan Italia, Turin, 1995)

107 G. Nicolas, "Essai sur les structures fondamentales de l'espace dans le cosmologie hausa", *cit.*

108 R.F. Thompson, *Flash of the Spirits*, cit. pp. 208-222, Id., "From the First to the Final Thunder: African-American Quilts, Monuments of Cultural Assertion" in E. Leon, *Who'd a Thought it. Improvisation in African-American Quiltmaking*, San Francisco Crafts and Folk Art Museum, 1987

109 M. Southwell Wahlman, "African Symbolism in Afro-American Quilts", *African Arts*, 4/1986; S. Price, R. Price, *Afro-American Arts of Suriname Rain Forest,* University of California Press, Berkeley 1980

110 J. Devisse, S. Labib, "L'Afrique dans les relations intercontinentales", *Histoires générale de l'Afrique*, vol. IV, Présence Africaine, Paris

111 J.M. Cordwell, "The Use of Painted Batiks by Africans" in J.M. Cordwell, R.A. Schwartz, *From the Fabrics of Culture. The Anthropology of Clothing and Adornment,* The Hague, Mouton 1979, pp. 495-498

112 I. Szombati-Fabian, J. Fabian, "Art, History and Society: Popular Painting in Shaba, Zaire", *Studies in the Anthropology in Visual Communications*, 1/1976

113 H. Drewal, "Performing the Other: Mami Wata Worship in Africa", *The Drama Review*, 2 1988

[114] D. Fraser, "The Fish-Legged Figure in Benin and Yoruba Art", *African Art and Leadership*, cit., pp. 261-294

[115] C. Roy, *The Art of Upper Volta*, cit. fig. 258

[116] C.B. Steiner, "Another Image of Africa: Towards an Ethnohistory of European Cloth Marketed in West Africa, 1873-1960", *Ethnohistory*, 32, 1985

[117] C. Meillassoux, *The Development of Indigenous Trade and Markets in West Africa*, Oxford University Press, 1971, Introduction (Ital. trans. *L'economia della savana: l'antropologia economica dell'Africa occidentale*, Feltrinelli, Milan 1981, pp. 144-148)

[118] C. Monteil, *Le coton chez les Noirs*, cit., p. 35

[119] C. Liedhom, "The Economics of African Dress and Textile Arts", *African Arts*, 3/1983; M. Johnson, "Technology, Competition and African Crafts" in C. Dewey, A.G. Hopkins, *The Imperial Impact Studies in the Economic History of Africa and India*, Athlone, London 1971, pp. 259-269

[120] P. Adler, N. Barnard, *African Majesty. The Textile Art of the Ashanti and Ewe*, Thames & Hudson, London 1992

[121] R. Nielson, "The History and the Development of Wax Printed Textiles Intended for West Africa and Zaire", in J.M. Cordwell, R.A. Schwartz, *The Fabric of Culture. The Anthropology of Clothing and Adornment*, Mouton, The Hague 1979, pp. 481-493; S. Domowitz, "Wearing Proverbs. Any Names for Printed Factory Cloths", *African Arts*, 3/1992

[122] J. Picton, J. Mack, *African Textiles*, British Museum, London 1989, pp. 147-167; M. Adams, "Fon Applique Cloth", *African Arts*, 2/1980; J.B. Eicher, T.V. Erekosima, *Pelete Bite. Kalabari Cut-thread Cloth*, University of Minnesota, Goldstein Gallery, St. Paul 1982

[123] T.E. Bowdich, *Mission from Cape Coast Castle to Ashantee*, London 1819, p. 124 (cit. in M.D. McLeod, *The Asante*, cit., p.153)

[124] P. Ben Amos, "Ptron-Artist Interaction", *African Arts*, 3/1980

[125] C. Monteil, *Le coton chez les Noirs*, cit., pp.22-31

[126] W. Rodney, *A History of the Upper Guinea Coast: 1545-1800*, Clarendon Press, Oxford 1970, cit. in P. Stoltz Gilfoy, *Patterns of Life. West African Strip-Weaving Traditions*, Smithsonian Institution Press, Washington 1987

[127] J. Meurant, *Abstractions aux Royaumes des Kuba*, Dapper, Paris 1987

[128] E. Bassani, *La grande scultura dell'Africa nera*, cit., p. 67

[129] J. Vansina, *The Children of Woot. A History of Kuba People*, cit., pp.172-176; Id., "Long-Distance Trade Routes in Central Africa", *Journal of African History*, III, 3, 1962

[130] R.F. Thompson, "Naissance du dessin 'nègre': l'art mbuti dans une perspective mondiale", in R.F. Thompson, S. Bauchet, *Pygmées?*, cit.

[131] T.C. McCaskie, "Innovational Ecletism: the Asante Empire and Europe in the Nineteenth Century", *Comparative Studies in Society and History*, 1/1972

[132] I. Wilks, "The Northern Factor in Ashanti History: Begho and the Mande", *Journal of African History*, 2/1961; R.A. Bravmann, "The Diffusion of Ashanti Political Art", *African Art and Leadership*., cit.

[133] H.M. Cole, D.H. Ross, *The Arts of Ghana*, University of California Press, Los Angeles 1977, p. 212

[134] L. Prussin, *Hatumere, Islamic Design in West Africa*, cit., pp.239-241

[135] M.D. McLeod, *The Asante*, cit. pp.95-101

[136] D.H. Ross, "The Heraldic Lion in Akan Art: A Study of Motif Assimilation in Southern Ghana", *Metropolitan Museum Journal*, 16/1982

[137] T. Ranger, "L'invenzione della tradizione in Africa coloniale", cit., pp. 220-227

[138] D.H. Ross, "Queen Victoria for Twenty-Five Pounds: The Iconography of a Breasted Drum from Southern Ghana", *Art Journal*, 47, 2, 1988; R.F. Thompson, *Black Gods and Kings*, cit., pp. 13,17

[139] T. Ranger, "L'invenzione della tradizione in Africa coloniale", cit., p. 235

[140] S. Wenger, H.U. Beyer, "Adire – Yoruba Pattern Dyeing", *Nigeria Magazine* 54, 1957; J. Picton, J. Mack, *African Textiles*, cit., pp. 157-158

[141] S.P.X. Battestini, "Sémiotique de l'adire", *Semiotica*, 1-2/1984, p. 87

[142] *Ibi.,* p. 80

[143] T. Ranger, "L'invenzione della tradizione in Africa coloniale", cit., pp. 217-218

[144] J. Janzen, W. McGaffey, *An Anthology of Kongo Religion*, University of Kansas Press, Lawrence 1974, p. 13

[145] W. Bascom, *Ifa Divination. Communication Between Gods and Men in West Africa*, Indiana University Press, Bloomington 1969, oo. 109-110

[146] H.M. Cole, D.H. Ross, *The Arts of Ghana*, cit., pp. 186-199

[147] S. Leprun, "L'architecture néo-soudanaise, parure exotique et/ou tradition?", in *Espaces des Autres*, cit., pp. 121-141

[148] C.-R. Ageron, "L'exposition coloniale du 1931. Mythe républicain ou mythe impérial?" in P. Nora, *Lieux de mémoire. 1. La République*, Gallimard, Paris 1984, pp. 561-591

[149] S. Leprun, "L'architecture néo-soudanaise, parure exotique et/ou tradition?", cit., p. 137

[150] L. Prussin, *Hatumere, Islamic Design in West Africa*, cit., pp.182-186

[151] P. Maas, G. Mommersteeg, "L'architecture dite soudanaise: 'le modèle de Djenné'", in AA.VV., *Vallées du Niger*, Editions de la Réunion des Musées Nationaux, Seuil, Paris 1993; pp. 485-490

[152] B.W. Blackmun, "From Trader to Priest in Two Hundred Years: The Transformation of a Foreign Figure on Benin Ivories", *Art Journal*, 47,2, 1988

[153] W. Liking, *Statues colons*, Les Nouvelles Editions Africaines, Paris 1987

[154] P.L. Ravenhill, "Baule Statuary Art: Meaning and Modernization", Working Papers in Traditional Art, Institute for the Study of Human Issues, Philadelphia 1980

[155] *ibid.*

[156] B. Salvoing, *Les missionaires à la rencontre de l'Afrique au XIX siècle*, L'Harmattan, Paris 1994

[157] J. Janzen, J. MacGaffey, *An Anthology of Kongo Religion*, cit.

[158] P.B. Clarck, *West Africa and Christianity*, Arnold, London 1986, p. 14

[159] D. Frazer, *Primitive Art*, London 1962 (Ital. trans. *Arte primitiva*, Il Saggiatore, Milan 1957, p. 57)

[160] P.B. Clarck, *West Africa and Christianity*, cit., p.41

[161] K.A. Opoku, "La religion en Afrique pendant la domination coloniale", *Histoire générale de l'Afrique*, vol. VII, Présence Africaine, Paris

[162] P.B. Clarck, *West Africa and Christianity*, cit., p. 59

[163] V.Y. Mudimbe, *The Idea of Africa*, cit., pp.120-123

[164] P.B. Clarck, *West Africa and Christianity*, cit., pp.37-41

165 T. Ranger, "L'invenzione della tradizione in Africa coloniale", cit., p. 206

166 J.-F. Bayart, *L'illusion identitaire,* Fayard, Paris 1996, pp. 60-63

167 *ibid.,* A. Dupront, "L'antropologia religiosa", in G. Le Goff, P. Nora, *Fare la storia,* Einaudi, Turin, pp. 167-169

168 G. Balandier, "I movimentii d'innovazione religiosa nell'Africa nera", in H.-C. Puech, *Le religioni nell'età del colonialismo e del neocolonialismo,* Laterza, Bari 1990, pp. 262-263

169 AA.VV., *Des prêtes noirs s'interrogent,* 1956; Mulago, *Un visage africain du christianisme,* Présence Africaine, Paris 1965; Mbiti, *New Testament Eschatology in an African Background,* Oxford University Press, London 1970

170 V.Y. Mudimbe, *The Idea of Africa,* cit., p. 56

171 "Costituzione sulla Sacra Liturgia 'Sacrosanctum Concilium'", 37, *I Documenti del Concilio Vaticano secondo*, Massimo, Milan 1966, p. 118

172 *Ibid.,* 122,123,141

173 C. Costantini, *L'arte cristiana nelle missioni,* Tipografia poliglotta vaticana, 1940, pp.3-42

174 P. Tempels, *La philosophie bantoue,* cit.

175 C. Costantini, *op. cit.,* p. 26

176 K. Carrol, *Yoruba Religious Carvings,* Chapman, London 1967, pp. 124-153

177 *Ibid.,* p. 113

178 *Ibid.,* p. 138

179 E. Mveng, *L'Afrique dans l'Eglise,* L'Harmattan, Paris (Ital. trans. *Identità africana e cristianesimo,* SEI, Turin 1990, pp. 63, 72)

180 E. Mveng, *op. cit.,* pp. 17, 26

181 E. Mveng, *op. cit.,* p. 75

182 E. Mveng, *L'art d'Afrique noire. Liturgie cosmique et langage religieux,* Ed. CLE, Yaoundé 1964; Id., *Art nègre ou art chrétien?,* Amis de Présence Africaine, Rome 1967

183 S. Latouche, *L'occidentalisation du monde. Essai sur la signification, la portée et les limites de l'uniformisation planétaire,* La Découverte, Paris 1989 (Ital. trans. *L'occidentalizzazione del mondo. Saggio sul signification, la portata e i limiti dell'uniformaxione planetaria ,* Bollati Boringhieri, Turin 1992).

184 T. Mc Evilley, *Art & Otherness. Crisis in Cultural Identity,* McPherson & Co., New York 1992, p. 94.

185 J.D. Gandaolou, *Entre Paris et Bancongo,* Centre Georges Pompidou, Paris 1984; J. Friedmann, "Essere nel mondo: globalizzazione e localizzazione" in M. Featherstone (edit.), *Global Culture. Nationalism, Globalization and Modernity,* Sage Publ., London 1990 (Ital. trans. *Cultura globale: Nationalismo, globalizzazione e modernità,* SEAM, Rome 1996, pp. 183-189).

186 L. Gaffuri, "Vedere racconti e. leggere immagini: obiettivo sul cinema africano", *Terra d'Africa,* Unicopli, Milan 1994

187 S. Latouche, *La planète des naufragés. Essai sur l'après-développement,* La Découverte, Paris, 1991 (Ital. trans. *Il pianeta dei naufraghi. Saggio sul doppio-svillupo,* Bollati Boringhieri, Turin, 1993); Id. *L'autre Afrique. Entre don et marché.* (Ital. trans. *L'altra Africa. Tra dono e mercato,* Bollati Boringhieri, Turin, 1997).

188 G. Bertolini, *Rebuts ou resources? La socio-économie du déchet,*Entente, Paris 1978.

189 C. Cerny, S. Seriff, *Recycled, Re-Seen: Folk Art from the Global Scrap Heap,* Abrams, New York 1996.

190 A.F. Roberts, "Change Encounters, Ironic Collage," *African Arts,* 2/1992.

191 S. Vogel, *African Explorers, 20th Century African Arts,* Museum of African Art, New York 1991, pp. 14-55.

192 B. Jewsiewicki, "Painting in Zaire. From the Invention of the West of the Representation of Social West", in S. Vogel (edit.), *African Explorers,* cit., pp. 130-151.

193 D. Paulme, "Naissance d'un culte africain", *Cahiers d'Etudes Africaines,* 149, 1998; AA.VV, *Magiciens de la terra,* Centre George Pompidou, Paris 1989.

194 H.R. Silver, "Calculating Risks: the Socioeconomic Foundations of Aesthetic Innovation in an Ashanti Carving Community", *Ethnology,* 2/1981.

195 D.J. Crowley, "The Contemporary-Traditional Art Market in Africa", *African Arts,* 1/1970.

196 P. Ben-Amos, "Patron-Artist Interactions in Africa", *African Arts,* 3/1980; R.A. Bravmann, *Open Frontiers,* cit.

197 B. Jules-Rosette, *The Message of Tourists Art. An African Semiotic System in a Comparative Perspective,* Plenum Publ. Corporation, 1987, pp.50-51.

198 T. Secretan, *Il fait sombre, va-t'en. Cercueils au Ghana,* Hazan, Paris 1994; S. Vogel, *African Explorers,* cit., pp. 97-100.

199 B. Jules-Rosette, *The Message of Tourists Art. An African Semiotic System in a Comparative Perspective,* cit., p. 158.

200 M. Houlberg, "Sirens and Snakes. Water Spirits in the Arts of Haitian Vodou", *African Arts,* 2/1996, p. 35.

201 J. Mason, "Yoruba-American Art: New Rivers to Explorer", in R. Abiodun, H.J. Drewal, J. Pemberton III, *The Yoruba Artist,* cit., pp.241-250.

202 J. Kennedy, *New Currents, Ancient Rivers. Contemporary African Artists in a Generation of Change*, Smithsonian Institution Press, New York 1992, pp. 58-66.

203 C.B. Steiner, *African Art in Transit,* cit., pp.94-99.

204 J. Ebong, "Negritude Between Mask and Flag: Senegalese Cultural Ideology and the Ecole de Dakar" in S. Vogel, *Africa Explorers,* cit. pp. 198-209.

205 P. Ben-Amos, "Pidgin Languages and Tourist Art", *Studies in Anthropology of Visual Communication,* 4/1977; B. Jules-Rosette, *The Message of Tourists Art. An African Semiotic System in a Comparative Perspective,* cit.

206 D.K. Washburn, "Style, Classification and Ethnicity: Design Categories on Bakuba Raffia Cloth", *Transactions,* 3/1990.

207 P.J. Lane, "Tourism and Social Change Among the Dogon", *African Arts,* 4/1988.

208 B. Jules-Rosette, *op. cit.,* p. 55.

209 S.L. Kasfir, "African Art and Authenticity A Text Without a Shadow", *African Arts,* 2/1992.

210 B. Jules-Rosette, *op. cit.,* p. 219.

211 H.J. Drewal, "Performing the Other: Mami Wata Worship in Africa", *The Drama Review,* 2/1988, p.160.

212 L. Drummond, "The Cultural Continuum: a Theory of Intersystems", *Man,* 2/1980; J.-L. Amselle, *Logiques métisses. Anthropologie de l'identité en Afrique et ailleurs,* Payot, Paris 1990.

213 F. La Cecla, *Il malinteso. Antropologia dell'incontro,* Laterza, Bari 1997.

214 V.Y. Mudimbe, *The Invention of Africa,* cit.; K.A. Appiah, *In My Father's House. Africa in the Philosophy of Culture,* Oxford University Press, New York 1992.

Locations of Represented Works

The reference is made in bold-faced type for the color plates and in Roman type for the black and white figures and the drawings.

A. Nosey Gallery, New York: 157
Fine Arts Museum of San Francisco: **110a**
Fowler Museum of Cultural History, UCLA, Los Angeles: 112; **53**
Galleria Fred Jahn, Munich: 85
Indiana University Art Museum, Bloomington: **49**
Indianapolis Museum of Art: 125
Linden Museum Stuttgart: **52, 88, 99**
Locksley/Shea Gallery, Minneapolis: 108
Metropolitan Museum, New York: 11, 87; **63**
Musée de l'Homme, Paris: 3, 141, 142 , 145; **7, 13, 16, 18, 28, 48, 62**
Musée des arts d'Afrique et d'Océanie, Paris: 77; **1, 26, 32, 33, 39, 44, 45, 48 , 54 , 55**
Musée National d'Art Moderne, Centre Georges Pompidou, Parigi: **111**
Musée Royal de l'Afrique Centrale, Tervuren: 17, 58 , 88; **17, 31, 34, 38, 64, 108**
Musée Dapper, Paris: 36
Museo L. Pigorini, Roma: 119
Museu Etnografico, Lisboa: **23**
Museu Nacional de Arte di Maputo: 168
Museum für Völkerkunde Wien: **69**
Museum of International Folk Art, Santa Fe: 156
Museum Rietberg, Zurich: 82; **61, 65**
Museum voor Volkenkunde, Rotterdam: **110b**
Naprstek Museum, Prague: **167**
National Museum of African Art, Washington: 94
National Museum of Ireland, Dublin: **25**
Nigerian Museum, Lagos: 8, 132
Peter Adler Gallery, London: **70**
Preussischer Kulturbesitz, Museum für Völkerkunde, Berlin: 98; **75, 81, 94, 95, 102, 103**
Rijskmuseum voor Volkenkunde, Leiden: 115
Saint Louis Art Museum: 100
SMA, Arts Africains, Paris: 148
Smithsonian Institution, Dept. of Anthropology: **12**
Société d'Arts Primitifs et F. Neyt, Bruxelles: 38
Staatliches Museum für Völkerkunde Dresden: 80
The British Museum, London: **14, 72, 89**; 53, 69 , 70, 134 113; 60 , 79 , 139
The National Museum of Denmark, Department of Ethnography, Copenhagen : **74**
The St. Mungo Museum of Religions Life & Art, Glasgow: **37**
The University of Iowa Museum of Art, Iowa City: **24**
Ulmer Museum, Ulm: 5
University Art Museum Obafemi, Ile Ife, Nigeria: **79**

Collection Giorgio Bargna, Capiago (Como): **3, 4, 5, 8, 9, 10, 11, 15, 19, 21, 22, 29, 30, 35, 40, 41, 42, 43, 46, 47, 50, 52, 56, 57, 58, 59, 60, 66, 67, 68, 73, 76, 77, 82, 83, 92, 93, 96, 97, 98**; 4, 7, 10, 15, 21, 22, 28, 32, 33, 34, 39, 41, 42, 43, 44, 45, 48, 52, 55, 56, 62, 64, 76, 80, 81, 83, 86, 122, 135
Collection A. P. Fernandez : 93
Collection Barbier-Müller: 29, 47, 49, 90, 147
Collection Bram Goldsmith: 154
Collection B. de Grunne: 91
Collection D. Kanlannféi: 169
Collection of Senegal government: 166
Collection L. Wunderman: 40
Collection M. and J.C. Chérot: 111
Collection M. and D. Ginzberg: 12
Collection T. Westerbergs: 107
Private collection, Italy: **20, 70**; 16, 126, 127
Private collection, Munich: 35
Private collection, Paris: **2, 36, 90, 91, 109**; 155
Private collection, U.S.A: 123
Private collection (former Rasmussen collection): 131
Private collections: 129, 45, 97, 74, 137, 95

Illustration Credits

G. Bargna: **7, 84, 106, 107**
I. Bargna: 51, 54, 164
Jaca Book/Excalibur, Milano: **4, 5, 8, 9, 10, 11,15, 19, 21, 22, 29, 40, 41, 42, 43, 46, 47, 50, 52, 56,
57, 58, 59, 60, 67, 68, 73, 76, 77, 82, 83, 97, 98, 100, 101,** 4, 19, 22, 32, 33, 34, 39, 41, 42, 48, 55, 56,
62, 76, 80, 81, 83, 86, 122
Jaca Book/Umana Avventura: **85, 86**
D. e O. Nidzgorski: **2, 36, 90, 91, 109,** 78, 110,152, 153, 159
Obiettivo effe, Anzano del Parco: **3, 30, 35, 66, 92, 93, 96,** 7, 10,15, 28, 43, 44, 45, 52, 64, 135
Punto Zero, Mariano Comense: **70**

Sources of the drawings

B.V. Blackmun, *Art Journal*, 2/1988: 138; J.P. Bourdier, *African Arts*, 3/1993: 104; G. Cardona, *Antropologia della scrittura*, Loescher, Torino 1981: 61; M. Coquet, *Tissus africains*, Biro, Paris 1993: 114; J. Drewal, S. Pemberton III, R. Abiodun, *Yoruba*, The Center for African Art, New York 1987: 73; G. Gabus, *Art nègre*, La Baconnière, Neûchatel, 1967: **87,** 66; J.P. Imperato, S. Marli, *African Arts*, 4/1970: 117; S.L. Kasfir, *Art History, History in Art*, 1985: 106; G. Nicolas, *Journal de la Société des Africanistes*, 1/1966: 103; Id., *Journal de la Société des Africanistes*, 2/1969: 124; D.H. Ross, in *Art Journal*, 2/1988: 133; A. Rutter, in Olivier, *Shelter in Africa*, Barrie & Backliff, London,197: 130; F. Schwerdtfeger, in Olivier, *Shelter in Africa*, Barrie & Backliff, London 1971: 102; J. Vansina, *African Art in History*, Longman, London, 1984: 30, 96; G. Calame-Griaule, *Ethnologie et langage*, Institut d'ethnologie, Paris 1987: 27; Y. Cissé, in AA.VV, *La notion de personne en Afrique noire*, CNRS, Parigi 1973: 26; D. Fraser, *African Art as Philosophy*: 9; Id., *Village Planning in the Primitive World*, 1968: 24 right; A.P. Lagopoulos in P. Oliver, *Shelter, Sign & Symbol*, Barrie & Jenkis, London, 1975: 13 up; J.P. Lebeuf, *Les Fali, montagnards du Cameroun*: 13 down; M.A. Fassassi, *L'architecture en Afrique noire*, Maspero, Paris 1978: 14; M. Griaule, *Dieu d'eau*, Fayard, Paris 1966: 24 left; H.Cole C. Aniakor, *Igbo Art*, Regents of the University of California, 1984: 20; E. Mveng, *Art nègre ou art chrétien?*, Amis de Présence Africaine, Roma 1967: **104, 105;** G. Niangoran-Bouah, *L'univers akan des poids à peser l'or*, Les Nouvelles Editions Africaines, Abidjan 1984: 63; P. L. Ravenhill, Institute for the Study of Human Issue, Philadelphia1980: 140; R.F. Thompson, *The Flash of the Spirit*, Vintage Books, New York 1983: 67.

Museums

Fine Arts Museum of San Francisco, Gift of Vivian Burns, Inc., 74.8: **110a**
Fowler Museum of Cultural History, UCLA, Los Angeles: **53**
Indiana University Art Museum, Bloomington: **49**
Linden Museum Stuttgart: **52, 88, 99**
Musée des arts d'Afrique et d'Océanie, Paris, Photo RMN: **32, 33, 39, 44, 45, 48,** Photo RMN, M. Bellot: **1, 26,** Photo RMN, Arnaudet: **54,** Photo RMN, J.G. Berizzi: **55**
Collection Musée de l'Homme, Paris: 3, 141, 142, 145; Photo M. Duval: 7, Photo B. Hatala: **13, 16,** Photo D. Destable et Ch. Lenzaouda: **18, 28,** Photo D. Ponsard: **48, 62**
Documentation du Musée National d'Art Moderne, Centre Georges Pompidou, Paris, photo Ignatiadis: **111**
Museo Rietberg, Zurigo, Eduard von der Heydt Collection. Photo Wettstein & Kauf: **61, 65**
Musée Royal de l'Afrique Centrale, Tervuren, Belgium, Photo R. Asselberghs: **17, 31, 34, 38, 64, 108**
Museum für Völkerkunde Wien, Foto-Archiv, Foto Nr. 65.944: **69**
Museum voor Volkenkunde, Rotterdam: **110b**
National Museum of Ireland, Dublin: **25**
Peter Adler Gallery, London: **70**
Preussischer Kulturbesitz, Museum für Völkerkunde: 98; Photo Hesmera: **75,** Photo Waltraud Schneider-Schutz **81, 103,** Photo MV-Fotoatelier: **94, 95,** Photo E. Hesmerg: **102**
Smithsonian Institution, Dept. of Anthropology (cat. Nr. 341658): **12**
Sociedade de Geografia de Lisboa, Foto de Carlos Ladeira: **23**
Staatliches Museum für Völkerkunde Dresden, Eva Winkler: **80**
The British Museum, London: **14, 72, 89**
The Metropolitan Museum of Art, The Michael C. Rockfeller Memorial Collection, Bequest of Nelson A. Rockefeller, 1979 (1979.206.8): **63**
The National Museum of Denmark, Copenhagen, Department of Ethnography, Kit Weiss: **74**
The St. Mungo Museum of Religions Life & Art, Glasgow: **37**
The University of Iowa Museum of Art, Iowa City, The Stanley Collection, X 1986.512, UIMA, all rights reserved: **24**